MONUMENTAL JOURNEY

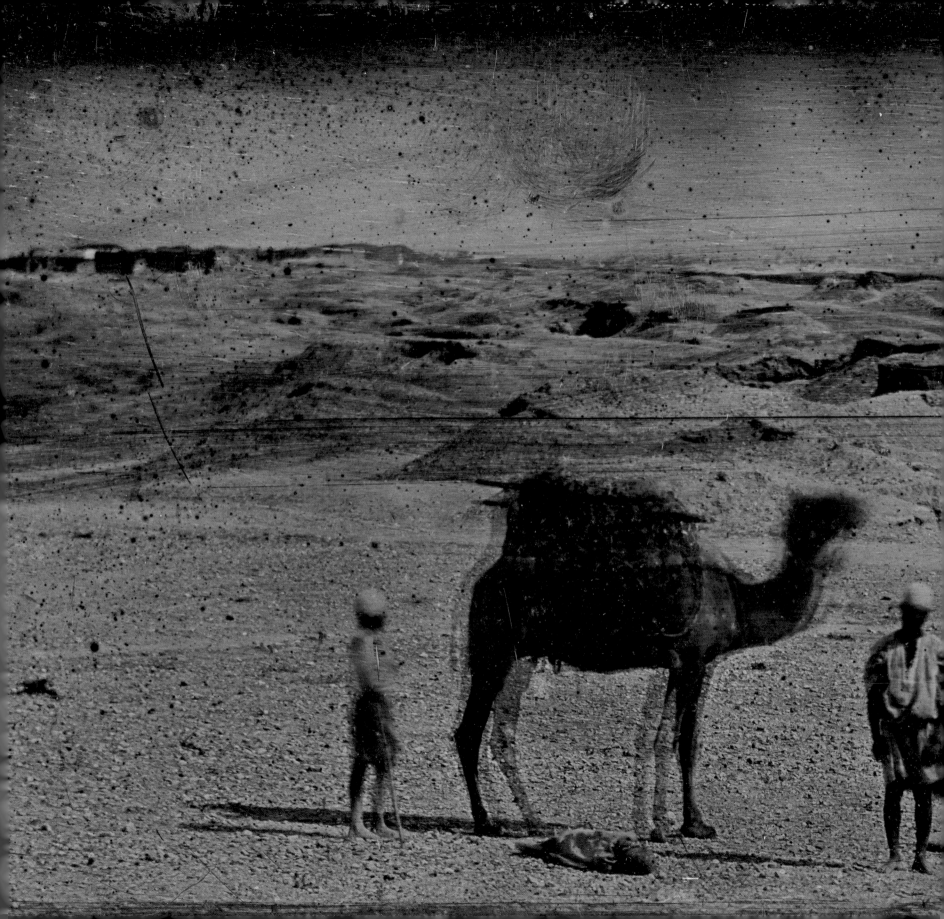

MONUMENTAL JOURNEY

The Daguerreotypes of Girault de Prangey

Stephen C. Pinson

With contributions by Sylvie Aubenas, Olivier Caumont, Silvia A. Centeno, Thomas Galifot, Nora W. Kennedy, Grant B. Romer, Martina Rugiadi, Andrea E. Schlather, Lindsey S. Stewart, Andrew Szegedy-Maszak, and Ariadna Cervera Xicotencatl

THE
MET

The Metropolitan Museum of Art, New York

Distributed by Yale University Press, New Haven and London

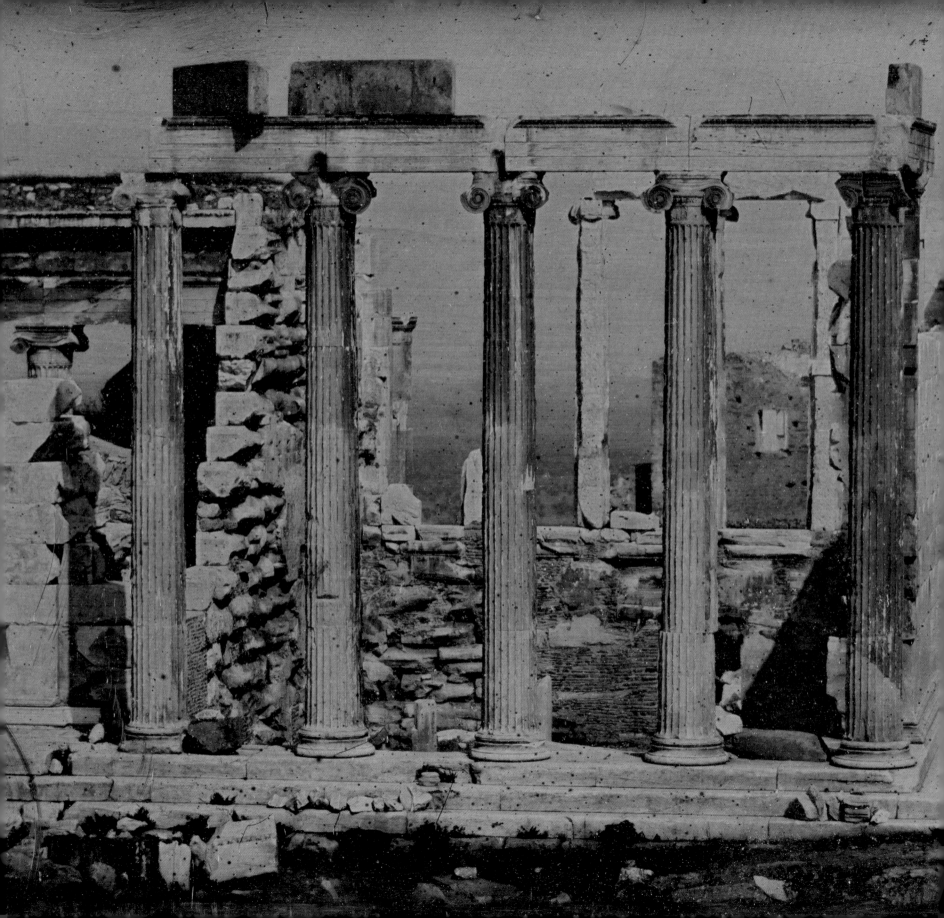

Contents

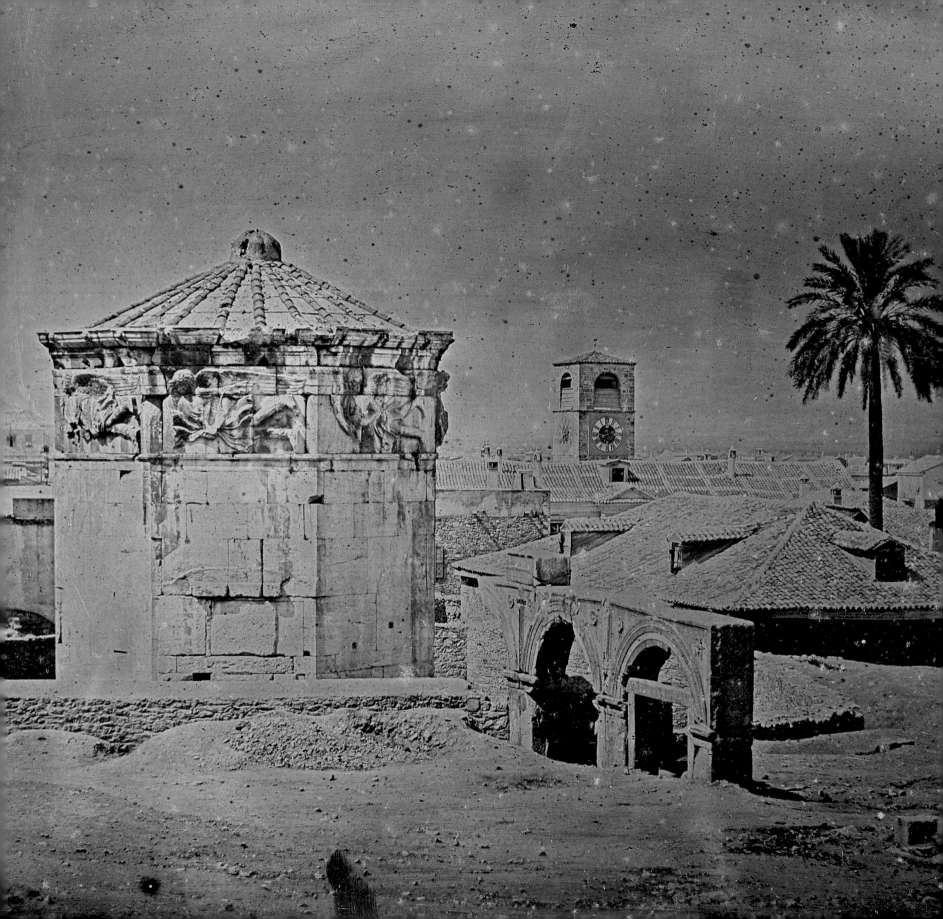

Director's Foreword

"M. GIRAULT IS HAPPILY NOT, in the choices he has to make, a devotee to any one particular genre; a partisan and propagator of progress, his cult is the equal and undifferentiated admiration of everything beautiful and interesting." Although written in 1843, this description of the artist, architectural historian, and daguerreotypist Joseph-Philibert Girault de Prangey seems especially apt today. Tech-savvy contemporary viewers are well equipped to appreciate his astonishing innovation as a pioneer photographer and the enduring splendor of his pictures. That the majority of the images he made when traveling throughout the Eastern Mediterranean from 1842 to 1845 are also the earliest surviving photographs of those places—some of which have been irrevocably altered by urban planning, climate change, or conflict—renders his accomplishment all the more significant. At the same time, Girault himself was the product of a complex network of political, social, and historical forces that had far-reaching impact on the West's relationship with the world he depicted. *Monumental Journey* endeavors to bring this complicated, important artist to life.

Conceived and organized by Stephen C. Pinson, Curator, Department of Photographs, the exhibition is the first monographic treatment of Girault in the United States and the first to focus on his daguerreotype campaign. It situates his photographic accomplishments within the nascent discipline of archaeology and against a backdrop of cultural preservation, colonial concerns, and technological change. We are profoundly grateful to the Arête Foundation and Betsy and Ed Cohen for their generous support of the exhibition and for helping us present Girault and his story to a wider public. We also recognize the Diane W. and James E. Burke Fund for making possible this beautiful catalogue.

The Met first exhibited daguerreotypes by Girault in the 2003 exhibition *The Dawn of Photography: French Daguerreotypes, 1839–1855*, thanks to generous loans from the Bibliothèque nationale de France, Paris. We are grateful to that institution's President, Laurence Engel, and to Sylvie Aubenas, Director, Département des Estampes et de la photographie, for their assistance in making this exhibition possible. We extend our gratitude to Her Excellency Sheikha Al Mayassa and the Qatar Museums, Doha, for opening their collection of Girault's daguerreotypes for study by our conservators. We also thank Olivier Caumont, Director of Culture and Curator, Musées de Langres, and we appreciate the generosity of the numerous public and private lenders to the exhibition, who are listed on page xi alongside this book's many talented contributors.

The Met's acquisition of works by Girault did not begin until 2015, thanks in large part to the initiative of Jeff L. Rosenheim, Joyce Frank Menschel Curator in Charge in the Department of Photographs. Our exemplary collection of his daguerreotypes would not have been possible without the generosity of many donors, most especially Joyce Frank Menschel, Mr. and Mrs. John A. Moran, Annette de la Renta, Dr. Mortimer D. Sackler, Theresa Sackler and Family, and the Joseph Pulitzer Bequest.

MAX HOLLEIN
Director, The Metropolitan Museum of Art

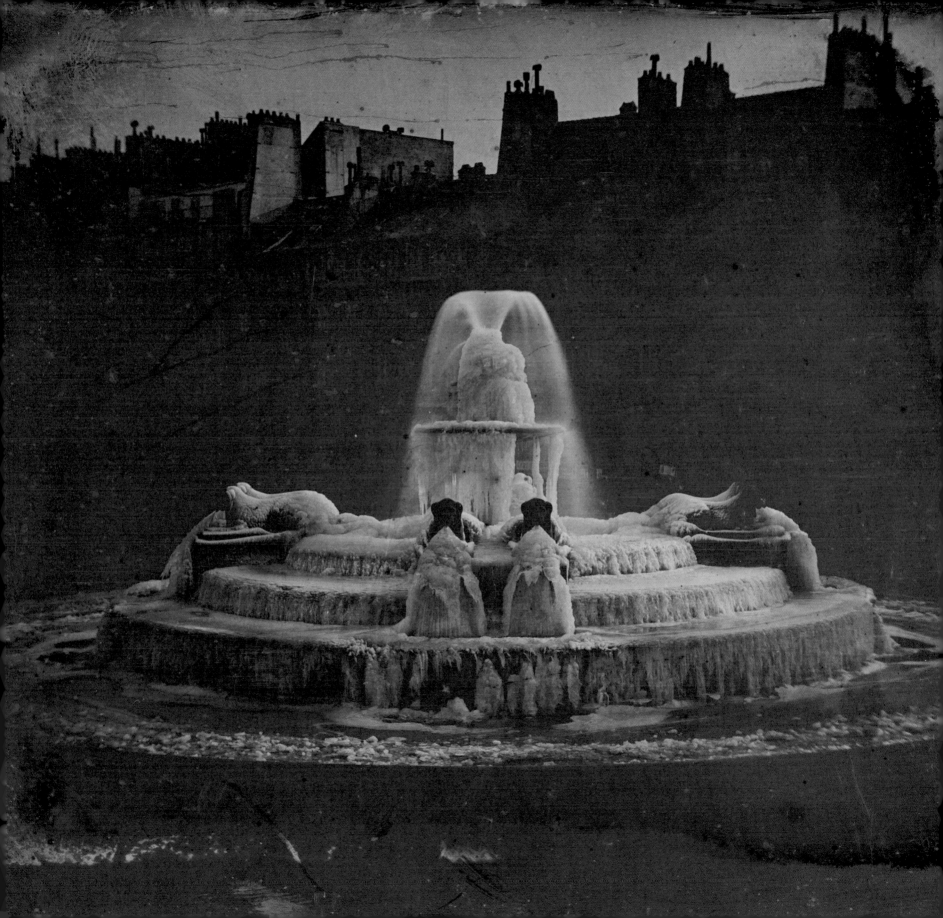

Acknowledgments

THAT THE JOURNEY to complete this exhibition and catalogue was approximately the same length as Girault's through the Eastern Mediterranean does not by itself provide evidence of similar achievement. However, I can testify that the effort put toward this project by an international, remarkable group of people was equally monumental. It is thus with deep humility that I express my thanks to everybody who had a hand in this project. I hope to thank the majority of them here.

First and foremost, I am indebted to Sylvie Aubenas, Director, Département des Estampes et de la photographie, Bibliothèque nationale de France (BNF), Paris, who has been a trusted partner in all things Girault since we first discussed a possible exhibition in November 2015. Sylvie oversees the most important institutional repository of Girault's work, and the exhibition would not have been possible without her deep knowledge and generosity. I also thank Curator of Photographs at the Musée d'Orsay, Paris, Thomas Galifot, who embraced the idea and is working with Sylvie to bring the exhibition to Paris. At the BNF, I thank Thomas Canzentre and Vanessa Selbach, both in the Département des Estampes et de la photographie. I also extend my thanks to Olivier Caumont, Director of Culture and Curator, Musées de Langres, for welcoming me to Girault's hometown and opening its rich collections of works by its native son. Of course, the exhibition would not have been realized without the exemplary generosity of Betsy and Ed Cohen and the Arête Foundation, together with the Diane W. and James E. Burke Fund's important support for the catalogue.

From the outset of this project, a number of people provided guidance and helped to open doors. My gratitude is owed to Mitra M. Abbaspour, Pierre Apraxine, Denis Canguilhem, Philippe Garner, and Darius Himes. Lindsey S. Stewart provided unfailing support and a wealth of information, as did Christophe Dutoit. I also acknowledge the individuals and institutions who agreed to lend works to the exhibition, listed nearby, and the many people who assisted with administrative tasks and research queries, both in person and from a distance: at the Qatar Museums, Doha, Martin Michael Byrne, Giles Matthew Hudson, Lucia Alberta Moutinho Dos Santos, and Sefa Saglam; at the Harry Ransom Center at the University of Texas at Austin, Barbara Brown, Diana Diaz Cañas, Roy L. Flukinger, Ester C. Harrison, and Jessica S. McDonald; at the J. Paul Getty Museum, Los Angeles, Sarah Freeman, Mazie M. Harris, Virginia Heckert, and Karen Hellman; at the National Science and Media Museum, Bradford, Kendra Bean, Geoffrey Belknap, Kirsty Fife, Rhiannon Jones, Sarah Murray, Vanessa Torres, and Zoe Wolstenholme; and at the Museum of Modern Art, New York, Lee Ann Daffner, Krista Lough, and Sarah Meister. Thanks are also due to Doris Behrens-Abouseif, School of Oriental and African Studies, University of London; Stephen Murray, Columbia University; and Bernard O'Kane, American University in Cairo.

At The Met, a virtual village arose in service of Girault, and I gratefully recognize this unparalleled museum community. I thank former Director Thomas P. Campbell for his initial encouragement and, for their continued support, Daniel H. Weiss, President and CEO; Max Hollein, Director; and Quincy Houghton, Associate Director for Exhibitions. For executing innumerable behind-the-scenes details to keep the exhibition on track, I thank Martha Deese, Senior Administrator for Exhibitions and International Affairs; Jennifer Spoley, Senior Production Manager for Exhibitions; Gillian Fruh, Manager for Exhibitions;

Rachel Ferrante, Exhibition Project Manager; Meryl Cohen, Exhibition Registrar; and Amy Lamberti, Associate General Counsel.

In the Department of Photographs, I owe special thanks to Jeff L. Rosenheim, Joyce Frank Menschel Curator in Charge; much-missed former Assistant Curator Beth Saunders; and Collections Manager Meredith Reiss, and I am grateful for the counsel and camaraderie of my colleagues Douglas Eklund, Curator; Mia Fineman, Associate Curator; Karan Rinaldo, Collections Specialist; and Elena Tarchi, Assistant Administrator, as well as former colleagues Myriam Rocconi and Anna Wall. Former curatorial research fellow Laetitia Barrere and longtime volunteer Jeanne Savitt deserve special mention for their early, essential aid. Departmental technicians Predrag Dimitrijevic and Ryan Franklin lent not only their support but also their hands in the ingenious framing and installation of works.

Conservation played a key role in both the research and planning of the exhibition, and I am grateful to my colleagues in the Department of Photograph Conservation, particularly Nora W. Kennedy, Sherman Fairchild Conservator in Charge, along with Lisa Barro and Katherine C. Sanderson, Associate Conservators; Natasha Kung, Research Assistant; and Mollie Anderson, Assistant Administrator. Special thanks go to Georgia Southworth, Associate Conservator, who prepared the works on paper alongside Mindell Dubansky and Sophia A. Kramer in the Sherman Fairchild Center for Book Conservation. In the Department of Scientific Research, I thank Research Scientist Silvia A. Centeno and former Annette de la Renta Senior Fellow Andrea E. Schlather.

For brilliant design and warm collegiality, I thank Exhibition Designer Fabiana Weinberg and Senior Graphic Designer Chelsea Amato, along with their Design Department colleagues Emile Molin, Anna Rieger, and Brian Butterfield. For bringing the design to life (and light), my deep appreciation goes to preparators Frederick J. Sager and Matthew Cumbie and lighting designers Clint Ross Coller, Richard Lichte, Amy Nelson, and Andrew Zarou. In the Digital Department, Paul Caro, Senior Manager of Media Production and Technology Services; Kate Farrell, Managing Producer; Melissa Bell, Producer; Bryan Martin, Production Coordinator; and Alex Guns, Audio-Visual Specialist, together with director Jonathan Chekroune, all lent their talents to the video featured in the exhibition, and in the Department of Greek and Roman Art, Seán Hemingway, John A. and Carole O. Moran Acting Curator in Charge, and Jennifer S. Soupios, Associate Manager for Collections, facilitated the film shoot in their galleries. I would also like to acknowledge colleagues in the departments of Education: Sandra Jackson-Dumont, Frederick P. and Sandra P. Rose Chairman; Darcy-Tell Morales, Associate Educator; and Julie-Marie Seibert and Marianna Siciliano, Assistant Educators; Development: Jason Herrick, Chief Philanthropy Officer; and Marilyn B. Hernández, Deputy Chief Development Officer for Individual Giving; Communications and Marketing: Kenneth Weine, Vice President and Chief Communications Officer; Alexandra Kozlakowski, Senior Publicist; and Micol Spinazzi, Associate Publicist; Drawings and Prints: Nadine M. Orenstein, Drue Heinz Curator in Charge; Ashley Dunn, Assistant Curator; and Elizabeth Zanis, Collection Specialist; and European Paintings: Asher E. Miller, Associate Curator.

The beautiful book in your hands is due to a formidable editorial team led by Mark Polizzotti, Publisher and Editor in Chief, assisted by Gwen Roginsky, Associate Publisher and General Manager; Peter Antony, Chief Production Manager; and Michael Sittenfeld, Senior Managing Editor. I am deeply grateful to Image Acquisition Manager Elizabeth De Mase and Production Manager Paul Booth, respectively, for their expert handling of reproduction rights and production, and to Senior Editor Marcie M. Muscat for her gracious spirit and top-notch editing. Thanks also to designer Carl W. Scarbrough, cartographer and artist Adrian Kitzinger, translator Rose Vekony, and bibliographer Giada Damen, as well as to Senior Editor Jennifer Bantz for editing the exhibition labels and text panels.

Finally, I thank all the authors for their critical insights, with special thanks to Grant B. Romer for several supportive emails during the writing of my own essay. And thanks to Jon Wagner, Hana Perez, Dustin Duke, Ali Fard, and Ricard Valero for believing in GdP.

STEPHEN C. PINSON
Curator, Department of Photographs, The Metropolitan Museum of Art

CONTRIBUTORS TO THE CATALOGUE

STEPHEN C. PINSON is Curator, Department of Photographs, The Metropolitan Museum of Art, New York.

SYLVIE AUBENAS is Director, Département des Estampes et de la photographie, Bibliothèque nationale de France, Paris.

OLIVIER CAUMONT is Director of Culture and Curator, Musées de Langres, France.

SILVIA A. CENTENO is Research Scientist, Department of Scientific Research, The Metropolitan Museum of Art, New York.

THOMAS GALIFOT is Curator of Photographs, Musée d'Orsay, Paris.

NORA W. KENNEDY is Sherman Fairchild Conservator in Charge, Department of Photograph Conservation, The Metropolitan Museum of Art, New York.

GRANT B. ROMER is Founding Director, Academy of Archaic Imaging, Rochester, New York.

MARTINA RUGIADI is Associate Curator, Department of Islamic Art, The Metropolitan Museum of Art, New York.

ANDREA E. SCHLATHER is former Annette de la Renta Senior Fellow, Department of Scientific Research, The Metropolitan Museum of Art, New York.

LINDSEY S. STEWART is an independent scholar and photography consultant in London.

ANDREW SZEGEDY-MASZAK is Jane A. Seney Professor of Greek and Professor of Classical Studies, Wesleyan University, Middletown, Connecticut.

ARIADNA CERVERA XICOTENCATL is Scholar in Residence, Academy of Archaic Imaging, Rochester, New York.

LENDERS TO THE EXHIBITION

Bibliothèque nationale de France, Paris
The J. Paul Getty Museum, Los Angeles
Pierre de Gigord
Frédéric Hoch
Serge Kakou
W. Bruce and Delaney H. Lundberg
Jennifer and Philip Maritz
Musées de Langres
National Science and Media Museum, Bradford
Private collections
Qatar Museums, Doha
Harry Ransom Center, The University of Texas at Austin
Mike Robinson
Daniel Wolf

COORDINATING CURATORS, FRANCE

SYLVIE AUBENAS, Bibliothèque nationale de France, Paris
OLIVIER CAUMONT, Musées de Langres
THOMAS GALIFOT, Musée d'Orsay, Paris

NOTE TO THE READER

National borders in Girault's lifetime, particularly in the regions encompassed by the former Ottoman Empire and the modern Middle East, were differently and often less concretely defined than they are today. Accordingly, geographic locations throughout the catalogue are referred to using nineteenth-century naming conventions, in acknowledgment of how these places would have been known to and understood by Girault and his contemporaries. For clarity, modern place names are also provided where possible and as appropriate.

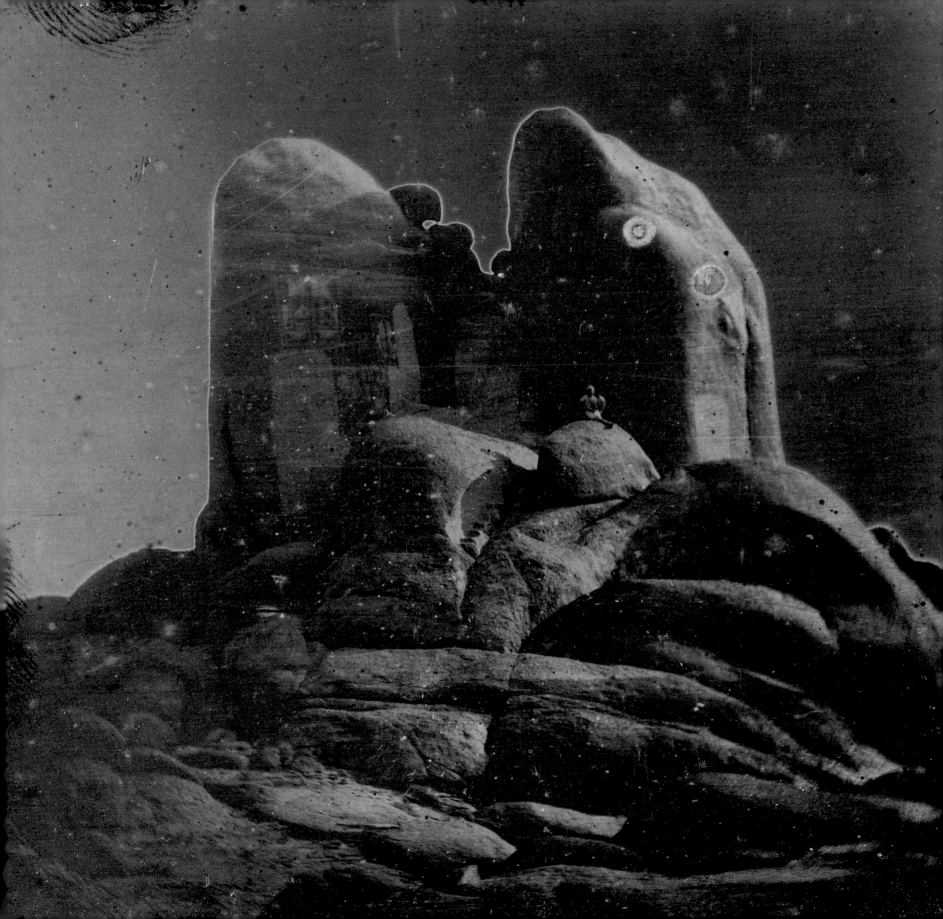

MONUMENTAL JOURNEY

The Odyssey of an Artist and His Work

Sylvie Aubenas

JOSEPH-PHILIBERT GIRAULT DE PRANGEY was born in Langres, Haute-Marne, on October 21, 1804, the scion of two families that had been part of the Langres aristocracy since the sixteenth century. The deaths of his siblings at an early age, of his father in 1819, and of his mother in 1825 rendered him the sole heir to a fortune that included the Hôtel Piétrequin, a seventeenth-century mansion in Langres formerly owned by his maternal uncle, as well as numerous lands and properties in the surrounding area. He could have followed the traditional professions of his family—many had joined the military or clergy; some were scholars—but he instead chose the arts. At barely twenty years old, he oriented his future to suit his tastes, taking "drawing classes at the city's art school along with [Jules] Ziegler, [Joseph] Berger, [Joseph] Lescornel, and other artists.... Then he went to Paris and, heeding only his penchant for the fine arts, took lessons in various studios from the great landscape painters of the period,"[1] namely François-Edme Ricois and Jules Coignet (fig. 1). In addition to these studies, Girault earned a Bachelor of Arts degree in 1826 and a Bachelor of Laws two years later.

Upon returning to Langres, he joined a group of well-born, well-educated young people who had undertaken the study of their city's glorious past; for enclosed within its ramparts

FIG. 1. Jules Coignet (1798–1860), *View of Beirut*, 1844. Oil on paper, laid down on canvas, 13⅛ × 20⅜ in. (33.3 × 51.7 cm). The Metropolitan Museum of Art, New York, The Whitney Collection, Promised Gift of Wheelock Whitney III, and Purchase, Gift of Mr. and Mrs. Charles S. McVeigh, by exchange, 2003 (2003.42.12)

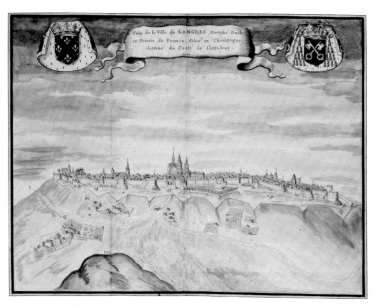

FIG. 2. French, 18th century, *Vue de la ville de Langres*, ca. 1700. Ink wash and watercolor, 14⁵/₁₆ × 18¹⁵/₁₆ in. (36.6 × 48.2 cm). Bibliothèque nationale de France, Paris (VA-52 2)

and overlooking a vast horizon, Langres was rich in ruins from the Roman period up to the eighteenth century (fig. 2). The tendency was in keeping with a general movement in France at that time to preserve and study its architectural and artistic treasures. The exercise proved a powerful distraction for the sons of noble families that were adversely affected by the Revolution and who were disappointed by the accession to power in 1830 of Louis Philippe I, a king they deemed too bourgeois. According to one contemporary account, "In 1833, a group of art lovers from Langres … formed a committee and … inventoried the inscriptions and the many remnants of sculptures scattered throughout the city. Girault de Prangey was one of the most active members of this committee, which in 1842 became the nucleus of the Société historique et archéologique de Langres" (figs. 3, 4).[2]

Amid his activities at home, in 1831 Girault embarked on his first trip abroad, visiting Italy, as was expected of any young artist. Then, from 1832 to 1834, he toured Tunisia, Algeria, Spain, Sicily, and, following

the example of his teacher Coignet, Switzerland. He devoted a particularly long stay to Andalusia and Sicily, where he took interest in what was then called "Arab" architecture (fig. 5). The influence of the latter would linger: upon Girault's return to France after the second journey, he partook to build a villa outside Langres, at Courcelles-Val-d'Esnoms, and modeled its gardens on those of the Alhambra. He also decided to publish a collection of lithographs based on the drawings he had made in Spain. Part 1 of *Monuments arabes et moresques de Cordoue, Séville et Grenade* appeared in 1836, with parts 2 and 3 following by 1839. In 1841 he published a companion text, *Essai sur l'architecture des Arabes et des Mores, en Espagne, en Sicile et en Barbarie*, and a year later followed with another book of lithographs, *Choix d'ornements moresques de l'Alhambra*.

It was about this time that Girault began experimenting with daguerreotypes, capturing several photographic views of Parisian monuments (see Thomas Galifot's essay in this volume, pp. 170–75). He made use of this new technology during his next journey abroad,

which from 1842 to 1845 would take him back to Italy and across the Eastern Mediterranean (figs. 6, 7). The photographs he made there would serve as a reference for illustrations in numerous publications he was planning. In 1846 he published *Monuments arabes d'Egypte, de Syrie et d'Asie-Mineure*. Between 1847 and 1849, he wrote five articles for the *Bulletin de la Société historique et archéologique de Langres*. Finally, in 1851 he published *Monuments et paysages de l'Orient*, a set of chromolithographs based on the paintings, drawings, and photographs he had made on-site during his journey. This costly volume, produced at his own expense, never won him the scholarly recognition he expected, even though his body of writings had prompted his election, in 1846, as an honorary member of the Royal Institute of British Architects. Save for a few contributions to local periodicals and specialized publications,[3] he thereafter ceased his publishing activities.

He did, however, continue to travel—to Dijon, Paris, and Switzerland—and to make daguerreotypes through the early 1850s, as attested by sixty-one views of Switzerland now in the Musée Gruérien in Bulle (pls. 120–23), and by several views of his villa at Courcelles-Val-d'Esnoms, the construction of which was then nearing completion. Nestled against a sunny cliff and watered by abundant springs, it was the perfect place to pursue his other passion: cultivating rare flowers and exotic fruits in greenhouses. He also created a lavish garden, at first modeled on the gardens of the Alhambra, and then on those of the Golden Horn, reflecting the influence of his travels.

Thereafter dividing his time between his idyllic country outpost and the mansion in Langres, Girault primarily kept the company of those who shared his interests and aspirations, among them Nicolas Perron, a medical doctor and orientalist scholar who had lived in Algiers

FIG. 3. Henri Lesecq des Tournelles (1818–1882), "Vue de Langres," from *Recueil: Monuments de l'est de la France*, 1851. Salted paper print. Bibliothèque nationale de France, Paris (FOL-VE-643)

FIG. 4. Alfred Guesdon (1808–1876) after Girault, *Cathédrale Saint-Mammès, Langres*, ca. 1850. Lithograph, 12¾ × 9¾ in. (32.3 × 24.7 cm). Musée d'art et d'histoire, Langres (R 2008.1.10.1)

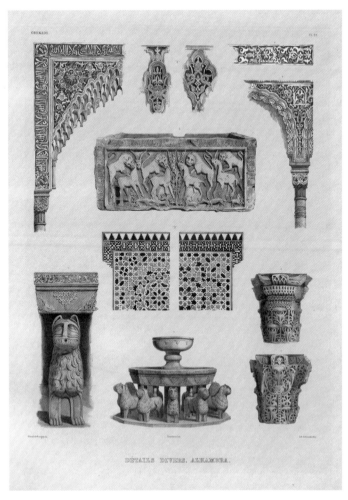

FIG. 5. "Détails divers, Alhambra," from *Monuments arabes et moresques de Cordoue, Séville et Grenade*, ca. 1837. Lithograph by Léon-Auguste Asselineau (1808–1889) after Girault, 22¼ × 16¾ in. (56.5 × 42.5 cm). The Metropolitan Museum of Art, New York, Harris Brisbane Dick Fund, 1944, transferred from the Library (1991.1073.20)

and Egypt, where Girault visited him (pl. 65), and who had stayed in Langres in 1847; Alfred Clerc, from Langres, who had also lived in Egypt; the scholar Théodore Pistollet de Saint-Ferjeux; and A. Demongeot de Confévron. With the deaths of his friends, however, he gradually withdrew from local society and, according to contemporary accounts, toward the end of his life made only brief appearances: "When he came to Langres, he would generally stroll along the circle, where his visits were unwelcome; people dreaded his verbal attacks."[4]

Given his character, "often a bit brusque and very biting,"[5] along with his uncommon way of spending his inheritance, he was viewed as an eccentric and a misanthrope within the conservative milieu of Langres. He died at his villa on December 7, 1892.

"With no concern for his brothers, heedless of the future, Joseph-Philibert Girault de Prangey, a solitary dreamer, built for himself alone a fragile plaything that disappeared along with him."[6] This somewhat harsh epitaph by a distant relative, comte Charles de Simony (1869–1952), sums up the general opinion of Langrois society toward Girault at the time of his death. Simony made the claim in 1934 at a conference at the Académie de Dijon, where he delivered a lecture on Girault called "The Curious Figure of an Artist." Beneath the mantle of this constraining title, Simony helped create the image of a man that was far from reality but has proved enduring, since his assessment has long served as the main reference on the artist.

The hundreds of daguerreotypes Girault produced during his Mediterranean voyage retained a mythic quality into the second half of the twentieth century. While they do not comprise his entire body of work, they are inarguably its heart—its raison d'être. To this day, many remain the first, if not the only, photographic records of important archaeological sites and celebrated cities that have been transformed or destroyed since the 1840s.[7] They were, in fact, famous even before they were produced: in January 1842, shortly before his departure to the Eastern Mediterranean, the artist's project was lauded by the Société française pour la conservation des monuments, whose *Bulletin monumental* reported on Girault's intentions "to study the origin of the Gothic arch and the factors that led to its appearance following Byzantine architecture … he will sometimes employ daguerreotypes, the utility of which the Académie des inscriptions recognized in one of its last meetings. This method … offers invaluable information … especially in the hands of an artist who knows how to use it in a way to reproduce objects in their proper aspect and in the conditions most beneficial to science."[8] A special edition of the *Bulletin monumental* issued upon his return reported on his photographic bounty: "[M. Girault de Prangey] has just arrived in Paris with a wealth of observations and images taken by daguerreotype: we estimate the number of

views daguerreotyped by M. de Prangey at three thousand. Privileged with health that did not flag for a single instant, M. de Prangey took full advantage of his three years of travel, with the zeal and acumen that he has always demonstrated, and one can appreciate all the important results for science that such an exploration produced."[9]

Three thousand appears to be an exaggerated figure, but this exaggeration is part of the legend; today, the known number of daguerreotypes is a little more than a thousand, which is not in itself inconsiderable, and accords with a statement made in an obituary of the artist by Henry Brocard: "The number of Daguerreian plates that he brought back [from the Mediterranean] is considerable; they fill immense cases and are filed in perfect order."[10] It was Simony who would discover these cases in the ravaged attic of Girault's villa. He purchased the house in 1920, decades after Girault's death, for the artist had no direct heirs, and his estate had been left in a period of limbo. The estate first passed to a distant cousin, Adrien de Tricornot, who entrusted its stewardship to Girault's longtime gardener, Claude Blin, and his family. The Blins, faithful employees of Girault's, lived in a house built for them on the property. Beginning in the 1850s, they were joined in service to Girault by Marie and Gérard Flocard and their great-grandson, Robert. The estate remained in the care of the Blins and the Flocards after Tricornot's death, in 1902. However, after Claude Blin died, in May 1914, and his son, Lucien, was killed at Les Vosges that December, at the start of World War I, the villa was abandoned: the rare plants perished, the garden grew wild, and the buildings fell into disrepair. Robert Flocard (1905–1998) was the last to bear witness to the villa's splendor, which he described to former Musées de Langres curator Philippe Quettier in 1997, just before his death.[11]

Simony, in effect, salvaged a ruin on the brink of destruction. Speaking of the collection at the abovementioned conference in Dijon, Simony recounted, "In a dark loft, a pile of rectangular boxes lay abandoned—the collection, no doubt complete, of the daguerreotypes brought back from Girault de Prangey's travels in the Eastern Mediterranean and in Upper Egypt in 1843 and 1844."[12] Simony also noted that Girault had taken a census of the contents of the boxes on at least

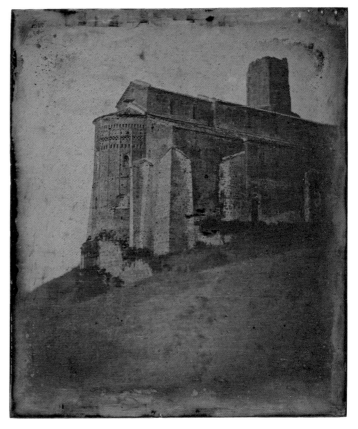

FIG. 6. Girault de Prangey, *Apse, Basilica San Pietro, Toscanella (Tuscania)*, 1842. Daguerreotype, 3¾ × 3⅙ in. (9.5 × 8 cm). The Metropolitan Museum of Art, New York, Purchase, Mr. and Mrs. John A. Moran Gift, in memory of Louise Chisholm Moran, Joyce F. Menschel Gift, Joseph Pulitzer Bequest, 2016 Benefit Fund, and Gift of Dr. Mortimer D. Sackler, Theresa Sackler and Family, 2016 (2016.607)

two occasions, in 1865 and 1880, with the help of the parish priest. The storage boxes bear inscriptions referencing this informal inventory. The daguerreotypes themselves, however, are numbered, not sequentially or chronologically, but rather according to their format (e.g., half or quarter plate; see p. 206 for Girault's system of numbering and notation). To illustrate his lecture, Simony presented "a magnificent selection of daguerreotypes, mostly of views of Italy and Asia-Minor,"[13] representing the first time the images were displayed publicly.

After the war, in 1947, Simony was approached about the collection by some "American *amateurs*."[14] Their query awakened Simony's interest and ascribed financial value to the collection, even though the "market"

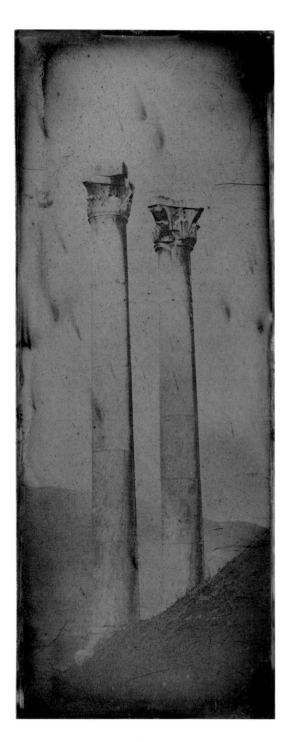

FIG. 7. Girault de Prangey, *Temple of Bacchus, Athens*, 1842. Daguerreotype, 9⁷⁄₁₆ × 3¾ in. (24 × 9.5 cm). The Metropolitan Museum of Art, New York, Purchase, Philippe de Montebello Fund, Mr. and Mrs. John A. Moran Gift, in memory of Louise Chisholm Moran, Joyce F. Menschel and Annette de la Renta Gifts, and funds from various donors, 2016 (2016.95)

for historic photography was yet in its infancy. On the advice of his friend Pierre Quarré, curator of the Musée de Dijon, Simony reached out to the Bibliothèque nationale de France (hereafter BNF) and confided to Jean Prinet, curator in the Département des Estampes et de la photographie, "I would gladly part with some of these plates."[15] So began a two-year exchange between Simony and Prinet, from February 1948 to July 1950. Prinet showed interest in acquiring "some or all of the daguerreotypes that you saved. As of now I think that the first and the last box that appear on your list would have a place here."[16] At the time he was preparing an exhibition as part of the centennial commemoration of the 1848 Revolution, and he asked Simony whether some of the images might be suitable for inclusion. Simony replied, "The only images that may be of interest for your exhibition depict Parisian monuments—Tour St-Jacques, Notre-Dame, Fontaine des Pyramides, etc. But there is one that you might like. It shows a military parade in the Tuileries. An extraordinary plate" (see fig. 40).[17] The selection he described relates to the group proposed as a gift in July 1949 and finally donated unconditionally to the BNF in March 1950, in return for which Simony hoped to get help selling the remainder of the collection.[18]

Writing to Prinet on March 30, 1950, Simony enclosed with his letter a list of all twenty-nine boxes containing Girault's works, as well as a brief description of their contents: "There are about a thousand plates. I am still determined to negotiate the sale of this collection and would be grateful for any help you could give me in this matter."[19] In June 1950, when he officially made his gift to the library, he made another entreaty for the BNF to acquire the collection: "I hope that these pieces will interest you. Given their size, their artistic value, and their rarity, they form a curious group. But do not forget that I have about nine hundred more, rarer and even more curious."[20] Unfortunately, Prinet settled for the gift alone, and he sent Simony to the collector Georges Sirot, and then to the president of the Société française de photographie, Georges Poivilliers, for appraisal and potential acquisition of the rest of the collection.[21]

Simony also offered sixty-one images taken in and around Switzerland to Henri Naef, curator of the Musée Gruérien, on the advice of a

mutual friend, Henri Charrier, who was then secretary general, and later president, of the Académie des sciences et belles-lettres de Dijon. Finally, on July 2, 1952—the year of his death—Simony wrote to the collector Helmut Gernsheim after seeing his name in *Paris Match* in an article about the early photography pioneer Nicéphore Niépce.[22] Gernsheim and his wife visited the count's family and chose ten plates for acquisition; these were subsequently published in 1955 and 1956.[23] Some years later, in 1970, Simony's heirs approached the collector and bookseller André Jammes, who gave them advice on conserving the plates, which had remained bare and unglazed in their boxes since 1844, thus risking damage.[24] Jammes's actions were decisive in safeguarding the collection. He received several dozen plates on that occasion. During the same period, Bernard Marbot, the newly appointed curator of early photographs at the BNF, sought in vain to reestablish relations with Simony's family.

It was only toward the end of the twentieth century that Girault's work began to garner significant attention. Fittingly, the Musées de Langres organized the first exhibition devoted to the artist, in 1998, reproducing in the accompanying catalogue numerous watercolors and drawings that Girault made during his travels.[25] Concurrent with this event, negotiations were taking place between Simony's descendants and the BNF, which in 2000 acquired 158 daguerreotypes, several of which would be included in an exhibition of French daguerreotypes at the Musée d'Orsay and The Met in 2003.[26] Sales at Christie's in London between 2000 and 2004 led to more of Girault's works entering the collections of major institutions, notably the J. Paul Getty Museum, Los Angeles, and the Qatar Museums, Doha,[27] with exhibitions following in due course. In 2001, several of the daguerreotypes that the BNF had acquired a year earlier were presented to the public for the first time in the exhibition *Voyage en Orient: Photographies, 1850–1880*,[28] together with the lithographs for which they had served as models. In 2005 to celebrate its reopening after renovation, the Getty Villa in Malibu organized an exhibition of early photographs of archaeological sites, dedicating an entire chapter of the catalogue to Girault.[29] And in 2008, the Musée Gruérien presented the sixty-one views of Switzerland and France that had been donated to the museum by Simony in 1950. The show's catalogue recounts the incredible circumstances that led to the rediscovery of these treasures in 2002, as well as new information on the collection and a more comprehensive biography of the artist.[30]

In 2008, Sotheby's fourth and final sale of the photography collection of Marie-Thérèse and André Jammes included thirteen of the daguerreotypes they had received from the Simony family in 1970.[31] At the same time, the BNF purchased twelve other plates from the collectors, who then donated to the library a thirteenth. It also obtained another whole plate that had been in the possession of the Simony family; it was the last work by Girault to enter the library's collection. Seventy-four additional daguerreotypes were brought to market in 2010, in a sale at Christie's held at the request of Simony's descendants,[32] but it must be noted that, among the hundreds of daguerreotypes remaining in their possession, some may have been sold privately, leaving no bibliographic record. Nevertheless, thanks to numerous sales and exhibition catalogues, as well as several online databases,[33] more than five hundred plates are now available to researchers, either directly or as reproductions.

Last but not least in this story of twists and turns, it seems certain that in the six years (1914–20) that Girault's villa was left untended, between the death of its steward and its purchase by Simony, residents of the region pilfered boxes of daguerreotypes, among other of the artist's former possessions. Girault may also have given away some of this material prior to his death. At least two of these boxes have resurfaced: one with thirty-six views of Italy and another with views of France, Italy, Egypt, and Greece, which was put up for auction by Christie's in November 2015. The set that Simony found in the attic in 1920 was thus incomplete. As noted, Girault did not make a comprehensive inventory of the entire collection, so it is difficult to know for certain how many daguerreotypes did at one time exist. The box lists made by Simony are therefore the only documentation that remains. So, while we know there were more than one thousand, the exact number of plates in Girault's corpus, like so many other details of this extraordinary artist's life, remains a mystery.

Splendor in the Dust

Stephen C. Pinson

THE SURVIVAL OF Girault de Prangey's collection of daguerreotypes is remarkable, but not necessarily unintentional. As Sylvie Aubenas has demonstrated (see pp. 1–7), Charles de Simony, who discovered the collection, is responsible for salvaging the daguerreotypes and facilitating their dispersal among numerous collectors and institutions. Equally important is the fact that Girault, in his very conception of the collection, created the conditions by which such a redeployment could occur. This point is worth making because so few daguerreotypes from the same period, particularly before 1845, are known to exist. For that matter, much of Girault's own, related material (photographic equipment, correspondence, travel notes, and sketches) has yet to be recovered. So, why are his daguerreotypes different? At the most basic level, Girault protected his daguerreotypes by storing them in custom-built wood boxes (see p. 186); in addition, he carefully sorted, labeled, and dated the images so that he could retrieve them for future use, occasionally recording when he utilized them, for example, as the basis for a painting or published print (fig. 8). He also had them inventoried several times during his lifetime, possibly with an eye to future publications or as a donation to his hometown museum; whatever his intentions, he certainly seems to have had posterity in mind.[1]

FIG. 8. Label on the verso of Girault's *Ruins and Foreground, Acropolis, Athens* (pl. 40)

FIG. 9. Girault de Prangey, *Cast from the Alhambra*, 1832–33. Plaster, 13 × 9¹⁵⁄₁₆ × 2⅜ in. (33 × 25.2 × 6 cm). Musée d'art et d'histoire, Langres (2018.0.116.1)

Such an archival approach to photography was precocious at the time, even if today it seems commonplace. Our smartphones store collections of data-sorted images, all retrievable through the flick of a finger, which makes Girault seem relatable, even modern. For Girault, however, making a photograph was difficult. He was an innovator of what was then a brand-new, cutting-edge technology. Using an oversize, custom-made camera, he exposed more than one image on a single plate to create at least six different formats (see pp. 185–86), including unprecedented horizontal panoramas and narrow vertical compositions that suited the profiles of some of his subjects: towers, columns, and minarets. Several of his multiple-exposure plates, left uncut, now present instructive comparisons and surprising juxtapositions (pls. 15, 49, 56). The resulting archive is unique not only in its appearance but also in its scope, scale, and ambition. No other photographer of the period embarked on such a long excursion and successfully made a quantity of plates anywhere near Girault's production of more than a thousand daguerreotypes (see p. 206).[2] His photographic campaign remains a feat without analogy.

Girault was also the first daguerreotypist to methodically use the medium in the service of a specific scientific goal—a comparative study of Eastern and Western architecture—which makes him a pioneer of archaeological photography at a time when archaeology itself was a nascent discipline.[3] Archaeology and photography came of age simultaneously in the 1840s, which perhaps explains their close affinity, a correspondence the archaeologist Michael Shanks has termed "archaeography."[4] For Shanks, the two disciplines are types of site-specific engagements—what he calls "arrested or fragmented moments"—that continue to unfold in the present, most productively in the form of archives or collections. Girault, judging from evidence in his few surviving letters—he refers to his collection as a "picturesque harvest" and as the "spoils of battle"—similarly viewed the daguerreotype as a product of place-based labor, a literal type of fieldwork in which the photographic process was his tool. Having already made plaster casts both in Langres and at the Alhambra (fig. 9), he unsurprisingly characterizes the new process as something similar: the "precious and incontestably faithful imprint" of sites visited.[5] For Girault, then, the daguerreotype

was not only a means of representation but also an artifact similar to a sherd obtained by looting or excavation, the process by which archaeology would henceforth collect its primary data (fig. 10).[6] From the beginning, he conceived of his daguerreotypes as precious objects, priming them for future discoveries, translations, and interpretations, and setting in motion an evolving relationship to the sites depicted.

Following Simony's recovery of the collection, Western subjects were initially prized over Eastern ones, not only by the French curator Jean Prinet (see p. 6) but also by Helmut Gernsheim. Of the ten plates Gernsheim acquired, only two depicted sites outside of Greece and Italy.[7] Beaumont Newhall, who at the time was in charge of the photography collection at the George Eastman House in Rochester, New York, disregarded the depicted subjects completely, telling Gernsheim that the museum already had enough early French daguerreotypes.[8] By the time the collection publicly resurfaced in the early 2000s, the growth of the heritage industry, along with increased Western intervention in the Middle East after September 11, 2001, spurred renewed interest in Girault's images from Egypt, Anatolia, Syria, Lebanon, and Jerusalem, which are the earliest surviving photographs of these regions. The ongoing vulnerability of sites in many of these places lends these daguerreotypes even more import today.

Photography's intersection with Western interests in the Middle East, however, dates back to the medium's origins in the 1830s. During an episode known in France as the "oriental question," Russia and Syria (which included present-day Lebanon, Jordan, Israel, and the Palestinian territories) were making headlines, not unlike in our own recent history.[9] A renegade commander from the Ottoman army, Muhammad 'Ali, had taken control of Egypt and parts of Syria and by 1838 also was threatening Constantinople (Istanbul). Russia, meanwhile, was making incursions into Syria against the interests of France and England. Alone among the European powers, France initially backed Egypt, in which it already had claimed a colonial stake, but it eventually sided with the Ottoman Empire in order to maintain the status quo.

It was against this backdrop that Girault, a privileged aristocrat, undertook his photographic campaign, which did not, as Martina

FIG. 10. Cartonnage fragment from a mummy case. Egyptian, Memphite period, 3rd millennium B.C. Painted plaster, 7⁵⁄₁₆ × 6¹¹⁄₁₆ in. (18.5 × 17 cm). Musée d'art et d'histoire, Langres, originally donated by Girault to the Société historique et archéologique de Langres, 1844 (847.4.18)

Rugiadi demonstrates in this volume (see pp. 157–63), transcend questions of cultural hegemony. On the other hand, his encounter with the Mediterranean was not wholly inequitable. He regretted the retreat of Egypt from Palestine and Syria but did not hold France blameless for the resulting lack of government, which, he claimed, led to endless "revolts, pillaging, and murders."[10] He also criticized certain health regulations issued by Clot Bey (Antoine-Barthélémy Clot), the French doctor recruited as Muhammad 'Ali's surgeon-in-chief.[11] Upon his return to France, Girault constructed the perfect manifestation of a fantasized "Orient," a villa filled with exotic plants and birds constructed on a site known as Les Tuaires (fig. 11); but he also genuinely admired the domestic architecture and *khans* (inns) of Syria for what might now be called their "global aesthetic."[12] If, like Gustave Flaubert in Egypt, he was able to appreciate that "splendid things gleam in the dust," it was not because he could only see the East's past triumphs as illuminated by the light of Western civilization. Rather, Girault's encounter with the Mediterranean was dynamic, and marked by contrast.[13] A medieval revivalist and

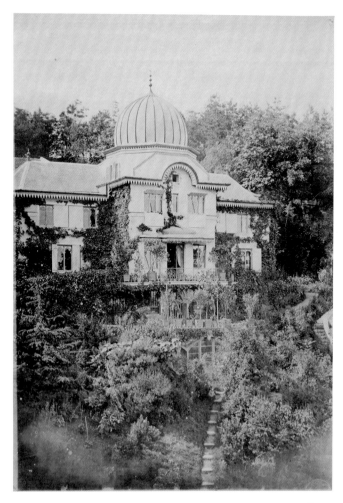

FIG. 11. Attributed to Girault de Prangey, *Villa at Les Tuaires*, 1860s. Albumen print, 10¾ × 7½ in. (27.3 × 19.1 cm). Musée d'art et d'histoire, Langres, Fonds Flocard (2012.14.1)

printmaker of the picturesque, he was also an adventurer and archaeologist with a penchant for new technology. All of these qualities played a part in fashioning his identity and forging his legacy.

MONUMENTAL HISTORY

One of Girault's earliest daguerreotypes is a self-portrait in which he sits before an arabesque backdrop, presumably at his villa, presented not as a photographer but as an artist (pl. 1). In one hand he prominently

displays a drawing stick, most likely a Conté crayon, a precursor to our modern pencil. His other arm rests along the top of a bound folio volume with gilt lettering on the spine. The title is illegible, but it is easy to imagine that it is one of Girault's own recently published volumes from *Monuments arabes et moresques de Cordoue, Séville et Grenade*.[14] It is telling that he chose to present himself with a pencil rather than with a paintbrush or maulstick. He was, after all, a proficient painter. His teachers were respected landscapists, Jules Coignet and François-Edme Ricois, who, as evidenced by Girault's two major Salon showings—a classicizing view of Saint Mark's Square in Venice (fig. 12), shown in 1831, and a picturesque, more overtly Romantic scene of the Alhambra (fig. 13), shown in 1836—equipped him with the prevailing modes of depiction for painting in 1830s France. The Venetian scene was the product of Girault's first visit to Italy (ca. 1830–31), a coming-of-age ritual for all wealthy young artists at the time. The Alhambra painting was the result of a much more decisive journey to Spain, at the end of which he emerged as the subject of his self-portrait: a notable draftsman, architectural historian, and promising archaeologist. The pivotal event between these two trips was a seemingly mundane but fateful episode in Girault's hometown of Langres.

In 1832, in response to a municipal plan to safeguard the city's cultural heritage, Girault undertook an initial census of Langres's remaining Gallo-Roman antiquities, most of which were dispersed along the old city's ancient walls. The ultimate goal, in which Girault also played an integral role, was to open a museum of antiquities in the medieval church of Saint-Didier, which had been desecrated during the French Revolution.[15] For the young artist, this must have presented an irresistible opportunity. Girault grew up during the "scramble to collect antiquities" ushered in by Napoleon's military campaign in Egypt and Syria (1798–1801), and he was in Paris when Jean-François Champollion began giving public lectures on Egyptology at the Musée du Louvre.[16] In France, a general fascination with antiquity and the East was paired with a nationalist drive toward the preservation of cultural patrimony, leading to a Gothic revival. A burgeoning industry of illustrated books resulted, typified by accounts of travel to exotic locales and

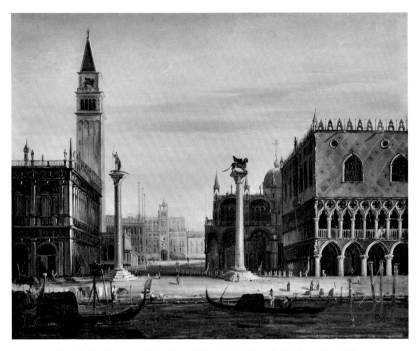

FIG. 12. Girault de Prangey, *Vue de la Place Saint-Marc à Venise*, 1831. Oil on canvas, 12⁹/₁₆ × 16⅛ in. (32 × 41 cm). Musée d'art et d'histoire, Langres (888-2)

FIG. 13. Girault de Prangey, *Promenade et tours d'enceinte du palais de l'Alhambra à Grenade*, 1833. Oil on canvas, 35⁷/₁₆ × 43¼ in. (90 × 110 cm). Private collection, on deposit to the Musée d'art et d'histoire, Langres (D 2015.1.1)

pictorial albums documenting France's medieval past, the most influential of which was Baron Isidore Taylor's multivolume *Voyages pittoresques et romantiques dans l'ancienne France* (1820–78).[17] These dual cultural strands coincided in a relatively new field of study, "histoire monumentale" (monumental history), the forerunner of modern building archaeology.[18] It was this discipline, the study of the historical built environment, in which Girault set out to make his mark, nourished by his experience in Langres and his trip to Spain.

As travel destinations go, pride of place in 1832 was still given to the Ottoman lands of the Eastern Mediterranean.[19] For an artist interested in medieval architecture, however, Spain, Sicily, and North Africa were relatively uncharted territories. Of particular interest to archaeologists was the relationship of Moorish architecture in these regions to the French Gothic, but few pertinent studies existed at the time.[20] Baron Taylor, who played a key role in popularizing Spanish art and culture

in the nineteenth century, summed up the situation in 1826 by differentiating travelers to the region: "if worldly men and scholars have kept us informed about Spain, few *artists* have been there."[21] In the witty preface to his own pictorial album, *Voyage pittoresque en Espagne* (1826–51), Taylor expands on this distinction. First claiming to have prepared a "measured picture" of Spain on a "colossal scale," Taylor writes that he had to renounce such a "grand archaeological work," because mere "will and ardor of a life completely dedicated to the arts" was insufficient to the task.[22] The requisite large-scale folio volumes would have necessitated immense funding and support from self-interested societies or the government. Instead, he decided to pursue a book with no scientific pretense, in a smaller (octavo) format, a kind of travel journal embellished with sketches and notes. In so doing, Taylor set up a dichotomy between his brand of artist-driven, picturesque archaeology and a trend toward more scientific observation, as represented through

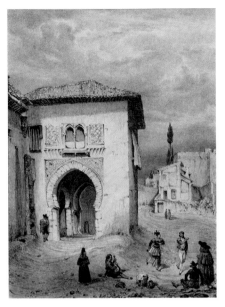 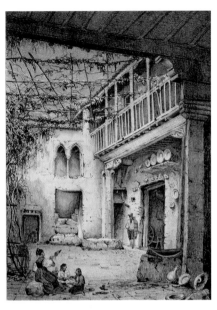

FIG. 14A, B. "Porte du Vin Alhambra" and "Maison à l'Albaysin," from *Monuments arabes et moresques de Cordoue, Séville et Grenade*, ca. 1837. Lithographs by Girault, sheet 22¼ × 16¾ in. (56.5 × 42.5 cm). The Metropolitan Museum of Art, New York, Harris Brisbane Dick Fund, 1944, transferred from the Library (1991.1073.20)

measured drawings, plans, elevations, and, eventually, daguerreotypes.[23] In his own work, Girault would attempt to navigate a path between and ultimately beyond these two models, experiencing in reality the pitfalls that Taylor had hypothetically expressed as a jest. His use of the daguerreotype abetted and complicated this project.

Girault was almost certainly familiar with Taylor's work.[24] Not only did the two men employ many of the same printmakers, but Girault was himself trained in lithography, executing two of the prints in his *Souvenirs de Grenade* (fig. 14a, b), part 3 of *Monuments arabes et moresques*.[25] This choice not only aligned his work with Taylor's seminal *Voyages pittoresques et romantiques* but also gave him more artistic control over the final prints, which ran the gamut from scenes of local color that rivaled or surpassed Taylor's own (fig. 15) to the finest measured drawings and plans of the Alhambra produced up to that time (fig. 16).[26] His chosen format for the three parts of *Monuments arabes et*

moresques, large folios issued in four editions, clearly aspired to a "grand work of archaeology," and he also contributed to two other deluxe albums devoted to medieval architecture: *Le Moyen-Age pittoresque* (1837–40) and *Le Moyen-Age monumental et archéologique* (1840–45).[27] When reproached by the art critic Etienne Delécluze, who worried that the format of *Souvenirs de Grenade* made it inaccessible while its lack of historical content belied its intellectual goals, Girault responded in 1841 with his *Essai sur l'architecture des Arabes et des Mores, en Espagne, en Sicile et en Barbarie*, a lower-cost, smaller-format publication that served as a historical introduction to his larger albums. A first-of-its-kind treatise examining the development of Moorish architecture, it

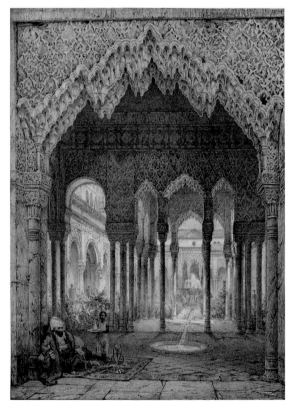

FIG. 15. "Entrée de la Cour des Lions, Alhambra," from *Monuments arabes et moresques de Cordoue, Séville et Grenade*, ca. 1837. Lithograph by Nicolas Chapuy (1790–1858) after Girault, sheet 22¼ × 16¾ in. (56.5 × 42.5 cm). The Metropolitan Museum of Art, New York, Harris Brisbane Dick Fund, 1944, transferred from the Library (1991.1073.20)

also set Girault on the path to his Mediterranean voyage.[28] First, however, he decided to make a detour through his native France.

Following Girault's earlier archaeological foray in Langres, the French government formally encouraged research and publications on French history through the creation of a national committee in 1834.[29] The same year, the archaeologist Arcisse de Caumont founded the first French archaeological organization, the Société pour la conservation et la description des monuments historiques, known today as the Société française d'archéologie (SFA).[30] Efforts to create a similar organization in Langres resulted in 1836 in the authorization of the Société historique et archéologique de Langres (SHAL), of which Girault was a founding member; as such, he was subsequently named the departmental representative for the Haute-Marne to the national SFA and began spending more time in Paris. Encouraged by his higher profile, Girault undertook in June 1839 a "monumental" tour of his home region, in the northeast of France, where he worried that medieval architecture was being destroyed, poorly restored, or replaced by "vulgar" classical buildings.[31] His publishers agreed to produce an album of fifty of the Haute-Marne's most important sites, provided that Girault guarantee a subscription of at least one hundred copies, which he attempted to secure from the departmental council. Although supported by his fellow townsman Jules Ziegler, already a decorated artist, his plan was met (in an echo of Taylor's warning about scientific pursuits) by "only a half-page of compliments … and a refusal too much motivated by an absolute lack of funds."[32]

Girault downplayed the episode in a letter to Jean-Félix-Onésime Luquet, the architect with whom he had planned the museum in Langres, claiming that his "little trip" had been greatly exaggerated.[33] In his official report to the SFA, however, he expressed bitter regret, stating that the publication was the "most certain way to ensure the conservation of the department's antiquities and monuments by attracting everybody's attention and respect."[34] Although wounded, he formulated a new plan while preparing the manuscript for his *Essai sur l'architecture*. In the preface to that volume, first presented as a report to the SFA in August 1840, he lamented the fact that so few artists had

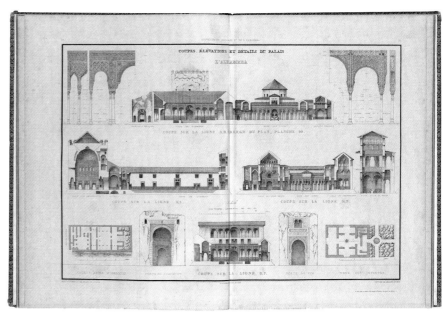

FIG. 16. "Coupes, élévations, et détails du palais l'Alhambra," from *Monuments arabes et moresques de Cordoue, Séville et Grenade*, ca. 1837. Lithograph by an unidentified printmaker after Girault, 44½ × 33½ in. (113 × 85 cm). The Metropolitan Museum of Art, New York, Harris Brisbane Dick Fund, 1944, transferred from the Library (1991.1073.20)

sufficiently examined and drawn the mosques and monuments of Cairo, Jerusalem, Damascus, and Constantinople. By the time the *Essai* was published, in 1841, he made clear his intention to draw those buildings himself in order to establish their connection to the Moorish architecture of Spain. Before he departed, however, his professional and social connections in Paris led him to reconsider the representational means through which he would carry out the project.

DAGUERREIAN EXCURSIONS

Among the works by Girault de Prangey that have recently resurfaced are a number of small portrait drawings, including one with more than a striking resemblance to Louis Daguerre, the eponymous inventor

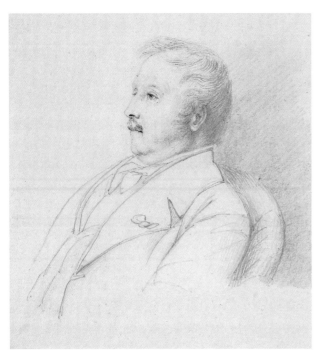

FIG. 17. Girault de Prangey, Detail of *Portrait of a Man (Possibly Daguerre)*, 1840s. Graphite on paper, 6¹³⁄₁₆ × 4⅛ in. (17.3 × 10.4 cm). Musée d'art et d'histoire, Langres, Fonds Flocard (2012.14.48)

of the daguerreotype (fig. 17). While Girault's introduction to photography has been linked to Jules Ziegler, he also was connected to other key players in the early history of the daguerreotype, including, perhaps, Daguerre himself.[35] Both Ziegler and Girault belonged to a Parisian social club, the Cercle des arts, which opened in 1836.[36] Among its members were Horace Vernet (with whom Girault was already acquainted) and his son-in-law, Paul Delaroche, who was part of a committee tasked by the French government to study the daguerreotype.[37] Vernet and Delaroche were instrumental in spreading news of Daguerre's invention after François Arago announced it to the Académie des sciences on January 7, 1839. The artist Prosper Lafaye memorialized one such occasion, at which Vernet and Delaroche attempted to explain the daguerreotype to an astonished crowd at the salon of the art collector Augustin Irisson (also a member of the Cercle des arts).

Although Girault is not depicted in Lafaye's painting, he was in Paris in January, and also in August 1839, when Arago divulged the details of the daguerreotype process.[38]

Between the end of 1839, when publication of his French tour was derailed, and February 1842, when he departed for the Mediterranean, Girault had ample opportunity to consider the daguerreotype's potential for his own work, starting with the first wave of "photographer-travelers" who ventured out with cameras over the next few years.[39] Vernet and one of his students, Frédéric Goupil-Fesquet, left Paris in October 1839 and traveled to Egypt and the Levant with daguerreotype equipment in tow. In Alexandria, they met another intrepid daguerreotypist, the Swiss-born Canadian entrepreneur Pierre-Gustave Joly de Lotbinière, who had visited Greece already and was the first person to photograph the Acropolis. Théophile Gautier and the writer and collector Eugène Piot arrived with a daguerreotype camera in Spain in May 1840; in May 1841, the English polymath Alexander John Ellis began collecting and making daguerreotypes in Italy (fig. 18). Linking these men together was a general curiosity about the new technology and, in many cases, a desire to collect and publish albums of views and sites.[40]

The architect and Egyptologist Hector Horeau, who arrived in Paris in 1839 after two years in Egypt, immediately understood the daguerreotype's value to his own travel album, even though the technology had not been available on his journey. His prospectus for *Panorama d'Egypte et de Nubie* (1841) states that his own drawings made on-site, along with the "benevolent communication of daguerreotyped views," afforded him great accuracy in reproducing the wonders of the Nile.[41] Horeau thus introduced photography as a discursive ploy to add authenticity to the engravings in his book, even if their connection to daguerreotypes is not always evident.[42] Only one of his illustrations, a wood engraving depicting burned-out buildings in Cairo after a citywide fire in June 1838, is identified as "drawn from the daguerreian collection of M. Joly de Lotbinière" (fig. 19). Horeau likely met the Canadian explorer through Goupil-Fesquet, whom he had put in touch with fellow architect Alphonse Hubert in September 1839, shortly before Goupil-Fesquet and Vernet departed for Egypt.[43] Hubert, sometimes identified

FIG. 18. Alexander John Ellis (1814–1890), *Florence. The Campanile and Portion of the South Side of Cathedral*, 1841. Daguerreotype, 13⅜ × 11 in. (34 × 27.8 cm). National Science and Media Museum, Bradford, England (1890-56-F3)

as Daguerre's partner or student, also wrote the first technical treatise about daguerreotypes for the use of artists (1840), and Goupil-Fesquet consulted with both him and Daguerre when he was learning the process.[44] Such networks were common as early adopters of the technology

shared, borrowed, and modified various photographic methods. Girault, who knew Vernet and Delaroche and who subscribed to Horeau's *Panorama d'Egypte et de Nubie*, very likely moved in the same circles, so a connection to Daguerre is credible.

Through these same connections, Girault would have been familiar with *Excursions daguerriennes*, the publication through which we now know the work of Goupil-Fesquet and Joly de Lotbinière.[45] The brainchild of the Parisian optician Noël-Paymal Lerebours, *Excursions* used daguerreotypes to exploit the growing popularity of travel views presented as empirically neutral, or "journalistic."[46] Unlike in the work of Taylor, the artist/author guaranteed the veracity of the view, not by having drawn or painted it, but by providing a daguerreotype of what was seen. In this way, Goupil-Fesquet discounted a fake story that had circulated in the Parisian press claiming that Vernet had gained access to Muhammad 'Ali's harem.[47] In *Excursions*, he relates the more mundane reality of the episode, which is represented by an ordinary view of a guarded section of the palace (fig. 20), the most remarkable aspect of which was that the daguerreotype it reproduced was made in only two minutes. Goupil-Fesquet asserts that the image, and thus his version of the story, cannot be questioned, because he was "both ocular witness and daguerreotype operator."[48] This notion of the artist/daguerreotypist as eyewitness gained cultural currency and appeared across other media, which were often similarly collapsed: Gautier thus described himself as a "literary *daguerréotype*," and Charles Baudelaire later attacked Vernet for being a journalist ("gazetier") of painting.[49] Such comparisons ran parallel to the advent of the reporter and the rise of the illustrated press in the 1830s.[50]

These developments would not have gone unnoticed by Girault. After the disappointing failure of his French tour in 1839, along with two rejections from successive Salons, in 1839 and 1840, the new technology offered a fresh and expedient tool for his arsenal of representational strategies.[51] As suggested by Horeau and Lerebours, moreover, the daguerreotype presented a potential means of reconciling Baron Taylor's artist-driven archaeology with the more scientific model to which Girault aspired.

FIG. 19. "Vue d'une partie du Caire," from *Panorama d'Egypte et de Nubie*, 1841. Wood engraving by A. Debraine after Pierre-Gustave Joly de Lotbinière (1798–1865), sheet 24 × 18⅛ in. (61 × 46 cm). The Metropolitan Museum of Art, New York, Joyce F. Menschel Photography Library Fund, 2017 (2017.140)

A MONSTER DAGUERREOTYPE

Girault announced his Mediterranean trip to his SFA colleagues at a meeting on May 3, 1841, although it was not until the following January that he added a more detailed itinerary and mentioned that he would use a daguerreotype camera.[52] This timeline matches the dates of his earliest daguerreotypes, made in Langres and Paris (1841–42, pls. 1–12), indicating that his most intense apprenticeship with the medium occurred in the last eight months of 1841. Hubert, who may have been one of his first contacts, died on May 16 of that year, but he, along with Daguerre, could have advised Girault on the daguerreotype process, either in person or through his 1840 manual. Hubert was attuned to the needs of photographer-travelers through his contact with Goupil-Fesquet and geared his pamphlet to "artists undertaking long voyages," giving advice, for example, on exposure times in Egypt.[53] He counseled artists interested in publishing daguerreotype views not to worry about the lateral reversal of the images, which would be corrected once they were translated into published prints.[54] Hubert was also the first to recommend gold-plating daguerreotypes (in November 1839), and he publicized Hippolyte Fizeau's gilding method, which was introduced in March 1840 and subsequently used by Girault.[55]

By 1841, several additional opticians published pamphlets marketing enhancements to Daguerre's original process, including Noël-François-Joseph Buron and Charles Chevalier. Buron developed a camera that doubled as a carrying case; he also touted the fact that daguerreotype cameras and plates were not bound to the original dimensions prescribed by Daguerre.[56] Chevalier, who was Daguerre's lens supplier, advertised a camera that borrowed all the best modifications to the original model sold by Alphonse-Gustave Giroux; as a bonus, the camera, plates, and iodizing box fit into a portable leather bag, which doubled as a dark cloth during exposure.[57] He also marketed the first convertible camera lens, which could be reconfigured to achieve different focal lengths and was recognized for its superior ability to focus an image over the entire surface of the plate.[58] In the absence of travel and technical notes, Girault's connection to these suppliers remains theoretical; any number of opticians, or even Daguerre himself, could have advised him on the appropriate design for his requirements: a large travel camera with a lens that could accommodate oversize plates and their various permutations.[59] His unusual equipment did not go without comment: his colleague at the SFA the vicomte Pierre de Cussy referred to Girault's "monster daguerreotype"; Simony remarked on the "supple case" that contained all his equipment and which served as both laboratory and darkroom.[60]

As suggested by Buron, a successful daguerreotype of almost any dimension could be produced with a proper camera and lens. Opticians at the time in fact experimented with various sizes.[61] The format introduced in 1839 by Daguerre and Giroux (6½ by 8½ inches) became the standard whole-plate size, however, and the dimensions of the plates used by Girault (7½ by 9½ inches) appear to be unique to his practice (see p. 182). His choice of a larger plate size is instructive; it required a bigger, less easily transportable camera and entailed increased difficulties in handling the plate.[62] The decision was a purposeful trade-off, in part related to the fact that Girault associated scientific publications

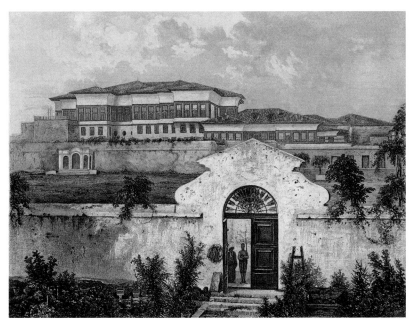

FIG. 20. "Harem de Méhémet-Ali," from *Excursions daguerriennes*, 1840–44. Etching by Antoine-Jean Weber (1797–1875) after Frédéric Goupil-Fesquet (1817–1878), image 10¼ × 15 in. (26 × 38 cm). The Metropolitan Museum of Art, New York, Harris Brisbane Dick Fund, 1938 (38.174)

with larger formats, as opposed to the smaller (quarto) format of *Excursions daguerriennes*, which had established the daguerreotype and its corresponding print as interchangeable representations. Girault's previous major publication, *Monuments arabes et moresques*, presented large individual images or multiple figures (such as details, plans, and elevations) on a single sheet (see fig. 31). His desire for the same flexibility from photography led him to conceive unorthodox formats and multiple exposures on a single daguerreotype plate. Through trial and error, he chose the largest size that he still found manageable and then worked with an optician on the construction of the camera. Although there is evidence that he set technical challenges for himself (see pl. 8 and p. 175), some of his more experimental efforts must be missing. The majority of the extant plates made in France show that he was already working with the larger format, and often with great technical skill (pls. 2, 8).

Just as Girault had a network of support in Paris for his introduction to the daguerreotype, he had equal assistance during his travels (see pp. 157–59). Of the various portraits he made, only a couple might be identified as hired workers, a sailor (pl. 68) and a "surudjé," or Turkish horse driver (pl. 79). Other portraits comprise acquaintances, contacts, and generally anonymous people he photographed along the way (pls. 65, 67); the latter fall within stereotypical categories of preconceived social types and evidence the complex relationship between photography, modernity, and subjectivity in the Mediterranean world.[63] This is particularly true of the multiple portraits of the woman identified as Ayoucha (pl. 66), whose confident gaze counters her performance of various roles assigned to the exotic "oriental" woman. Girault also needed guides and interpreters, probably in each of the countries he visited, as well as servants to help carry his photographic and drafting instruments.[64] His photographic equipment alone weighed more than a hundred pounds, and the difficult conditions in which he operated, especially in the desert, cannot be overstated.[65]

Girault's itinerary, although somewhat off the beaten track, was not completely unprecedented, and seems at least partially modeled on that of the artist Prosper Marilhat, another member of the Cercle des arts, who traveled a similar path between 1831 and 1833.[66] Girault departed from Paris in February 1842, then sailed by steamship from Marseille to Italy, arriving in Rome, by way of Genoa and Civitavecchia, in April. His Roman sojourn is partially documented in letters from Jean-Victor Schnetz, director of the Académie de France in Rome, to the archaeologist Désiré Raoul-Rochette, who had provided Girault with letters of introduction.[67] Schnetz was inexplicably nonplussed by Girault's daguerreotypes, many of which are remarkable, including his view of the gardens at the Académie de France (pl. 25). Schnetz was, however, impressed by Girault's industriousness: he reportedly made more than three hundred daguerreotypes by the time he left in mid-July, photographing "everything that passed."[68] From Italy, Girault stopped at Malta for one day on his way to Athens, where he spent the rest of the summer (about six weeks) before traveling on to Alexandria and Cairo in September. From Cairo, he wrote to his SFA colleague Jules Gailhabaud

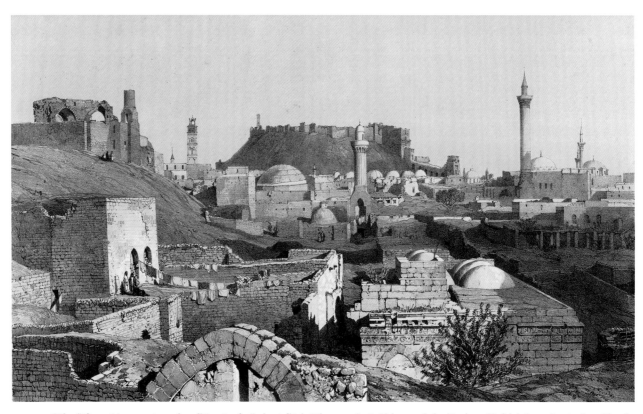

FIG. 21. "Alep," from *Monuments arabes d'Egypte, de Syrie et d'Asie-Mineure*, 1846. Lithograph by Eugène Cicéri (1813–1890) after Girault, sheet 22⅜ × 15⅝ in. (56.9 × 39.7 cm). The Metropolitan Museum of Art, New York, Purchase, Joyce F. Menschel Photography Library Fund, 2017 (2017.66.7)

and enthused about his work in Athens: "I lost less time [than in Rome], and, by my faith, I left very little behind."[69] He also confessed his affinity for the "extremely picturesque" cathedral (pl. 28), which he captured from all sides and counted among his most beautiful daguerreotypes. Girault made at least five whole-plate daguerreotypes of the church and was, in fact, rather profligate in his use of plates during this first leg of his excursion. In Italy, he used multiple plates for the purpose of bracketing, or testing, exposure times (pls. 20, 21),[70] and more whole plates survive from Greece than from any other Mediterranean location.

In Egypt, Girault first explored Alexandria (pls. 44–47) and Rosetta (pl. 49), then settled in Cairo through the rest of 1842. Early the next year, using Constantinople as a base, he explored the Troad (the Biga Peninsula, in northwest Turkey) before moving on to Smyrna (Izmir) in April 1843.[71] His plan was to travel down the Turkish coast (pls. 76–78) and through Antalya before returning to Constantinople in September.[72] From there, he wrote again to Gailhabaud, explaining that his course had been impeded at Lycia by the excavation—Girault calls it the "new eruption"—led by British archaeologist Charles Fellows and his "numerous escort."[73] Because of this rerouting from his stated itinerary, Girault's exact path in 1843 remains uncertain, but based on the dated labels of his daguerreotypes, he also made initial visits to Damascus (pls. 102–4) and Baalbek (pls. 105–14). He returned to Cairo

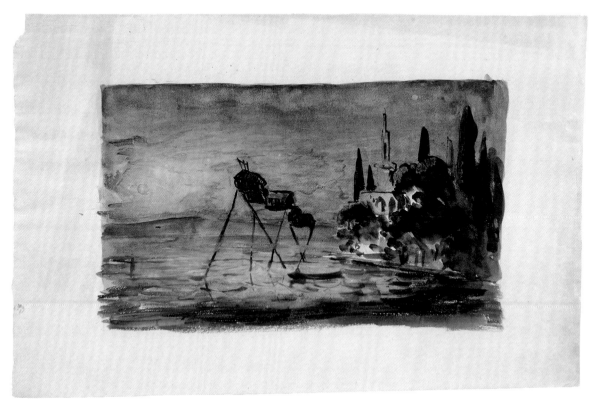

FIG. 22. Girault de Prangey, *Bosphore. Pêcheries*, 1843. Watercolor, sheet 11⁷⁄₁₆ × 17⁵⁄₈ in. (29 × 44.9 cm). Musée d'art et d'histoire, Langres, Fonds Flocard (2012.14.40)

in October 1843 to finish the work he had started the previous year, possibly after restocking his supply of plates.[74]

Girault spent the first few months of 1844 exploring Upper Egypt. It was perhaps at the beginning of this trip that he made his only known daguerreotype of a pyramid, the burial complex of the pharaoh Unas at Saqqara, which was already in ruins at the time (pl. 80). Although he intended to reach Abu Simbel, he made it up the Nile only as far as the first cataract, to Aswan and Philae (pl. 86).[75] From there, out of concern for the security of his daguerreotypes, he decided to return to Alexandria rather than risk the passage to Jerusalem through the Sinai.[76] Once there, he encountered the plague and was quarantined first for a

month, and then for an additional twelve days upon reaching Beirut. He traveled onward to Saida, Tyr (Tyre), Ptolemais (Acre), and Haifa, where he rested at the Carmelite monastery. He arrived in Jerusalem for the Feast of Corpus Christi on May 21, 1844, sixty days after Easter, when he originally had hoped to arrive.[77] In Jerusalem, Girault was discouraged by his inability to gain entry to all the sites he wished to study, which perhaps explains his documentation of the city gates (pls. 90–92) and the various approaches to the Haram al-Sharif, including a view of the Bab al-Silsila minaret and a portion of the Mughrabi, or Moroccan, quarter (pl. 95). In August, he revisited Beirut, Damascus, and Baalbek en route to Aleppo. He returned to France early in 1845.

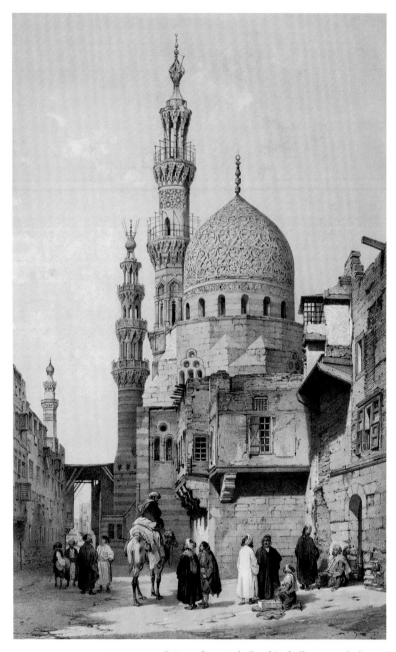
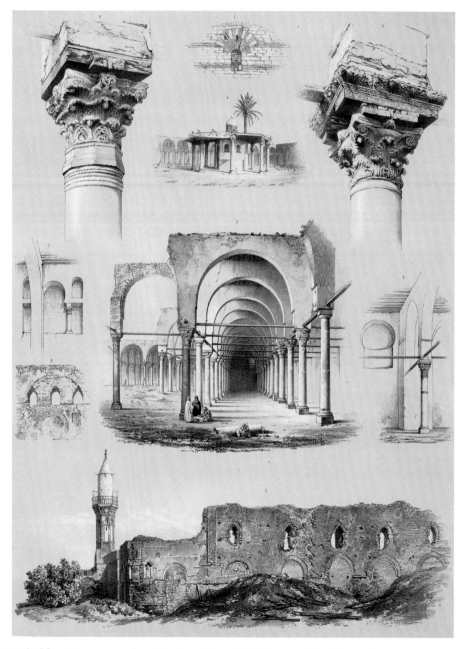

FIG. 23A, B. "Mosquée, au Kaire" and "Détails, mosquée d'Amrou, au Kaire," from *Monuments arabes d'Egypte, de Syrie et d'Asie-Mineure,* 1846. Lithographs by Auguste Mathieu (1810–1864) and Michel-Charles Fichot (1817–1903) after Girault, each sheet 22⅜ × 15⅝ in. (56.9 × 39.7 cm). The Metropolitan Museum of Art, New York, Purchase, Joyce F. Menschel Photography Library Fund, 2017 (2017.66.12, .2)

A HEAVY TASK

Back in Paris, Girault rented rooms in the rue Duphot and began work on *Monuments arabes d'Egypte, de Syrie et d'Asie-Mineure*, the first installments of which appeared in 1846.[78] His plan to publish one hundred prints in twenty installments over two years was ambitious, especially given that his longtime publishers, Veith et Hauser, had separated, and he was producing the book at his own expense.[79] This process, similar to that for his later 1851 publication, likely involved the preparation of larger intermediate drawings as models for the lithographers (see Olivier Caumont's essay in this volume, pp. 176–81). Although such drawings have not yet come to light, the finished prints can nevertheless be compared to the source daguerreotypes in order to determine Girault's working methods.

In some cases, one or two daguerreotypes (pls. 116, 117) served as models for a corresponding print (fig. 21), with Girault and the lithographer making only minor additions and changes to the visible field of the image.[80] In the print of Aleppo, for instance, the laundry is already visible in the daguerreotype, but foliage and staffage have been added to enliven the scene. The viewer's position, moreover, has shifted slightly closer and to the left of the foreground arch, rendering subtle differences between the print and daguerreotype. This change, though small, at least suggests the possibility of an additional model—a drawing made on-site in conjunction with the daguerreotype. This supposition is supported by two extant watercolors not associated with published prints: an impressionistic view of fishing huts along the Bosphorus (fig. 22), which might be a color study for the related daguerreotype (pl. 73); and a view of the facade of the Church of the Holy Sepulchre, drawn in its proper orientation and so presumably made on-site in Jerusalem.[81]

Other prints in *Monuments arabes d'Egypte* follow slightly different models. Some subjects, such as *Mosquée, au Kaire* (fig. 23a), are "reconstructed" from two or more daguerreotypes (pls. 50, 51), while other plates present a single site through multiple details (fig. 23b). This last example is particularly important because it is the only instance in which Girault directly invokes photography in his accompanying text,

stating that certain details have been traced from daguerreotypes made on-site and then scrupulously copied by the lithographer.[82] While it is true that two of the printed representations approximate the size of corresponding daguerreotypes from the Mosque of 'Amr ibn al-'As (pls. 58, 61), there also are obvious differences. Compared to the daguerreotype of the wall fragment, for example, the related print depicts a more distant view and shows the minaret in its entirety, whereas the modern interventions into the lower portion of the wall are either completely elided or hidden by mounds of dirt in the courtyard.[83] Apart from their size, then, these images are not that different from the other representations based on Girault's daguerreotypes. Unlike views of entire buildings, however, fragments compel from viewers a different type of reading or interpretation, similar to the kind of mental projection required to understand an architectural plan or elevation. The wall was the most ancient structure of the mosque (which explains why Girault represents it without signs of excavation), and its upper register of pointed arch windows played a pivotal role in his study of Islamic architecture—he even made a separate detail, as if to remind himself of their importance (pl. 59).[84] His specific appeal to the daguerreotype within this context, then, is not merely rhetorical; it is a test case for a new representational strategy. Instead of Lerebours's extension of the "voyage pittoresque" tradition, in which the artist/daguerreotypist guaranteed the authenticity of the depicted subject, Girault deploys the daguerreotype itself as a kind of fragment or sherd, a material referent and a new kind of scientific image.

Girault points to this difference in his petition for support to Narcisse-Achille de Salvandy, Minister of Public Instruction, explaining that his book was targeted to a niche market of scholars and artists and that its very nature excluded it from speculation; he insisted that he could not even cover production costs through sales.[85] It remains unclear whether or not Salvandy subscribed to *Monuments arabes d'Egypte*; Girault continued to work on it but published only six installments and twenty-four prints before ceasing publication sometime after 1847. In March of that year, he sent the first three installments to Thomas Leverton Donaldson, the secretary of the Royal Institute of

FIG. 24. Girault de Prangey, *Alpine Rock Wall*, 1845–50. Daguerreotype, 3¹¹/₁₆ × 3³/₁₆ in. (9.4 × 8.1 cm). Musée Gruérien, Bulle (GP-DAG-041)

paysages de l'Orient, also remained unfinished, and it seems by comparison more indebted to the picturesque tradition and aimed at a general audience; whereas he might have emphasized his use of photography, the title page instead announces color lithographs made after his watercolors and a "historical and descriptive text" that never appeared.[90]

By the 1850s, Girault's focus had shifted away from archaeology, although he did maintain contact with associates in the field, including Donaldson and the architect Pascal Coste.[91] He turned his attention to his villa outside Langres, where he pursued his interests in horticulture and continued to experiment with new photographic processes, including collodion on glass and stereoscopy (see pls. 124–27). Apart from the few daguerreotypes related to his research for the archaeological society in Langres and a study of the Gallo-Roman ruins at Mont-Dore in the Auvergne (pl. 120), his only other sustained use of the medium was in Switzerland and its border with France (fig. 24; pls. 121–23).[92] He never again used the daguerreotype on the same monumental scale as he did on his Mediterranean journey.

British Architects, into which he had been inducted as an honorary member the previous year.[86] Girault confessed to Donaldson a reason beyond expense for why he eventually abandoned his publication: "How heavy is the task I have undertaken, I understand it more every day. Our unfortunate orientalists find nothing, see nothing. For them, everything seems reduced to the experience of words, to pure philology; and so [there are] no or too few historical ideas in their books."[87] In expressing this frustration with words, Girault exposed his reliance on, and dissatisfaction with, the philological roots of archaeology. Even while his work still depended on specialists in Arabic texts and language, which he made an effort to use correctly, he clearly foresaw a future in which archaeology was primarily a science of reading objects rather than texts.[88] Unfortunately for his own work, such a photographic turn did not occur on a general level in archaeology until the 1860s, and his *Monuments arabes d'Egypte* failed to find the audience or support it needed to survive.[89] His follow-up publication in 1851, *Monuments et*

CAMERA MAN

One other presumed self-portrait of Girault exists, a stereograph from about 1860 (pl. 127). He stands beside a large-format camera, from which he has removed the lens cap and performs the act of making an exposure. Since the camera's plateholder is not in place and the dark cloth remains bundled on the flowerpots beneath his hat, the photograph he pretends to make is perhaps, by analogy, the one he is in. He looks not only at the stereoscopic camera in front of him, making his picture, but also at future viewers of his image, including himself. The camera on the tripod beside him might be the one that accompanied him to the Mediterranean, repurposed for large glass-plate negatives, several of which have recently come to light.[93] It was also about the time that this image was made, or not long after, that Girault inventoried the contents of his daguerreotype collection. Perhaps the voyage was on his mind, but why?

It has been pointed out that Girault never exhibited his daguerreotypes, which might be construed as evidence of his ambivalent attitude toward photography. This brings to mind another illustrious proponent of the daguerreotype, John Ruskin, who initially embraced the medium in the mid-1840s before adopting a more critical stance later in his career. The two men shared a similar artistic approach to daguerreotypes in terms of vision, subject matter, and as models for their publications (fig. 25; compare to Girault's detail from San Lorenzo, pl. 13).[94] Ruskin, like Girault, conceived of the daguerreotype not as a mere reproduction, but rather as "something that was, or is almost, part of the original."[95] If Ruskin's daguerreotypes were "very nearly the same thing as carrying off" the photographed subjects, those of Girault were equivalent to data collected or measured in the field— new models of information that could be seen and studied at a distance from the monuments themselves.[96] In this way, Girault anticipated the American physician Oliver Wendell Holmes's notion of photographs as "morphotypes" or "form-prints," terms by which he distinguished them from "logo-types" or words.[97] For Holmes, "forms" were pure image, divorced from matter, and only dependent on glass, paper, or pasteboard as vehicles through which to be seen. He predicted a near future in which such forms were so prevalent that they would be collected, "classified and arranged into vast libraries," a statement that generally has been interpreted as a portent of the database mentality of our image-saturated digital age.[98]

If Girault's nascent archival impulse was motivated by a need for "forms" of architectural documentation, however, it is equally clear that he prized the materiality of those forms—the daguerreotypes that he carefully cut, labeled, dated, stored, checked, and rechecked. His daguerreotypes served not only as a literal (visual) impediment to archaeology's textual origins; they were also the means by which he came to understand himself as subject to a kind of metaphorical archaeology, one in which a memory-based sense of the self could be stored, retrieved, reassembled, and displayed.[99] If this sounds familiar, it is because Girault originated a thoroughly modern conception of photography that has persisted despite the enormous changes in

FIG. 25. John Ruskin (1819–1900) and John Hobbs (ca. 1825–1892), *Venice, St. Mark's. South Facade and the Pillars of Acre. The Thistle Capital of the Vine Pillar*, 1849–52. Daguerreotype, $3^{15}/_{16} \times 3$ in. (10 × 7.6 cm). Collection of Ken and Jenny Jacobson

technology that have since ensued. We appreciate his daguerreotypes as material proof of the life he lived and the way in which he saw the world or, more precisely, as his vision of the world as seen through photographs. We marvel at his still-astonishing vertical compositions and thrill to the starburst of fronds at the crown of a palm tree (pl. 29), a stork nesting on ancient columns (pl. 77), or the discovery of his camera in front of the Temple of Bacchus at Baalbek (pl. 113). This is because, when pressed, most of us would still distinguish between the "weightless," ephemeral "visual notes" that we make on our camera phones, send as texts, and throw away, and those more substantial photographs that, one way or another, we wish to save and return to as evidence of our former selves.[100]

PLATES

Reproductions of Girault's daguerreotypes, like the originals, are laterally reversed. To the extent that is possible, they are presented here at or near actual size.

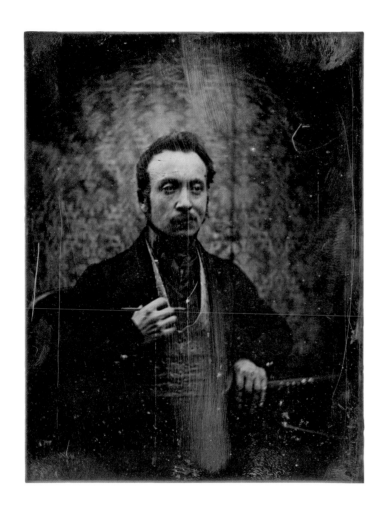

PLATE 1. *Self-Portrait*, ca. 1841

PLATE 2. *Rose Window, Notre-Dame Cathedral, Paris,* 1841

PLATE 3. *Porte Rouge, Notre-Dame Cathedral, Paris*, 1841

31

32 PLATE 4. *Window Details, North Chevet, Notre-Dame Cathedral,* 1841

PLATE 5. *Assumption of the Virgin, North Side of Notre-Dame Cathedral*, 1841

33

PLATE 6. *Tuileries, Paris,* 1841

PLATE 7. *Fountain, Place du Château d'Eau, Paris*, 1841–42

36 PLATE 8. *Plant Study, Paris*, 1841

PLATE 9. *Plant Study, Paris*, 1841

38

PLATE 10. *In Douy*, 1841

PLATE 11. *Girault's Villa, Les Tuaires*, ca. 1841

39

PLATE 12. *Girault's Villa, Les Tuaires*, ca. 1841

PLATE 13. *Portal Detail, San Lorenzo Cathedral, Genoa*, 1842

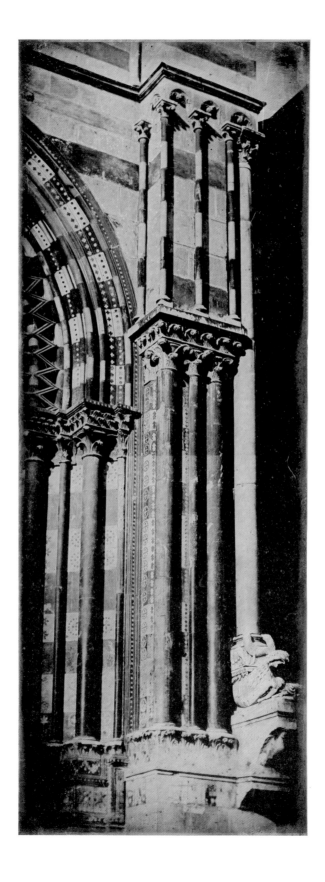

PLATE 14. *Etruscan Lion, Toscanella*, 1842

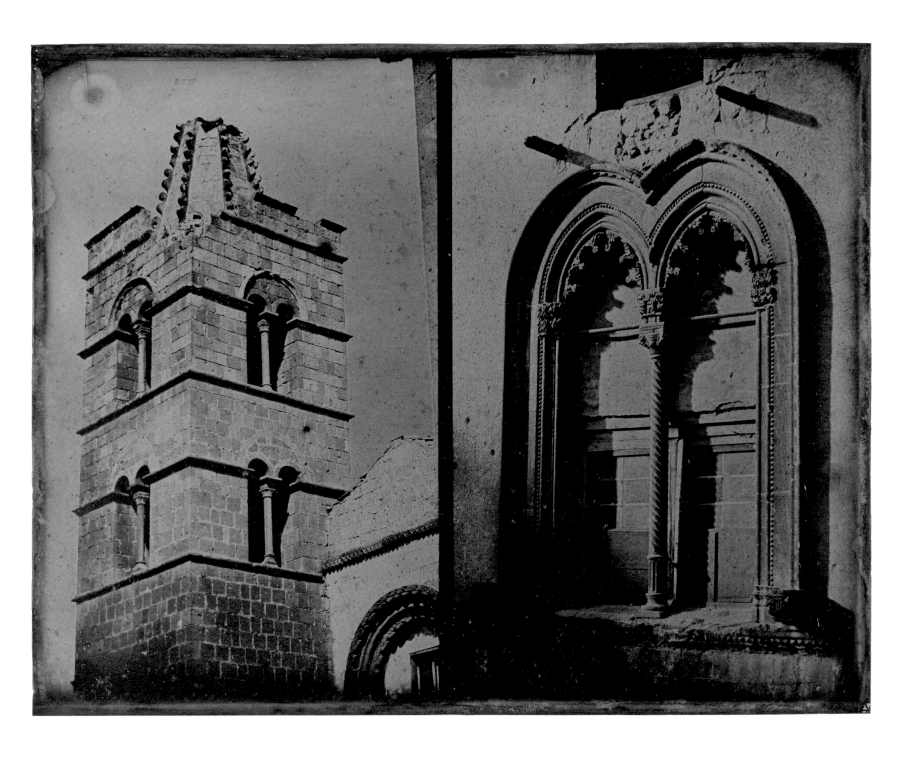

PLATE 15. *Window and Bell Tower, Corneto, 1842* 43

44

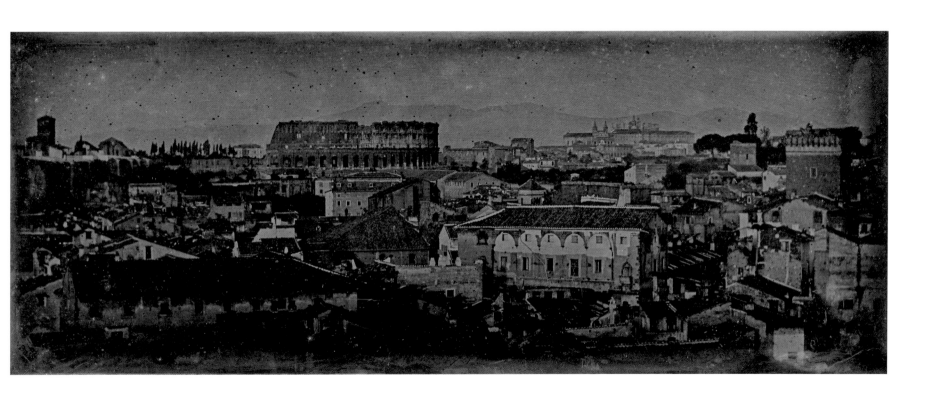

PLATE 16. *Column of Trajan, Rome*, 1842

PLATE 17. *Rome, Viewed from the Column of Trajan*, 1842

45

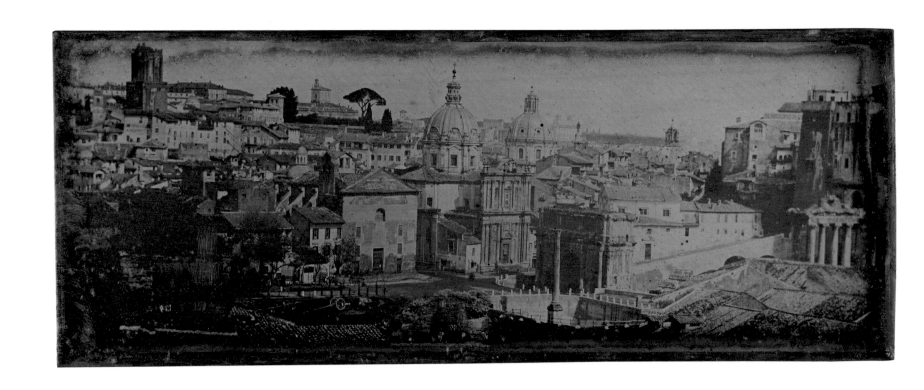

PLATE 18. *Roman Forum, Viewed from the Palatine Hill, 1842*

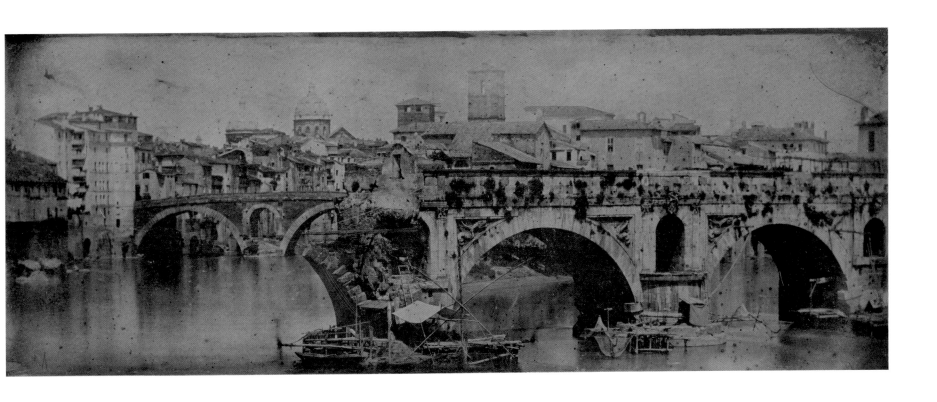

PLATE 19. *Ponte Rotto (Pons Aemilius), Rome*, 1842 47

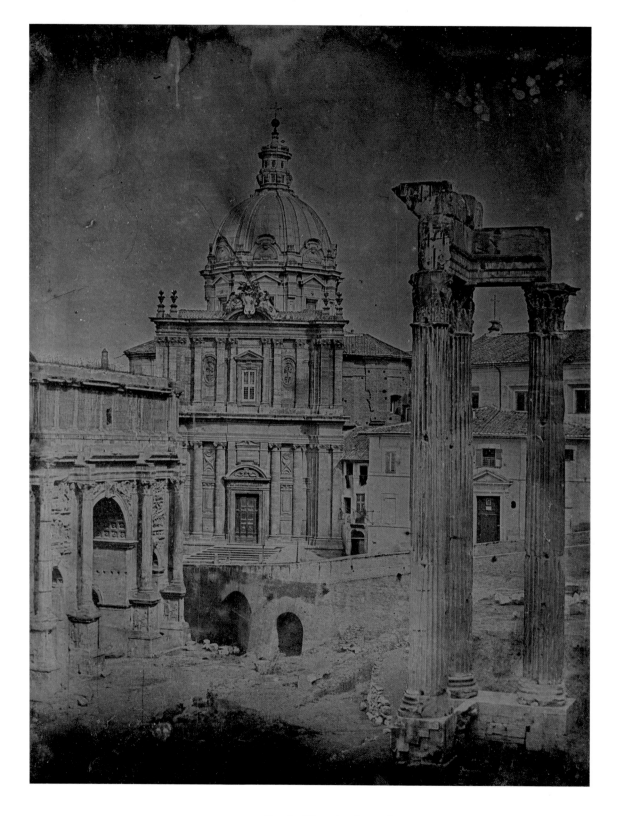

48 PLATE 20. *Temple of Vespasian, Rome,* 1842

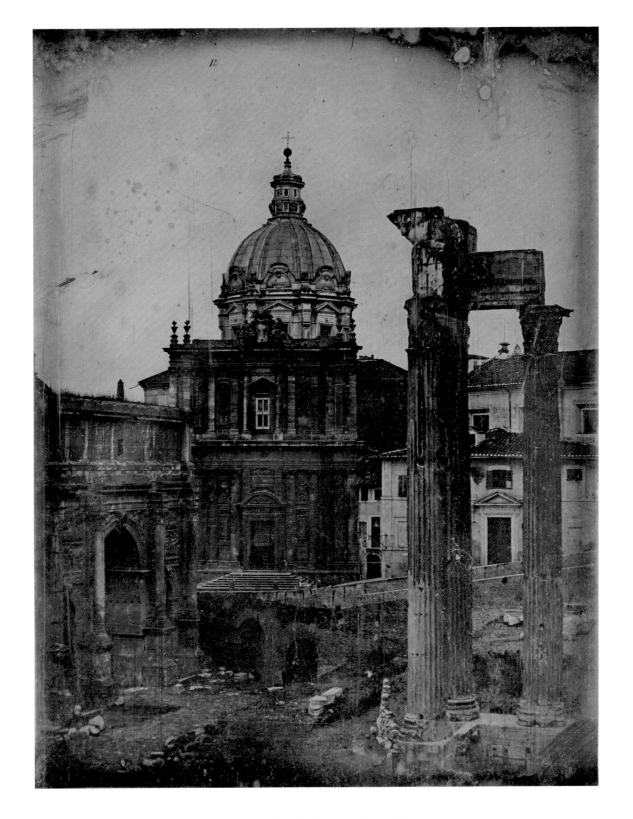

PLATE 21. *Temple of Vespasian, Rome*, 1842

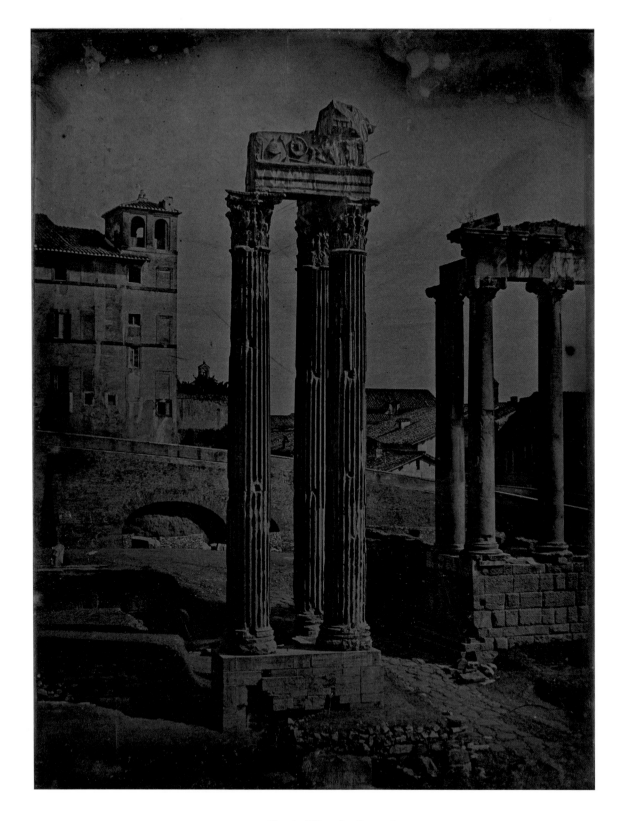

50 PLATE 22. *Temple of Vespasian, Rome*, 1842

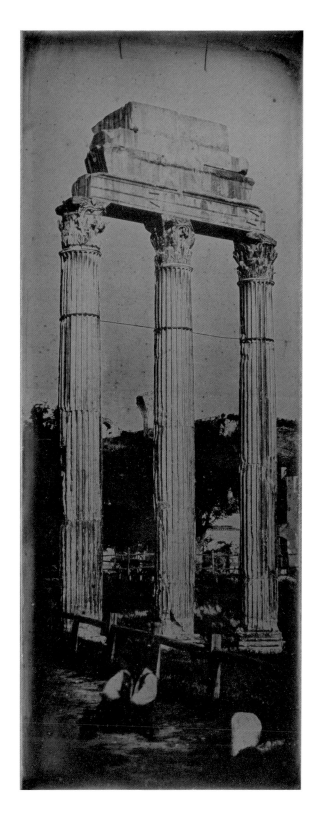

PLATE 23. *Northwest Facade, Temple of Castor and Pollux, Rome, 1842*

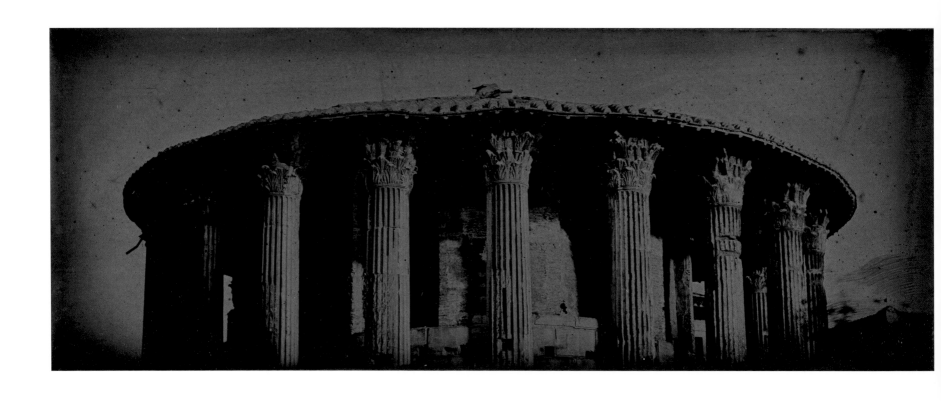

52 PLATE 24. *Temple of Vesta, Rome,* 1842

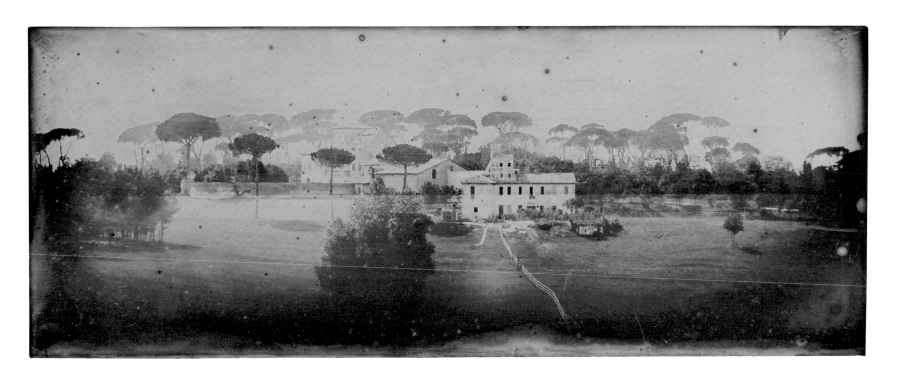

PLATE 25. *Gardens, Villa Medici, Rome, 1842*

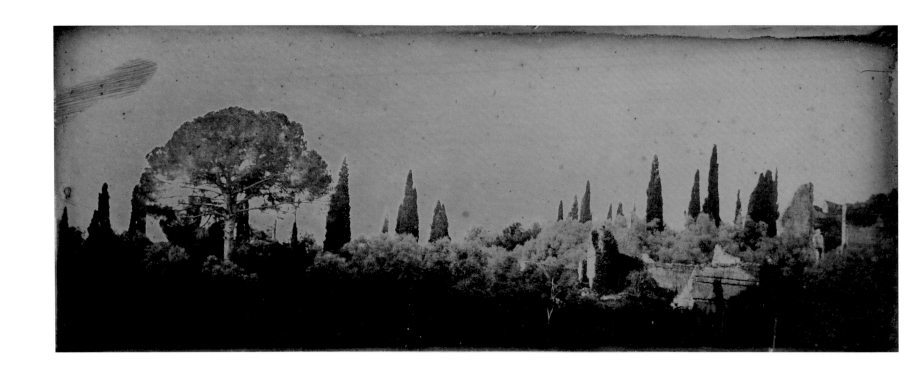

54 PLATE 26. *Hadrian's Villa, Tivoli, 1842*

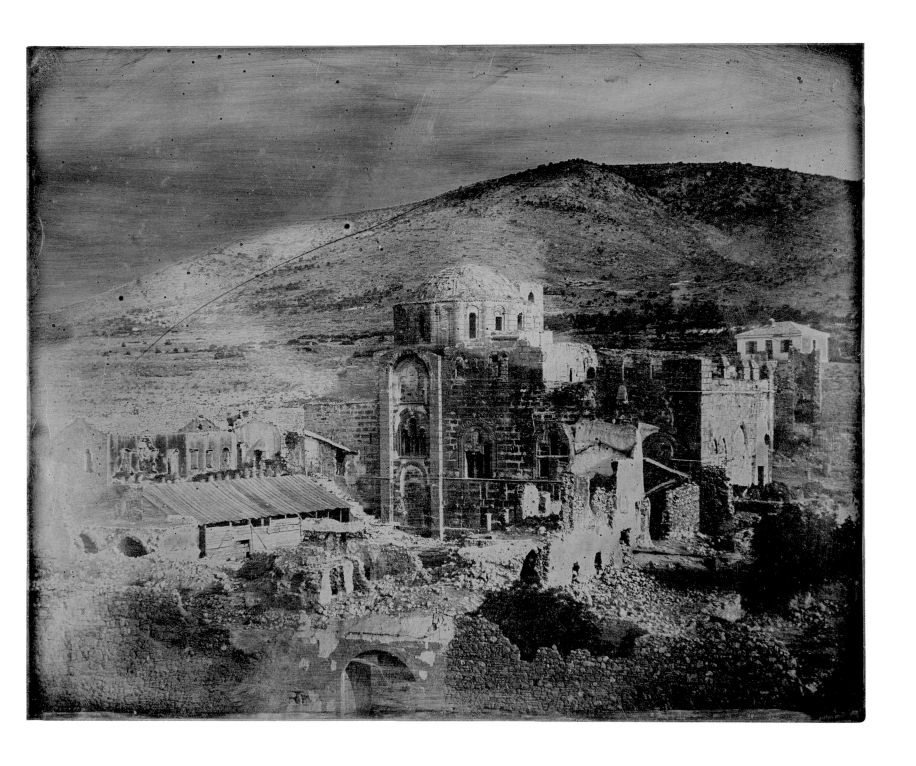

PLATE 27. *Monastery of Daphni, Attica*, 1842

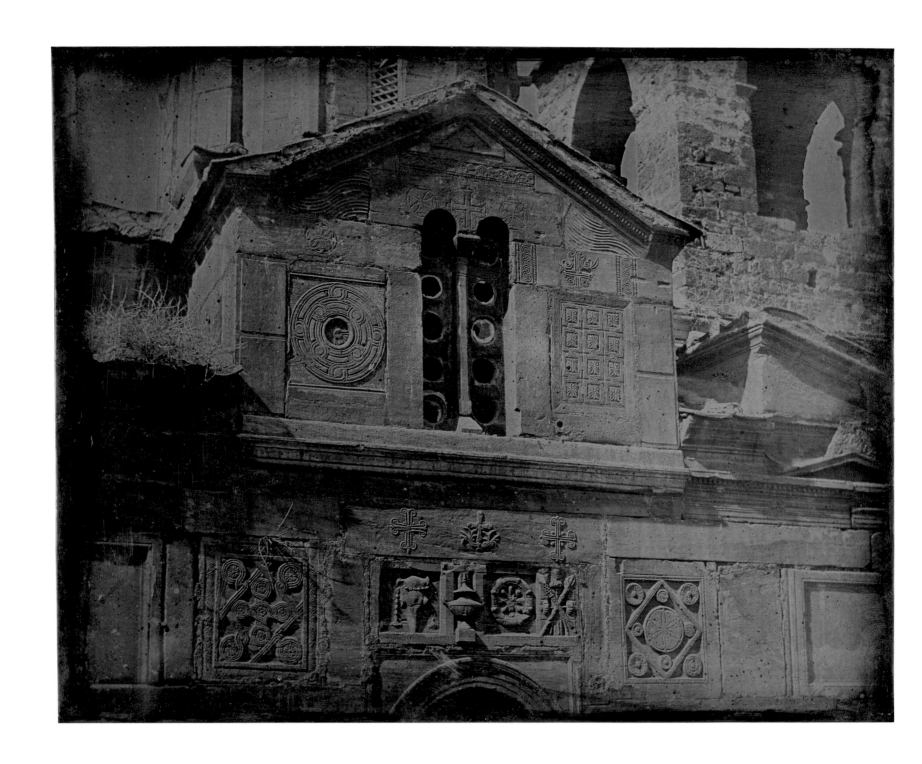

PLATE 28. *Agios Eleftherios Church, Athens,* 1842

PLATE 29. *Palm Tree near the Church of Saints Theodore, Athens,* 1842

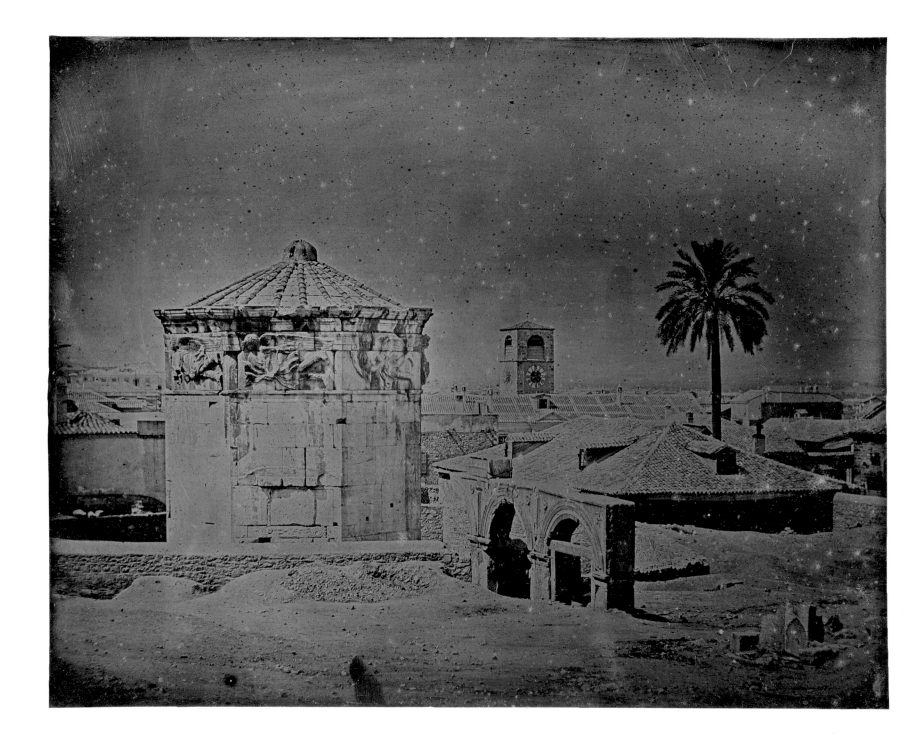

PLATE 30. *Tower of the Winds, Athens*, 1842

PLATE 31. *Tower of the Winds, Athens*, 1842

59

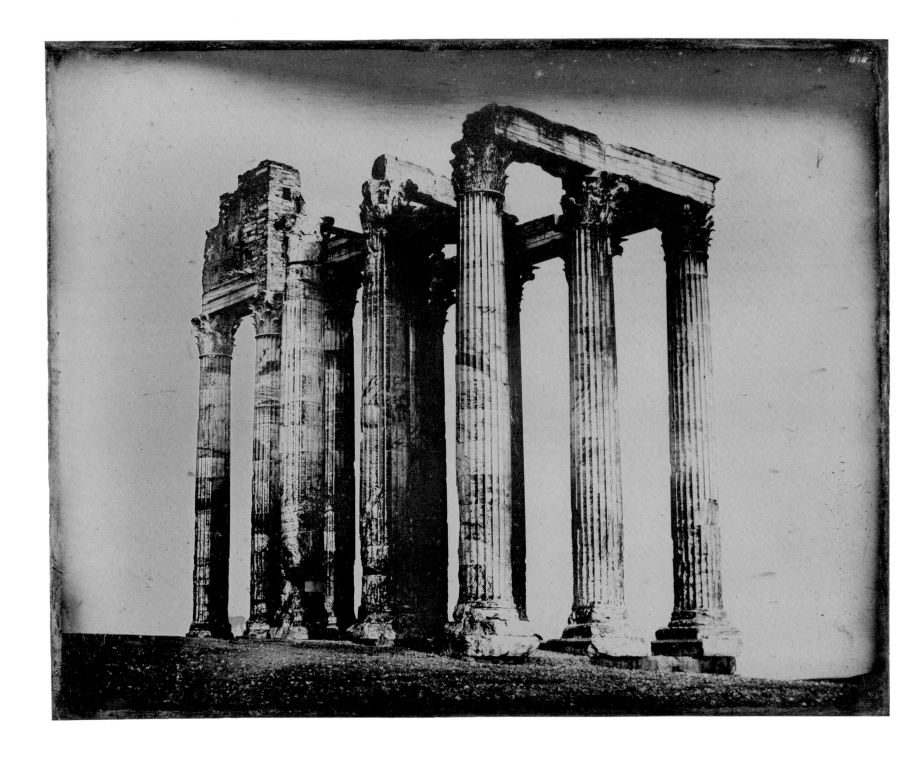

PLATE 32. *Olympieion, Athens, Viewed from the East*, 1842

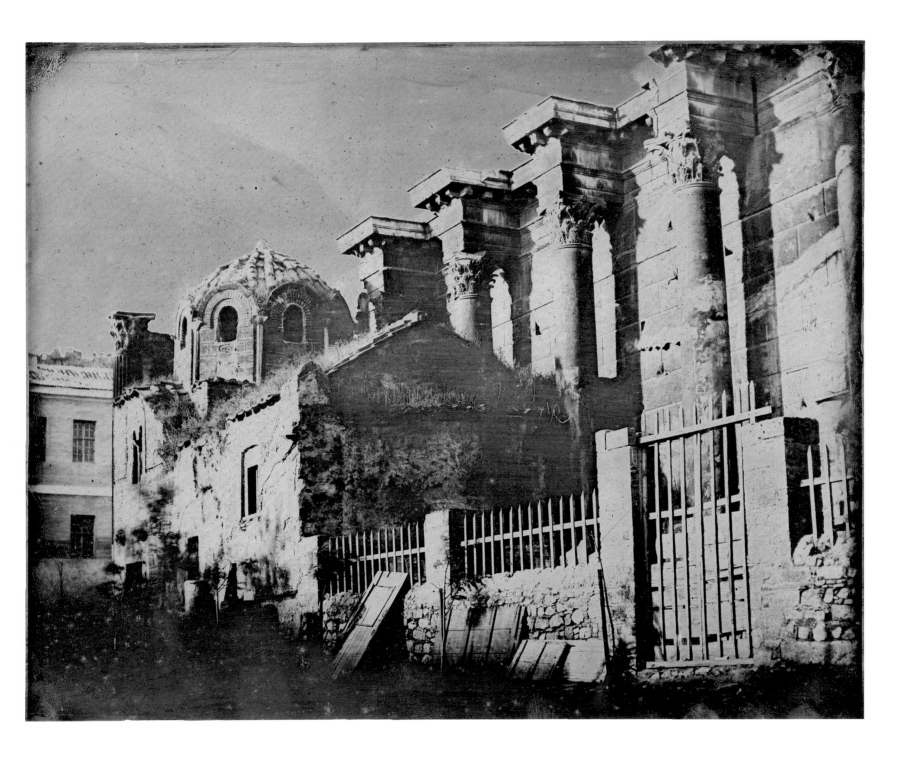

PLATE 33. *Stoa, Athens,* 1842

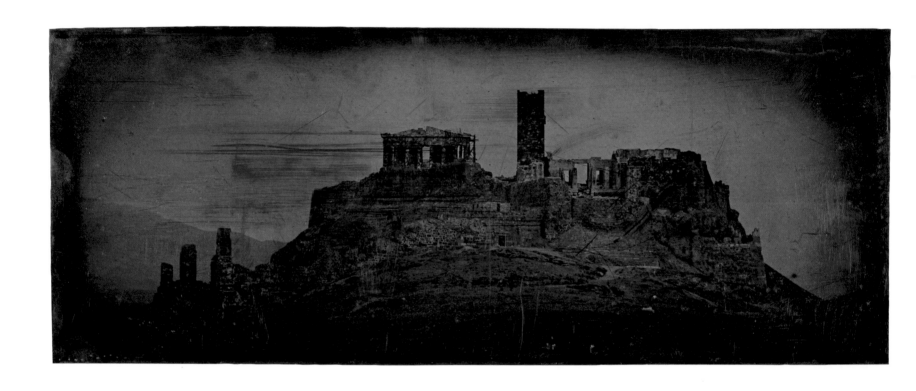

PLATE 34. *Western Approach to the Acropolis, Athens,* 1842

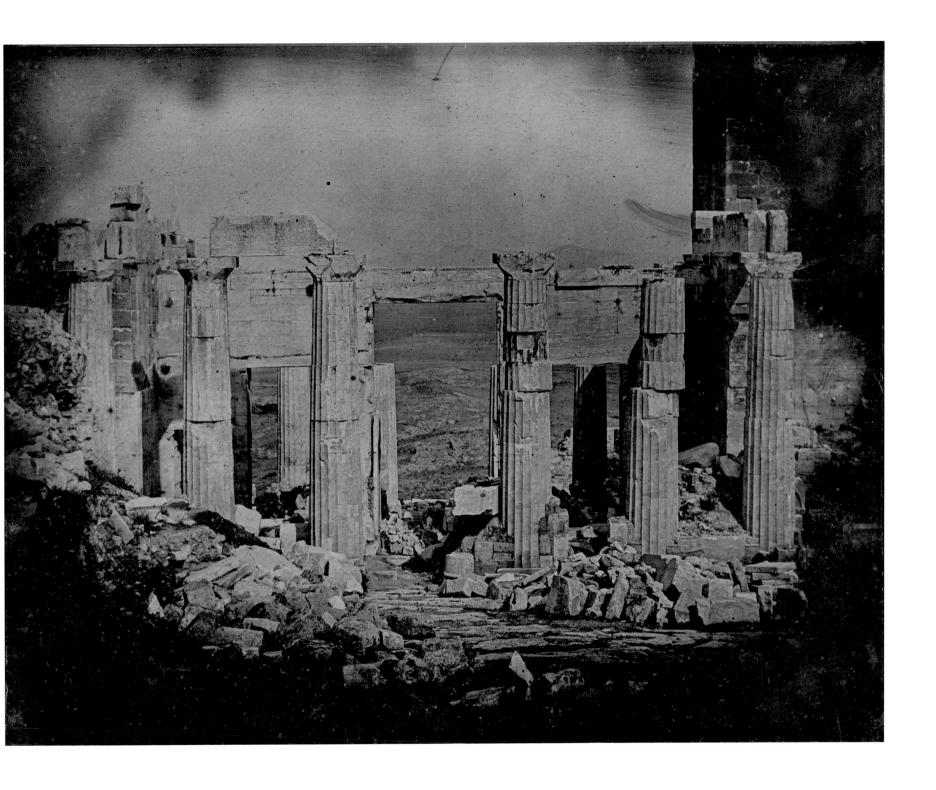

PLATE 35. *Propylaea, Acropolis, Athens*, 1842

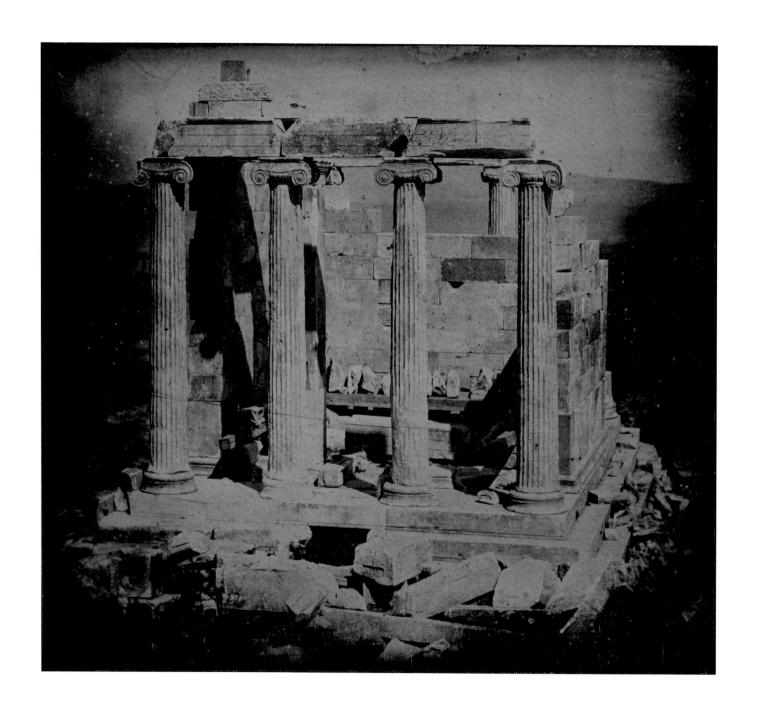

PLATE 36. *Temple of Athena Nike, Acropolis, Athens*, 1842

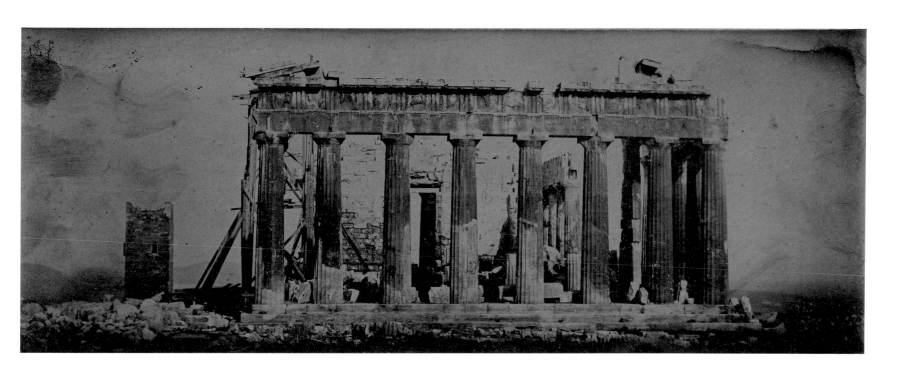

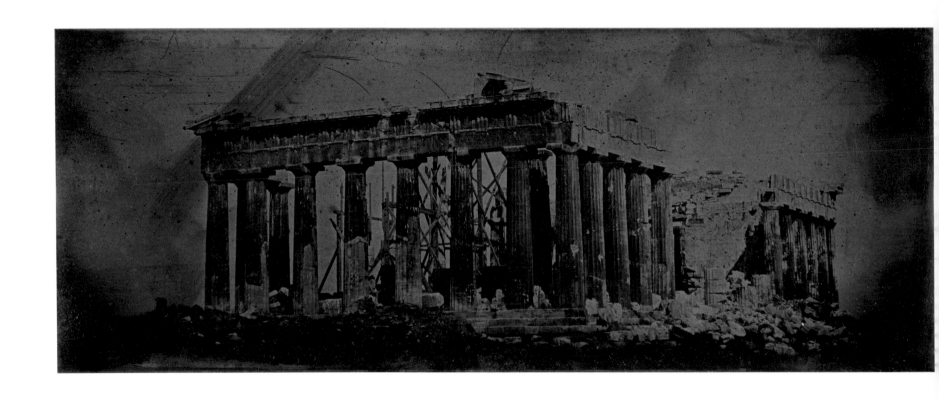

66 PLATE 38. *North and East Sides of the Parthenon, Athens,* 1842

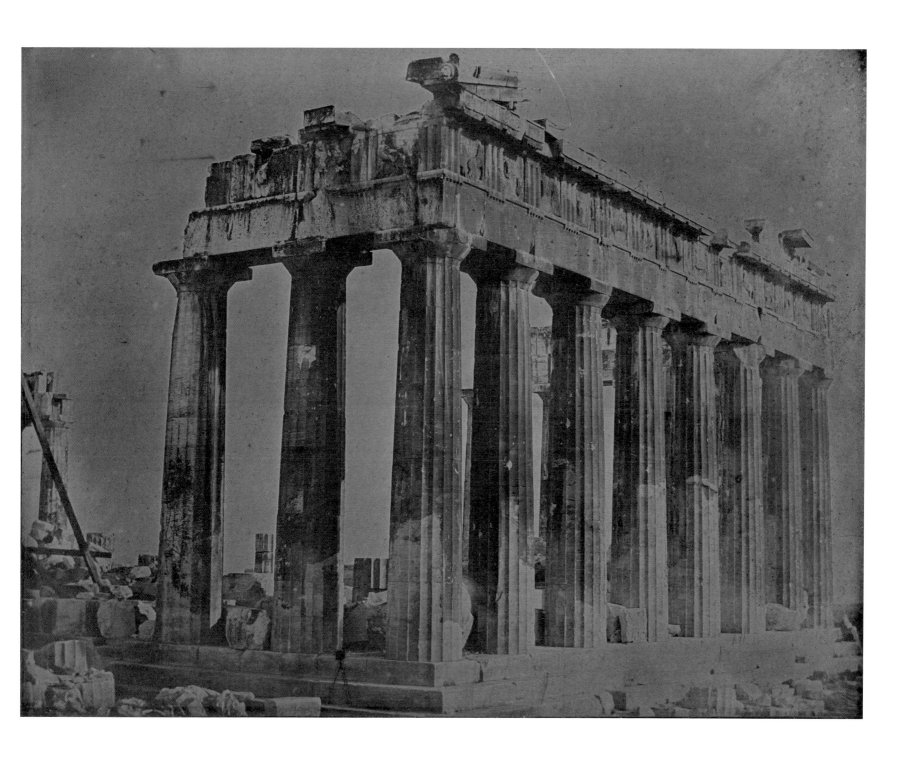

PLATE 39. *Facade and North Colonnade, Parthenon, Athens,* 1842 67

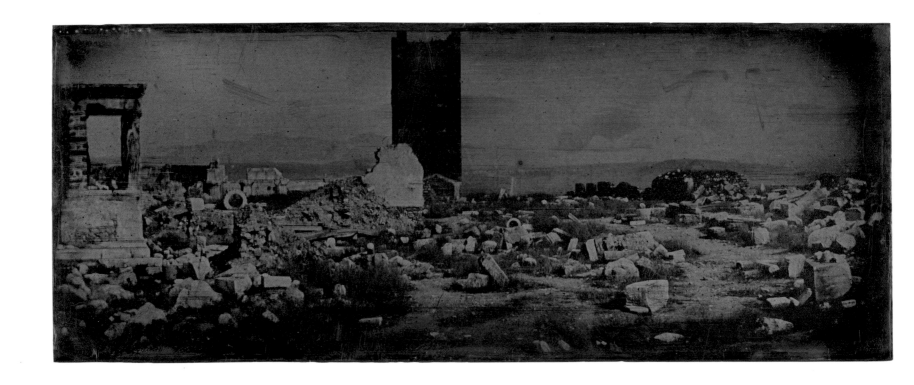

PLATE 40. *Ruins and Foreground, Acropolis, Athens, 1842*

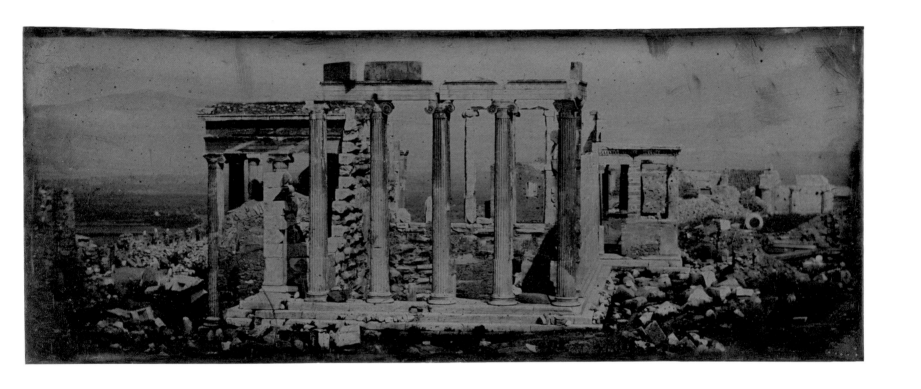

PLATE 41. *Erechtheion, Athens,* 1842

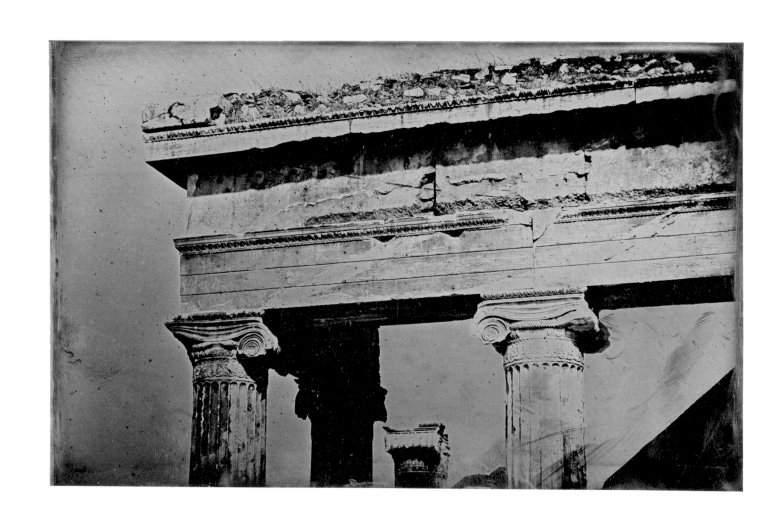

PLATE 42. *Capital Detail, Erechtheion, Athens,* 1842

PLATE 43. *Caryatid, Erechtheion, Athens,* 1842

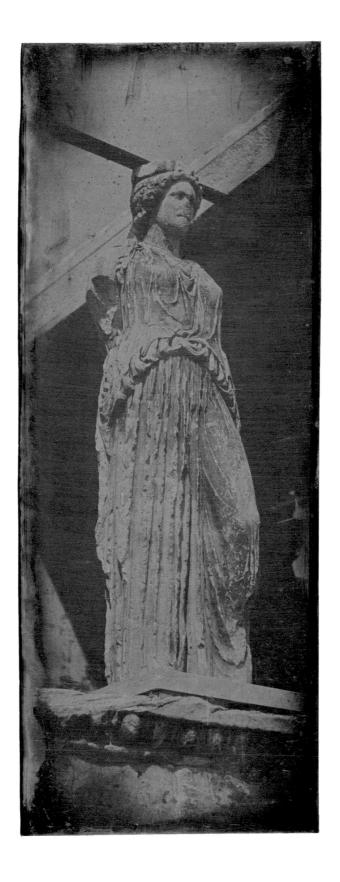

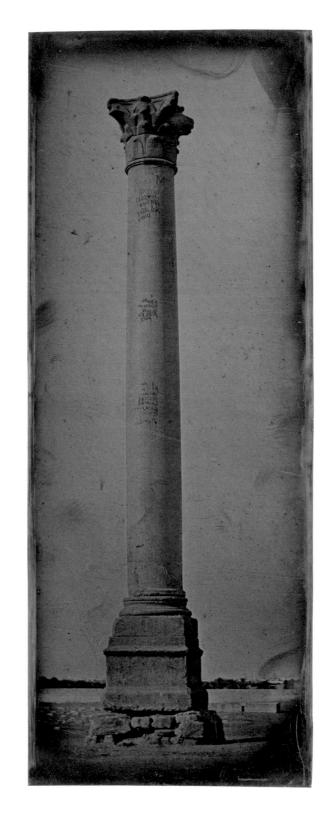

PLATE 44. *Pompey's Column, Alexandria,* 1842

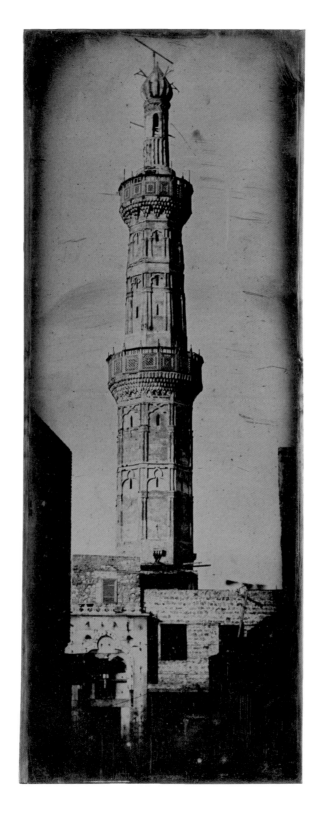

PLATE 45. *Grand Minaret, Alexandria,* 1842

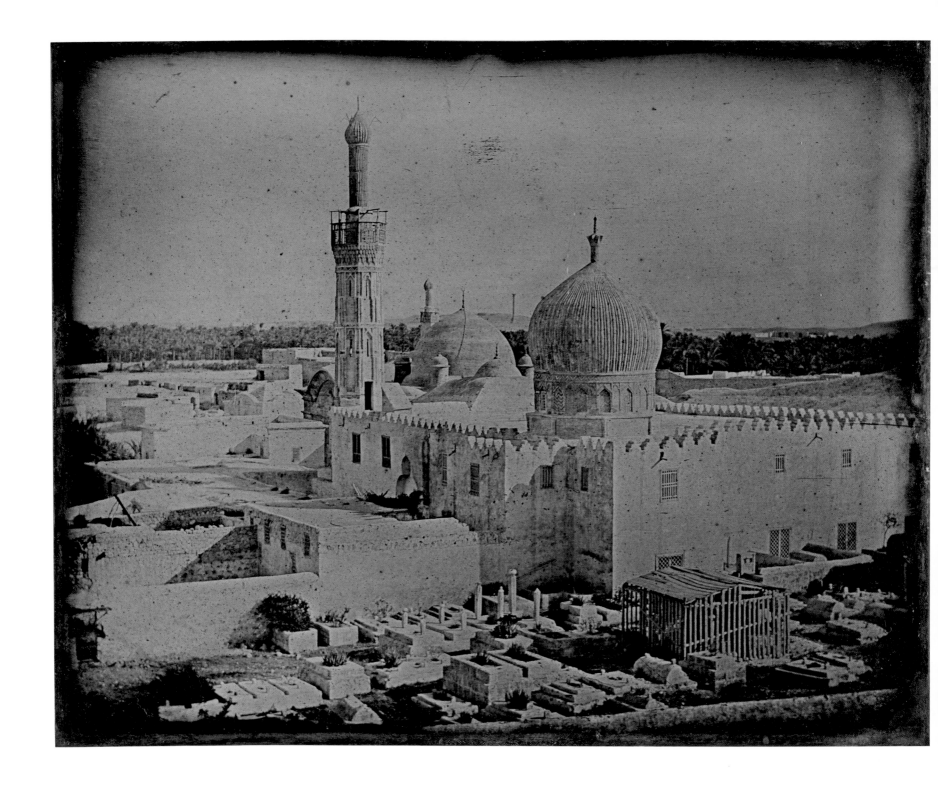

PLATE 46. *al-Naby Daniel Mosque, Alexandria,* 1842

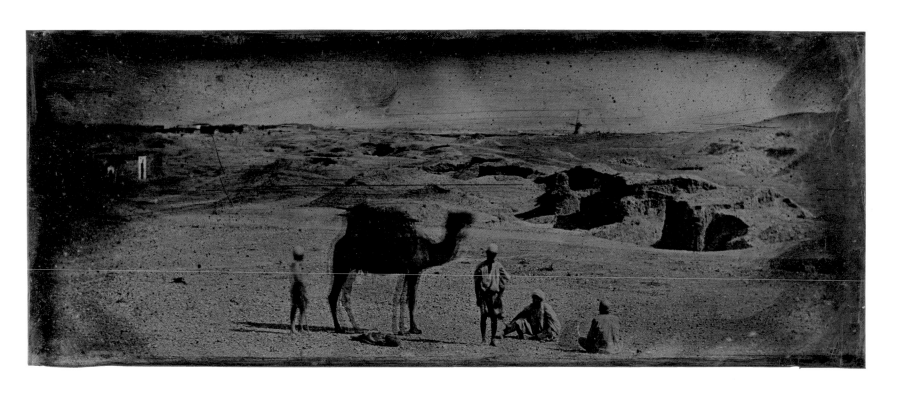

PLATE 47. *Desert near Alexandria,* 1842

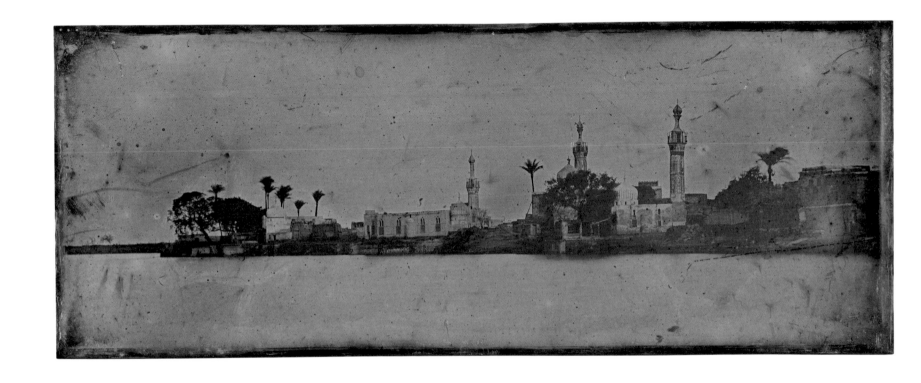

PLATE 48. *Fuwa, Viewed from the Island*, 1842

PLATE 49. *Street in Rosetta*, 1842

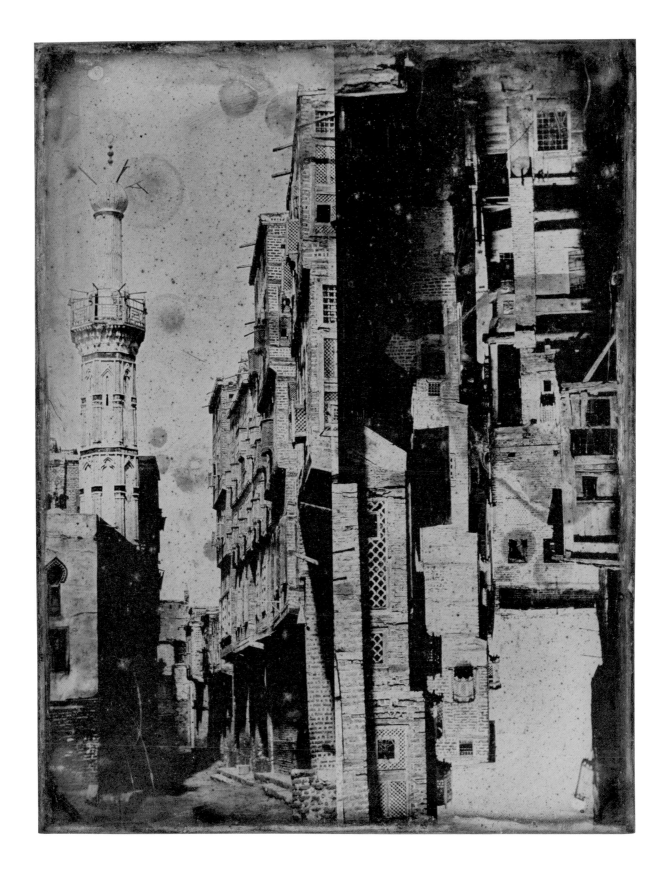

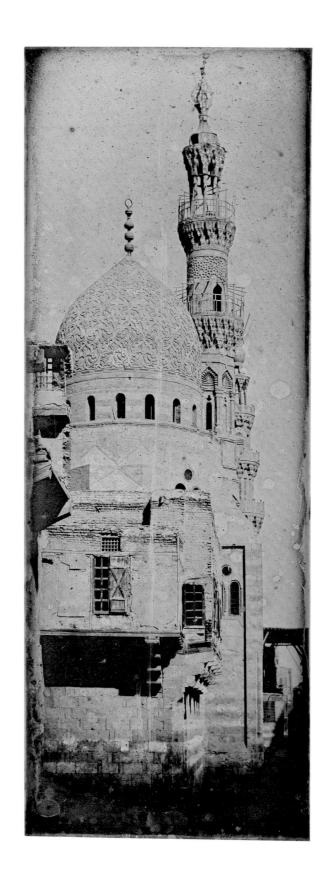

78

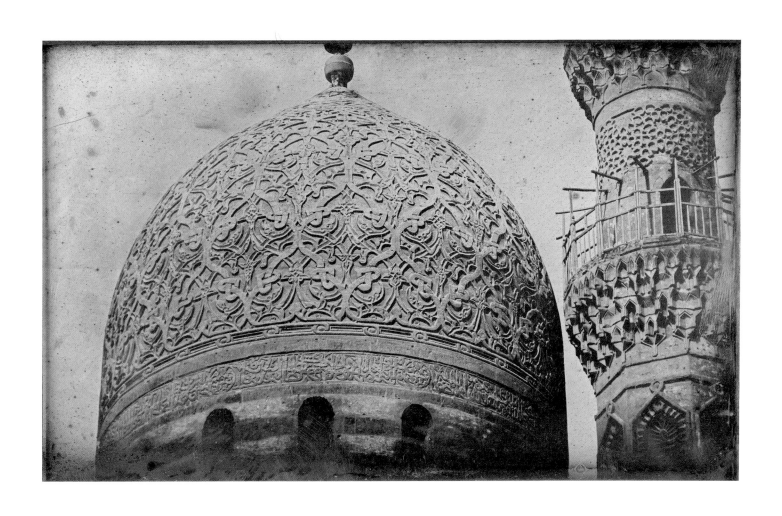

PLATE 50. *Minaret and Dome, Khayrbak Mosque, Cairo*, 1843

PLATE 51. *Dome, Khayrbak Mosque, Cairo*, 1843

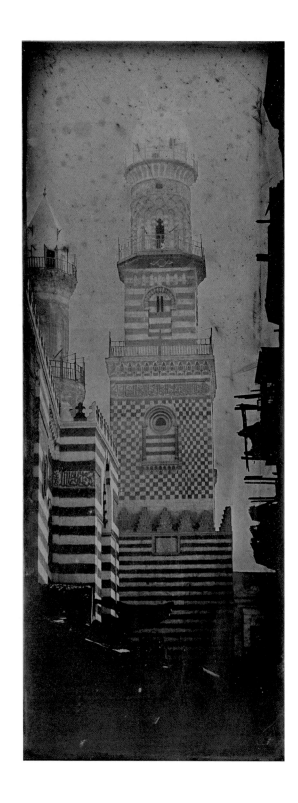

PLATE 52. *Minaret of the Maristan, Complex of Sultan Qalawun, Cairo, 1842–43*

PLATE 53. *Detail, Complex of Sultan Qalawun, Cairo*, 1843

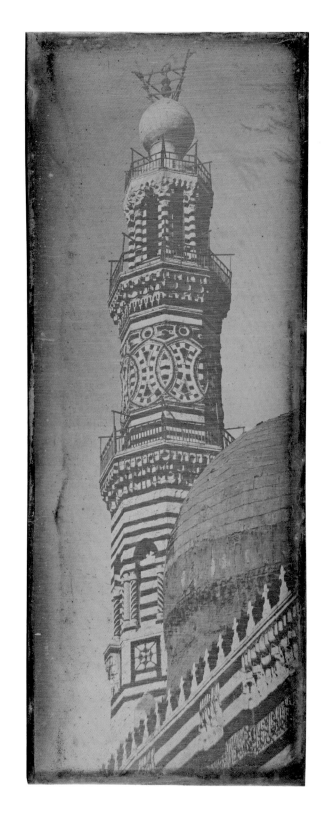

PLATE 54. *Mosque of Sultan Barquq, Cairo, 1843*

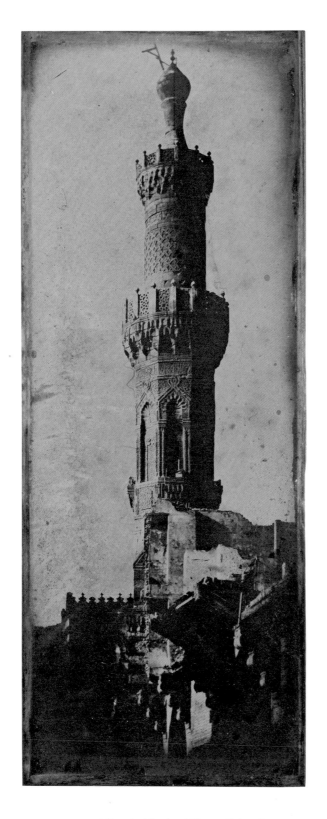

PLATE 55. *Minaret, al-Burdayni Mosque, Cairo*, 1843

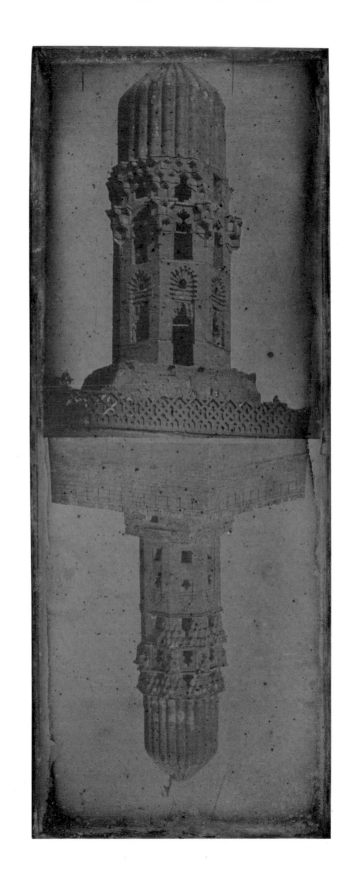

84

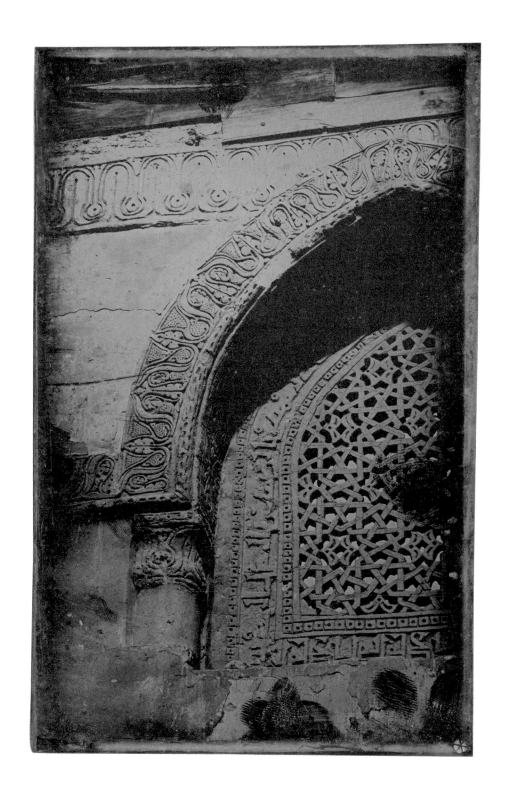

PLATE 56. *Mosque of Sultan al-Hakim, Cairo,* 1842–43

PLATE 57. *Window, Mosque of Ibn Tulun, Cairo,* 1842–43

85

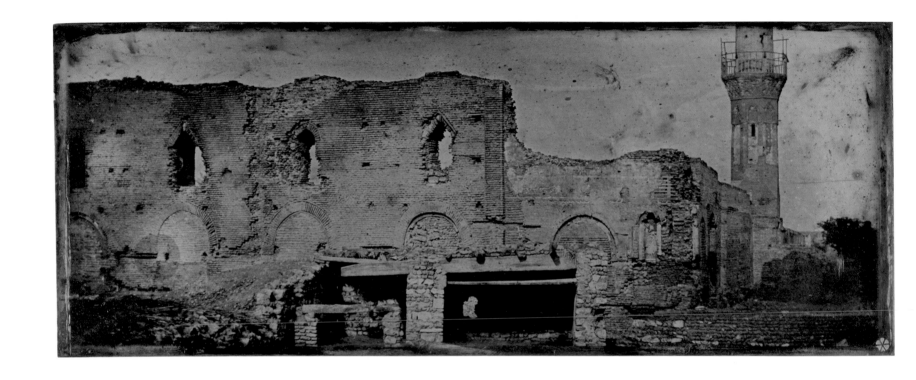

PLATE 58. *West Side, Mosque of 'Amr ibn al-'As, Cairo,* 1843

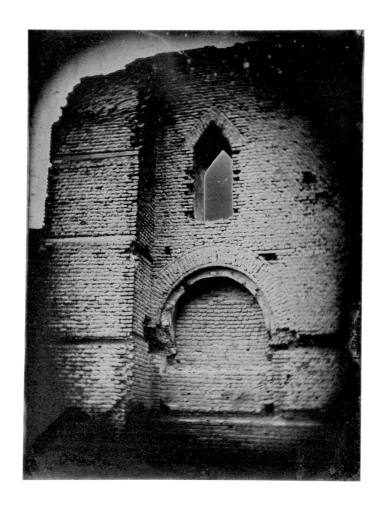

PLATE 59. *Exterior Arch, Mosque of ʿAmr ibn al-ʿAs, Cairo, 1842–43*

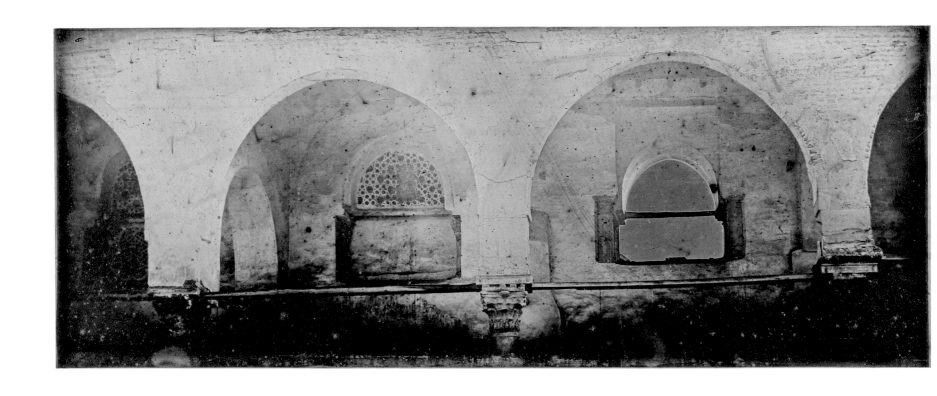

88 PLATE 60. *Mosque of 'Amr ibn al-'As, Cairo, 1842–43*

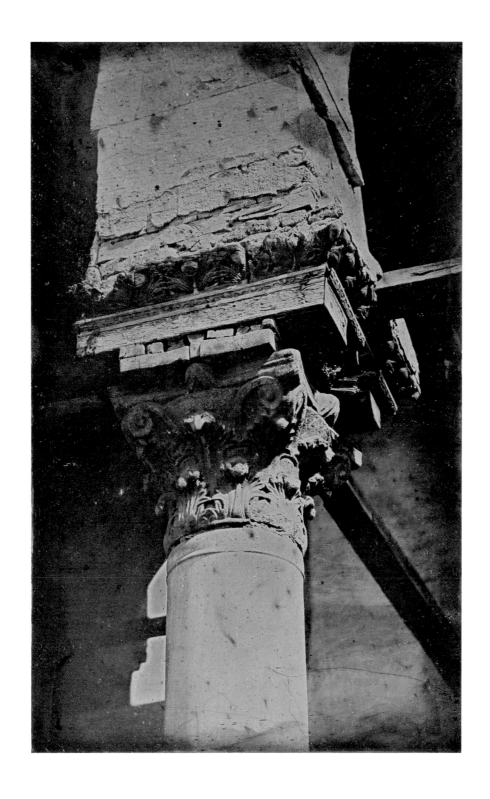

PLATE 61. *Capital, Mosque of 'Amr ibn al-'As, Cairo, 1842–43*

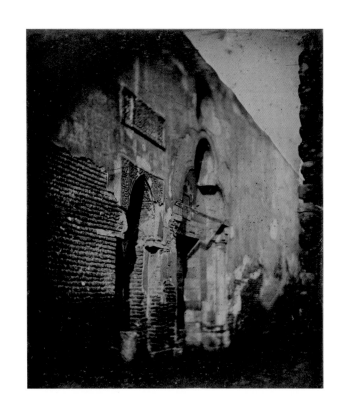

PLATE 62. *Exterior Mihrab, Mosque of ʿAmr ibn al-ʿAs, Cairo, 1842–43*

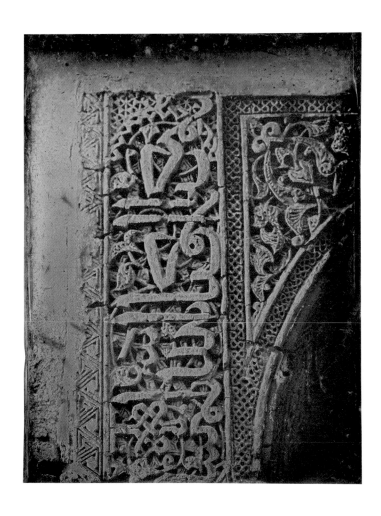

PLATE 63. *Mihrab Inscription, Mosque of ʿAmr ibn al-ʿAs, Cairo, 1842–43*

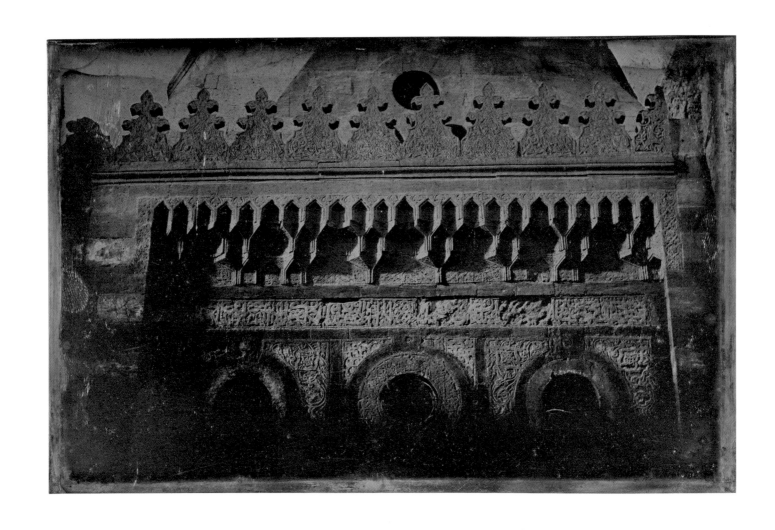

PLATE 64. *Detail, Mosque of Amir Ghanim al-Bahlawan, Cairo, 1842–43*

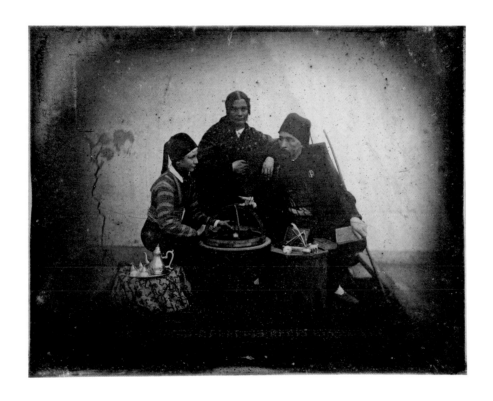

PLATE 65. *Nicolas Perron and His Family, Cairo*, 1842–43

93

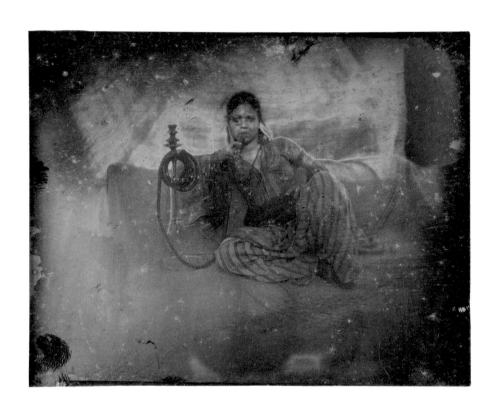

PLATE 66. *Ayoucha, Cairo,* 1842–43

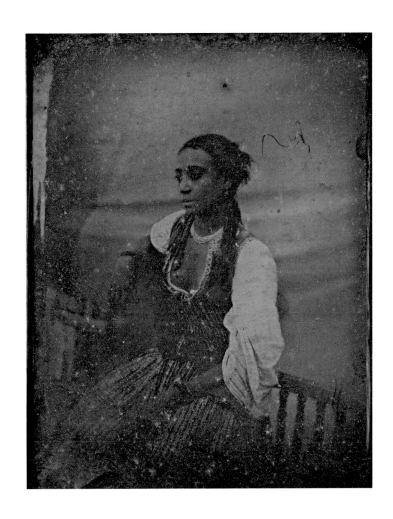

PLATE 67. *Bedouin from Giza, Cairo*, 1842–43

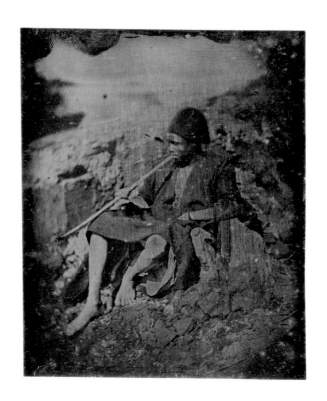

96 PLATE 68. *Sailor, Cairo*, 1842–43

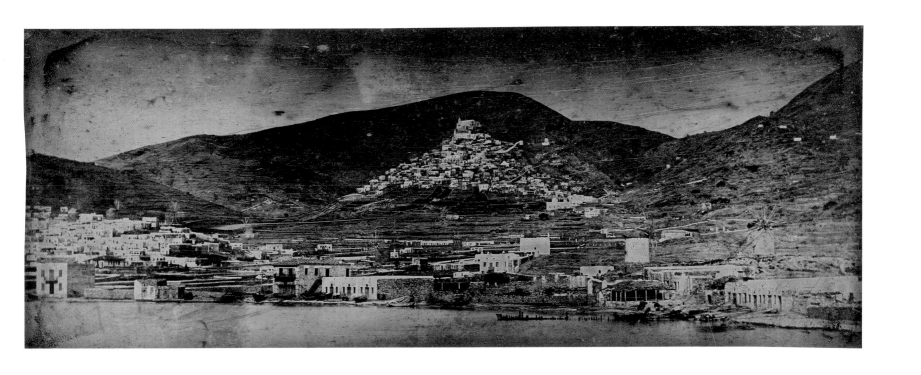

PLATE 69. *Syros*, 1843

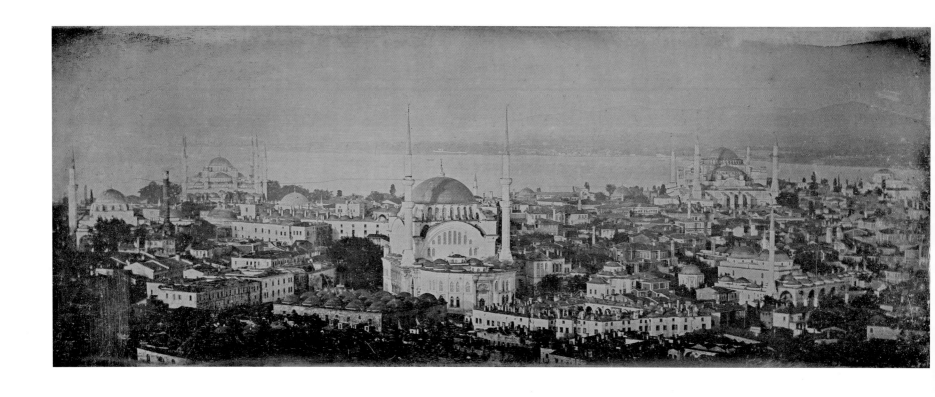

PLATE 70. *Constantinople*, 1843

PLATE 71. *Fountain near Galata, Constantinople*, 1843

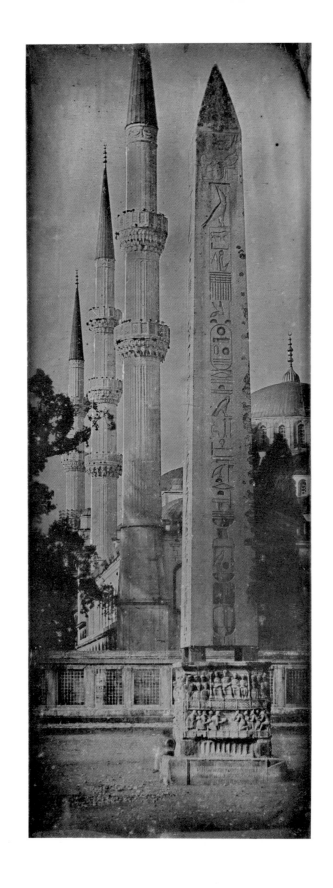

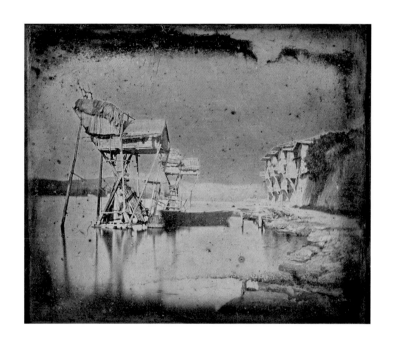

PLATE 72. *Hippodrome, Constantinople*, 1843

PLATE 73. *Fishing Huts, Northern Bosphorus*, 1843

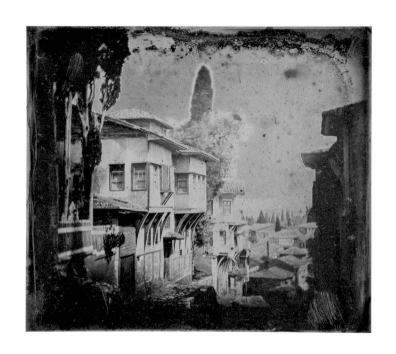

PLATE 74. *Stepped Street, Scutari, Constantinople*, 1843

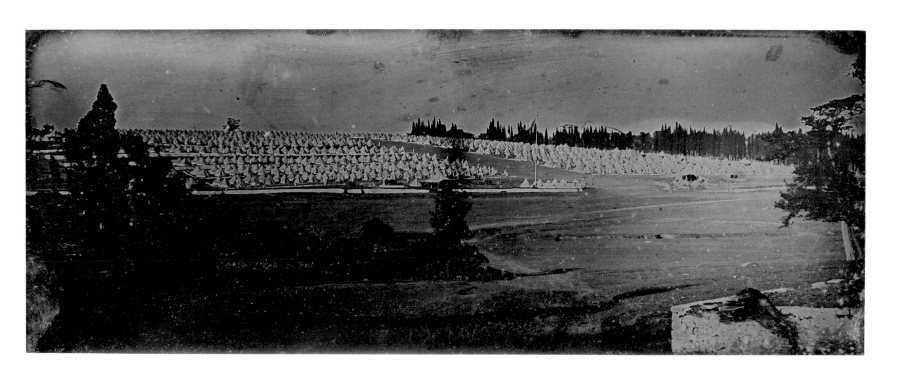

PLATE 75. *Ottoman Camp at Haidar Pasha, Scutari, Constantinople*, 1843

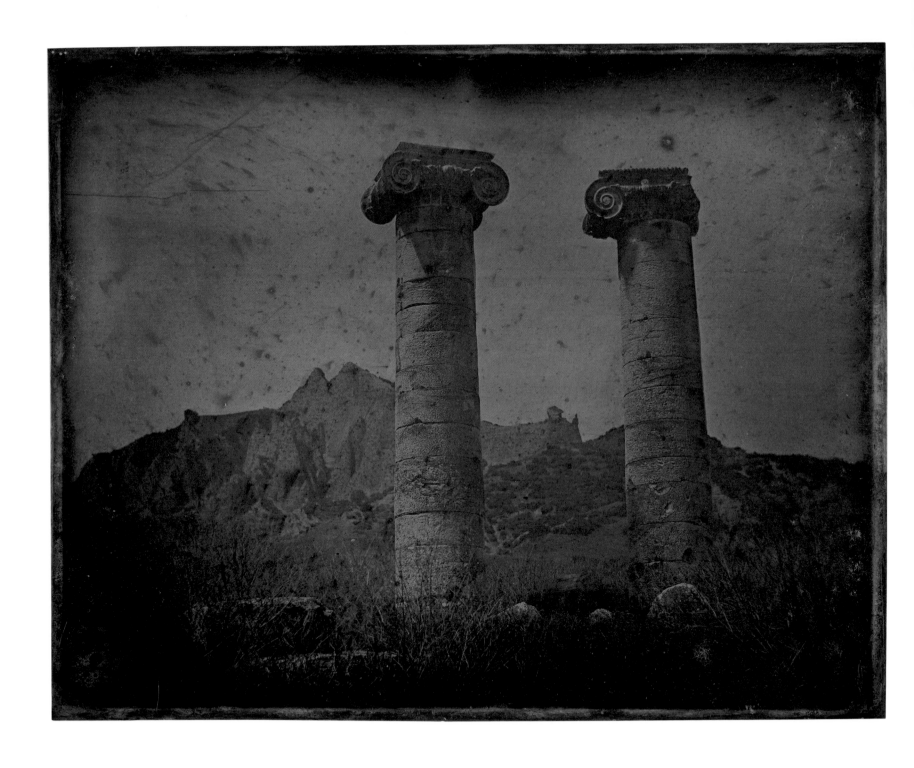

PLATE 76. *Temple of Artemis, Sardis*, 1843

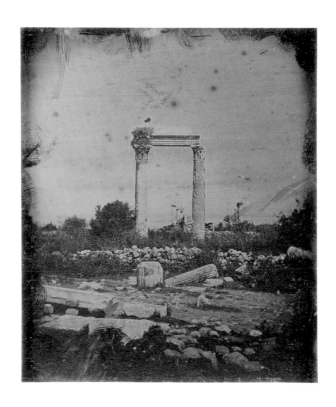

PLATE 77. *Spiral Columns, Aphrodisias*, 1843

PLATE 78. *Capital, Greco-Roman Theater, Miletus,* 1843

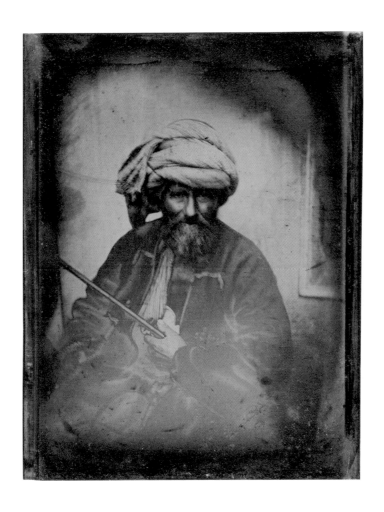

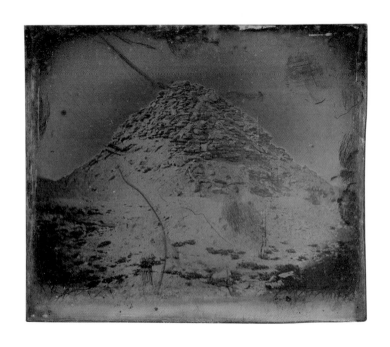

PLATE 80. *Pyramid of Unas, Saqqara, 1843–44*

PLATE 81. *Pylon of Ptolemy III, Karnak, Thebes, 1844*

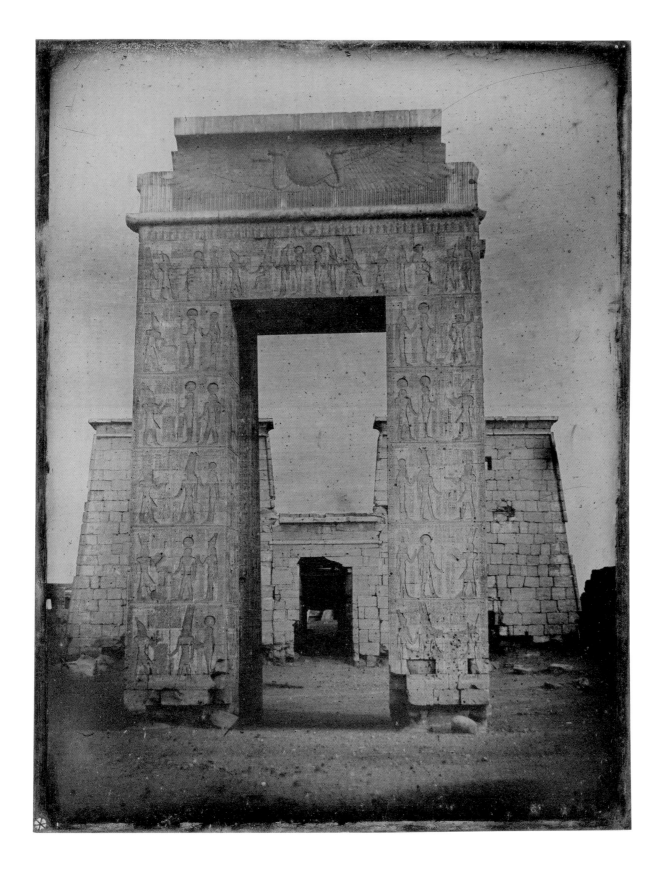

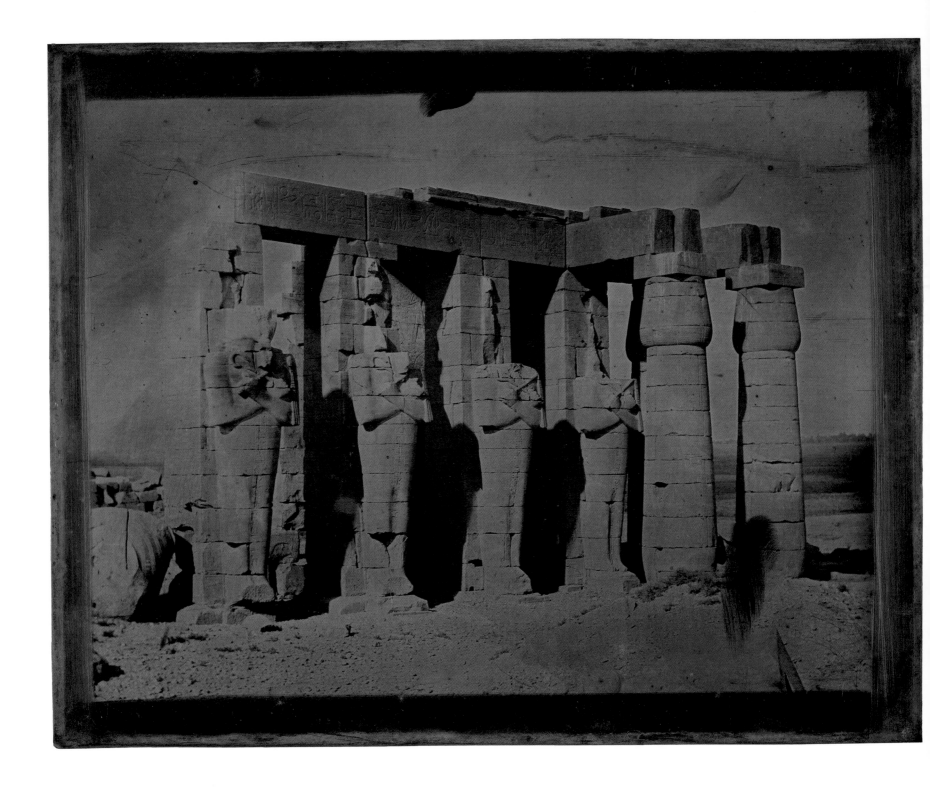

PLATE 82. *Ramesseum, Thebes,* 1844

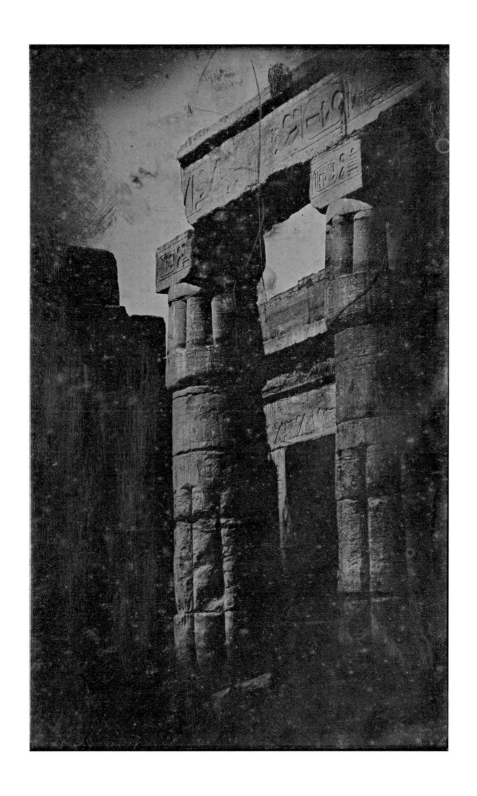

PLATE 83. *Columns, Temple of Seti, Kurna, Thebes,* 1844

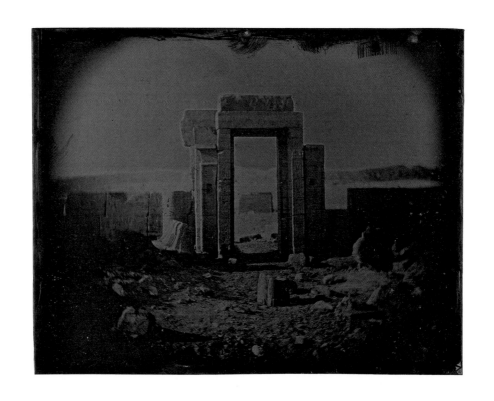

PLATE 84. *Temple of Horus, Edfu,* 1844

PLATE 85. *Capital, Temple of Horus, Edfu,* 1844

PLATE 86. *Rocks, Philae,* 1844

PLATE 87. *Palm Trees, Alexandria,* 1842–44

PLATE 88. *Man Standing under a Tree, Jaffa*, 1844

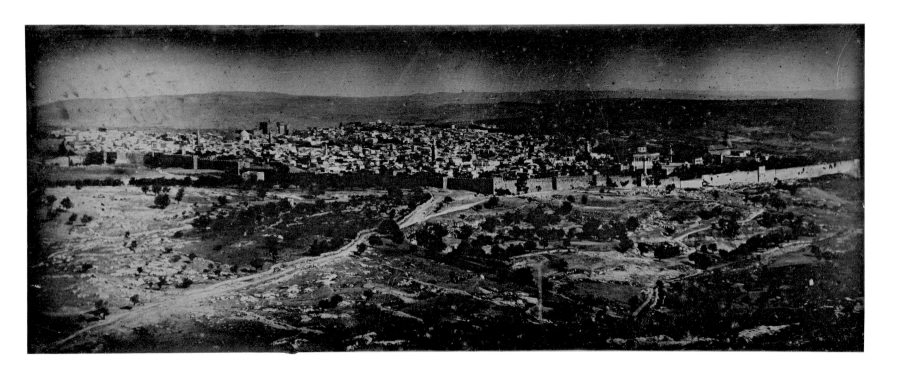

PLATE 89. *Jerusalem within the Ramparts of the City*, 1844

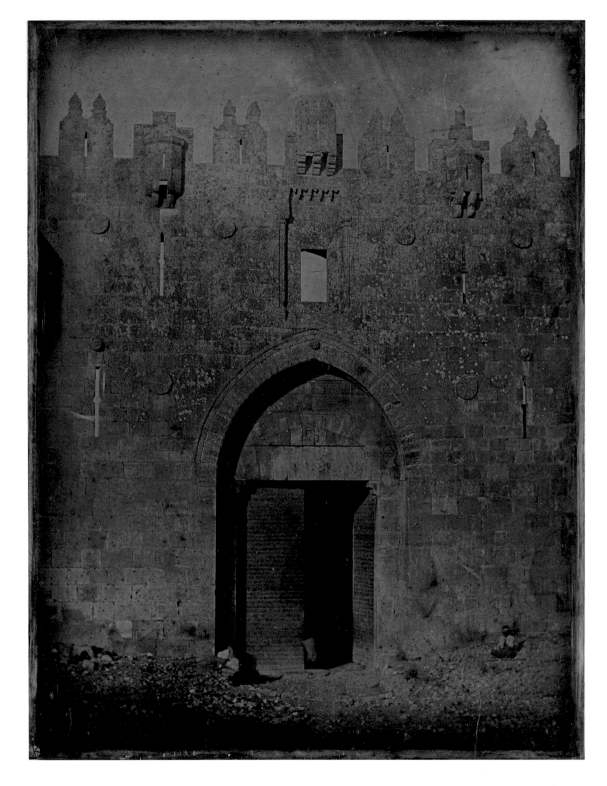

PLATE 90. *Damascus Gate, Jerusalem*, 1844

PLATE 91. *Damascus Gate, Jerusalem*, 1844

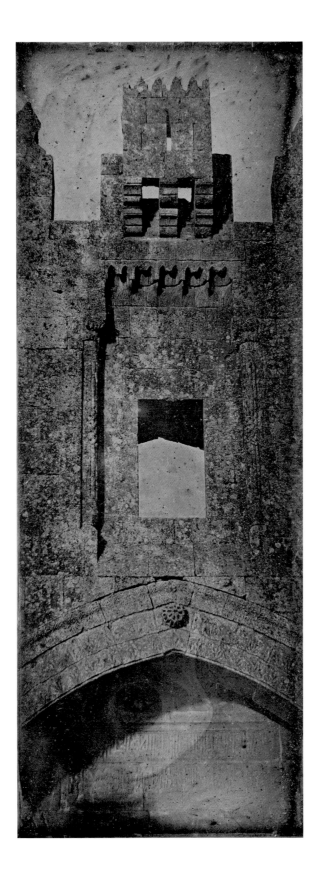

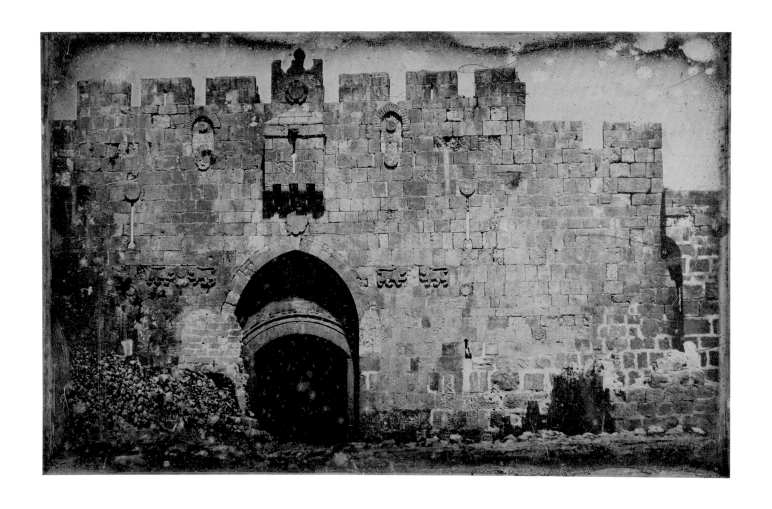

PLATE 92. *Lion Gate, Jerusalem, 1844*

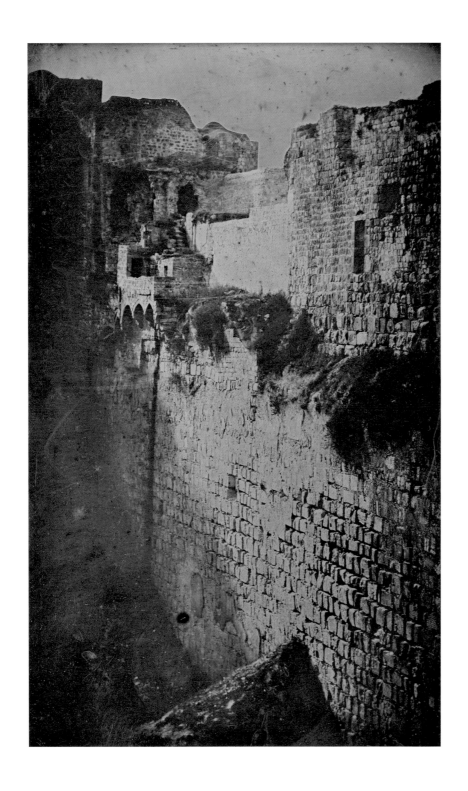

PLATE 93. *Probatic Pool (Pool of Bethesda), Jerusalem*, 1844

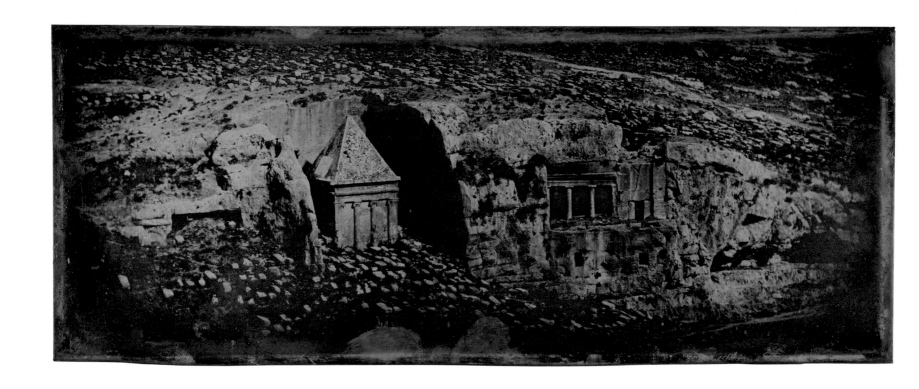

PLATE 94. *Tombs, Valley of Josaphat, near Jerusalem,* 1844

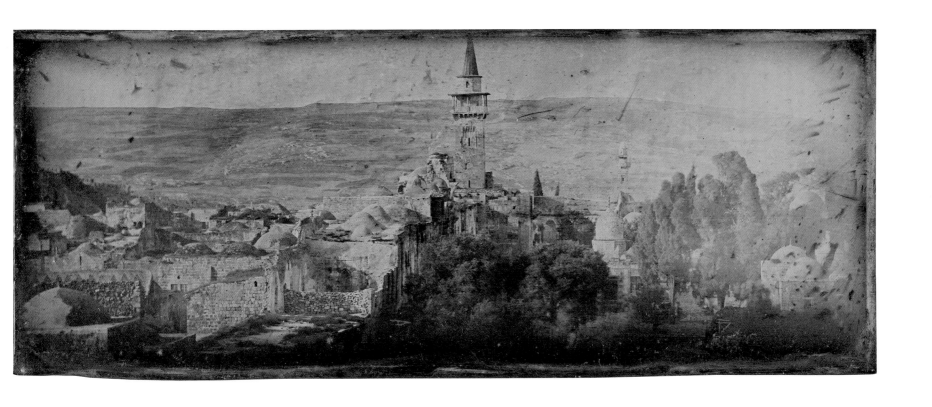

PLATE 95. *Bab al-Silsila Minaret and Mughrabi (Moroccan) Quarter, Jerusalem,* 1844

123

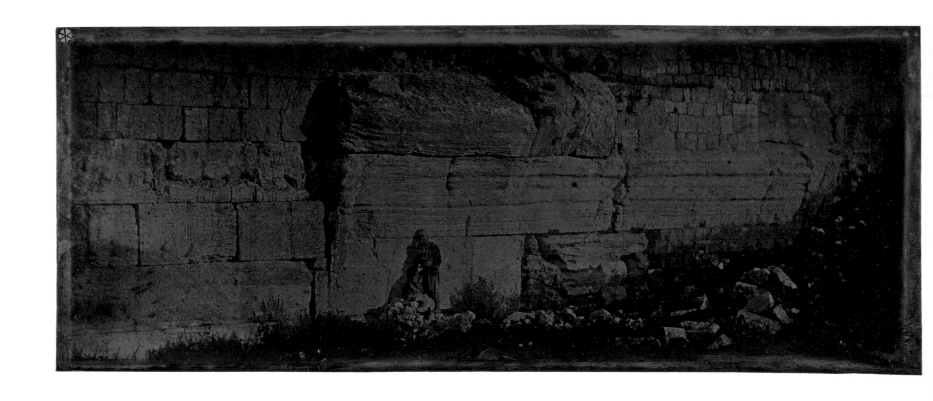

124 PLATE 96. *Robinson's Arch, Jerusalem, 1844*

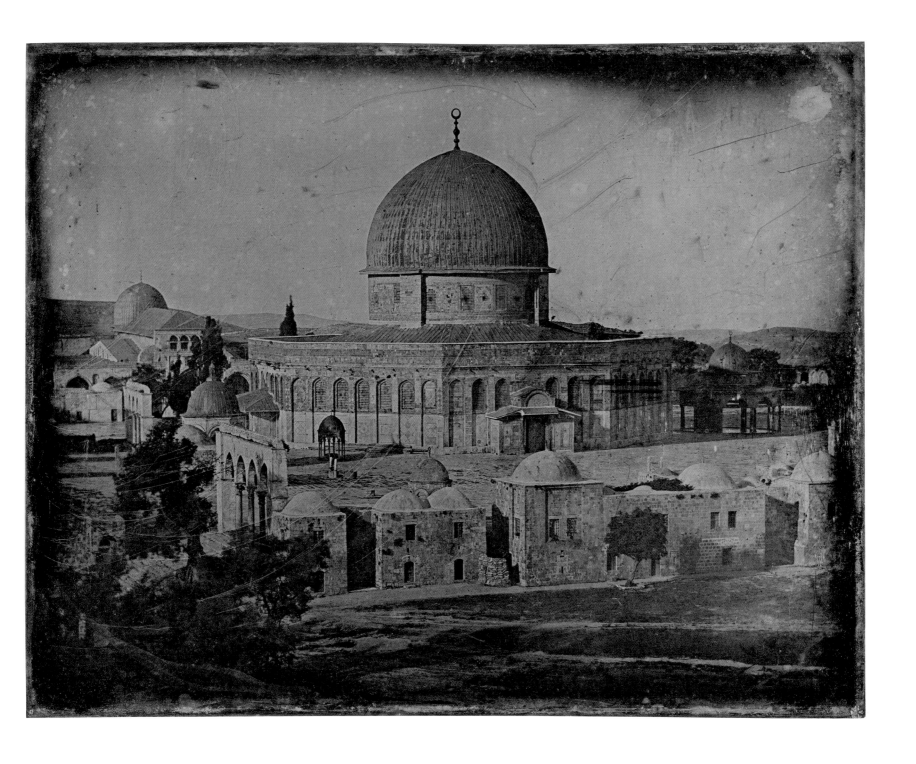

PLATE 97. *Dome of the Rock, Jerusalem, 1844*

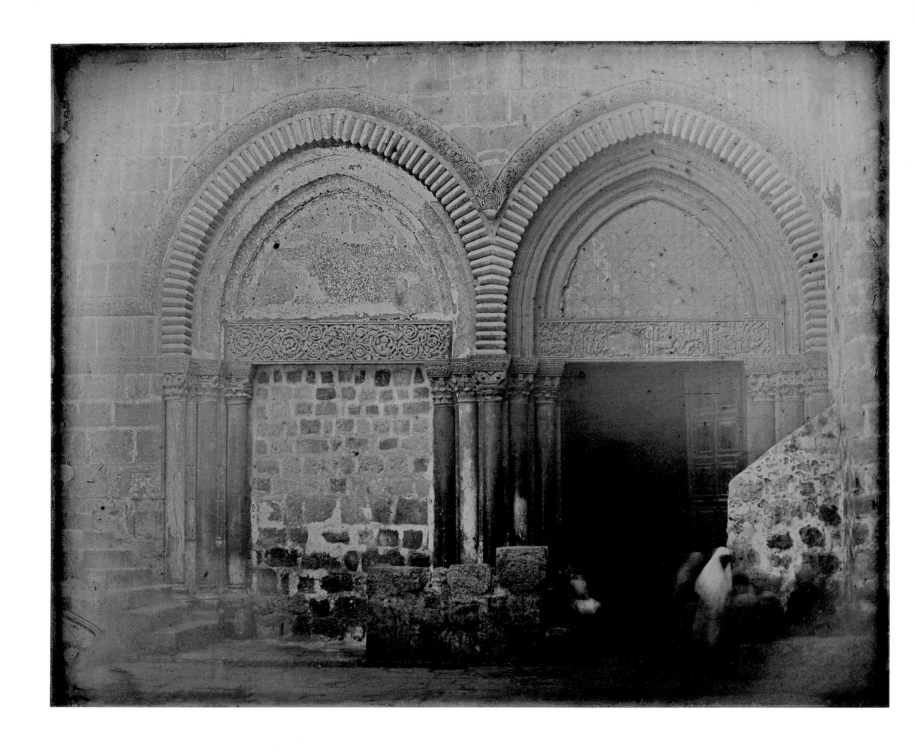

126 PLATE 98. *Portal, Church of the Holy Sepulchre, Jerusalem, 1844*

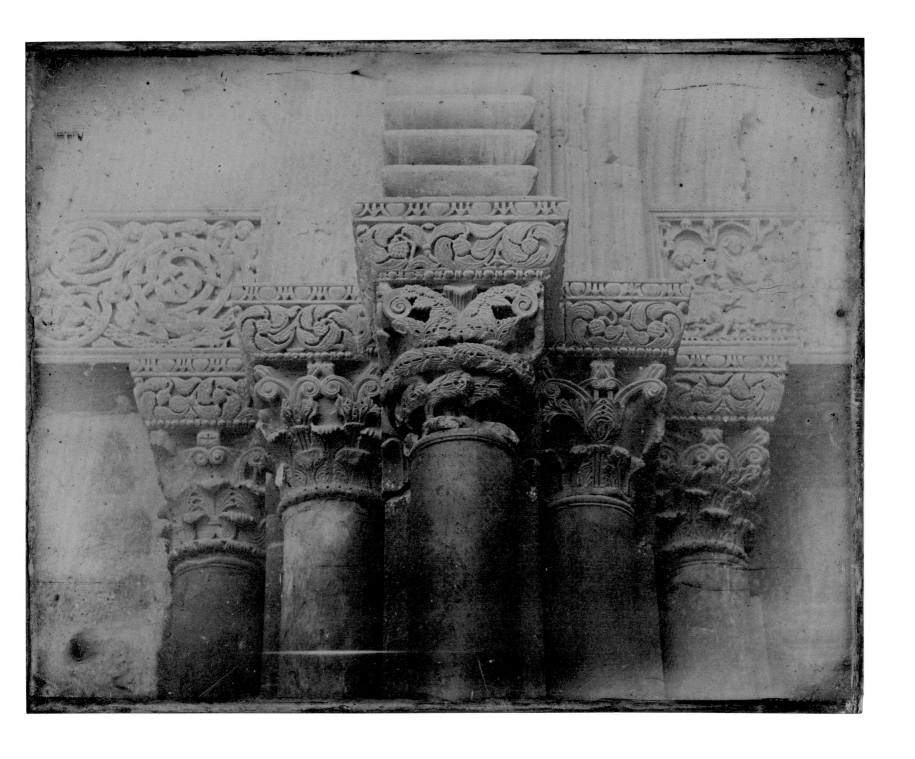

PLATE 99. *Portal Detail, Church of the Holy Sepulchre, Jerusalem,* 1844

127

128 PLATE 100. *Church of the Nativity and Convents, Bethlehem, 1844*

PLATE 101. *Tombs, Souq Wadi Barada (Abila)*, 1844

129

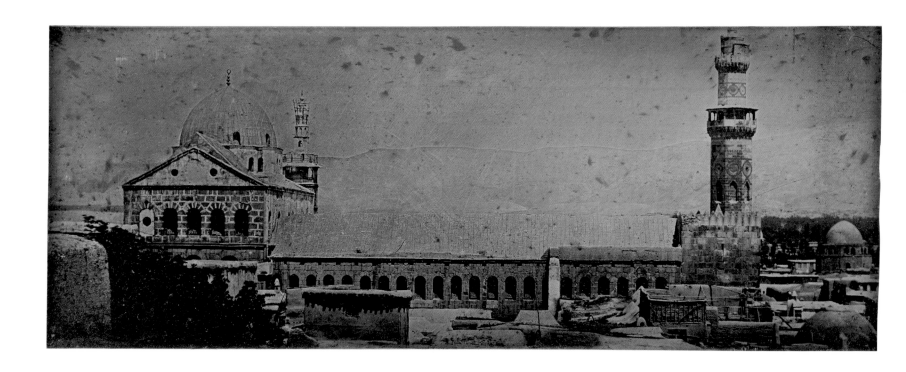

PLATE 102. *Great Mosque of Damascus, 1843*

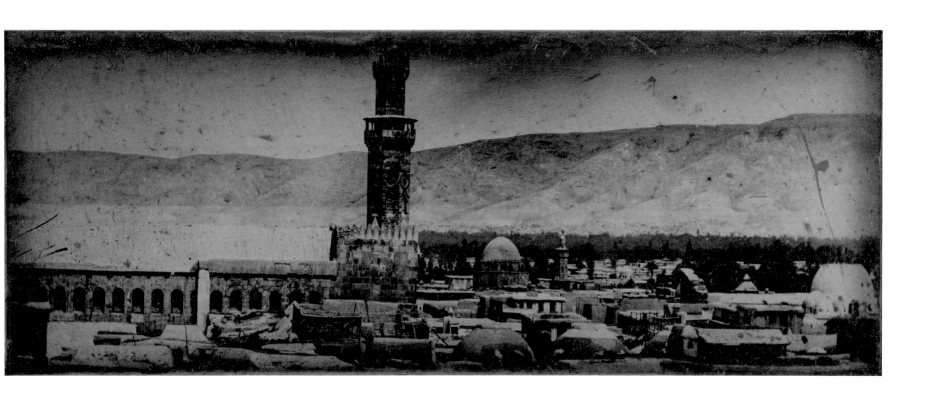

PLATE 103. *Great Mosque of Damascus, Viewed from Khan As'ad Pasha,* 1843

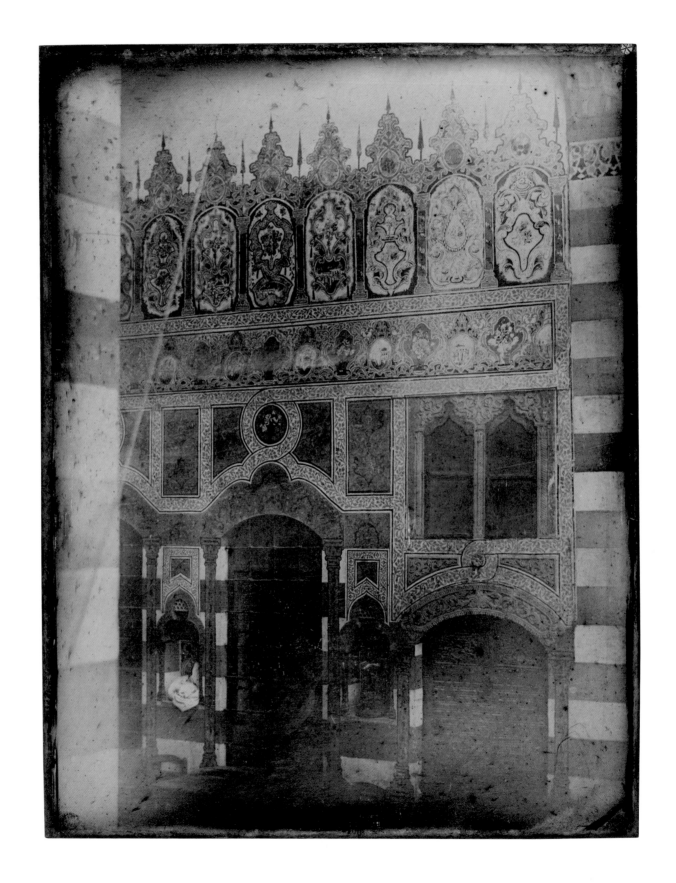

132

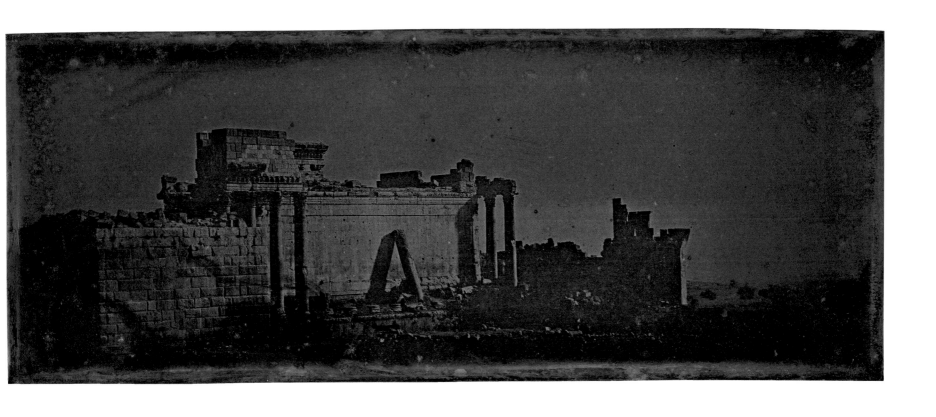

PLATE 104. *Iwan, Damascus*, 1844

PLATE 105. *Baalbek*, 1843–44

133

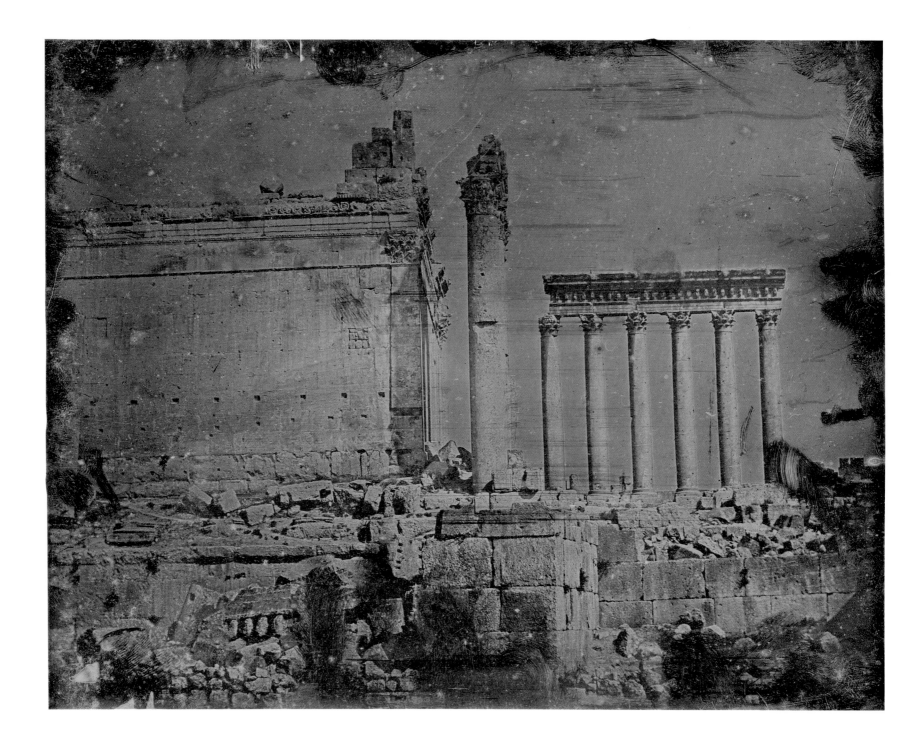

PLATE 106. *Temples of Jupiter and Bacchus, Baalbek, 1844*

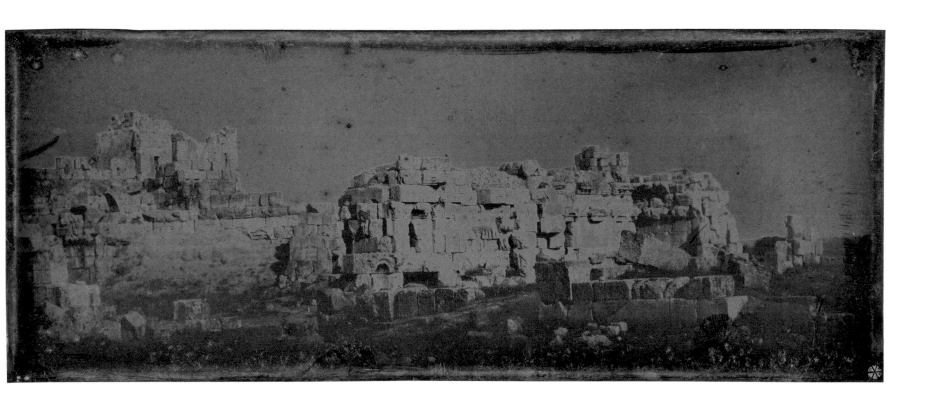

PLATE 107. *Hexagonal Court, Temple of Jupiter, Baalbek, 1843* 135

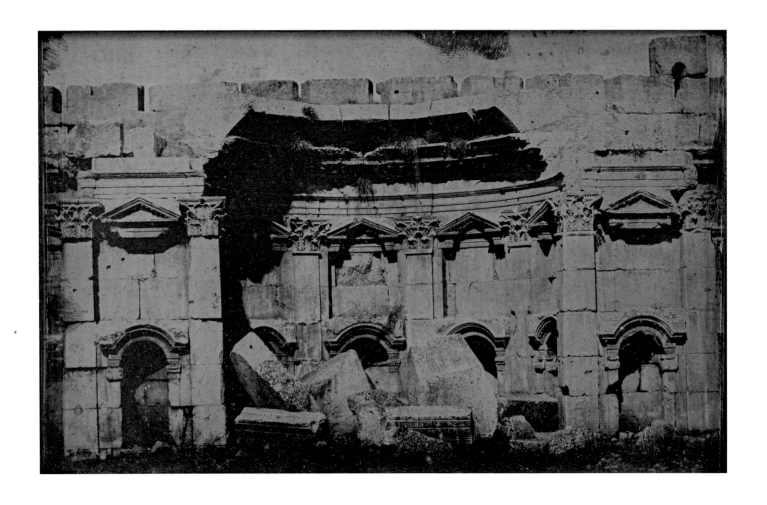

PLATE 108. *Wall of the Great Court, Temple of Jupiter, Baalbek, 1843–44*

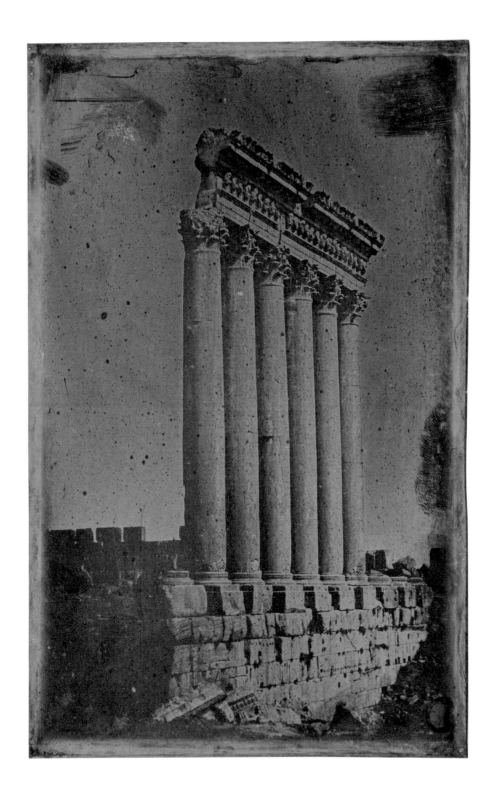

PLATE 109. *Colonnade, Temple of Jupiter, Baalbek, 1843–44*

PLATE 110. *Entablature, Temple of Jupiter, Baalbek, 1843–44*

PLATE III. *Interior Detail, Temple of Venus, Baalbek,* 1844

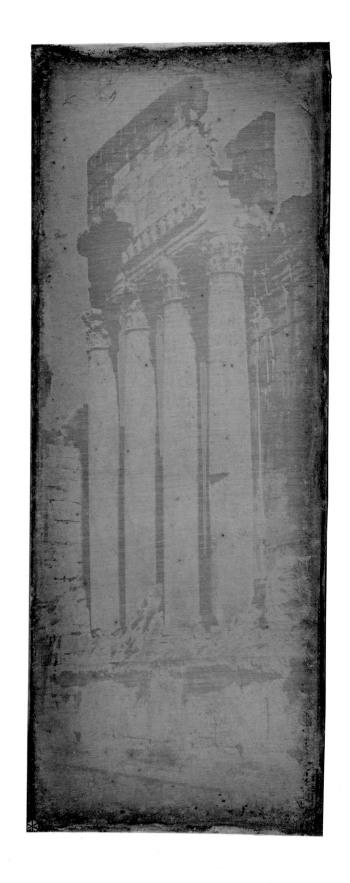

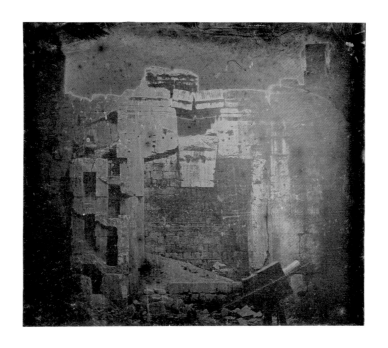

PLATE 112. *Southeast Colonnade, Temple of Bacchus, Baalbek*, 1843–44

PLATE 113. *Interior Entrance, Temple of Bacchus, Baalbek*, 1843–44

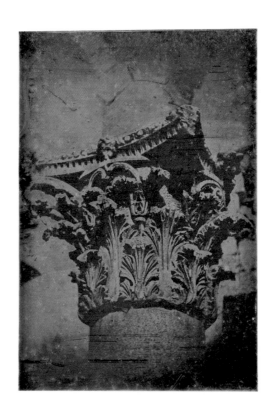

PLATE 114. *Capital Detail, Mosque at Baalbek, 1843–44*

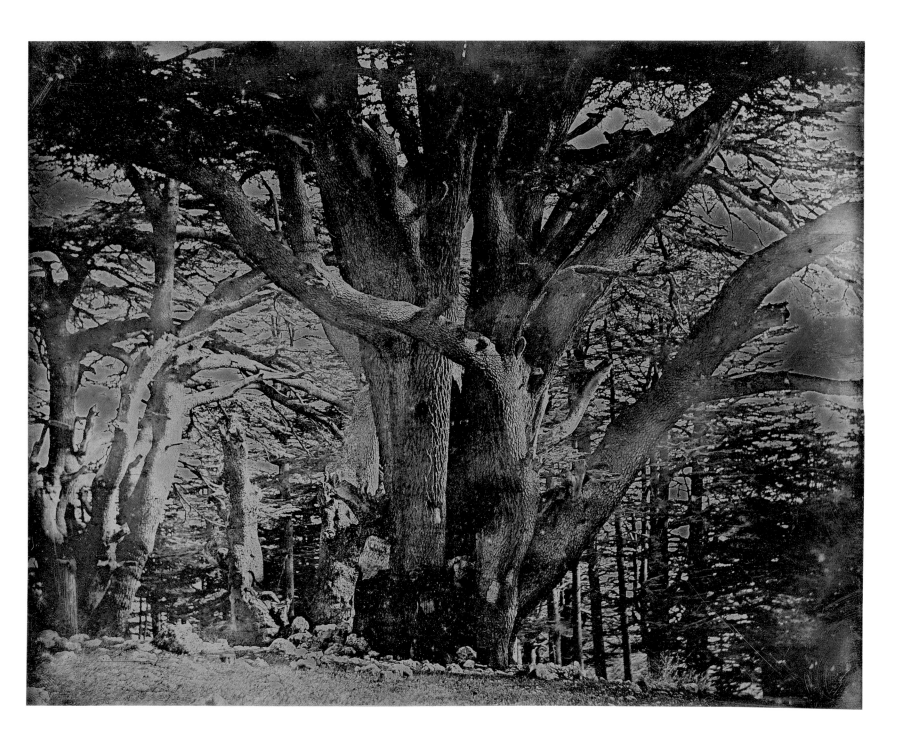

PLATE 115. *Cedars of Lebanon, 1844*

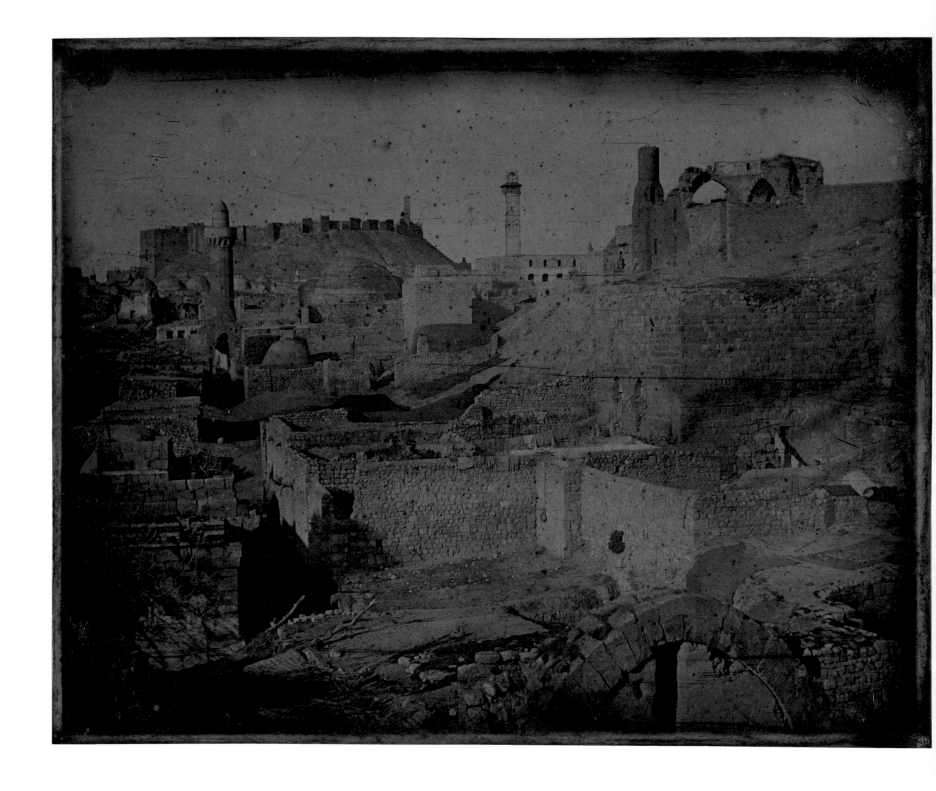

144 PLATE 116. *Aleppo, Viewed from the Antioch Gate, 1844*

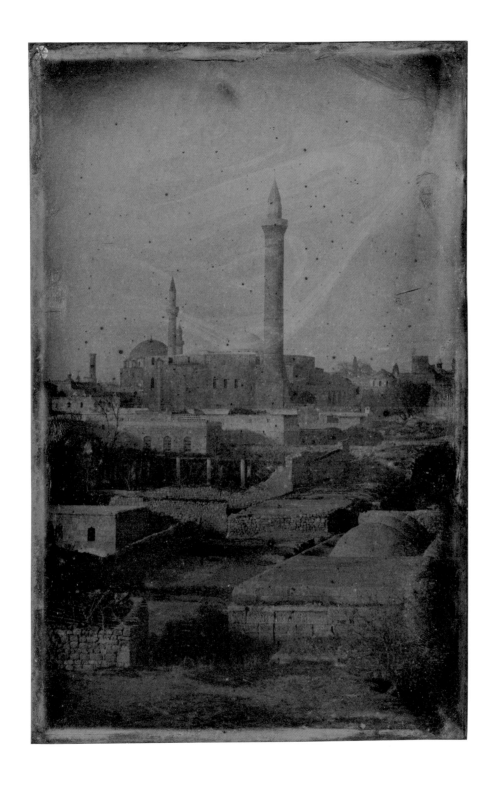

PLATE 117. *Aleppo, Viewed from the Antioch Gate,* 1844

145

PLATE 118. *Minaret, Bahsita Mosque, Aleppo,* 1844

PLATE 119. *Porte Gallo-Romaine, Langres,* ca. 1847

PLATE 120. *Capital Topped with a Cupid, Ancient Baths of Mont-Dore, Auvergne, 1845–50*

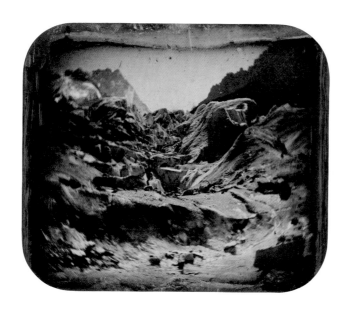

PLATE 121. *Mer de Glace, Mont Blanc Massif*, 1845–50

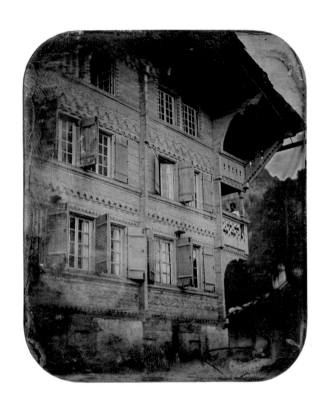

PLATE 122. *House Located on the East Side of Obere Gasse, Meiringen, 1845–50*

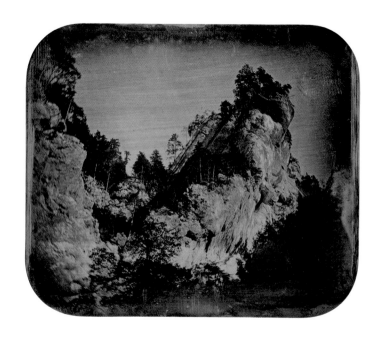

PLATE 123. *Limestone Rocks between Moutier and Roches*, 1845–50

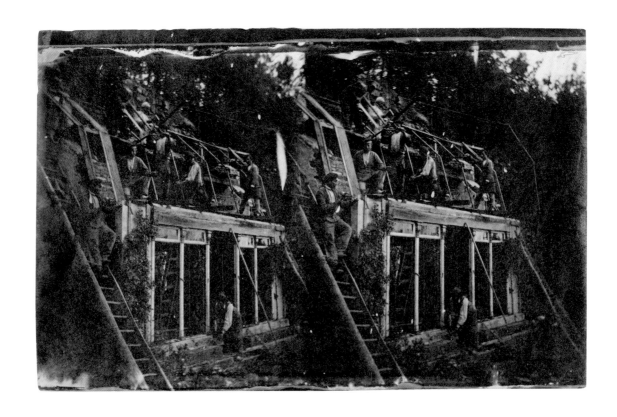

PLATE 124. *Greenhouse Construction, Villa des Tuaires, 1860s*

PLATE 125. *Men with a Barrel, 1860s*

PLATE 126. *Clematis monstruosa and Sophia*, 1860s

PLATE 127. *Self-Portrait in the Garden*, ca. 1860

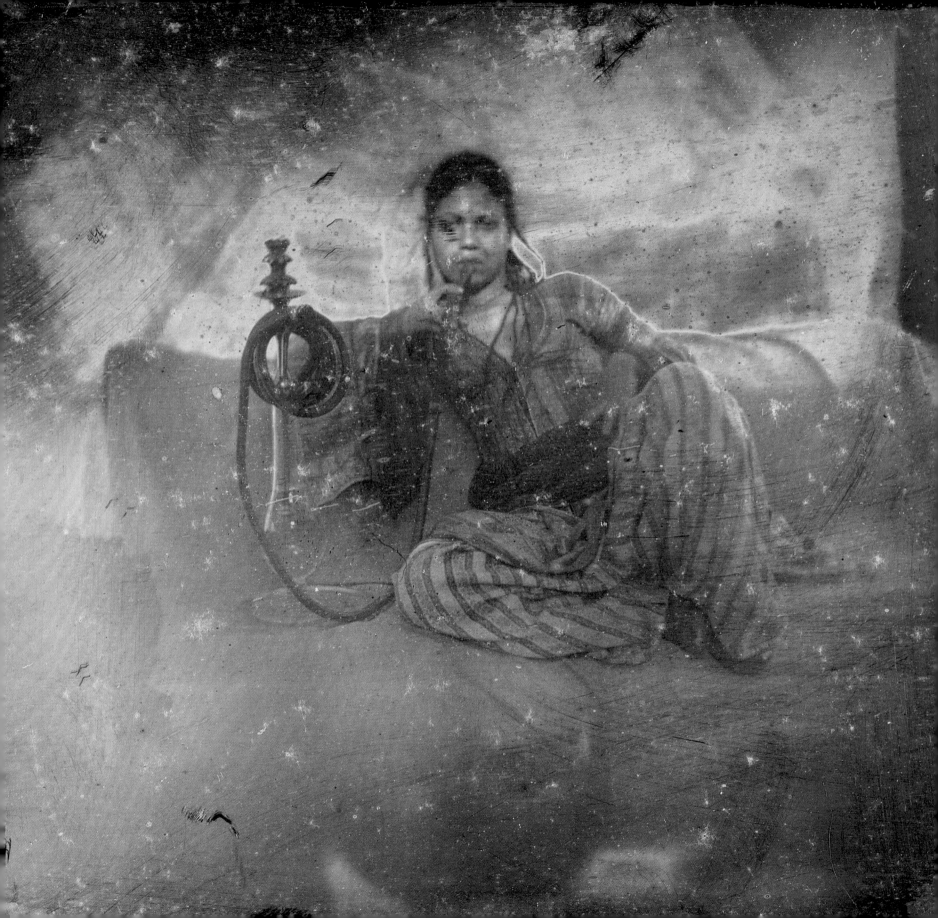

Framing an Islamic Art

Martina Rugiadi

It is deeply regrettable that our scholars and artists have hitherto been unable to examine and draw, with the attention and care they deserve, the mosques of Jerusalem, Damascus, Constantinople, Cairo, Kairouan, Asia-Minor, etc., as well as those no-less interesting [mosques] in Baghdad and the lands occupied by the Arabs after the conquest of Persia; it is only then, and through a comparison of these buildings with one another, along with a perfect knowledge of the Christian monuments of Rome and Byzantium, that it will one day be possible to have a general history of Architecture, starting from the decline.[1]

WHEN JOSEPH-PHILIBERT GIRAULT DE PRANGEY set out in 1832–34 to document monuments in Spain, Sicily, Tunisia, and Algeria, a field of Islamic art studies did not yet exist. European scholars most often used ethnocultural terms such as *Arab*, *Persian*, or *Moorish* to designate what we refer to today as Islamic art—that is, art produced in regions historically ruled by Muslims or with a majority Muslim population.[2] References to this art and architecture were appearing with increasing frequency in travelogues and catalogues, written by diplomats, artists, antiquarians, and linguists, but a dedicated field of study would develop only in the second half of the century. Girault was a precursor. He returned from this first trip to the Western Mediterranean with the ambition of writing a "general history of the Architecture of the Arabs,"[3] and thus expanded his field of research, traveling in 1842–45 to Egypt, Syria, Lebanon, Palestine, Greece, and Anatolia, this time with daguerreotype equipment in hand. By 1851, he had published six books on what he called "Arab" architecture (fig. 26a, b).[4]

While Girault's investigations into Islamic art and architecture were innovative in his time, his impact on the emerging field is contested, owing in part to differing historiographies (French scholars are more scrupulous in remembering him than English-speaking ones) and to more commercially successful publications by others, most prominently Owen Jones.[5] Further complicating his legacy was the incomplete publication and only modest dissemination of his *Monuments arabes d'Egypte, de Syrie et d'Asie-Mineure*, a multivolume compendium of images based on daguerreotypes made during his journey.[6] By the 1850s Girault was devoting himself to other passions, namely rare plants and birds, at his orientalizing villa outside Langres (see fig. 11).

The rediscovery of his daguerreotypes thirty years after his death has led historians of photography to return to this enigmatic figure, but less so scholars of Islamic art.[7] And yet Girault's works, and his considerations of "Arab" art as a cultural whole,[8] are early expressions of a European environment in which Islamic art studies were being framed and defined. Girault's work reflects a time when colonialism, post-Enlightenment positivism, Romantic notions of the exotic, and picturesque and orientalizing art were converging, and when an engagement with intellectual and artistic developments outside of the West was rarely pursued—a complex legacy that has shaped narratives of Islamic art.

NETWORKS

How did an aristocratic young Frenchman, having received a conventional education in *lettres* and law, become acquainted with the subject

FIG. 26A, B. Title pages to Girault's *Souvenirs de Grenade et de l'Alhambra* (1837; left) and *Essai sur l'architecture des Arabes et des Mores* (1841; right). Note the difference between the earlier, illustration-focused publication and the later one, which aspired to a more scholarly approach.

of "Arab" art?[9] By the nineteenth century, curiosity for non-European cultures had grown in tandem with European colonial expansion into Asia and Africa, and orientalist studies proliferated.[10] There was an emphasis on languages, which were taught mostly in missionary or state-funded schools, such as the Ecole des langues orientales vivantes, in Paris.[11] The general climate rarely acknowledged or challenged the epistemological and military implications of colonial ventures; France's colonialism grew alongside its assumed *mission civilisatrice*, or "civilizing mission," a concept that emerges as a backdrop to Girault's work. Although Girault was not directly linked to any official state projects and remained something of an outsider to the orientalist academic world, his connections and writings reflect the larger colonial experience and the beliefs then motivating the French intellectual elite.[12]

It remains a matter of speculation as to when and how Girault came into contact with orientalist scholars, but it is possible to reconstruct

some of the networks he built between Langres, Paris, and the Mediterranean cities he visited. These linguists, architects, diplomats, and expatriates, some of whom he knew through his membership in "several learned Societies," supported and perhaps even guided his interest in "Arab" art, and/or provided him with logistical assistance before and during his travels.[13] In the Ottoman Empire and Egypt, these connections often overlapped with France's diplomatic activities, although we have little evidence that these relationships afforded Girault distinct privileges. In fact, he seems not to have been granted authorization to enter mosques in Tunis or Kairouan in 1832 or in the Ottoman territories in 1843–44, but his daguerreotypes, lithographs, and texts suggest that he might have received permission to do so in Egypt, in the 1840s, where the French presence was more significant.[14] In Cairo, for example, Girault admired the Mosque of Ibn Tulun, the "originality" of which made it "the most perfect type of Arabian architecture of the first epoch."[15] He reproduced its prayer hall with a scene populated by figures (fig. 27), and its stucco decoration, arches, and window grilles in composite lithographs of those details.

Remarkably, besides crediting unspecified "facilités" for his research in Constantinople (Istanbul), Girault's surviving letters make no mention of help from Ottoman institutions or locals.[16] Written from Smyrna (Izmir), Beirut, Constantinople, and Cairo between 1843 and 1844, they are all addressed to diplomats and members of French academic institutions.[17] One recipient, Désiré Raoul-Rochette, secretary of the Académie des Beaux-Arts in Paris, wrote Girault references for Smyrna and Constantinople, including one to Edmond de Cadalvène, an orientalist scholar and local director of the French postal service. This same letter implies that Raoul-Rochette and Girault were acquainted with Joseph-Touissant Reinaud, chair of Arabic at the Ecole des langues orientales vivantes and the author, in 1828, of the first book devoted to Islamic objects.[18] Reinaud had been Girault's point of reference for the translation of texts and inscriptions, but the two must have had richer intellectual exchanges, as revealed by shared ideas in their work.[19]

Thanks to references obtained in Rome through Cardinal Luigi Lambruschini, Girault could also rely on the Franciscans' network of

monasteries during his travels in Palestine.[20] It is not known how Girault came into contact with the cardinal, but he must have distinguished himself in Roman circles during his 1842 visit, maybe through his scholarly-diplomatic networks, or perhaps even through his daguerreotypes. Jean-Victor Schnetz, director of the Académie de France, claimed that "M. Girault de Prangey [...] has the ambition of holding his instrument even before the nose of the Holy Father." Girault may or may not have succeeded in photographing the pope, but he was honored with the decoration of the Pontifical Order of Saint Gregory the Great.[21]

Vague yet tangible information about Girault's travels in Egypt and the Ottoman regions can also be gleaned from the places he photo-

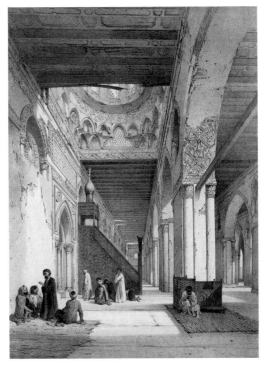

FIG. 27. "Intérieur, mosquée d'Ibn Toûloûn," from *Monuments arabes d'Egypte, de Syrie et d'Asie-Mineure*, 1846. Lithograph by Auguste Mathieu (1810–1864) after Girault, sheet 22⅜ × 15⅝ in. (56.9 × 39.7 cm). The Metropolitan Museum of Art, New York, Purchase, Joyce F. Menschel Photography Library Fund, 2017 (2017.66.4)

graphed,[22] most of them known to contemporaneous European travelers. Jean-Baptiste Baudin, France's consular agent in Damascus and the go-to contact for Europeans there, was instrumental in shaping this European "route," which for Girault included the Hôtel de Palmyre, on Straight Street; the "Maison Salomon" (identified as Beit Mourad Farhi); and the "terrasse Baudin," or possibly the French consulate, from where he took one of the earliest photographs of the Umayyad Mosque.[23] This spectacular rooftop view offers a glimpse inside the courtyard of the building (otherwise inaccessible to him), revealing the transept facade still partially decorated in mosaics (see also pls. 102, 103). Other daguerreotypes show members of French expatriate communities in Cairo, Aleppo, and Constantinople.[24] In Egypt in particular, the French presence had grown substantially after the failure of Napoleon's 1798 campaign, owing in part to invitations from the *wali* (viceroy) Muhammad 'Ali, who sought support implementing his modernization reforms (and his anti Ottoman strategy), as well as to the aspirations of individuals who believed in the *mission civilisatrice*. At least two of Girault's daguerreotypes depict Soliman Pacha, formerly Colonel Joseph Anthelme Sève, a Muslim convert who ascended to the highest ranks in Muhammad 'Ali's army (fig. 28). Other daguerreotypes show the director of Cairo's Ecole de medicine, the Arabist Nicolas Perron (pl. 65), who may have been closer to Girault: both were originally from Langres and would become donors to its museum through the town's Société historique et archéologique.[25] Perron was also associated with the Saint-Simonian French community in Cairo, which followed a utopian ideology infused with colonialist spirit. Although there is no evidence of Girault's affiliation with the group, some of its notions may not have been too distant from his thought.[26]

CULTURAL ENVIRONMENT

Girault's work reveals a debt to the post-Enlightenment preoccupation with cultural taxonomy, historical progression, and positivist documentation. The passage quoted at the start of this essay, from Girault's

FIG. 28. Girault de Prangey, *Soliman Pacha and His Children, Old Cairo*, 1842–44. Daguerreotype, 4¾ × 3¾ in. (12 × 9.5 cm). Bibliothèque nationale de France, Paris (EG3-723)

Essai sur l'architecture des Arabes et des Mores, en Espagne, en Sicilie et en Barbarie (1841), underscores several key elements of his thought. His holistic conceptualization of "Arab" architecture, from Spain to Iran, was novel in his time, though gaining ground among scholars in his circle. He conveys the idea through a reliance on documentation and comparison, a focus on race as an underlying element of cultural expression, and a historicist understanding of the "decline" of Islamic countries. The goal was to achieve a global history that included Islamic architecture

but positioned it vis-à-vis classical and European traditions.[27] Such ideas were rooted in nineteenth-century thought and shaped perceptions of Islamic cultures, including the nascent field of Islamic art studies.[28]

A progressive notion of history, emerging in his time with Henri de Saint-Simon and Auguste Comte, sustained Girault's understanding of "Arab" architecture in Spain as developing in three phases—Arab-Byzantine, transitional, and Arab-Moorish or Moorish—before reaching its "natural" decline.[29] Such Eurocentric stances were prevalent among European, and occasionally Ottoman, intellectuals, who often could not reconcile the possibility of an Islamic modernity, despite a paradoxical anxiety over the loss of its idealized past. Girault, for instance, though he understood the need for sanitary measures, was dismayed that one consequence of a planned whitewashing of Cairo would be to destroy its "couleur local si merveilleuse."[30] Similarly, he expressed an architectural disinterest in the Ka'ba, the most sacred edifice for Muslims, which he found to be "tout moderne" after its many reconstructions.[31] Aspects of these tendencies persisted in scholarship with the continued medievalization of Islamic art and, until recently, a paucity of research into late Ottoman and other modern arts in these geographies.[32]

The perceived pettiness of Arab modernities was set in contrast to the glory of its medieval history and in parallel to the vacuum of its more distant past; the belief that Arabs had no sedentary culture, and therefore no architecture before Islam, was a major trope in the nascent field: "Scattered, dwelling under their tents ... the Arabs had no choice but to remain strangers at length to the arts, sciences and letters, those brilliant feats of civilization."[33] Such assumptions, long since overturned by unceasing discoveries in the Arabian peninsula, persisted throughout the nineteenth century, albeit modified by input from Hegel's hierarchical classification of the arts and concurrent racialist beliefs. Their traces still resonate today, most notably in resurgent waves of Arabo- and Islamophobic sentiment.[34]

The contemporary discourse on Islamic art and architecture was drenched in race-based assumptions, especially that of Arab (Semitic) art's inferiority to Iranian (Indo-European) art, and was paired with the belief that art was an inherent expression of a people or civilization.[35]

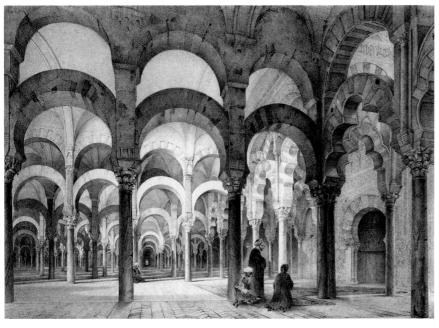

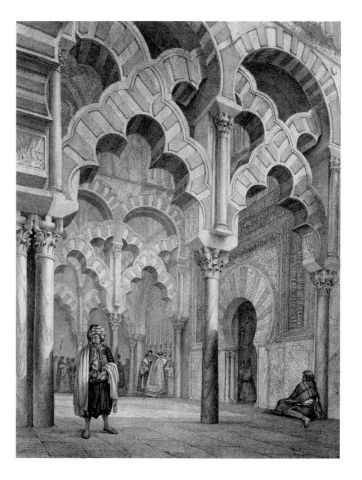

FIG. 29. "Vue intérieure de la mosquée," from *Monuments arabes et moresques de Cordoue, Séville et Grenade*, ca. 1837. Lithograph by Charles Villemin (active 1835–49) after Girault, sheet 22¼ × 16¾ in. (56.5 × 42.5 cm). The Metropolitan Museum of Art, New York, Harris Brisbane Dick Fund, 1944, transferred from the Library (1991.1073.20)

FIG. 30. "Mirah ou sanctuaire de la mosquée," from *Monuments arabes et moresques de Cordoue, Séville et Grenade*, ca. 1837. Lithograph by William Wyld (1806–1889) after Girault, sheet 22¼ × 16¾ in. (56.5 × 42.5 cm). The Metropolitan Museum of Art, New York, Harris Brisbane Dick Fund, 1944, transferred from the Library (1991.1073.20)

FIG. 31. "Détails et façade de la chapelle du mirah," from *Monuments arabes et moresques de Cordoue, Séville et Grenade*, ca. 1837. Engraving by Paul Dumouza (b. 1812) after Girault, sheet 22¼ × 16¾ in. (56.5 × 42.5 cm). The Metropolitan Museum of Art, New York, Harris Brisbane Dick Fund, 1944, transferred from the Library (1991.1073.20)

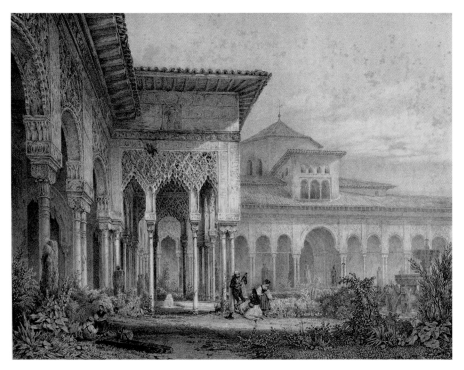

FIG. 32. "Cours des Lions, Alhambra," from *Monuments arabes et moresques de Cordoue, Séville et Grenade*, ca. 1837. Lithograph by Nicolas Chapuy (1790–1858) after Girault, sheet 22¼ × 16¾ in. (56.5 × 42.5 cm). The Metropolitan Museum of Art, New York, Harris Brisbane Dick Fund, 1944, transferred from the Library (1991.1073.20)

Girault, for example, in articulating his admiration of "Moorish" art, ascribed its "poetry of invention" and "marvelous elegance of form" to "an effeminate people."[36] He also belongs to these traditions insofar as he implies that Arab achievements in architecture could only be explained by the "external" influence of the Classical and the Byzantine.[37] An emphasis on influences, which implicitly denies the agency of "receiving" cultures, has endured among historians of Islamic art; the idea has merit in its acknowledgment of cultural interconnections, which are today investigated in terms of mutual inspiration, adaptation, and translation. At the same time, Girault had a more multifaceted understanding of certain aspects of "Arab" art than those of his contemporaries, for instance, with regard to the impermissibility of figural imagery,

a notion that first emerged in the nineteenth century and remains one of the most resilient ideas about Islamic art. Girault admitted that this "severe interdiction" was often ignored in nonreligious spaces.[38]

PRACTICES

Such a reading of "Arab" civilizations was sustained by what were considered to be rigorous methods of documentation and analysis. Following an orientalist philological approach, Girault commissioned translations of Arabic inscriptions and texts. His surveying practices, which at first included sketches from life, plaster casts (see fig. 9), and measured and drafted drawings of plans, sections, and details (see fig. 16), reveal the attention he paid to reproducing a measurable reality.[39] At the same time, Girault represented an ideal reconstruction of the buildings he studied, and added and omitted elements to create picturesque tableaux—that is, the very atmosphere he feared modernity was destroying in "the Orient."[40] This tendency is exemplified by his series of plates of the mosque in Cordoba, a sequence that includes the prayer hall with Muslims at prayer, presumably a scene set back in time (fig. 29); the prayer hall facing the mihrab, presumably in its then-current state, populated with Catholic priests and Andalusian figures but also an uncanny turbaned figure (fig. 30); and an elevation, partial-section, and plan of the mihrab, with details of the ornament (fig. 31).[41] That architectural accuracy was of concern is evident by the plan reproduced in the accompanying text, showing the perspective of each plate.

To these tools of representation, Girault eventually added the daguerreotype.[42] His enthusiasm for the new technology is evident in his letters, and his plates are carefully framed, balanced compositions, confirming both his training as an artist (see pp. 12–15) and his sensibility toward innovation. Yet he seems to have acknowledged the daguerreotypes only rarely, raising crucial questions regarding his relation to these objects.[43] In a letter from Beirut in August 1844, he calls the daguerreotypes "a precious and undeniably faithful imprint that neither time nor space can weaken."[44] And in fact, while active as an

architectural historian (until about 1850), Girault used daguerreotypes as an aid to producing more accurate architectural reproductions, capturing both general context and detail (see fig. 23a, b), the same method he used in his drawings.[45] It was a precocious use of photography that would later become a consistent sentiment among architects and architectural historians of the era, who valued photography especially for its ability to document an external reality more accurately than the naked eye.[46]

In the nineteenth century, such striving for exactitude was not always expressed in the same terms for other subjects, namely people, in which case the photographer's interpretation of reality is perhaps more apparent.[47] Attitudes toward sitters often expose classist and orientalizing tropes that were prevalent at the time, and which proliferated after the invention of photography and the subsequent surge in photographic portraiture. Girault archived the names of his French sitters but, for the most part, left his Turkish and Arab subjects unnamed, or categorized them by their alleged identities—camel driver, beggar, Bedouin (pl. 67), sailor (pl. 68), "surudjé" (perhaps *sürücü*, or "driver," pl. 79).[48] Their individuality forgone, these figures became characters in a predefined landscape of alterity, mirroring the picturesque Andalusian musicians and dancers that Girault added to his Spanish lithographs, to both give a sense of scale and re-create the "spirit" of the place (fig. 32).[49] As with much early photography in these geographies, human subjects are often staged within tableaux that conform to the conventions of orientalist iconography, which Girault must have been familiar with from his Parisian artistic circles (fig. 33; see also pl. 66).[50] The orientalist gaze, in either drawings or photographs, could reposition non-Westerners in ways that transcended both present and past realities; as such, a court at the Alhambra might be populated by a turbaned Arab figure, even if the building had not been a Muslim palace for six centuries (see fig. 15).[51] Notably, however, in comparing Girault's lithographs of Spanish landscapes in *Souvenirs de Grenade* with those of the Eastern Mediterranean in *Monuments arabes d'Egypte*, one can see in the later works—that is, those made partly after his daguerreotypes—that his attitude toward reproduction had shifted somewhat away from the picturesque.[52] While

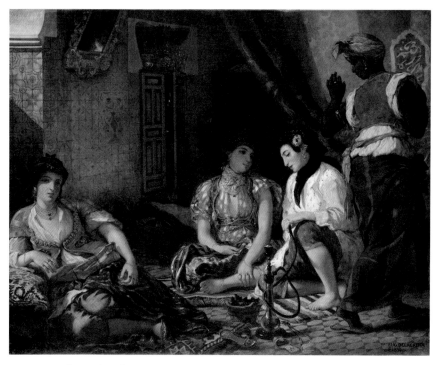

FIG. 33. Eugène Delacroix (1798–1863), *Femmes d'Alger dans leur appartement*, 1834. Oil on canvas, 70⅞ × 90⁹⁄₁₆ in. (180 × 230 cm). Musée du Louvre, Paris (3824)

concurrent publications and developments in the field of architectural history probably had a hand in inspiring this adjustment, as did each publication's target and Girault's changed experience, the new medium seems also to have been an important influence on his practice.

Considering Girault's attested interest in these geographies and architectures—a curiosity that led him to formulate novel approaches to their investigation and recording—his work remains understudied with regard to not only the history of Islamic art and architecture, but also the role of photography in the development of the field. His documentation and representation of since-disappeared or altered monuments and sites, and of the presence and activity of Europeans in the Ottoman lands and Egypt, are likewise a significant aspect of his legacy. At the same time, his work tells of the framing of an Islamic art modeled on the changing visions and anxieties of Europeans looking at it.

The Pleasure of Ruins

Andrew Szegedy-Maszak

In April 1843, Joseph-Philibert Girault de Prangey wrote to Désiré Raoul-Rochette, a renowned archaeologist and the secretary of the Académie des Beaux-Arts in Paris, "You will see with pleasure … the use I have made of the valuable instrument invented by Daguerre. In a variety of circumstances, I have captured, often with complete success, several bas-reliefs and statues from the Acropolis, and many entire monuments in Athens and Rome. … Today it is with real joy that I find myself so close to monuments that it would be so important to possess with total accuracy."[1] When he wrote this letter, Girault had been abroad for more than a year, on a tour of the Mediterranean that would last three years and take him from Rome to Athens and on to Egypt and the Middle East. As elaborated elsewhere in this volume, Girault, like many of the early photographers, had been trained in drawing and painting; he had also acquired scholarly expertise in architecture and archaeology. Again and again, he created remarkably innovative and complex images, among them studies of Classical monuments and artworks, which were informed by his knowledge of history, archaeology, and art and which demonstrate his mastery of the new medium of daguerreotype.[2]

By the mid-nineteenth century, Europe had become "a scripted continent."[3] Every nation possessed a set of scenes and sights that every conscientious traveler felt compelled to visit. For travelers from the North, there were few places more thoroughly scripted than Italy, and in particular Rome. The city's principal attractions were its famous Classical antiquities, both monuments and sculptures, along with its copious and equally renowned Renaissance art and architecture. Travel

memoirs—like Chateaubriand's *Voyage en Italie* (1833) and Lamartine's *Voyage en Orient* (1835)—had a large readership, and their recommendations were echoed and amplified by the new genre of guidebooks aimed at the middle-class tourist. There also existed a long tradition of visual depictions of Rome in paintings, drawings, and, especially, the widely distributed printed views called *vedute*.[4] When Girault arrived in Rome, therefore, his imagination would have been stocked with a precise catalogue of the most important sites in the Eternal City.[5]

Among the ancient monuments in Rome, the Colosseum, built during the reign of the Flavian emperors in the late first century A.D., held pride of place. The fact that it had been badly damaged in its later history actually enhanced its appeal. Lord Byron famously described it as "a noble wreck in ruinous perfection" (*Manfred* III.4). As both the largest and most immediately identifiable ruin, it had come to symbolize the Roman Empire and indeed all of ancient Roman civilization, because it was seen as a physical embodiment of Rome's decline and fall. It was invariably the first destination for the newly arrived foreign visitor. After having been represented in countless *vedute* (fig. 34), it also became one of the most frequently photographed structures in Rome.[6]

So far as is known, Girault made no daguerreotypes that depict the Colosseum from nearby or from the interior. The great amphitheater, however, does appear in a horizontal panoramic view of the city that he made from the Column of Trajan (pl. 17). The panorama was then, and remains today, one of the most popular genres in travel photography. Made from a height and from some distance away, these pictures have little to do with architecture as such. They belong to the tradition

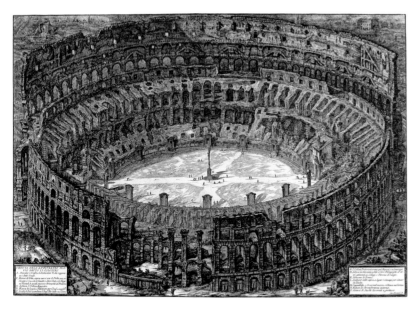

FIG. 34. Giovanni Battista Piranesi (1720–1778), "Veduta dell'anfiteatro Flavio detto il Colosseo," from *Vedute di Roma*, 1776. Etching, 30 × 40 in. (76.2 × 101.6 cm). The Metropolitan Museum of Art, New York, The Elisha Whittelsey Collection, The Elisha Whittelsey Fund, 1959 (59.570.426)

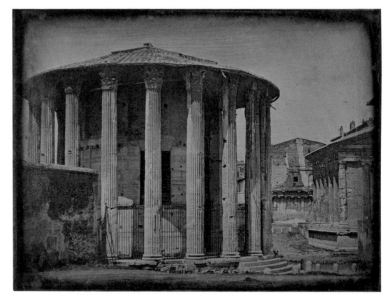

FIG. 35. Comte Charles-François-Maximilien de Perrochel (1779–1853), *Temple of Vesta, Rome*, ca. 1840. Daguerreotype, 4⁹⁄₁₆ × 6¹⁄₁₆ in. (11.5 × 15.5 cm). Musée d'Orsay, Paris (2008 3 1)

of travel narratives and the "views from above," as from a mountain or a tower, that allow travelers to survey the territory and identify its principal attractions.[7] Despite their unavoidable miniaturization of individual structures, panoramas afford a satisfying sense of completeness, much like that of a map.

The Column of Trajan, with its lavish decoration, was itself a mandatory stop on any Roman itinerary, and Girault's study of it—almost certainly the first vertical photographic panorama made—is stunning (pl. 16).[8] To reach the top of the column, which rises over 97 feet (29 meters), Girault had to carry his cumbersome equipment up the steep, poorly lit spiral staircase in its interior. Once he gained his vertiginous perch, he produced one of his most original compositions. As scholars have noted,[9] and as has been elaborated elsewhere in this volume (see pp. 185–86), Girault was not constrained by the conventional format of the daguerreotype. He used plates that were larger than standard, and he frequently cut them to create horizontal and vertical panoramas.

In this horizontal panorama, the Colosseum, just off-center, dominates the image, successfully conveying the sheer immensity of the building. After one takes into account the lateral reversal created by the daguerreotype, the picture also enables the viewer to situate the Colosseum within the city's topography. While most nineteenth-century views of Rome were utterly predictable, Girault's *vue d'ensemble* is unique. Working in the very earliest age of photography, he seems to have been exploring the potential of the new medium to be simultaneously factual and evocative.

Although not nearly so huge as the Colosseum, the so-called Temple of Vesta, dating from the second century B.C., was a favorite for local artists and foreign visitors.[10] It also became a lure for photographers. A number of elements contributed to its appeal: its simplicity and graceful proportions, fine material (white Pentelic marble), relative completeness, and secluded location near a fountain in a small piazza next to the Tiber.[11] Over the centuries, it had lost its original entablature

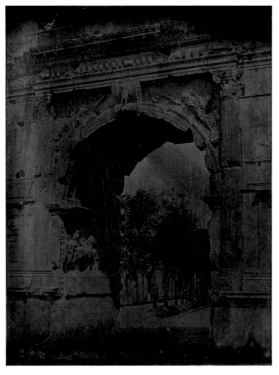 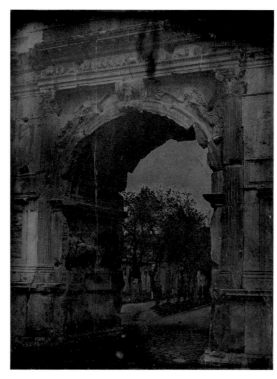 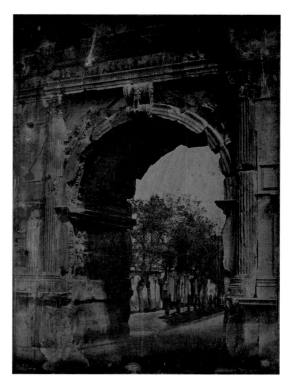

FIG. 36A–C. Girault de Prangey, *Arch of Titus, Rome*, 1842. Daguerreotypes, each 9 ½ × 7 ⅜ in. (24.1 × 18.7 cm). Daniel Wolf Collection

and its roof, which had been replaced by rough terracotta tiles. Once again using elongated panoramic plates, Girault made two nearly identical views of the temple, both of which concentrate on its top (see pl. 24).[12] The image is elegant and rather ascetic in that it excludes the temple's picturesque setting, as well as the commonplace tile roof. Informed by Girault's deep knowledge of architecture and his understanding of photography's strengths, the view isolates and frames what he identified as a significant detail, the post-and-lintel system, a compositional feature that appears frequently in Girault's work.[13] The notional audience for such a picture would comprise viewers as educated as himself, scholars or connoisseurs who could appreciate the ancient construction techniques and intricately carved Corinthian capitals. Today we can also contemplate the daguerreotype's extraordinary detail, which belongs to the medium, along with its formalist precision and symmetry, which belong to Girault. It is worth noting that Girault made two studies of the same structure, and from the same angle. Given

the time and labor required for every exposure, one can only admire his patience and persistence as he considered how best to record what he saw. An almost contemporary daguerreotype by the comte de Perrochel (fig. 35) shows the entire temple in its setting (and has been corrected for lateral reversal). It is much more conventional than Girault's and could be considered the prototype for innumerable subsequent tourist views.

Girault seems to have taken genuine pleasure in the complexity of the Roman Forum, which, despite its historical importance, contained so many disparate ruins that most visitors found it confusing.[14] Yet in their juxtaposition of architectural forms, Girault's images of the Forum vividly evoke the rich layers of history in and around the site. Again making expert use of the vertical plate format, he conveyed the towering height of the triad of columns from the Temple of Castor and Pollux, which stand somewhat apart and so could be shown in isolation (pl. 23). Notably, given the long exposure time a daguerreotype

required, he also included a seated man in identifiably Italian garb. The figure both provides a sense of scale and alludes to the pictorial convention of a landscape with a picturesque local resident. Elsewhere in the Forum, Girault captured two nearly identical studies that include the three remaining columns of the Temple of Vespasian and Titus, the baroque facade of the Church of Santi Luca e Martina, and the Arch of Septimius Severus (pls. 20, 21). He also made three studies of the Arch of Titus, each with a slightly different visual effect: one can observe, as if in time-lapse, sunlight and shadow moving over the ancient monument (fig. 36a–c). Once again, Girault seems to have been exploring the daguerreotype's expressive range.

Having spent three months in Rome, Girault continued his journey to Athens, in the late summer of 1842, for what would be a stay of six weeks. The Greeks had waged a decade-long war through the 1820s, had won independence from the Ottoman Empire, and had initially located their capital in the southern port city of Nafplio. The decision to move the center of government to Athens in 1834, a few years before Girault's arrival, was largely motivated by Athens's Classical past and splendid monuments.[15]

Girault's move to Athens was not merely a change of scene. Whereas Rome had long been familiar to the rest of Europe, Athens was more distant both geographically and culturally, and it differed from Rome in significant ways. Athens was still small, with a total population of some 12,000. It was provincial—"little more than a dusty village," in the words of one modern historian[16]—and a far cry from the large, sophisticated city on the Tiber. Hazardous travel along with restrictions imposed by the Ottoman government meant that, before the nineteenth century, relatively few foreigners had made the journey there. Unlike their Roman counterparts, therefore, the Athenian monuments had engendered few travelers' accounts and little or no pictorial tradition.[17] Their fame stemmed from their literary and historical associations with the fifth-century Periclean "Golden Age." Rome's ancient monuments are distributed throughout the city, but Athens's renowned antiquities are clustered on or next to the Acropolis; during his six weeks in Athens, Girault made twenty daguerreotypes at the

site. These monuments hold undisputed primacy in any visitor's itinerary, with the Parthenon, built between 447 and 432 B.C., being the most exalted.[18] It has long been an iconic structure and, like the Colosseum, has come to represent not only a historical era but also an entire civilization. Not surprisingly, it is one of the most photographed buildings in the world.

The earliest photographic views of Athens appeared in *Excursions daguerriennes* (1840–44), which contains three aquatint images reproduced from daguerreotypes by Pierre-Gustave Joly de Lotbinière. The caption for the picture of the Parthenon (fig. 37) specifies that it was made in October 1839 and adds that it was "the first time the image of the Parthenon was fixed on a plate by Daguerre's ingenious process." It is very likely, though not certain, that Girault had seen *Excursions daguerriennes*, and indeed, his view from the interior of the Propylaea, the great formal entryway to the Acropolis, is very similar to that in

FIG. 37. "Le Parthenon à Athènes," from *Excursions daguerriennes*, 1840–44. Aquatint by Frédéric Martens (1809–1875) after Pierre-Gustave Joly de Lotbinière (1798–1865), image 10¼ × 15 in. (26 × 38 cm). The Metropolitan Museum of Art, New York, David Hunter McAlpin Fund, 1947 (47.152)

FIG. 38. Girault de Prangey, *Temple of Athena Nike, Athens*, 1842. Daguerreotype, 7⁷⁄₁₆ × 4¹³⁄₁₆ in. (18.8 × 12.2 cm). The J. Paul Getty Museum, Los Angeles (2003.82.3)

from closer up that depicts the northeast corner (pls. 37–39). In this latter photograph, the columns fill almost the entire frame, and "one can see the effects of years of neglect and damage, but the temple ruins tower above the rubble."[20] One can also see, to the far left, wooden beams that were being used in the temple's restoration. The process involved the removal of a small mosque, which had been erected in the cella and is still present in the print in *Excursions daguerriennes*.[21] Girault also included in his view a small camera on a tripod, which he probably used to record some detail of construction. It may well be "the first archaeological photograph to depict the process of archaeological photography."[22] In Girault's view, the Parthenon is magnificent, but he does not present it for our uncritical admiration. Instead, his picture actively engages our attention and prompts us to consider how we think about the ancient shrine and the changes it has undergone.

In the letter to Raoul-Rochette quoted at the beginning of this essay, Girault speaks of having captured several bas-reliefs and sculptures from the Acropolis, among them an exquisite depiction of a winged Nike that once adorned the parapet around the Temple of Athena Nike (fig. 38).[23] Girault also made a number of studies of the Acropolis's other great monument, the Erechtheion (pl. 41). It is a complicated building that was home to a number of cults, including shrines to Athena, to Poseidon, and to Erechtheus, an early hero of Athens after whom the structure is named.[24] Its most famous feature is on its southern facade, the Porch of the Maidens, or the Caryatid Porch, so called because, instead of columns, six monumental statues of women supported the roof.[25] When Girault was there, the Erechtheion had not yet been restored, and his view of the porch clearly shows the unsightly brick pillars that stood between the statues, which were removed later in the 1840s (fig. 39). Girault also selected one of the maidens for a dramatic vertical close-up (pl. 43). He does not neglect her structural function, for she bears a crossbeam on her head, as he also celebrates her beauty. He waited until the sunlight was in exactly the right position to illuminate the fine carving of the drapery and the caryatid's graceful contrapposto stance, with one leg braced and the other slightly raised under her flowing dress. The image confirms Girault's modest

the print. Otherwise, he chose to go his own way. Joly de Lotbinière's *Parthenon* is an oblique view of the western end of the temple, which is both the first side a visitor sees on entering the Acropolis and relatively the best preserved, with much of the triangular pediment intact. It became the canonical point of view, replicated, with variations, by numerous later photographers.[19] Girault, on the other hand, made several images of the Parthenon, none of them from that same angle. There are at least two longer views of the eastern facade and one made

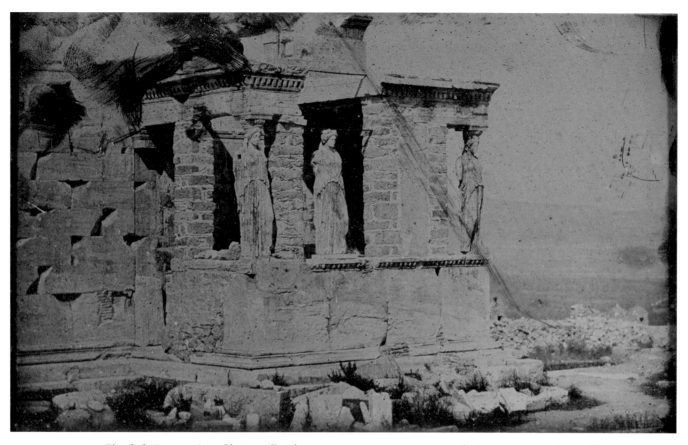

FIG. 39. Girault de Prangey, *Caryatids, Acropolis, Athens*, 1842. Daguerreotype, 4³⁄₄ × 7⁷⁄₁₆ in. (12 × 18.8 cm). Private collection

boast in his letter to Raoul-Rochette that he had made some studies of sculpture "with complete success."

Girault doubtless possessed a number of significant privileges, not least of which were wealth, leisure, and a fine education. More important, however, were his seriousness of purpose, his eagerness to explore the potential of his new medium, and his extraordinary intellectual breadth. For example, his interest in ancient monuments was not limited to Greco-Roman sites on European soil.[26] After some time traveling and photographing in Egypt, he journeyed in 1843 to Baalbek, in what is now Lebanon, where he made more daguerreotypes than he had in any other place.[27] He was the first to produce photographic documentation of the vast site and its many splendid ruins, most dating from Roman Imperial times and as yet unexcavated. The views from Baalbek convey Girault's fascination with its remains, to which he

devoted as much attention as he had to the more famous monuments of Rome and Athens. His panoramic study of the unusual hexagonal courtyard of the Temple of Jupiter (pl. 107) looks like a collage of rubble, large carved stone blocks, archways, and a few columns. Though the picture does not provide much information about the size or function of the original structure, it does suggest the immense amount of labor that went into building the temple and so, by implication, confirms its significance in ancient times.

In their selection of subject, point of view, framing, lighting, and variety of dimensions, Girault's daguerreotypes are revelatory. He used what was then the most modern of techniques to depict many of the most venerable ancient sites in Europe and the Middle East. His images could serve as illustrations for a grand cultural history, spanning the lands and the centuries from Pharaonic Egypt to the Roman Empire.

Daguerreotype Work in France

Thomas Galifot

IN A MONOGRAPH devoted to a nineteenth-century French photographer, it is unusual for work produced within France to emerge as a legitimate angle of study in itself, but Joseph-Philibert Girault de Prangey is among the rare early practitioners of photography to be primarily associated today with works he made abroad. Since the 2000s, the exceptional nature of Girault's international work has gained prominence, as dramatic proceedings in the art market have revealed its breadth and quality (see pp. 5–7 in the present volume). His domestic output was consequently pushed into the background, after being of primary interest to historians and curators as early as the mid-twentieth century.[1] From what is known today of Girault's body of work, the number of his French daguerreotypes can be estimated at about 150 plates.[2] The present survey is based on the knowledge of half of them.

Among Girault's dated plates, the oldest were made in 1841. They attest to a level of ambition and technical mastery—particularly in the whole-plate format, already unconventional in its dimensions—that suggest the experiments of Girault's learning period may be lost to us.[3] Bearing in mind that photographing out the window was a kind of rite of passage for numerous pioneers of the medium, it may be tempting to consider Girault's images of the Tuileries Palace, made that year, among his earliest known achievements. The architecture of the central pavilion, courtyard (pl. 6), and adjoining wings of the Louvre are the subject of at least eight daguerreotypes, produced in three or more sessions and all taken from the same vantage point, possibly a room at the Hôtel de Nantes, a place frequented by Girault.[4] As ambitious as this project was, the concomitant desire to capture a typical moment in time and place—here, two different parades of troops watched by crowds (fig. 40)—is no less remarkable, given that Girault's subsequent work offers little context that would bring the monuments he reproduced to life.

A large part of Girault's corpus produced before his "grand tour" points to his interest in the antique and medieval archaeology of France, an inclination that dates back to the late 1820s.[5] This interest prompted another series in Paris, also in 1841, whose theme may have been the city's Gothic architecture. He devoted thirteen plates—half of his known Parisian output—to the Cathedral of Notre-Dame, alternating between overviews and details of its west facade, lateral portals, rose window, gables, and bell towers (pls. 2–4). The close-ups count among the first and most daring daguerreotype studies ever made. Girault took eager advantage of the unequaled descriptive potential of the medium but at times sacrificed archaeological detail so as to capture the dramatic expressiveness of the shadows. These two tendencies were perhaps more balanced in Girault's work than the known corpus implies. They correspond to the two approaches he developed in his drawings for illustrated publications: on the one hand, the scientific and archaeological, and on the other, the "romantic picturesque."[6] These were the two main veins of this burgeoning sector, and together they ensured its success. Logically, both were evident in the first publications illustrated after daguerreotypes.

Among these volumes, Noël-Paymal Lerebours's *Excursions daguerriennes*, which likewise features several images of Notre-Dame, advocates for the new technology and its pledge of authenticity, going so far

as to include a preview of Hippolyte Fizeau's process of transforming a Daguerreian plate into an engraving plate—in this case, a reproduction of the bas-relief sculpture of the Entombment of the Virgin from the cycle on the Life of the Virgin that decorates the north chevet of Notre-Dame.[7] Girault, for his part, focused on the relief of the Assumption (pl. 5), which is exactly adjacent and complementary to the scene immortalized by Fizeau. The original plate may offer a clue to understanding Girault's interest in Parisian heritage, a predilection as intense as it was singular in his life as a photographer. Indeed, it served as a model for his drawing in *Le Moyen-Age monumental et archéologique* published in 1842 by Hauser, the publisher of Girault's orientalist books.[8] The corresponding lithograph (plate 95 in that volume), credited to Jules Peyre, rivals Fizeau's plate in its quasi-photomechanical precision. Similarly, Girault's daguerreotype of the west portal of Notre-Dame was scrupulously copied by Philippe Benoist, credited as the draftsman and lithographer of a print (plate 163) produced in 1843, when Girault was abroad. Could Girault's two 1841 daguerreotypes of the Tour Saint-Jacques (fig. 41) likewise be related to the preparatory work that led the following year to a very graphic print of the same subject, lithographed by Peyre (plate 108), but which does not credit a draftsman?

There are additional indications reinforcing the connection between Girault's 1841 daguerreotypes of architectural subjects and the contemporary milieu of illustrated publishing. This connection may also explain the view(s) of Troyes Cathedral or the photographic campaigns that resulted in the "twenty-five views of France" summarily inventoried by the comte de Simony (see pp. 5–7 in the present volume). Did concurrent preparations for his long Mediterranean journey and his major publications of 1841 and 1842 prevent Girault from producing more drawings after the daguerreotypes he had made in that context?

The same question inevitably applies to Girault's daguerreotypes of Parisian fountains. We know of four different views he made of the Château d'Eau with its waters frozen over, two of which date to 1842 (pl. 7).[9] Transposed through the analytical gaze and methodologies of

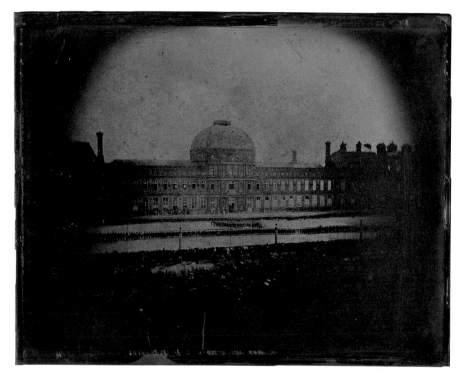

FIG. 40. Girault de Prangey, *Review of Troops, Tuileries, Paris*, 1841. Daguerreotype, 3⁷⁄₁₆ × 4⁷⁄₁₆ in. (8.7 × 11.3 cm). Bibliothèque nationale de France, Paris (EG7-547)

the archaeologist-photographer, the fountain on the boulevard Saint-Martin is represented by Girault following two different descriptive approaches, each one in two formats. The results run far from the picturesque norms customarily associated with a portrayal of fountains: they both monumentalize the subject itself and elevate a recurring climatic event to the level of an "urban spectacle," of a sort that would still be remembered in 1872, five years after the fountain was moved to the market hall at La Villette.[10] The same rigor characterizes Girault's image of the Fontaine du Square Louvois. And according to Simony, the artist also photographed at least one "fontaine des Pyramides," probably the one known as the Fontaine du Palmier, at place du Châtelet.[11] Could Girault have been engaged in a thematic series in connection with another illustration project, one that ultimately

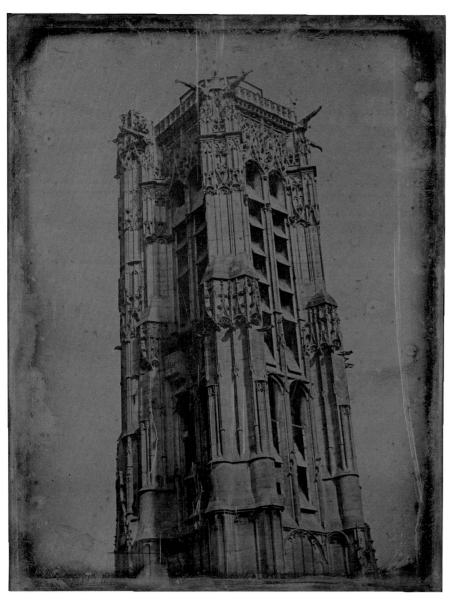

FIG. 4I. Girault de Prangey, *Tour Saint-Jacques, Paris*, 1841. Daguerreotype, 9 × 6⅞ in. (22.9 × 17.5 cm). Bibliothèque nationale de France, Paris (EG7-548)

would also have been compromised by his departure for the Mediterranean? Such a hypothesis would not only explain Girault's exceptional interest in these structures—ones, moreover, that had recently been built[12]—but also shed light on his specific choices. Indeed, the fountains that Girault photographed were those consistently used to promote what had become a recurrent Parisian theme in illustrated publications of the day, notably the first ones to feature illustrations based on daguerreotypes.[13]

By February 1842, Girault was in Marseille, ready to embark on his journey eastward. He could not resist sacrificing some of the precious stock of whole plates he had brought with him to immortalize the fortresses of Saint-Nicolas and Saint-Jean (fig. 42) which, facing each other, formed a gateway to the East and all its promises. In 1845, Girault returned from his expedition (the details of which are explored in depth elsewhere in this volume). Probably in 1846, after the publication of his book *Monuments arabes d'Egypte, de Syrie et d'Asie-Mineure*, Girault could reengage fully in Langres society and return at last to his studies of the archaeological treasures of the Haute-Marne. It is no surprise that these endeavors were revitalized by his use of the daguerreotype, which in the meantime had become systematic.[14]

Girault's output on the heritage of the Haute-Marne was likely far greater than the few plates by or attributable to him would imply.[15] Between 1847 and 1851 he was not only art director of the *Mémoires de la Société historique et archéologique de Langres* (*MSHAL*) but also its main illustrator, whether for his own articles or for those by others. In two cases—namely, a reproduction of a cast in the Musées de Langres, after a Gallo-Roman ruin (ca. 1848), and a view of a street in Chaumont with the Church of Saint-Jean-Baptiste in the background (ca. 1849)—a correspondence between Girault's daguerreotypes and the lithographs made after drawings by his hand proves that his recourse to the photographic medium as an aide-mémoire was hardly limited to images captured during his temporary sojourns outside the Haute-Marne.[16]

By applying this same strict criterion of correlation, we can also attribute to Girault two other daguerreotypes of Langres, from about 1847 at the latest. The first is of one of the city's Gallo-Roman gates (pl. 119),

copied but also adapted, like so many other plates, to the conventions of the picturesque. Girault's drawing of the subject not only was interpreted as a lithographic plate but also appeared in variant form as a frontispiece to the *MSHAL*.[17] The second is of the so-called Porte des Moulins, then under demolition. The daguerreotype served as the model for an illustration that appeared in an article Girault wrote about that monument.[18] Although it is not impossible that Girault occasionally worked after daguerreotypes made by other members of the Société historique et archéologique de Langres, who may have been trained by him or have photographed alongside of him,[19] it seems reasonable to consider several other of Girault's illustrations for the *MSHAL* as a likely reflection of additional daguerreotypes by him that remain unknown into the present day. And this may be true in spite of—or perhaps owing to—the fact that Girault himself covered his photographic tracks by insisting that the lithographed subject (in this case, another cast from the Musées de Langres) was "copied *directly*," with "the original before [his] eyes."[20]

Girault's photographic excursions to at least two other cities surely took place during these same years (1846–50) of intense study of Langres's Gallo-Roman past: Mont-Dore, in the Auvergne (pl. 120), and Aix-les-Bains, in the Savoie, both ancient spa cities. Indeed, in his archaeological writings Girault repeatedly extols the virtues of the comparative method, and his harvest of photographic studies of archaeological details no doubt contributed to such an endeavor.[21] This span of dates might also encompass several, if not all, of Girault's other views of France (and Switzerland) that were found together in a single wood box, if one considers their perfect material homogeneity as the result of the use of the same equipment over a relatively short period of time.[22] The Savoie would not become an official part of France until 1860 and was in Girault's day largely associated with imagery of Switzerland. The alpine region of Chamonix, the Mont Blanc massif, and the Mer de Glace (pl. 121) in particular inspired Girault to create spectacular landscapes, as well as several botanical and geological studies. These were the many aspects of nature that the artist never ceased to explore, whether he was abroad or closer to home, on the Langres plateau.[23]

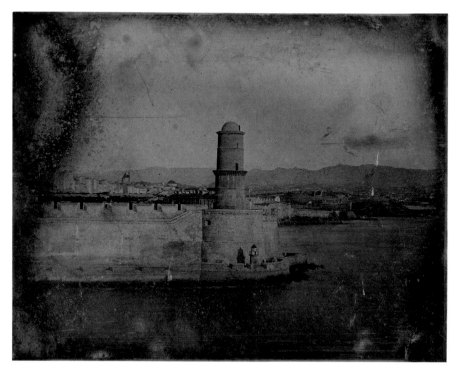

FIG. 42. Girault de Prangey, *Fort Saint-Jean, Marseille*, 1842. Daguerreotype, 7 1/2 × 9 7/16 in. (19 × 24 cm). Daniel Wolf Collection

After 1851, the year of his final contributions to the *MSHAL*, but also of his last, unfinished publication on the Eastern Mediterranean, Girault turned almost entirely away from archaeological studies in favor of this longstanding interest for natural heritage and the natural sciences.[24] He is known to have shot vegetal subjects from the very beginning of his photographic practice, producing spectacular "plant studies" in Paris in 1841, likely in the courtyard of an artist's studio.[25] One of these, in the unusual format of a cut square whole plate, offers a bold close-up of various species of climbing plants (pl. 9). Its analytical accuracy is on a par with that of the extremely rare botanical daguerreotypes of his contemporaries Alphonse de Brébisson and Léon Foucault, both eminent scholars.[26] Closer to Girault, the theme evokes contemporary works by fellow Langres native Jules Ziegler, both his

FIG. 43. Girault de Prangey, *Villa*, 1841. Daguerreotype, 9⁷⁄₁₆ × 7⁷⁄₁₆ in. (24 × 18.8 cm). Private collection

ceramics with designs of grape leaves and his paintings.[27] Indeed, Girault's use of the term *study* to caption these works hearkens back to the fine-arts tradition, and thus encapsulates the ambiguous nature of botanical subjects during this period, particularly in the work of a painter and photographer who was also an archaeologist. As Girault himself wrote, ivy and climbing vines were at the very heart of the concept of the picturesque when it came to ancient monuments and their representation.[28] As for Girault's composition that includes the bust of Venus de' Medici (pl. 8), the plate brings together so many challenges that, in addition to being a gorgeous, sophisticated image, it can be considered the result of an exercise spectacularly achieved. It provides a detailed rendering of plants of various textures, far surmounting the basic obstacle of reproducing in a daguerreotype the color green. Likewise, it translates the transparency not only of the windowpanes but also of the veil, which covers the plaster to prevent overexposure. Such an aesthetic sensibility once more recalls that of Ziegler, this time as a practitioner of photography on paper, and that of Ziegler's friend Hippolyte Bayard. Both made numerous garden compositions involving antique casts, ceramics, arbors, and gardening implements.

During the same period, Girault had himself become a gardener and landscape designer, supervising the development of his vast estate at Courcelles-Val-d'Esnoms (fig. 43). This site was probably his true testing ground for the daguerreotype, as well as the inspiration for his last known shots on metal (1855). By taking an exceptional approach to this technique, he depicted the same location for nearly fifteen years, producing dozens of plates that, in his characteristic manner, fluctuate between the pictorial tradition and documentary ambition.

The area around the "Douy" River, to use Girault's own spelling,[29] lent itself to the most traditionally picturesque compositions, in the vein of the painted and drawn studies by his teachers, François-Edme Ricois and Jules Coignet. No fewer than seven known plates portray the same majestic tree in different seasons, with or without figures, set against cliffs.[30] Girault's work on the estate also captured several stages in its development, including views of the picturesque chalet, apparently finished by 1841 (fig. 44);[31] studies of imposing rocks, which

FIG. 44. Girault de Prangey, *Wood Chalet on the Grounds of Les Tuaires*, 1841. Daguerreotype, 2³/₁₆ × 2¾ in. (5.5 × 7 cm). Bibliothèque nationale de France, Paris (EG5-738)

were to be used in shaping the evolving landscape; and, of course, his villa, erected by 1835, first in a sober Western style, and destined to become both the vantage point and the focal point for the whole complex (fig. 11; pl. 12). Well before the greenhouses and aviaries filled the grounds with exotic flora and rare birds, Girault had turned to architecture to give shape to the idea of "armchair travel" that reconciled the passion of his first life, Eastern archaeology, with those of his second, horticulture and aviculture. Already by the early 1850s, the top floor of the villa was adorned by its evocative dome, which sheltered and crowned the photography studio.[32] On the verge of abandoning the daguerreotype, Girault thus positioned himself as a photographer at the heart of the domain he had by then chosen as his life's work. The bedrock of a completely renewed sociability, this realm would be the main source of inspiration for Girault's future works on paper.

From Drawing to Photography

Image-Production Techniques

Olivier Caumont

WHETHER EXECUTED ON-SITE during his travels or upon his return to France, the drawings, watercolors, and daguerreotypes made by Girault de Prangey to document his two "grand tours" indirectly furnished his publications on the art and architecture, both Christian and Muslim, of the Mediterranean. That is because the landscapes, monuments, and architectural details he captured via these various techniques were subsequently published as lithographs, a group of works that together form a notable aspect of Girault's oeuvre.

Over the past five years, via gifts and acquisitions, the Musées de Langres have significantly increased their holdings of works by Girault, particularly with respect to his drawings, watercolors, and previously unpublished paintings. Notable among these acquisitions, in 2013, was that of the Fonds Flocard, an ensemble of fourteen drawings, twenty-five watercolors, thirty-two lithographs, thirteen photographs, and assorted documents relating to Girault and his Villa les Tuaires. The Fonds Flocard's principal significance resides in its origins: it was retained by Marie and Gérard Flocard, domestic servants at the villa, and then passed on to their great-grandson, Robert Flocard, having originally been assembled and preserved by Girault himself. This corpus has helped us chart the chronology of Girault's movements across the Mediterranean with greater precision while shedding new light on his work as a "traveler-publisher"—that is, as both an artist and an artisan of the image. Corresponding to stages of a process of creation and replication whose ultimate aim was the publication of lithographs, these works make perceptible the evolution of Girault's methods from the early 1830s to the early 1850s.

THE FIRST JOURNEY: DRAWING AND THE CAMERA LUCIDA?

Between February/March 1831 and September 1834, Girault de Prangey set out on a journey that would take him first to Italy, back to his hometown of Langres, France, and then onward to the Maghreb, Spain, Sicily, and, finally, Switzerland. The technique that Girault most often used to document these travels was line drawing, subsequently highlighted in white. Eleven such drawings have been conserved, as opposed to only two watercolors. His publications devoted to the Western Mediterranean feature eighty-four full-page lithographs, not counting the maps and details included on the text pages.

Girault's images of Cordoba, Seville, and Granada (published in three parts, the first prior to 1837 and the remaining two by 1839) are in black and white only.[1] Based on the ratio of drawings to watercolors preserved in the Fonds Flocard, the scant number of original images in color from Girault's first trip suggests that he was either unable or unwilling to consider anything but black-and-white lithography; the Fonds Flocard contains only two color images produced on-site during that trip.[2] They were not used in the earliest publications—that is, those prior to 1837—but some seventeen years after the end of this journey, they served as models for color lithographs of Algiers and Porto Farina (Tunisia) in *Monuments et paysages de l'Orient* (1851). The two images of Algiers both reveal a strict observance of framing, of the general appearance of the city, and of architectural details. What changed was the position of the boats on the sea, as well as the sea itself, which in

the lithograph is rougher than in the watercolor, espousing a more Romantic spirit. The printing, in yellows, browns, and greens, transposes the original, more bluish and pink tones. For Porto Farina, a comparison between the watercolor, a quite pale intermediate proof (Fonds Flocard), and the image that appeared in the 1851 publication shows a move toward intensifying color. Indeed, whether working in black and white or in color, the accuracy and balance of tone seem to have been important concerns for Girault. As in other prints, figures are added in the foreground and middle distance. The fact that the artist retained the intermediate proof shows that he took part directly in making corrections. Another trial proof, of the print *Halicarnasse (Boudroun) Asie-Mineure*, inserted into a copy of *Monuments et paysages de l'Orient* at the Bibliothèque Arland in Langres, was annotated and monogrammed by Girault.[3] Along with the penciled instructions indicating changes to the texture and color of this plate, it is labeled "2nd," surely in reference to the stage it represented in the printing process.

Monuments et paysages de l'Orient, a less scholarly work with few texts, was probably intended for broader distribution than his preceding publications.[4] Its wide page format and numerous color images support this conjecture. Owing to the lack of color documents taken during the first journey, however, the album contains only two color views of the Western Mediterranean (the abovementioned images of Algiers and Porto Farina), as opposed to seventeen of the Eastern Mediterranean.[5] Girault clearly gave priority to the color plates, titling them while leaving the black-and-white ones untitled. In the mind of the artist/technician, the new method of printing in color relegated black and white to second place.

The extreme precision of certain drawings made during the first journey suggests the use of the camera lucida,[6] a projection device invented in 1806 by the English physicist William Hyde Wollaston. It comprises a prism placed at the end of a stand, the foot of which is clamped to the edge of a work surface holding a sheet of paper. This "light chamber" (hence, *camera lucida*) reflects the image to be reproduced onto the sheet of paper, and by focusing through the prism, one can trace what one sees with a pencil. The camera lucida can be used in

FIG. 45. Girault de Prangey, *Cloître de la cathédrale à Zurich*, August 1834. Lead pencil enhanced with black ink on paper, image 6 13/16 × 4 5/16 in. (17.3 × 10.9 cm). Musée d'art et d'histoire, Langres, Fonds Flocard (2012.14.37)

broad daylight, which is indispensable for architectural surveys and was thus important to Girault, given the priorities that motivated his travel. It also makes it possible to flip the image and draw it in the inverse direction, as with the lithographic stone, but Girault seems not to have done so during the first journey, as all his drawings have the same orientation as the original subject. Since no inversions are known, it is difficult to confirm the use of the instrument, which leaves no specific trace. Its use can be deduced only indirectly, by the lack of construction lines that characterize classical drawings of architecture. Some of Girault's architectural drawings raise the question, such as *Cloître de S. Pablo del Campo à Barcelone 29 8bre 1833* or *Cloître de la cathédrale à Zurich* (fig. 45), in which no underlying lines can be seen. At the same time, however, the drawing *Tarragone 19 8bre 1833* does show construction lines. It is possible that Girault reserved use of this technique for his most complex images involving the imbrication of volumes and convergence lines, as in the cloisters, for example.

While we cannot yet prove that our artist/artisan used the camera lucida, the possibility of a direct inversion of the image before the subject may be what led him to choose the photographic process for his second trip, in 1842–45. Girault was attentive to new technical processes, as his purchase of a daguerreotype camera as early as 1839 or 1840 shows. It thus would not be surprising if he had equipped himself with a camera lucida before departing on his first journey, which would likewise mean that the practice of directly inverting a subject to be reproduced would have been familiar to Girault even before he adopted the daguerreotype. Although today the choice of that process may be considered limiting, for Girault it further attests to the priority he accorded to precise documentation. The plans, cross-sections, measurements, and plaster molds follow this same principle. Girault was above all an archaeologist. Artistic concerns came later, in particular with regard to the picturesque details of the lithographed versions or paintings.

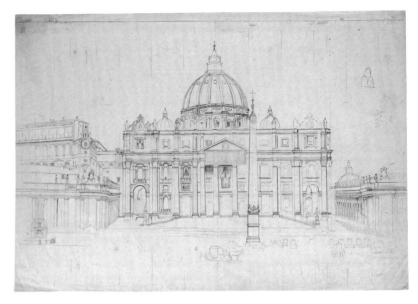

FIG. 46. Girault de Prangey, *Place et façade de Saint-Pierre de Rome*, ca. 1842. Lead pencil on paper, image 11 × 16 in. (27.9 × 40.5 cm). Musée d'art et d'histoire, Langres, Fonds Flocard (2012.14.52)

THE SECOND JOURNEY: DAGUERREOTYPES AND WATERCOLORS

At the beginning of the 1840s, Girault set out eastward, documenting his travels mostly through daguerreotypes. Notably, it was on the basis of these images that he produced the lithographs for *Monuments arabes d'Egypte, de Syrie et d'Asie-Mineure* and *Monuments et paysages de l'Orient*.[7] We can recognize the use of the daguerreotype from the inversion of the images, which was characteristic of the technique during that period. Girault returned to France at the beginning of 1845 with a great number of plates in various formats.

Clearly, photographs had replaced drawings as Girault's documentary tool of choice, and he made them in greater number, since they could be produced more quickly than drawings. Indeed, the large number of "oriental" plates dwarfs the number of drawings produced during his first trip. Girault did not, however, abandon his earlier methods altogether: twenty watercolors and one drawing made during this second trip are preserved in the Fonds Flocard. Unlike those made on his first trip, the watercolors are almost all in color. Girault doubtlessly had in mind the publication of chromolithographs, for which he would need to document sites and monuments in color. Since photography would not enable him to preserve that information, he was obliged to return to his brushes. The distinctive feature of all these images, however, is their inversion with respect to the original orientation of their subjects—an indication that the artist did not draw or paint from life. We must therefore conclude that these images were based on daguerreotypes. This process may seem odd at first but makes sense if we recall that the primary objective was a lithographic publication.

The oldest example of this new technique, the sole drawing from the second trip, depicts the facade of Saint Peter's Basilica in Rome (fig. 46). Although Girault also visited Rome during his first journey, this undated drawing was certainly made at the beginning of the second trip, for it corresponds precisely to a daguerreotype with the same framing and details produced in 1842: *Bénédiction du Jeudi Saint à*

St. Pierre.[8] The drawing is highly precise, with vertical and horizontal construction lines. Girault would not have needed to make use of such guides had he used the camera lucida, regardless of whether he chose to invert the image. This drawing provides insight into the artist's working process: the construction lines allowed a precise transfer of the details of the image exposed on the layer of silver. We notice, however, slight changes in perspective and the omission of details, such as the crowd at the foot of the facade, that might have impeded comprehension of the image.[9] Such simplification of the image was surely carried out in preparation for its adaption as a lithograph, proving that Girault drew primarily with that goal in mind. During the second trip, drawings and watercolors were no longer the first media used to document subjects; they were merely the second step of a three-stage process, coming after the photograph and before the lithographic stone.

When reproducing an image as a lithograph, Girault referred to his photograph to replicate line, perspective, and detail, and then to the watercolor to recall color, light, and atmosphere. We can imagine him first observing the plates and then reproducing the inverted image before finally applying the colors, though the actual chronology of this process is uncertain. We do not know whether Girault produced the color images at the sites themselves. Indeed, there is no reason not to suppose that he painted the watercolors after the fact, some days or weeks later, or even in the studio, after his return to France. None of his Eastern watercolors is dated, unlike some of the drawings from the first trip, the precise dates of which attest to his working on-site. The absence of dated drawings from the second trip would argue for the work having been done after the fact. Moreover, the framing of the daguerreotypes differs from that of the corresponding watercolors, which have wider formats. Were these enlarged margins pure invention or proof that the work was done on-site? In most cases, it is hard to tell, but it is undeniable that the watercolors were destined for adaptation into lithographs, to which the daguerreotype format does not correspond. The evolution of the dimensions between the plates, watercolors, and lithographs can be seen in both *Palais de Rhamsès, à Thèbes* (fig. 47 and pl. 82) and *L'Atmeïdan, à Constantinople*.[10] For the latter, the width of

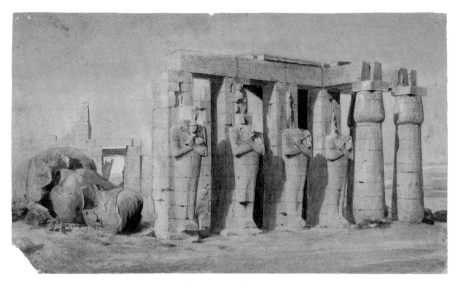

FIG. 47. Girault de Prangey, *Palais de Rhamsès, à Thèbes*, ca. 1844. Watercolor and lead pencil on paper, image 7³⁄₁₆ × 12⁵⁄₁₆ in. (18.2 × 31.3 cm). Musée d'art et d'histoire, Langres, Fonds Flocard (2012.14.41)

the daguerreotype (pl. 72) is 3 ½ inches (9 cm), while that of the watercolor (fig. 48) is 7⁷⁄₁₆ inches (18.8 cm), which matches the width of the lithograph (7⁵⁄₁₆ inches [18.6 cm]) almost exactly (fig. 49).

The watercolors documenting the second journey, even the roughest, hastiest views, such as that of the fisheries on the Bosphorus (see fig. 22), have the same inverted orientation as the photographs, implying that they could not have been sketched from life. Even so, we should not dismiss entirely the hypothesis of works being produced or completed on-site, since to have done so would have been consistent with the concern for precision that characterizes all of Girault's work. The watercolor portraying the Obelisk of Theodosius in Constantinople shows, toward the edge in the background, a minaret that is absent from the daguerreotype but present in reality. In this case the artist did work on-site, or if not, he remembered the site exactly. Following this same logic, it seems unlikely that the colors would be purely fictive or the fruit of vague memories, for to preserve that information was crucial for the successful execution of the future chromolithographs. The

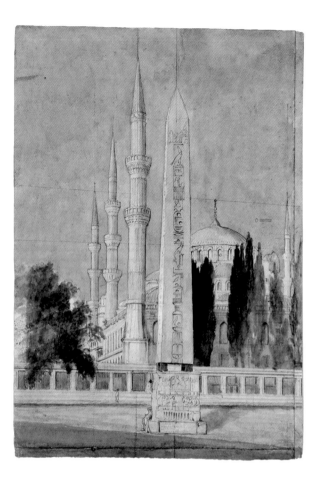

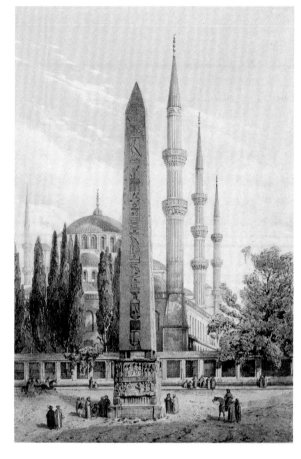

FIG. 48. Girault de Prangey, *L'Atmeïdan, à Constantinople*, ca. 1843. Watercolor and lead pencil on paper, image 10⅝ × 7⁷⁄₁₆ in. (27 × 18.8 cm). Musée d'art et d'histoire, Langres, Fonds Flocard (2012.14.39)

FIG. 49. "L'Atmeïdan, à Constantinople," from *Monuments et paysages de l'Orient*, 1851. Lithograph by Charles-Claude Bachelier (1834–1880) after Girault, image 11⅛ × 7⁵⁄₁₆ in. (28.2 × 18.6 cm). Bibliothèque nationale de France, Paris

corrected trial proofs for Porto Farina and Halicarnassus prove that the colors and their balance were important to the artist.

There is only one currently known instance of Girault's having made two different watercolors on the same subject: the *Tombeau de Si Med El-Baouâb, à Rosette*. Both are preserved in the Fonds Flocard and were used to make the corresponding lithograph of this tomb in *Monuments et paysages de l'Orient*. One portrays the monument itself, while the other (fig. 50), with very light, quick strokes, focuses on a clump of trees that would become a detail in the future print (fig. 51). The two watercolors are identically framed; the artist was already working with the final composition in mind. Were these images and the corresponding daguerreotypes all that were needed to produce the lithograph? Were there any later stages? We now know that the lithographer no longer had to invert the image provided, but it seems necessary at the

least to have had a drawing that would scale certain watercolors to the format of the stone. It could be, however, that such work was done directly on the stone. As of now, there is no evidence of an intermediary proof between the watercolor and the lithograph, although if one did exist, it would have been purely technical and surely would not have been conserved. Based on the initial evidence, one might think that the artist did not emphasize the intermediate stages of his work. However, Girault did mention his use of the daguerreotype in *Monuments arabes d'Egypte*, and he acknowledged, at least in one instance,[11] that the prints in *Monuments et paysages de l'Orient* were made after his watercolors.

As far as we know today, Girault neither exhibited nor circulated his photographs; his fame spread through his books or through salons, as in the traditional form of painting. In contrast to his paintings in oil, the daguerreotypes, drawings, and watercolors conserved today mostly came

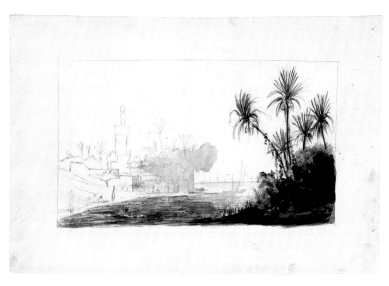

FIG. 50. Girault de Prangey, *Tombeau de Si Med El-Baouâb, à Rosette*, ca. 1844. Watercolor and lead pencil on paper, sheet 11¹¹⁄₁₆ × 16³⁄₈ in. (28 × 41.6 cm). Musée d'art et d'histoire, Langres, Fonds Flocard (2012.14.42)

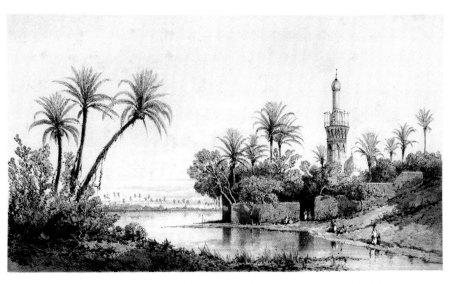

FIG. 51. "Tombeau de Si Med El-Baouâb, à Rosette," in *Monuments et paysages de l'Orient*, 1851. Color lithograph by Eugène Deshayes (1828–1890) after Girault, image 7¹⁄₁₆ × 12⁵⁄₁₆ in. (18 × 31 cm). Médiathèque Marcel-Arland, Langres (E 218 in2)

from his Villa les Tuaires; they were never disseminated. Like his pencils, brushes, or camera, they remained at the level of documentation.

Girault's working processes have not yet been studied with sufficient depth—previous work has focused instead on the historical aspects and documentary value of his images—but the recent growth of his known body of work, thanks in particular to the collections in Langres, has enabled new possibilities for greater research. Questions undoubtedly remain, but close observation of Girault's drawings and watercolors and their comparison to the photographs and lithographs allow us to better understand the stages and evolution of the artist's process of recording and disseminating the images.

With a newfound understanding of his work ethic and methods, we may be inclined to consider Girault an illustrator, as well. Pragmatic, rigorous, and attentive to technical solutions, this artisan of the image restricted himself to documentary precision, in a sense curbing his own creative freedom. Although his aims did not preclude aesthetics, as his desire to exhibit in the salons demonstrates, his foremost concern was

the accuracy of his images. He prioritized processes that offered veracity, practicality, and swift execution. To meet these needs, Girault remained alert to progress afforded by various technologies: lithography, the making of molds, the possible use of the camera lucida, on-site measuring, photography, and chromolithography. For Girault, these means were part of the same principle linking precise reproduction with ease of dissemination. His willingness to adapt led him to radically change his creative processes throughout his career. As bearers of primary information, the drawings he made from life, with or without mechanical transfer, formed the basis of his archaeological work in the 1830s. Starting in the 1840s with his adoption of the daguerreotype, drawings and watercolors became complementary tools of a method based on photographic inversion. As an artist Girault surely lost much freedom with this method, and he may have sacrificed a bit of fame, but the final goal—re-creating truth—outweighed all other considerations. As such, Girault was, yes, an artist, artisan, and technician, but above all a man of science and history.

"Un Daguerréotype Monstre"

Silvia A. Centeno, Nora W. Kennedy,

Grant B. Romer, Andrea E. Schlather, and

Ariadna Cervera Xicotencatl

THE GREATEST INSIGHTS into an artist's oeuvre can sometimes be revealed by clues derived from the artwork itself. Material evidence can be analyzed, the artist's hand leaves physical traces, and, in the case of photography, the images themselves speak of long-lost cameras and lenses. Joseph-Philibert Girault de Prangey's daguerreotype apparatus has not been recovered, but a large number of his daguerreotypes have. Their unconventional sizes, shapes, and wide-ranging image qualities indicate a highly unusual camera design and working method for the period. One hundred and eight plates from five institutional collections were analyzed and characterized for this essay. Protective plate packages were opened so that details on both sides of each daguerreotype could be examined and documented. All tool marks were noted; maker's marks documented; and other plate markings recorded. X-ray fluorescence spectroscopy was carried out to determine the presence of gold and any other elements that might give clues to the process used and to the subsequent history of the plates, which were viewed under a variety of light angles and wavelengths to reveal details not visible under ordinary lighting. Determinations about the cameras and lenses were derived from viewing both plates in person and images available online. Much was learned from this research, but many questions remain.

Daguerreotyping was a time-consuming and painstaking form of photography, compared in particular to twenty-first-century practice.

The steps illustrated here (fig. 52), in condensed form, are based on Daguerre's original published process, with the later addition in some cases of treating the resulting silver-mercury image with gold. Once having conceived of a grand daguerreotype campaign, Girault would have had to furnish himself with a sufficient supply of plates, the necessary chemistry, and a custom-built camera, as well as sensitizing and processing equipment. Two contemporary references to Girault's camera described it as being of improved design and monstrously large.[1] His largest plate measures 7½ by 9½ inches, a full inch larger on both sides than a standard whole plate, measuring 6½ by 8½ inches.[2] The camera and all processing equipment had to be accordingly larger. A search of period literature suggests that no plates in these dimensions were commercially available. Additionally, to our knowledge, there are no extant examples with these dimensions by other daguerreotypists.

Twenty-three of the plates studied bore two similar, and possibly related, maker's marks in the form of six-petaled rosettes (fig. 53). Hallmarks and maker's marks are small designs stamped into a silver object that provide information about the silver purity, the date, and/or the manufacturer. In this case, the maker remains unidentified and the mark provides no information about the silver. The earliest plate with a rosette has a completely rounded exterior, while the variant has two indented "petals." The rounded version appears on images Girault

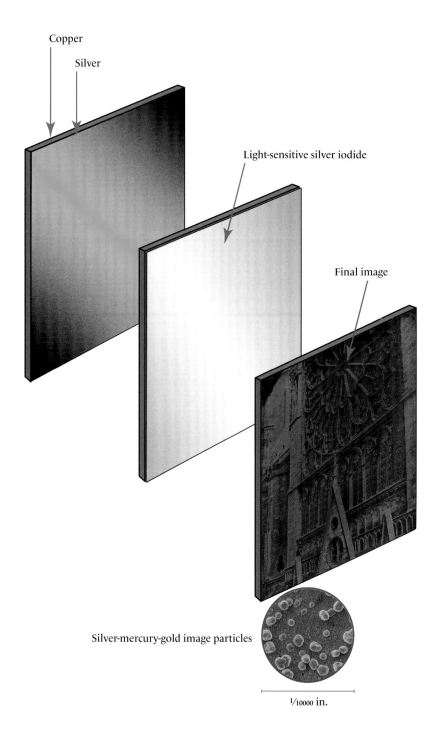

Copper

Silver

Light-sensitive silver iodide

Final image

Silver-mercury-gold image particles

$^{1}/_{10000}$ in.

made in France, while the indented florets appear on plates he made during the Mediterranean campaign. It is important to note that consistent quality of the plates was a requisite for control of the process, so Girault would have sought a full supply of plates of the best quality from a single manufacturer.

The typical French daguerreotype camera was of a rigid "box in a box" construction, and indeed, two cameras of this type of different sizes appear in two of Girault's daguerreotypes (pls. 39, 113). The "sliding box" camera, as it was known, comprised two boxes: one fixed with the lens attached at front; the other movable, like a drawer, on a rearward-extending bed (fig. 54). Sliding the smaller box backward and forward modified focus. Adjustment of the lens brought fine focus. The standard whole-plate camera of this description generally measured 12 inches wide by 12 inches high. Its length could vary from 10 inches compressed to 20 inches fully drawn out.

A camera of that size, intended to record architectural monuments, required a long focus lens of the highest optical caliber to fully cover the plate surface. The standard lens mounted on a whole-plate daguerreotype camera, not intended for portraiture, was a single objective with a wide field of view, and with a 3-inch diameter and a 15-inch focal length. Diaphragms of various sizes, depending on the view chosen, reduced the aperture to increase the depth of field. Rapid improvements in lens design resulted most importantly in faster, multielement

FIG. 52. Girault's Daguerreotype Method

1. Daguerreotypists purchased their plates pre-manufactured. A copper plate clad with a thin layer of silver was rolled under pressure, beaten or planished to unify the surfaces, and polished to a mirror shine.

2. The surface was made light-sensitive through exposure to iodine vapors. The desired scene was composed with a view camera and, once arranged and in focus, the light-sensitive plate was secured into the back of the camera with a plateholder. Girault would have prepared a whole plate and exposed multiple views, then cut them apart after processing or at a later date.

3. The exposed plate was removed from the camera and the image developed with vapors of mercury. Remaining light-sensitive silver iodide was washed away or "fixed" using sodium thiosulfate, followed by water. An optional gilding step during initial processing or at a later date added a thin layer of gold to stabilize and enhance the image.

FIG. 53. Microscope views of the maker's marks found on 23 of the 108 plates studied, 11 on whole plates and another 12 distributed evenly among 5 cut-down plate sizes (half, long half, quarter, sixth, eighth, and two-thirds panorama). The example at left appeared on only 2 plates, the one at right on the remaining 21. It is of interest that not all whole plates have marks.

lenses, such as those introduced by Charles Chevalier and Josef Petzval (see p. 18). It is highly probable that Girault traveled with at least one smaller camera, perhaps of quarter-plate size using a double lens, which would have been significantly faster than his large camera and most useful for portraiture. Analysis of the subject of his plates compared to size shows a high number of deliberate portraits in quarter- and sixth-plate sizes.

It is likely that Girault had access to the first edition of Noël-Paymal Lerebours's manual, coauthored with Marc-Antoine Gaudin in 1841.[3] In it, Lerebours comments on the rapid progress of the daguerreotype and the difficulty of keeping pace with improvements. He identifies exposure of the plate as the most difficult part of making an image, owing to a large number of variables including the type of light, the subject, and the sensitivity of the plate. Nevertheless, the 1841 edition does not provide specific guidelines, stating only that a plate exposed at sunset could take more than twenty times as long to achieve an intensity equal to that of a plate exposed at noon.[4] Time of day was indeed an important factor to consider in calculating exposure: optimum hours—that is, when the sunlight was most constant and active—were between eleven a.m. and three p.m. Lerebours's 1843 manual

contains an exposure chart comparing camera sizes, and gives a range of 1 to 15 seconds with a quarter-plate camera; 3 to 20 seconds with a half-plate camera; and 6 to 50 seconds with a whole-plate camera (fig. 55).[5] A larger camera, with stopping down of the lens to increase the depth of field, would entail exposures of 30 seconds to 20 minutes. Whether Girault followed a published guide or calculated his own exposure times is unknown, but it is safe to say that a range of light exposures played a role in the wide variety of images he obtained. An experienced daguerreotypist working in the field understood the processes' breadth of exposure latitude, usually producing at least some image, but the resulting image might be weak, lacking in shadow detail when underexposed, or tonally reversed, with too much contrast, and oddly colored when overexposed. If possible, an estimated trial exposure developed in the field gave guidance on whether it was correct or needed to be increased or decreased.

The multiple images found on some of Girault's plates give evidence that he used a camera with multiple-exposure capacity (see pls. 15, 49, 56). No example of such a camera clearly datable before 1842 is known to exist, nor is one described in any apparatus catalogue of the time period prior to Girault's departure on his campaign. An 1850 "Catalogue of Photographic Apparatus," manufactured and sold by "Thomas and Richard Willats, Opticians and Philosophical Instrument Makers, London," describes a multiple-exposure camera: "Improved French Pattern, Shifting Back Camera, with achromatic lens, 3 in. in diameter, mounted in brass sliding tube, with diaphragms to take pictures 10 by 8 in."[6]

Experimentation has demonstrated that a shifting mechanism, typical of later multiple-exposure camera backs, was not necessarily required. With the aid of various masks and through draws of the dark slide and rotation of the plateholder, a square plateholder with the internal capacity to hold the rectangular full plate in either a vertical or a horizontal position could produce all of the image formats found in Girault's production. Horizontal movement of a side-draw plateholder could expose the plate in its entirety or mask segments on the vertical axis of the plate. Masks of various formats inserted into a

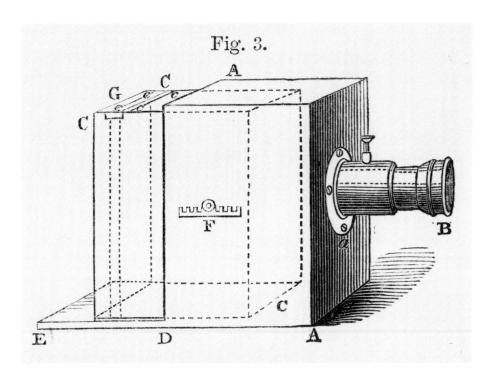

Fig. 3.

FIG. 54. The "sliding box" camera comprised two boxes: one fixed with the lens attached at front, the other movable, like a drawer, on a rearward-extending bed.

FIG. 55. Exposure table published by Noël-Paymal Lerebours in 1843

STATE OF THE ATMOSPHERE.		DURATION OF THE EXPOSITION.				
		With Plates, 1-6th.	With Plates 1-4th.	With Plates 1-half.	With whole or Normal Plates.	With Plates. 0m. 24, by 0m. 32.
		Seconds.	Seconds.	Seconds.	Seconds.	Minutes.
With a sky veiled by slight white clouds.	The apparatus turned towards the north . . .	2 to 4	10 to 15	15 to 20	20 to 50	½ to 2
	Towards the south . . .	1 to 2	5 to 10	10 to 15	15 to 30	20 to 60
						h. h.
On an open terrace . . .		1 to 2	5 to 12	10 to 20	20 to 40	1 to 1½
With the object illumined by the sun . . .		a fraction of a second.	1 to 4	3 to 6	6 to 10	s. s. 15 to 20

separate channel of the plateholder (between the plate and the dark slide) blocked light from reaching the plate on the horizontal axis. The manipulation of this mechanism appears straightforward, but Girault's multi-image plates would have required much practice and presence of mind to manage successfully (fig. 56).

A supply of one hundred whole plates had the potential to yield two hundred half- or long half-plate images, or four hundred quarter-plate images (fig. 57). Those made with this camera would have been exposed and developed as whole plates, and probably stored and transported as such, to be cut down later upon return to France. The number of Girault's daguerreotypes at the time of discovery, by differing accounts, is given as eight hundred to a thousand (see p. 206).[7] One contemporary source mentions an astonishing three thousand, a number not beyond credence.[8] While the standard whole-plate storage box had twelve slots, accommodating twenty-four plates, placed face to face, Girault's boxes had twenty-one slots, which could carry forty-two plates (fig. 58). Ten boxes of pre-polished whole plates carried on the campaign would therefore have provided 420 plates, sufficient, when using a multiple-exposure camera as described above, to produce many hundreds or even thousands of images.

All of the smaller-than-whole plates examined to date display clear evidence of having been cut down from full size, and plate boxes designed to accommodate five different plate sizes have survived. The manufactured sides are regular and slightly rounded, while the hand-cut sides reveal the use of a variety of tools, including blades to score the plate repeatedly until cut through and, surprisingly, files, presumably used to modify the cut edges. Other cutting tools such as shears or snips may also have been called into service. The imprint of tongs and grips may derive from handling the plates during various operations, from processing to cutting down. There is little evidence that the cutting down was done to prepare the plates for individual display, as only a few plates are found in what may be period passe-partout housings. It is possible that the daguerreotypes were cut to facilitate their copying for publication as lithographs, or perhaps for the convenience of referencing one image at a time.

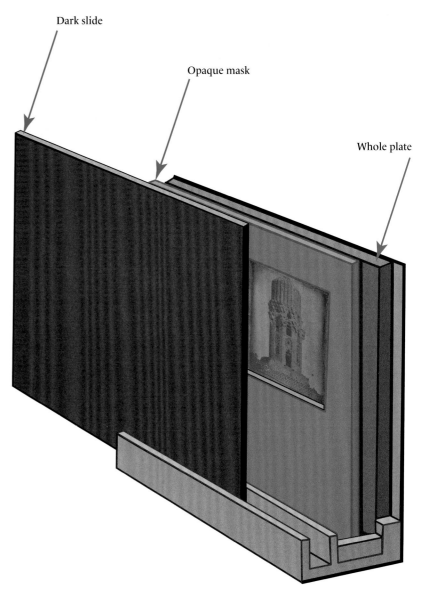

FIG. 56. Slide-Draw Camera Back with Masks

1. The opaque dark slide positioned in the outer channel of the plateholder, normally used to protect the daguerreotype plate from light exposure prior to its positioning in the camera back, can be moved from left to right to mask portions of the plate on the vertical axis during exposure in the camera.

2. An opaque mask with an aperture sized to the desired exposure is slid into the inner channel to mask further portions of the plate on the horizontal axis.

3. A whole plate is held in a fixed position in the wooden plateholder.

Whole plate
7½ × 9½ in. (19 × 24 cm)

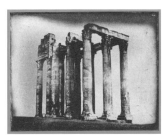

Whole plate
9½ × 7½ in. (24 × 19 cm)

Square plate
7½ × 7½ in. (19 × 19 cm)

FIG. 57. Girault used a whole-plate size of 7½ by 9½ inches, a full inch larger on both sides than the standard 6½ by 8½ inches. Plates with multiple exposures could be cut down into a variety of formats, including the unusual two-thirds panorama (not pictured) and square formats.

Half plate
4¾ × 7½ in. (12 × 19 cm)

Half plate
7½ × 4¾ in. (19 × 12 cm)

Long half plate
9½ × 3¾ in. (24 × 9.5 cm)

Long half plate
3¾ × 9½ in. (9.5 × 24 cm)

Third plate
6⁵/₁₆ × 3¾ in. (16 × 9.5 cm)
3¼ × 3¾ in. (8.2 × 9.5 cm)

Two-thirds plate
6⁵/₁₆ × 7½ in. × (16 × 19 cm)
3¼ × 7½ in. (8.2 × 19 cm)

Quarter plate
4¾ × 3¾ in. (12 × 9.5 cm)

Quarter plate
3¾ × 4¾ in. (9.5 × 12 cm)

Sixth plate
3³/₁₆ × 3¾ in. (8 × 9.5 cm)

Sixth plate
3¾ × 3³/₁₆ in. (9.5 × 8 cm)

Eighth plate
2⅜ × 3¾ in. (6 × 9.5 cm)

Eighth plate
3¾ × 2⅜ in. (9.5 × 6 cm)

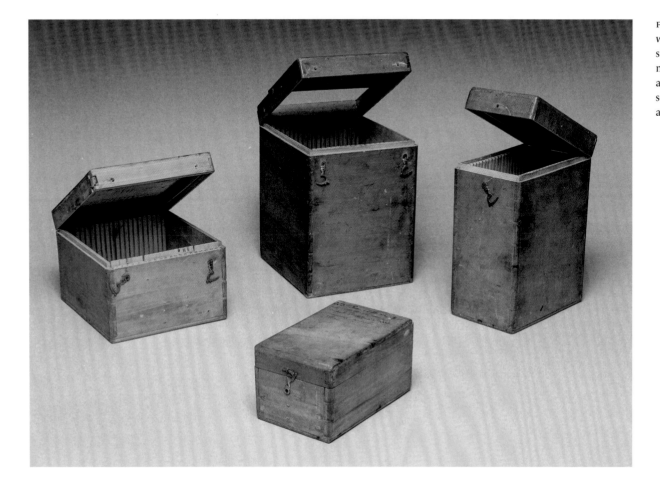

FIG. 58. Four of Girault's plate boxes, in whole-, long half-, half-, and sixth-plate size. All are of similar construction and materials; two show more deterioration, as they are believed to have been stored separately from the others after the artist's death.

A last step, commonly referred to as "gilding," was added to Daguerre's original method by French physicist Hippolyte Fizeau in 1840.[9] Gilding a daguerreotype after fixing consisted of pouring a solution of gold chloride and sodium thiosulfate over the mercury-developed image, followed by heating with a lamp. This step improved the contrast and, in principle, produced a more mechanically stable image.[10] Fizeau's procedure was hailed by his contemporaries not only for the beauty of the resulting images, but also for its simplicity and economical use of materials,[11] and it remained essentially unchanged throughout the Daguerreian era. Gilding was not always done immediately after development and fixation, and could be postponed to a later time. Elemental analysis using X-ray fluorescence (XRF) spectroscopy revealed the significant fact that only about half of the plates measured were ungilded, indicating that gilding was not necessarily the last step in Girault's process in the field. The plates analyzed were selected to include a diverse assortment of sizes and subjects within the artist's body of work, including daguerreotypes made in each country he visited during his 1842–45 expedition.[12] A large portion of the ungilded plates were made during the last year of his travels, in Egypt, Lebanon, Palestine, and Syria (fig. 59).

Runoff stains of gold on the reverse edges of some plates were found along cut-down edges, indicating that he would sometimes cut down the plate prior to gilding. Considering the extra chemistry, additional

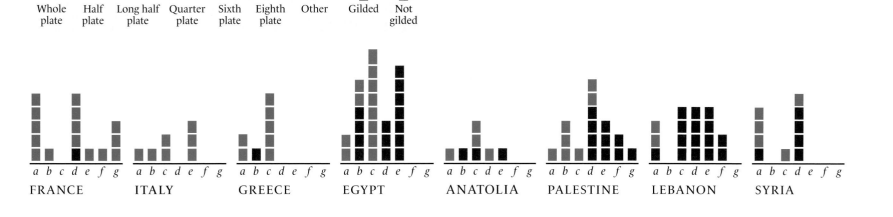

| *a* | *b* | *c* | *d* | *e* | *f* | *g* | Gilded | Not gilded |
| Whole plate | Half plate | Long half plate | Quarter plate | Sixth plate | Eighth plate | Other | | |

a b c d e f g *a b c d e f g* *a b c d e f g* *a b c d e f g* *a b c d e f g* *a b c d e f g* *a b c d e f g* *a b c d e f g*

FRANCE ITALY GREECE EGYPT ANATOLIA PALESTINE LEBANON SYRIA

1841 —— 1845

FIG. 59. Results of noninvasive analyses conducted by X-ray fluorescence on 108 plates, incorporating plate sizes, places of production, and chronology. Each square represents one daguerreotype plate. They are grouped first by plate size, then by place of production.

quantities of filtered or distilled water, consumption of time, and great delicacy in management required in this procedure, Girault may well have forgone gilding while traveling and reserved it only for more favored plates. Images destined for reproduction through tracing would have needed to be "hardened" through gilding, but not all plates that are gilded were reproduced.

Some intriguing signs on the plates have yet to be deciphered, among them curious indentations deliberately punched into edges

FIG. 60. Of the 108 plates examined, 32 have curious indentations at their edges. Twenty-four plates have one or two indentations, while two plates each have 10 and one has 13. The largest numbers of indentations appear on plates made at the start of the trip, in Italy (4, 5, and 10) and Greece (6, 10, and 13). Three plates have indentations in two locations on the same plate.

from the front of some plates that form braille-like bumps on the reverse (fig. 60). Was this a form of notation indicating orientation or prior exposure that could be sensed during the dark-handling of a sensitized plate? Such an explanation works for plates with one or two indentations, but plates with five, six, seven, ten, or thirteen indentations in neat rows are less easily comprehended.

After his journey, it seems that the photographer kept his archive of daguerreotypes in slotted wood boxes, where they remained for more than a century.[13] The full history after discovery has yet to be known. There is evidence on the plates of a series of chemical treatments at various times to reduce the natural tarnishing of the silver.[14]

We uncover clues to this significant photographer's work with every examination of his oeuvre, yet many mysteries remain. The sheer number of successful images made under what must have been less-than-ideal circumstances positions Girault in a place of honor in the history of the medium. The survival of these jewels of photography to our day is a great gift from the past.

Key Sites and Subjects

Lindsey S. Stewart

For clarity, the geographic sites listed in the following pages are grouped by country as defined by present-day national boundaries. For context, both nineteenth-century and modern place names are provided in the entries.

FRANCE

NOTRE-DAME, PARIS

Girault photographed France's most famous cathedral before the controversial renovations undertaken by Viollet-le-Duc, begun in 1845. The spectacular rose windows (pl. 2), retaining some of their original stained glass, were built in the mid-thirteenth century in the French Gothic style known as *rayonnant*, notable for the intricacy of its decorative motifs. The small Porte Rouge (pl. 3), on the north side of the cathedral, dates from the same period and provided a private means of access for the canons and choir. The chevet (pl. 4), an apse of radiating chapels outside the choir aisle, dates from the twelfth century. The bas-relief (pl. 5) shows the Assumption of the Virgin accompanied by angels, though all details have been smoothed and worn by centuries of weather.

TUILERIES, PARIS

The Tuileries Palace (pl. 6), named for the kilns for roofing tiles (*tuiles*) that previously occupied the site, was next to the Louvre. Commissioned by Henri II's widow, Catherine de' Medici, in the 1560s, it was home to France's kings and emperors. In 1841 the palace was occupied by Louis-Philippe I, who stayed until it was invaded in the 1848 Revolution and he fled to England. It was burned by supporters of the Paris Commune, the short-lived revolutionary government of Paris, in 1871.

FONTAINE DU CHÂTEAU D'EAU, PARIS

This drinking fountain (pl. 7), designed by Pierre-Simon Girard and built in 1811, was a feature of the place du Château d'Eau, a small square—and the site of Louis Daguerre's Diorama and studio—that was enlarged during Haussmann's renovation of Paris in the mid-nineteenth century. The square was eventually absorbed into the new place de la République, in 1880. The fountain was replaced and moved in 1867 to La Villette, the city's new cattle market.

LA DOUY

La Douy (also spelled Dhuys, Duys, and Dhuis) was a hamlet close to Courcelles-Val-d'Esnoms, where Girault kept an elaborate five-story villa (pls. 10–12). The house was built into the rock at basement level and was enlarged and embellished by Girault in an orientalist style after he returned from the Mediterranean. The grounds extended over 22 acres, with a series of terraces and glasshouses (pl. 124) for his collection of exotic plants. After the start of World War I, the house was abandoned, eventually becoming derelict, and the site overgrown.

PORTE GALLO-ROMAINE, LANGRES

The town of Langres predates the arrival of the Romans. The Porte Gallo-Romaine (pl. 119), a Roman triumphal arch built a little more than 2,000 years ago, is its oldest preserved structure and is unusual for having multiple arches, a single arch being more typical. Eventually of little use defensively, the arch was incorporated into the town's first fortifications, which date from the end of the third century.

MONT-DORE

Situated on the Massif-Central in the Auvergne, Mont-Dore is the site of thermal springs known since antiquity. Girault photographed the ruins of Roman baths there, including at least two views of a cupid-topped capital (pl. 120).

MER DE GLACE

The Mer de Glace, or "Sea of Ice," near the Alpine village of Chamonix, is the most famous portion of the Mont Blanc glacier (pl. 121). Although

it used to descend down into the valley, the tip of the glacier now retreats four to five meters every year, a result of human activity and climate change.

SWITZERLAND

Girault photographed throughout west-central Switzerland, most prominently in the canton of Bern. Among his many views of vernacular architecture was a house in the Bernese Highlands, in Meiringen, which was destroyed in a citywide fire in 1891 (pl. 122). In the Jura, he turned his attention to the limestone formations and rocky cliffs between the towns of Moutier and Roches (pl. 123).

ITALY

CATHEDRAL OF SAN LORENZO, GENOA

The port city of Genoa, on Italy's Ligurian coast, is home to San Lorenzo, one of the oldest and finest Romanesque-Gothic cathedrals in northern Italy. It was constructed between the twelfth and fourteenth centuries, with later additions. Girault captured a detail showing clusters of colonettes to the right of the main entrance (pl. 13). Colored glass, stone, and miscellaneous *spolia* from Roman and Byzantine ruins were incorporated within the decoration of the striped marble facade.

TOSCANELLA

Toscanella (modern Tuscania), about 250 miles south of Genoa, is home to several notable ancient tombs. In the nineteenth century the local Campanari family spearheaded their excavation, and some of their finds eventually entered important international collections. The family's own house was effectively a museum of Etruscan antiquities, the garden reportedly filled with stone lions (pl. 14), sphinxes, and so-called chimeras.

CORNETO

Visible in Girault's double-image of Corneto (modern Tarquinia; pl. 15) is the Romanesque bell tower of San Pancrazio, a Roman Catholic church begun in the thirteenth century. The window, with a double

Gothic arch decorated with carved foliage, seems more influenced by Byzantine or Moorish themes, closer to the style of Venetian Gothic.

COLUMN OF TRAJAN, ROME

The great column commemorating the victories of Emperor Trajan, erected in A.D. 113, is one of the finest and most original examples of Roman imperial art (pl. 16). Internally, the column has a spiral staircase of 185 steps. Girault was presumably one of the first to brave this climb with the equipment required to make a panoramic daguerreotype overlooking the city, with the Colosseum at center (pl. 17).

PONTE ROTTO, ROME

Girault's panorama of the Tiber River (pl. 19) features, midstream in the foreground, the single surviving arch of the Ponte Rotto (Pons Aemilius), the oldest stone bridge in Rome. It was built in the second century B.C. and suffered centuries of damage from generations of flooding and restoration before all but one arch collapsed, in 1598. Visible in the panorama to the left of the Ponte Rotto's remains is the Pons Fabricius, connecting the east bank of the river to Tiber Island.

TEMPLE OF VESPASIAN, ROME

Three Corinthian columns are all that remain of the Temple of Vespasian, on the Roman Forum (pls. 20–22). In 1842 it was still known as Jupiter Tonans (Thundering), as it was thought to have been erected by Emperor Augustus after he escaped a lightning strike. Over the centuries, sediment from Tiberian floods and debris from crumbling buildings raised the ground level of the Forum, and until the early nineteenth century the temple remained buried for two-thirds of its height. Girault's two views of the west end of the Forum show the temple and the Arch of Septimus Severus in front of the new Church of Santi Luca e Martina by Pietro da Cortona, begun in 1835.

TEMPLE OF CASTOR AND POLLUX, ROME

Girault captured the remains of the once-massive Temple of Castor and Pollux (pl. 23), built in the first century B.C. Castor and Pollux, known together as the Dioscuri, were twin brothers born to Leda, though by different fathers: Zeus, king of the Greek gods, seduced Leda

in the guise of a swan to father Pollux, while Tyndareus, king of Sparta, fathered Castor.

TEMPLE OF VESTA, ROME
The small, circular Temple of Vesta was one of the most photographed monuments in and around the Roman Forum in the nineteenth century, its scale and symmetry appealing strongly to a public hungry for images of the ancient city. Girault's panoramic detail (pl. 24), in a style quite unlike later photographers' efforts, emphasizes the slender proportions of the Corinthian order and the fine work of the capitals while minimizing the roof, which is not original.

GARDENS OF THE VILLA MEDICI, ROME
In 1803, the sixteenth-century Villa Medici, a palace on the Pincian Hill that had once been the site of an ancient Roman villa, became the seat of the Académie de France, where French artists in Rome lived and worked. The distinctive umbrella pines (pl. 25) were later additions to gardens of terraces with water features. In 1833, Horace Vernet designed a neo-Moorish Turkish room. Perhaps both inspired Girault's later redesign of his own gardens and villa.

HADRIAN'S VILLA, TIVOLI
Constructed in the second century A.D., Emperor Hadrian's villa at Tivoli, near Rome, is a massive complex of buildings and gardens on a site covering nearly 750 acres. It is the most complete estate to have survived the fall of the Roman Empire and was an obvious draw for Girault (pl. 26), whose main interests outside architecture were botany and garden design.

GREECE

MONASTERY OF DAPHNI, ATTICA
The eleventh-century Monastery of Daphni (pl. 27) is located in Attica, on the ancient sacred road from Athens to Eleusis. Dating from the middle Byzantine period, the exterior has a cloisonné style of masonry, in which rectangular stone blocks are separated or framed on all sides by bricks. The interior is noted for its gold mosaics.

AGIOS ELEFTHERIOS, ATHENS
The Agios Eleftherios is a tiny Byzantine church beside Athens's cathedral, in the Monastiraki area, which was the commercial center of Athens when the city was under Ottoman rule. The church was built using ancient fragments, and reliefs on the external walls date from the Greek and Byzantine periods. In Girault's image (pl. 28), the facade is dwarfed by the later bell tower, since removed. In the early 1840s the church became the National Library.

ACROPOLIS, ATHENS
The Acropolis, the hilltop citadel overlooking Athens, is the greatest architectural legacy of Greek antiquity. When Girault visited, much of the site was already covered in rubble (pl. 40). His view of the western approach (pl. 34) shows the Propylaea, the Temple of Athena Nike, the Parthenon, and, prominently, the tall "Frankish Tower," one of many Byzantine, Frankish, and Ottoman structures added to the site over the centuries. After Greek independence (1832), most non-Classical features were cleared away in an attempt to restore the Acropolis to its original state; the Frankish Tower was demolished in 1870.

TOWER OF THE WINDS, ATHENS
The octagonal Tower of the Winds (pls. 30, 31) was built in the first century B.C. and is the only surviving example of a clock tower from that period. Sundials were attached below the frieze, which comprises carved reliefs representing personifications of the winds; a projecting turret carried a tank that supplied the water clock. Although diminutive, the tower is considered one of the most perfect extant examples of Greek architecture. The detail in plate 31 shows the east wind, Apeliotes, with a harvest of fruit, grain, and honey, and the southeast wind, Euros, whose heavily folded garments are said to indicate clouds.

OLYMPIEION, ATHENS
By 1842 only a few columns remained of the once-large Olympieion (pl. 32), a key monument near the Acropolis. This temple to the Olympian Zeus (or Jupiter, as the god was known in the Roman tradition) was finally completed in A.D. 132, under the Roman emperor Hadrian.

The original interior was protected by 104 Corinthian columns. Excavations around the temple from the 1880s onward began to reveal the stepped base, barely visible in Girault's photograph.

STOA, ATHENS
Emperor Hadrian's *stoa*, a cultural complex located near the Acropolis (pl. 33), was described in John Murray's *Hand-Book for Travellers* (1840) as "almost concealed by modern ruined buildings. Eight fluted Corinthian columns, with their capitals, remain perfect, and project in front of the ancient wall." The capitals of its columns are considered among the best examples of the Corinthian order.

PROPYLAEA, ATHENS
The Propylaea (pl. 35) was designed by its architect, Mnesicles, as a monumental entrance to the Acropolis. It comprised a raised central building with five entrances, a portico with six Doric columns, and two wings, each lower than the central block and with a portico of three Doric columns. Construction started immediately after the Parthenon was completed. Excavations eventually flattened the debris seen in the 1840s, revealing the full height of the columns.

TEMPLE OF ATHENA NIKE, ATHENS
The tiny Ionic Temple of Athena Nike (pl. 36) stands next to the Propylaea and was built after that structure's completion. Destroyed by the Turks in the seventeenth century and rebuilt in 1835, it was dismantled and rebuilt again in the twentieth century, although without several sculpted reliefs from the frieze, which Lord Elgin had taken to London at the beginning of the nineteenth century.

PARTHENON, ATHENS
Considered to be a perfect model of ancient Greek construction, the Parthenon (pls. 37–39) is among the most admired, studied, and influential buildings in Western architecture. This great Doric temple to Athena, the patron goddess of Athens, was designed and built in the fifth century B.C. Raised above the surrounding buildings by a tall platform, the marble Parthenon dominates both the Acropolis and the city.

ERECHTHEION, ATHENS
The finest Ionic building on the Acropolis, the Erechtheion (pls. 41, 42) was begun about 420 B.C. It housed a shrine to Athena Polias (or Minerva, as she was known to the Romans) and was said to also include the tomb of Cecrops, the mythical founder of Athens. The structure is best recognized today by the caryatids, or columns in the shape of female figures, that support the entablature of the south porch (pl. 43).

SYROS
John Murray's *Hand-Book for Travellers* (1840) described the Greek island of Syros (pl. 69) as being "built upon the summit of a lofty hill, so remarkable for its conical form, that it may be compared to a vast sugar-loaf covered with houses. At the base of this cone … there are several warehouses for supplying vessels with the produce of the island … principally wine…. The Lazaretto [quarantine station for sick travelers] has lately become one of the best in the Levant."

EGYPT

POMPEY'S COLUMN, ALEXANDRIA
The Mediterranean port city of Alexandria, founded by Alexander the Great in the fourth century B.C., became a focus of commercial expansion in the nineteenth century and, in 1835, the destination for the first regular steamer from Europe, arriving from Marseille. Vestiges of its ancient past include the triumphal column of Pompey (pl. 44), which sits on a rocky plateau near the coast. It is all that remains of the Serapeum, the most magnificent temple in the Greek quarter of Alexandria.

GRAND MINARET, ALEXANDRIA
Girault did not identify this specific minaret (pl. 45), and it no longer survives in Alexandria today. Photographs of the bombardment of the city by the British in 1882 show it in what would have been the modern rather than the old city, so it was an early nineteenth-century minaret built in a traditional Mamluk style, and quite a recent addition to the city skyline when Girault visited.

AL-NABY DANIEL MOSQUE, ALEXANDRIA

The mosque now known as al-Naby Daniel is said to have been built over the tomb of Alexander the Great. The search for Alexander's burial place was the subject of much research and speculation in the nineteenth century, as it has been since. The building Girault photographed (pl. 46) had been rebuilt in the late eighteenth century and restored in the 1820s.

FUWA

Fuwa (pl. 48) is a peninsula city on the Rashid branch of the Nile. Its monuments date to the Abbasid dynasty, which had its seat in Baghdad and later Samarra in the eighth to tenth centuries A.D. Enormous wealth was created in the region as it became the center for world trade.

ROSETTA

Rosetta (or Rashid), a town in the northwest Nile Delta, on the Rashid branch of the Nile, is known as the location of the Rosetta Stone, the key that allowed scholars to decipher hieroglyphics. Girault's daguerreotype (pl. 49) reads at first as an unusual street scene with ruins on the right, but it is actually two separate views, with one rotated 180 degrees.

KHAYRBAK MOSQUE, CAIRO

The Khayrbak (or Khayrbay) Mosque was built for Amir Khayrbak, a former viceroy of Aleppo who defected and was later awarded the vice-regency of Egypt by the Ottoman sultan Selim. He had built his own mausoleum in 1502 and a madrasa-mosque in 1520, and he lived in the adjacent palace. Two notable features of the mosque are the domed roof with motifs of foliage and hearts and the minaret with geometric, star-shaped designs on the brick shaft (pls. 50, 51).

COMPLEX OF SULTAN QALAWUN, CAIRO

The massive complex of Sultan Qalawun, built in the thirteenth century, during the Mamluk period, includes a mosque, madrasa (religious school), and the first public *maristan* (hospital) in Cairo. The complex survives today, although much altered and restored. The minaret of the *maristan* (pls. 52, 53) is one of the most elaborate in Cairo, its vibrant patterns of tiles switching from stripes to checkerboard and back to stripes as each tower diminishes in size toward the cylindrical shaft, with its domed roof. The towers are further embellished with calligraphic friezes, geometric patterns, and an acanthus-leaf parapet.

MOSQUE OF SULTAN BARQUQ, CAIRO

The complex of Sultan Barquq, founder of the Burji dynasty, comprised a mosque, madrasa, mausoleum, and *khanqah* (dhervish monastery). It was built in the late fourteenth century and, to emphasize continuity with the earlier dynasty of Sultan Qalawun, Barquq chose a site next to the Qalawunid monuments, on prestigious al-Mu'izz Street. Its octagonal minaret (pl. 54), photographed by Girault before its restoration in the early twentieth century, survives today. It no longer displays the striped ornament seen in Girault's vertical panorama, and the balcony railings have since been replaced.

AL-BURDAYNI MOSQUE, CAIRO

The tiny al-Burdayni Mosque (pl. 55) was begun in 1616, during the Ottoman period, but exhibits the earlier Mamluk style. The minaret has an octagonal first tier, a circular second tier, and a bulb set directly above the top balcony. The two balconies rest on complex ornamental corbeling, or "stalactites," with different patterns.

MOSQUE OF SULTAN AL-HAKIM, CAIRO

The Mosque of Sultan al-Hakim was started in 990 and completed in the early eleventh century. Its two corner minarets, different in shape and decoration, are the earliest surviving minarets in Cairo (pl. 56). Their tops were replaced in the early 1300s after an earthquake destroyed the upper stories.

MOSQUE OF IBN TULUN, CAIRO

Built about A.D. 876–79, the Mosque of Ibn Tulun is the largest and second oldest mosque in Cairo. It is notable for its detailing (pl. 57) and for its spiral minaret, which is unique in Egypt. Ibn Tulun was sent from his native Iraq by the caliph in Baghdad to govern Egypt, and the design of the mosque is influenced by that of Iraqi mosques at Samarra. It has 128 carved-stucco windows, each with a different design.

MOSQUE OF 'AMR IBN AL-'AS, FUSTAT, CAIRO

The Mosque of 'Amr ibn al-'As was the first mosque built in Egypt, and the first in Africa. It was established in the seventh century A.D. by its namesake, 'Amr Ibn al-'As, commander of the Muslim army that conquered Egypt. Over the centuries it has been enlarged, destroyed by fire and earthquake, and rebuilt multiple times. Girault's daguerreotypes (pls. 58–63) date from the period between its reconstruction ahead of Napoleon's expedition to Egypt (1798–1801) and a further rebuild in 1875. Girault focused one detail on the inscription surrounding the mihrab (pl. 63), a niche in the wall that indicates the direction toward Mecca, and hence the direction that Muslims face when praying.

MOSQUE OF AMIR GHANIM AL-BAHLAWAN, CAIRO

The mosque and minaret of the Amir Ghanim al-Bahlawan funerary complex were built in the fifteenth century, with a mausoleum added in 1510. Girault focused on the elaborate ornamentation of one section of the mosque wall at roof level, showing the frieze and crenellations above three windows (pl. 64).

PYRAMID OF UNAS, SAQQARA

Saqqara is part of the necropolis of the ancient city of Memphis, about 15 miles southwest of Cairo. The Pyramid of Unas (pl. 80), the last king of the Fifth Dynasty, appears to the south of the more famous Step Pyramid of Djoser. Less grand than its neighbors, it is historically important as the first to have the Pyramid Texts carved on its internal walls, describing the rituals necessary for the pharaoh's ascent to the heavens.

TEMPLE OF KARNAK, THEBES

Located 400 miles south of Cairo on the east bank of the Nile, Karnak, in Thebes, is one of the largest and most important ancient Egyptian sites. It was constructed over a period of 1,300 years and served as the capital of the empire at the height of its power. The Temple of Karnak had ten pylons forming a series of processional gateways linking it with others, including the temple at Luxor, two miles away. Girault documented the southern gateway and the Pylon of Ptolemy III (pl. 81).

RAMESSEUM, KURNA, THEBES

The pillars of the Ramesseum (pl. 82), the funerary temple of Rameses II, incorporate figures of Osiris, the Egyptian god of death and resurrection. The temple was first studied during the survey commissioned by Napoleon and was published in the subsequent *Description de l'Egypte* (1809–28), in which it was called the Memnonium. Through such writings and images, the Ramesseum captured the public's imagination.

TEMPLE OF SETI I, KURNA, THEBES

The mortuary temple of Seti I, the father of Rameses II, sits across the Nile from Karnak, at the northernmost point of western Thebes. Girault captured a detail of a doorway and two columns from the ten along the temple's facade (pl. 83). The columns are usually described as papyrus-style, with closed lotus-bud capitals.

TEMPLE OF HORUS, EDFU

The Temple of Horus (the falcon-headed god), the second largest temple in Egypt, is located at Edfu, between the modern cities of Luxor and Aswan. Its oldest part was begun by Ptolemy III in 237 B.C. Today, it is one of ancient Egypt's best-preserved monuments, but when Girault visited, it was still buried under sand, not to be revealed until the French archaeologist Auguste Mariette uncovered it in the 1860s. Girault concentrated on a few fragments (pl. 84) and studied a fallen capital with palm motifs in close detail (pl. 85).

PHILAE

In 1842 Philae was still located near the vast first cataract of the Nile and was the site of an Egyptian temple complex. The river landscape was punctuated by boulders and rocky outcrops (pl. 86). These rapids and the surrounding area were flooded during the construction of the Aswan Low Dam in 1902.

TURKEY

CONSTANTINOPLE

Girault captured a panoramic view of Constantinople (modern Istanbul) from the Seraskier (or Beyazit) Tower (pl. 70). The view includes

the Sultanahmet (or Blue) Mosque and the Hagia Sophia, with the mouth of the Bosphorus and the Sea of Marmara beyond. At center is the eighteenth-century Nuruosmaniye Mosque, the first Baroque Ottoman mosque, built during a period of gradual westernization of Ottoman culture. Constantinople's combination of Western and Eastern cultures was a source of fascination for European visitors, who arrived in increasing numbers on the steamships that were introduced in the 1830s.

GALATA, CONSTANTINOPLE

Istanbul has never had abundant freshwater, and the provision of a public water supply was a concern for Ottoman rulers. Beginning in the sixteenth century, they commissioned public fountains across the city, which were often extremely decorative. They were the focal point of each neighborhood, as well as of the public squares in front of mosques (pl. 71).

HIPPODROME, CONSTANTINOPLE

Emperor Constantine moved his seat of government from Rome to Byzantium in A.D. 324, and the city became known as Constantinople. The Hippodrome, an arena for chariot races and other entertainments, was turned into an open-air sporting and social center (now Sultan Ahmet Square). Its pink granite obelisk (pl. 72) was brought to the city from Egypt by Theodosius the Great, a successor of Constantine.

BOSPHORUS STRAIT

The Bosphorus is a narrow natural strait in northwestern Turkey, connecting the Black Sea to the Sea of Marmara and acting as a natural division—or link—between Europe and Asia; as such, it has always been a strategic waterway. In contrast to the magnificence of the Ottoman center of Constantinople are the fragile-looking, picturesque wood structures of the fishing grounds along the strait. Girault's photograph (pl. 73) is the earliest known to survive.

SCUTARI, CONSTANTINOPLE

Scutari (pls. 74, 75) was the Greek name for the district known as Uskudar, on the Asian side of the Bosphorus. In the 1840s it was recommended to visitors for its fine mosques, crooked streets, and small timber houses. In his book *Three Years in Constantinople* (1844–45), Charles White wrote that Ottoman troops "quartered at Scutari occupy a camp on the brow of the hills, on either side of the valley of Haidar Pasha, where they find good water, some shade, and constant fresh air from the sea."

SARDIS

Sardis (modern Sart) was the capital of the ancient kingdom of Lydia. A large temple to the mother goddess Cybele, known as Artemis to the Greeks, was begun during the third century B.C. but never completed. Girault captured two columns topped with curvaceous Ionic volutes (pl. 76). Photographed from below, they appear strong but squat, likely reduced in height by an accumulation of earth over centuries.

APHRODISIAS

Aphrodisias was a Greek Hellenistic city in western Anatolia, near the modern village of Geyre, about 140 miles southeast of Izmir. In the 1840s two spiral columns were all that remained of the Tetrapylon ornamental gateway (pl. 77). The surrounding rubble was subsequently excavated, and the Tetrapylon has been re-erected, completed in 1990. In Girault's image, a stork's nest can be seen perched atop the entablature.

MILETUS

The Ionian city of Miletus, near the modern village of Balat, in Aydin Province, was a thriving commercial center for almost 1,400 years, flourishing under Greek, Persian, and Roman rule. The Greco-Roman theater was one of the most important buildings in the city, richly decorated in Roman times with columns, statues, reliefs, and finely detailed capitals (pl. 78).

ISRAEL

JAFFA

Jaffa is the oldest, southernmost part of the ancient port city of Tel Aviv. In 1799 Napoleon captured Jaffa, and many of the population died then and in a plague soon after. The town was gradually re-established and had a population of about 5,000 by the 1860s. Girault's image

could be of a very mature citrus tree (pl. 88), though it was not until the 1850s that the first Jaffa oranges were exported to Europe.

JERUSALEM

The city walls of Jerusalem (pl. 89), a place held sacred by three religions—Judaism, Christianity, and Islam—were constructed in the sixteenth century and still encircle the old city today. The curved stone detail distinguishing the stretch of wall depicted by Girault (pl. 96) was identified in 1838 by the scholar Edward Robinson. It represents the remains of a wide stone arch that had supported a monumental staircase at the southwestern corner of the Temple Mount, or Haram al-Sharif.

DAMASCUS GATE AND LION GATE, JERUSALEM

The Damascus Gate (pls. 90, 91), built in the 1530s by the Ottoman sultan Süleyman the Great, is one of the principal entrances to the old city of Jerusalem. It still has all the signs of fortification, with crenellations and arrow slits piercing the masonry. The Lion Gate (pl. 92), located in the eastern wall, derives its name from the pairs of sculpted lions to either side of the entrance. It marks the beginning of the Via Dolorosa, the path Jesus is thought to have walked to his crucifixion.

POOL OF BETHESDA, JERUSALEM

Known in the mid-nineteenth century as the Pool of Bethesda, the Probatic Pool (pl. 93) derived its name from the Greek *probatica*, or Sheep Gate, where the sheep market was held. The pool is described in the Gospel of John as a spring-fed pool with mysteriously troubled waters in which invalids could be cured. Its precise site has been the subject of debate and dispute for centuries.

VALLEY OF JOSAPHAT

Among the several important biblical monuments in the Valley of Josaphat, near Jerusalem, are the tombs of Zechariah (pl. 94, left) and Saint James (right). The Tomb of Zechariah is a monolith, carved out of solid rock with no internal space for a burial chamber. Girault favored a view of the tombs nestled in the harsh, rocky landscape, with its gaping caverns.

BAB AL-SILSILA MINARET, JERUSALEM

From a vantage point on the northern boundary of the Temple Mount, or Haram al-Sharif, Girault captured the tall Bab al-Silsila minaret with the old Mughrabi, or Moroccan, quarter of Jerusalem beyond (pl. 95). The minaret, built entirely of stone, has a Syrian-style square tower. After an earthquake damaged it, the top was replaced in the nineteenth century with the Ottoman-style "pencil-point" spire seen here, which has since been replaced by a smooth drum and dome.

DOME OF THE ROCK, JERUSALEM

The Dome of the Rock is the oldest extant Islamic monument in the world, dating from the late seventh century A.D. Standing on the rock known as the Temple Mount, or Haram al-Sharif, it dominates the old city of Jerusalem. In Girault's image (pl. 97), the Dome of the Chain can be seen on the right, and the dome and roof of al-Aqsa Mosque are visible in the background.

CHURCH OF THE HOLY SEPULCHRE, JERUSALEM

The Church of the Holy Sepulchre was first dedicated in the fourth century A.D., during the reign of the Roman emperor Constantine the Great. It is recognized by Christians as the site of Jesus's burial and has attracted pilgrims for centuries. A fire in 1808 damaged the dome and the area around the church, which had still not been repaired by the 1840s. Girault shows the contrasting open and sealed entrances (pl. 98) and the intricate Byzantine detailing of the capitals (pl. 99).

BETHLEHEM

Visible in Girault's view of the city of Bethlehem (pl. 100) is the Church of the Nativity, which stands on the site that has traditionally been considered the birthplace of Jesus. It was originally commissioned in A.D. 327 by Constantine the Great but was destroyed by fire, and a new basilica with many alterations and additions was built in the sixth century. Between 1834 and 1837 earthquakes damaged the church, which was subsequently looted, and the site fell into disrepair.

SYRIA AND LEBANON

Souq Wadi Barada (Abila)

Abila was an important Roman city along the imperial highway linking Damascus and Heliopolis (modern Baalbek). According to one contemporary account (1838), "on each side [of the Wadi Barada] are remains of ancient buildings, and caves, the work of men's hands" (pl. 101). The site is now the village of Souq Wadi Barada, about 12 miles northwest of Damascus.

Great Mosque of Damascus

The Great (Umayyad) Mosque in the old city of Damascus (pls. 102, 103) was adapted in the early eighth century from the massive Great Temple, previously used for Christian worship. It set precedents for other major cities during the early years of Islam, as churches were converted into congregational mosques. The temple's towers are said to have become the first practical minarets in Islam. The late fifteenth-century Western Minaret (Madhana al-Gharbiyya) is distinctive for its octagonal form and Egyptian-influenced design.

Iwan, Damascus

The *iwan* is a feature of palaces and homes in Islamic architecture. It comprises a three-sided hall, with the fourth side replaced by an open archway. Girault captured an elaborately decorated example (pl. 104) that was possibly within the building he described as l'Hôtel de Palmyre.

Baalbek

When Girault visited Baalbek (pl. 105), the city lay within Syria but is now part of Lebanon. Ruled by the Romans from the first century B.C., and then known as Heliopolis, Baalbek bears many traces of its ancient past, among them the Corinthian capitals of a ruined mosque (pl. 114) and remnants of three temples (pls. 106–13) that, together with the Pantheon and Hadrian's Villa, are considered to represent the ultimate in Roman Imperial architecture. Girault referred to the large Temple of Jupiter as "Le grand temple," the smaller Temple of Bacchus as "Le petit temple," and the yet smaller Temple of Venus as "Le temple circulaire."

Temple of Jupiter, Baalbek

All that remained of the Temple of Jupiter in the 1840s were six plain granite columns topped by an entablature (pls. 109, 110). The temple originally sat on a raised podium behind two courts. The ruins of the hexagonal forecourt (pl. 107) lay between the entrance portico and the second, great court. A section of a wall from the latter (pl. 108) reveals alternating semicircular and rectangular recesses, partly screened by red and gray granite columns. Later excavations removed the fallen chunks of stone at center and revealed the whole lower tier of niches and bases of the attached columns to either side.

Cedars of Lebanon

The ancient Cedars of Lebanon feature in religion, mythology, and medicine, and their forests are thought to have once covered large expanses of the mountains of the Near East. By the time of Girault's photograph (pl. 115), the remaining trees were to be found on the western slopes of the Lebanon mountain ranges.

Aleppo

The ancient city of Aleppo, in northwest Syria, was once the most important trading city in the Levant. Girault's two views of the city (pls. 116, 117) were taken from the Antioch Gate (Bab Antakya), one of Aleppo's oldest defensive gates. The city that gives the gate its name, Antioch (modern Antakya), was the capital of the Greek kings of Syria. The renowned square minaret of the Umayyad Mosque (pl. 116, center) collapsed in 2013 as conflict intensified during the Syrian Civil War.

Bahsita Mosque, Aleppo

The Bahsita Mosque, also known as Sita Mosque, is in the Aqaba district of the ancient city of Aleppo, near the modern National Library. It was built in 1350 and is known partly for its short octagonal minaret (pl. 118). In 1911, the minaret was moved to the eastern side of the building so that the nearby street could be widened.

Girault's Travels, 1831–50

AUSTRIA

HUNGA

STYRIA

CARINTHIA

CARNIOLA

TYROL

SLAVONIA

CROATIA

BOSNIA

HERZEGOVIN

DALMATIA

Paris

Chaumont

Troyes

La Douy

Langres

Basel

Baden

Zurich

Courcelles-Val-d'Esnoms

JURA

SWITZERLAND

Bern

Brienz

Unterseen

Meiringen

Vevey

Interlaken

Chamonix

VALAIS

Mont Blanc

Mer de Glace

KINGDOM OF LOMBARDY
AND VENICE

Venice

Aix-les-Bains

Mont-Dore

FRANCE

KINGDOM OF
SARDINIA

Genoa

PARMA

MODENA

ITALY

Adriatic Sea

Marseille

Ligurian Sea

TUSCANY

PAPAL
STATES

Toscanella

Corneto

Bracciano

Tivoli

Civitavecchia

Tusculum

Rome

Frascati

KINGDOM OF
NAPLES

Salerno

ATLANTIC OCEAN

Barcelona

SARDINIA

Tyrrhenian Sea

N

W E

S

Tarragona

SPAIN

40°N

MEDITERRANEAN

SICILY

Cordoba

Seville

Granada

Porto Farina

Tunis

MALTA
(Br.)

Marsa

Bône

TUNIS

Algiers

ALGIERS
(Fr.)

Kairouan

MOROCCO

BARBARY STATES

TRIPOLI
(Turkish)

12°E

12°E

Name □ = Girault's home bases

Black ____ = places visited 1831–35, before Girault's use of the daguerreotype

Red ____ = places visited 1842–45, during the Mediterranean campaign

Blue ____ = places visited 1845–50, after the Mediterranean campaign

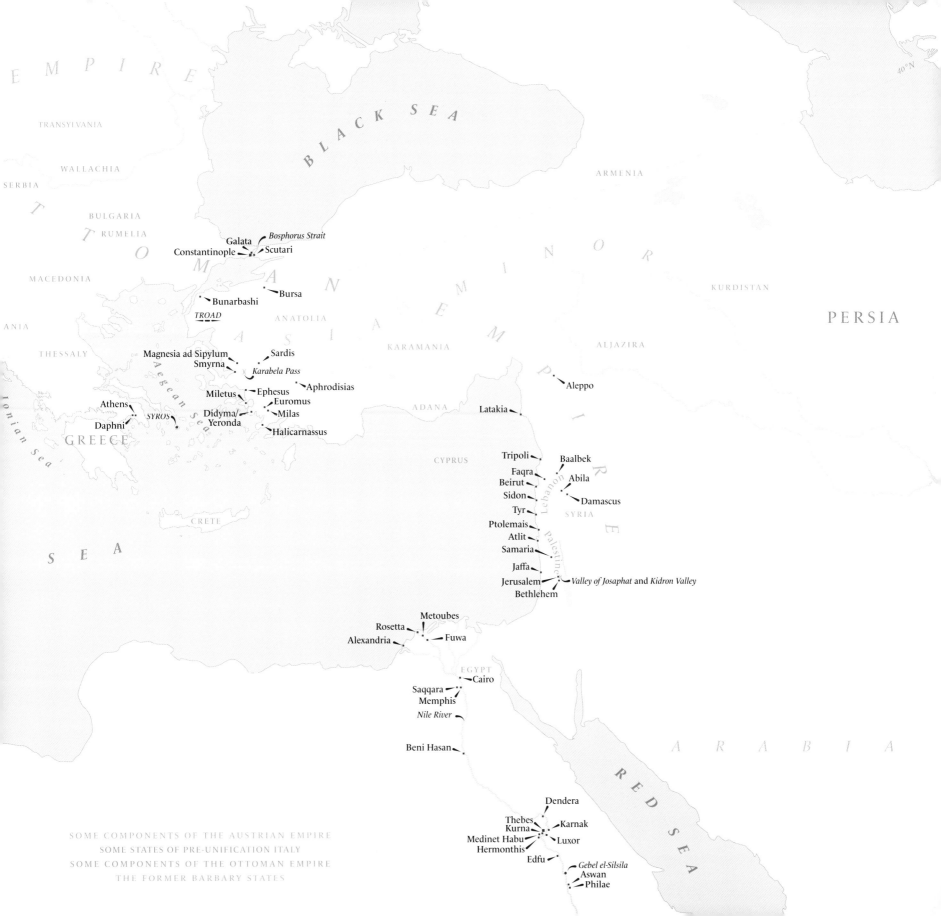

40°N

EMPIRE

TRANSYLVANIA

WALLACHIA

SERBIA

BULGARIA

RUMELIA

MACEDONIA

ANIA

THESSALY

GREECE

BLACK SEA

ARMENIA

KURDISTAN

PERSIA

Bosphorus Strait

Galata
Constantinople • Scutari

Bursa

Bunarbashi

TROAD

ANATOLIA

Magnesia ad Sipylum
Smyrna

Sardis

Karabela Pass

Miletus • Ephesus
Euromus
Didyma/ • Milas
Yeronda
Halicarnassus

Aphrodisias

KARAMANIA

ADANA

ALJAZIRA

Aleppo

Athens
SYROS
Daphni

Aegean Sea

Latakia

CYPRUS

Tripoli • Baalbek
Faqra
Beirut • Abila
Sidon • Damascus
Tyr
Ptolemais
Atlit
Samaria
Jaffa
Jerusalem •
Bethlehem

Lebanon

SYRIA

Palestine

Valley of Josaphat and *Kidron Valley*

Ionian Sea

CRETE

SEA

Metoubes
Rosetta
Alexandria • Fuwa

EGYPT

Saqqara • Cairo
Memphis

Nile River

Beni Hasan

ARABIA

RED SEA

Dendera
Thebes • Karnak
Kurna
Medinet Habu • Luxor
Hermonthis
Edfu • *Gebel el-Silsila*
Aswan
Philae

SOME COMPONENTS OF THE AUSTRIAN EMPIRE
SOME STATES OF PRE-UNIFICATION ITALY
SOME COMPONENTS OF THE OTTOMAN EMPIRE
THE FORMER BARBARY STATES

Chronology

1804

October 21 Birth of Joseph-Philibert Girault de Prangey (Girault).

Pablo Lozano publishes *Antigüedades arabes de l'España*.

1806

Alexandre de Laborde begins publishing *Voyage pittoresque et historique de l'Espagne* (1806–20).

1809

Volume I of *Description de l'Egypte* is published (1809–28).

1815

James Cavanagh Murphy begins publishing *The Arabian Antiquities of Spain* (1815–16).

1826

Baron Isidore Taylor begins publishing *Voyage pittoresque en Espagne* (1826–51).

1829–35

Horace Vernet is director of the Académie de France in Rome.

1830

June Prosper Mérimée travels to Spain. His *Lettres d'Espagne* start appearing in the *Revue de Paris* in 1831.

1831

March Girault, then in Italy, paints *Vue de la Place Saint-Marc à Venise*, shown at the Paris Salon that year.

May Prosper Marilhat travels to the Levant and the Near East with Charles von Hügel. He visits Greece, Egypt, Syria, Lebanon, Libya, and Palestine, then returns to Egypt, traveling up the Nile from Alexandria to Giza, Denderah, Kurna, Karnak, Luxor, Thebes, and Philae before returning to Cairo and Alexandria. He goes home to France in May 1833 with ten notebooks of drawings.

1832

Girault completes an initial inventory of the remaining antiquities in Langres—those that have not been destroyed or sold—with the idea of conserving and exhibiting them.

Washington Irving publishes *Tales of the Alhambra*.

January–June Eugène Delacroix travels to Spain and North Africa.

1832–35

Girault travels to Tunisia, Algeria, Spain, Italy, and Sicily, returning to France via Switzerland. He is known to have stopped at Tunis, Bône (Annaba), Seville, and Cordoba. Other known stops:

August 1832	Algiers, Algeria
November 1832	Alhambra, Granada, Spain
October 1833	Tarragona and Barcelona, Spain
May 1834	Salerno, Italy
August 1834	Baden, Switzerland

1833

July Baron Taylor and Adrien Dauzats in Spain.

1834

François Guizot, Minister of Public Instruction, creates the Comité des travaux historiques et scientifiques to direct research and publications related to the history of France and to encourage the formation of local learned societies. Prosper Mérimée is named Inspector General of Historic Monuments.

Arcisse de Caumont founds the Société pour la conservation et la description des monuments historiques, which would later be known as the Société française d'archéologie (SFA).

In Langres, the architect Jean-Félix-Onésime Luquet forms an association to raise money through subscription in order to safeguard local antiquities.

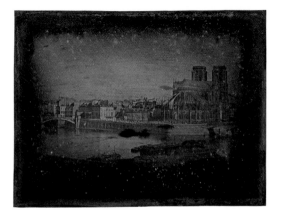 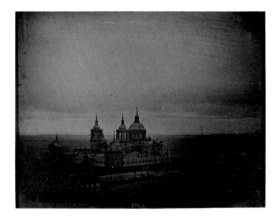

Louis-Jacques-Mandé Daguerre (1787–1851), *Notre-Dame de Paris, Viewed from the Pont des Tournelles*, ca. 1839. Daguerreotype, 6¹/₁₆ × 8¹¹/₁₆ in. (15.4 × 22.1 cm). Gernsheim Collection, Harry Ransom Center, The University of Texas at Austin (964:0020:0130)

Attributed to Théophile Gautier (1811–1872) and Eugène Piot (1812–1890), *The Escorial, Spain*, 1840. Daguerreotype, 2¹³/₁₆ × 3⁵/₈ in. (7.1 × 9.3 cm). The J. Paul Getty Museum, Los Angeles (84.XT.265.24)

1836

May 21 The Société archéologique de Langres is founded, and authorized by the Minister of the Interior two months later, on July 17. Girault is one of ten founding members elected to its administrative board.

The Cercle des arts opens at 22, rue de Choiseul, Paris; founding members include the artists Horace Vernet and Prosper Marilhat. Girault's name appears on its list of members from 1838 to 1841.

Girault exhibits his painting *Promenade et tours d'enceinte du palais de l'Alhambra à Grenade* at the Paris Salon.

Girault publishes *Mosquée de Cordoue*, part 1 of his *Monuments arabes et moresques de Cordoue, Séville et Grenade*. Parts 2 (*La Giralda et l'Alcazar de Séville*) and 3 (*Souvenirs de Grenade et de l'Alhambra*) appear through 1839.

1837

Luquet and Girault submit a plan to transform the apse of the Church of Saint-Didier in Langres into a museum of antiquities, which the municipal council approves in June 1838.

Veith et Hauser begins publishing *Le Moyen-Age pittoresque* (1837–40), which would eventually include eleven lithographs after drawings by Girault.

Pascal-Xavier Coste begins publishing *Architecture arabe; ou, Monuments du Kaire* (1837–39).

Léon de Laborde begins publishing *Voyage en Orient, Asie-Mineure et Syrie* (1837–62), which includes lithographs made after Marilhat's drawings.

1838

Girault's name appears on the list of SFA members published in the society's journal, *Bulletin monumental*. His work on the Alhambra was reviewed in the *Bulletin* in 1837.

1839

January 7 Louis Daguerre shows daguerreotypes to the Académie des sciences, and news of the invention spreads quickly.

June Girault announces to the SFA that he will document the monuments of the Haute-Marne; approaches Veith et Hauser with the idea of publishing an album of fifty lithographs made from drawings he will produce on-site.

August 19 François Arago announces details of the daguerreotype process. Charles Chevalier and Capitaine Richoux claim to make the first daguerreotypes in Paris shortly thereafter.

September 21 Pierre-Gustave Joly de Lotbinière departs Marseille for Greece, Egypt, Jerusalem, Syria, Lebanon, Constantinople (Istanbul), Cyprus, and Malta; describes eighty-six daguerreotype views in his notebooks.

October 21 Vernet, Frédéric Goupil-Fesquet, and Charles Burton depart Marseille for Egypt, Syria, Jerusalem, and Constantinople; make approximately thirty daguerreotypes.

November Joly de Lotbinière, Vernet, and Goupil-Fesquet meet in Alexandria.

1840

Veith et Hauser begins publishing *Le Moyen-Age monumental et archéologique* (1840–45).

April The first issues of Ferdinando Artaria's *Vues d'Italie d'après le daguerréotype* (1840–47) are published.

April 12 Vernet and Goupil-Fesquet return to Marseille.

May 10 Théophile Gautier and Eugène Piot arrive in Spain with a Susse Frères daguerreotype camera.

June 8 Joly de Lotbinière arrives back in Paris.

July Emanuel von Friedrichsthal travels to the Yucatan with daguerreotype equipment; two of twenty-five plates are thought to survive.

August The first livraisons of Noël-Paymal Lerebours's *Excursions daguerriennes* (1840–44) are published.

1841

Girault publishes *Essai sur l'architecture des Arabes et des Mores, en Espagne, en Sicile et en Barbarie*.

Girault makes daguerreotypes in Langres and Paris.

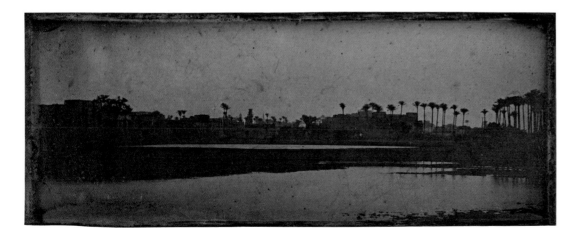

Girault de Prangey, *Egypt*, 1842–44. Daguerreotype, 3¾ × 9⁷⁄₁₆ in. (9.5 × 24 cm). The Metropolitan Museum of Art, New York, Purchase, Mr. and Mrs. John A. Moran Gift, in memory of Louise Chisholm Moran, Joyce F. Menschel Gift, Joseph Pulitzer Bequest, 2016 Benefit Fund, and Gift of Dr. Mortimer D. Sackler, Theresa Sackler and Family, 2016 (2016.600)

Hector Horeau publishes *Panorama d'Egypte et de Nubie.*

May 21 Alexander John Ellis begins making daguerreotypes in Italy, starting at Pozzuoli. The collection comprises 159 plates, of which 48, taken as early as 1840, are attributed to Achille Morelli and Lorenzo Suscipj and 77 to Ellis himself.

October John L. Stephens and Frederick Catherwood travel to the Yucatan with a daguerreotype camera to document Mayan ruins for *Views of Ancient Monuments in Central America, Chiapas, and Yucatan* (1844). The plates were likely lost in a fire at an exhibition of Catherwood's works in 1842.

November 7 The Société archéologique de Langres, which had originally been authorized for three years, is reestablished as the Société historique et archéologique de Langres; it is authorized in perpetuity on February 10, 1842.

1842

Stationed on a diplomatic mission in Colombia, Baron Jean-Baptiste-Louis Gros makes his first known daguerreotype, in Bogota.

Girault publishes *Choix d'ornements moresques de l'Alhambra.*

February Girault leaves from Paris for his Mediterranean excursion, embarking from Marseille en route to Genoa.

March 23 Egyptologist Richard Lepsius writes to William Henry Fox Talbot and ponders the use of the calotype in Egypt.

April–mid-July Girault in Rome, Toscanella (Tuscania), Corneto (Tarquinia), and Tivoli.

Late July Girault spends one day in Malta.

August–mid-September Girault in Athens.

Mid-September Girault in Alexandria and Rosetta; in late autumn he arrives in Cairo, from where he writes a letter to Jules Gailhabaud.

1843

January 1 Gérard de Nerval leaves Marseille for Malta, Syros, Alexandria, Cairo, Beirut, and Constantinople.

Girault travels to Constantinople, possibly through Syros, before moving on to Troad (Biga Peninsula).

April Girault in Smyrna (Izmir).

April 14 Archaeologist Charles Fellows first mentions to Talbot the possibility of using the calotype process for an archaeological excavation in Lycia.

May–August Girault visits Aphrodisias, Miletus, Didyma, Halicarnassus (Bodrum), and Milas.

Girault makes initial visits to Damascus and Baalbek.

Autumn (September?) Girault returns to Constantinople, about the same time as Nerval.

October–December Girault in Cairo, which he mentions in a letter to Artaud de Montor on October 30.

December Jules Itier leaves France with ambassador Théodore de Lagrené as part of a mission to negotiate a commercial treaty with China; returns at the end of 1845 through Sri Lanka and Egypt. About one hundred daguerreotypes made during the journey are known.

1844

January–March Girault in Upper Egypt, then decides to return to Alexandria.

April Girault is quarantined in Alexandria for twenty days because of plague.

May Girault is quarantined another twelve days after reaching Beirut, then travels to Sidon, Tyr (Tyre), and Ptolemais (Acre).

May 21 Girault arrives in Jerusalem.

August Girault returns to Beirut, followed by Baalbek, Damascus, and Aleppo.

1845

Girault returns to France.

Jules Itier (1805–1877), *Monsieur Itier's Cange Under Sail on the Nile*, 1845–46. Daguerreotype, 4³⁄₈ × 5¹⁵⁄₁₆ in. (11.1 × 15.1 cm). The Metropolitan Museum of Art, New York, Gilman Collection, Gift of The Howard Gilman Foundation, 2005 (2005.100.189)

Girault de Prangey, *Philae*, 1844. Daguerreotype, 3¹⁄₈ × 3³⁄₄ in. (8 × 9.5 cm). The Metropolitan Museum of Art, New York. Purchase, Mr. and Mrs. John A. Moran Gift, in memory of Louise Chisholm Moran, Joyce F. Menschel Gift, Joseph Pulitzer Bequest, 2016 Benefit Fund, and Gift of Dr. Mortimer D. Sackler, Theresa Sackler and Family, 2016 (2016.601)

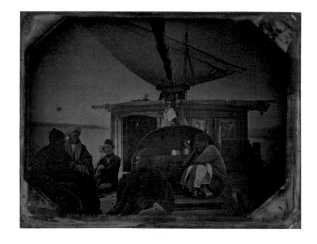
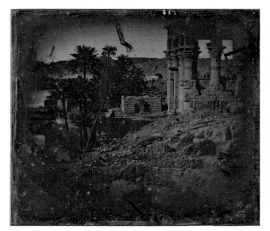

Girault de Prangey, *Capital, Near Jaffa Gate, Jerusalem*, 1842–44. Daguerreotype, 4¾ × 3¾ in. (12 × 9.5 cm). The Metropolitan Museum of Art, New York, Purchase, Mr. and Mrs. John A. Moran Gift, in memory of Louise Chisholm Moran, Joyce F. Menschel Gift, Joseph Pulitzer Bequest, 2016 Benefit Fund, and Gift of Dr. Mortimer D. Sackler, Theresa Sackler and Family, 2016 (2016.609)

Girault de Prangey, *Cedars of Lebanon*, 1842–44. Daguerreotype, 3⁵⁄₁₆ × 2⅞ in. (8.5 × 7.3 cm). Bibliothèque nationale de France, Paris (EG2-833).

1845–50

Girault travels to Mont-Dore and Aix-les-Bains, France; the French Alps; and throughout Switzerland (see map, pp. 200–201).

1846

Girault begins publishing *Monuments arabes d'Egypte, de Syrie et d'Asie-Mineure*, seeking the support of Salvandy, the Minister of Public Instruction, to garner subscriptions; writes that sales alone will not be enough to cover production costs.

Girault elected an Honorary and Corresponding Member of the Royal Institute of British Architects.

1847

Emile Prisse d'Avennes publishes *Monuments égyptiens*.

1851

Girault publishes *Monuments et paysages de l'Orient: Algérie, Tunis, Egypte, Syrie, Asie-Mineure, Grèce, Turquie*.

1858

Girault visits the thermal baths at Vichy.

1860

September 1 Girault visits Coste in Marseille.

1862

Daniel Ramée begins publishing *Sculptures décoratives, recueillies en France, Allemagne, Italie et Espagne, du XIIe au XVIe siècle* (1862–64).

December 5–6 Girault auctions a portion of his art and archaeology library in Paris.

1865

November–December Girault inventories his daguerreotype collection.

1869

Prisse d'Avennes begins publishing *L'art arabe d'après les monuments du Kaire* (1869–77). His publisher acquires some of the lithographic stones used for the production of Girault's *Monuments arabes d'Egypte*.

1870

Girault joins the Société zoologique d'acclimatation.

1871

November Thomas Leverton Donaldson, co-founder of the Royal Institute of British Architects, visits Girault at his villa.

1872

Girault inventories his daguerreotype collection.

1880

December Girault inventories his daguerreotype collection.

1884

Girault is listed as a Foreign Honorary Member of the Society of Biblical Archaeology, London.

1892

December 7 Death of Girault.

ADDRESSES IN PARIS

1836	1, place du Carrousel
1838	65, rue Neuve-Vivienne
1839–41	1, rue des Filles-Saint-Thomas
1846–47	4, rue Duphot

Checklist of Plates

All works are by Joseph-Philibert Girault de Prangey (French, 1804–1892). Numbers and titles in parentheses reflect notations inscribed by the artist on the backs of works, all of which, unless otherwise indicated, are daguerreotypes. Dates, when not provided in a notation, are based on the Chronology (see pp. 202–5), which was established from Girault's correspondence and from other daguerreotypes.

Girault numbered his daguerreotypes according to plate (and related box) size, rather than by location or date. Extant, numbered daguerreotypes indicate that he numbered the plates sequentially within at least five different classes, each of which correspond to one or more formats—whole, half, long half and third, quarter, and sixth and eighth. Sequentially numbered plates within a single class generally fall within groups by location, as expected, but the overall sequence does not always follow chronologically. For example, *Temple of Artemis, Sardis*, 1843 (pl. 76) is a whole plate numbered "134," even though it was taken after *Street in Rosetta*, 1842 (pl. 49), a whole plate numbered "148." This idiosyncratic system, which necessitates duplicate plate numbers across formats, makes it difficult to determine how many daguerreotypes Girault made, especially since there is no complete, original inventory or box list that accounts for each image separately. Many plates have no number at all, including the majority of daguerreotypes made in France. Assuming that Girault numbered his plates consecutively within the five classes, and taking the highest number in each class as the fixed limit of that range, analysis of data from approximately 1,015 extant plates (of which 835 are numbered) reveals almost 600 missing numbers; these numbers likely correspond to still-missing daguerreotypes. Of course, many more unnumbered plates, as well as numbered plates that extend beyond the known ranges, might also exist.

1. *Self-Portrait*, ca. 1841
4 11/16 × 3 11/16 in. (12 × 9.4 cm)
Bibliothèque nationale de France, Paris (EG3-733)

2. *Rose Window, Notre-Dame Cathedral, Paris* (*277. Troyes. 1841. Cathedrale. Gde. Rose. Fichot-Paris* [mislabeled]), 1841
9 1/2 × 7 7/16 in. (24.1 × 18.8 cm)
The Metropolitan Museum of Art, New York, Purchase, Mr. and Mrs. John A. Moran Gift, in memory of Louise Chisholm Moran, Joyce F. Menschel Gift, Joseph Pulitzer Bequest, 2016 Benefit Fund, and Gift of Dr. Mortimer D. Sackler, Theresa Sackler and Family, 2016 (2016.614)

3. *Porte Rouge, Notre-Dame Cathedral, Paris*, 1841
9 1/2 × 7 7/16 in. (24.1 × 18.8 cm)
Bibliothèque nationale de France, Paris (EG7-553)

4. *Window Details, North Chevet, Notre-Dame Cathedral* (*N. D. détails des fenêtres*), 1841
4 3/4 × 7 1/2 in. (12 × 19 cm)
Bibliothèque nationale de France, Paris (EG7-550)

5. *Assumption of the Virgin, North Side of Notre-Dame Cathedral* (*N. D. Vierge en gloire de l'ancien cloître mur nord*), 1841
7 7/16 × 8 3/8 in. (18.8 × 21.2 cm)
Bibliothèque nationale de France, Paris (EG7-554)

6. *Tuileries, Paris* (*Cour des Tuileries en 1841*), 1841
7 7/16 × 9 9/16 in. (18.9 × 24.2 cm)
Bibliothèque nationale de France, Paris (EG7-557)

7. *Fountain, Place du Château d'Eau, Paris*, 1841–42
3 11/16 × 4 3/4 in. (9.4 × 12 cm)
The Metropolitan Museum of Art, New York, Purchase, Mr. and Mrs. John A. Moran Gift, in memory of Louise Chisholm Moran, Joyce F. Menschel Gift, Joseph Pulitzer Bequest, 2016 Benefit Fund, and Gift of Dr. Mortimer D. Sackler, Theresa Sackler and Family, 2016 (2016.613)

8. *Plant Study, Paris* (*260. Paris. 1841. Etude de plantes.*), 1841
7 7/16 × 9 9/16 in. (18.9 × 24.2 cm)
Bibliothèque nationale de France, Paris (EG7-868)

9. *Plant Study, Paris* (*261. Paris. 1841. Etude de plantes.*), 1841
7 5/8 × 7 7/16 in. (19.2 × 18.8 cm)
National Collection of Qatar (OM.5)

10. *In Douy (à la Douy)*, 1841
9 7/16 × 7 1/2 in. (24 × 19 cm)
Daniel Wolf Collection

11. *Girault's Villa, Les Tuaires*, ca. 1841
3 3/4 × 4 3/4 in. (9.5 × 12 cm)
Daniel Wolf Collection

12. *Girault's Villa, Les Tuaires*, ca. 1841
3 3/16 × 3 3/4 in. (8.1 × 9.5 cm)
Bibliothèque nationale de France, Paris (EG2-870)

13. *Portal Detail, San Lorenzo Cathedral, Genoa* (*5. Gènes. 1842. Cathédrale. Dét[ail] du portail.*), 1842
9 1/2 × 3 3/4 in. (24.1 × 9.5 cm)
Bibliothèque nationale de France, Paris (EG7-875)

14. *Etruscan Lion, Toscanella* (*44. Toscanella Lion Etrusque.*), 1842
3 9/16 × 3 5/16 in. (9 × 8.5 cm)
Daniel Wolf Collection

15. *Window and Bell Tower, Corneto* (*82. Fenêtre. Clocher. Cornéto?*), 1842
7 3/8 × 9 1/2 in. (18.6 × 24.1 cm)
National Collection of Qatar (OM.7)

16. *Column of Trajan, Rome* (*9. Rome. 1842. Colonne Trajane.*), 1842
9 7/16 × 3 5/8 in. (24 × 9.2 cm)
National Collection of Qatar (IM.3584)

17. *Rome, Viewed from the Column of Trajan* (*28. Rome. 1842. Prise de la colonne de Trajane.*), 1842
3 3/4 × 9 7/16 in. (9.5 × 24 cm)
Daniel Wolf Collection

18. *Roman Forum, Viewed from the Palatine Hill* (*14. Rome. 1842. Forum. Port. Pres du Palais de neron.*), 1842
3¾ × 9¹¹⁄₁₆ in. (9.5 × 24.6 cm)
Gernsheim Collection, Harry Ransom Center, The University of Texas at Austin (964:0020:0121)

19. *Ponte Rotto (Pons Aemilius), Rome* (*31. Rome. 1842. Ponte Rotto.*), 1842
3⅝ × 9½ in. (9.3 × 24.1 cm)
The Metropolitan Museum of Art, New York, Purchase, Mr. and Mrs. John A. Moran Gift, in memory of Louise Chisholm Moran, Joyce F. Menschel Gift, Joseph Pulitzer Bequest, 2016 Benefit Fund, and Gift of Dr. Mortimer D. Sackler, Theresa Sackler and Family, 2016 (2016.605)

20. *Temple of Vespasian, Rome* (*26. Rome. Jupiter-tonnant et Eglise St. Luc. 1842. (lytographiée et publiée)*), 1842
9⁷⁄₁₆ × 7½ in. (24 × 19 cm)
Daniel Wolf Collection

21. *Temple of Vespasian, Rome* (*28. Rome. Jupiter-tonnant et Eglise St. Luc. 1842. (lytographiée et publiée)*), 1842
9⁷⁄₁₆ × 7½ in. (24 × 19 cm)
Daniel Wolf Collection

22. *Temple of Vespasian, Rome* (*23. Rome. Jupiter-tonnant. 1842*), 1842
9½ × 7⁷⁄₁₆ in. (24.1 × 18.8 cm)
W. Bruce and Delaney H. Lundberg Collection

23. *Northwest Facade, Temple of Castor and Pollux, Rome* (*12. Rome. 1842. Graecostasis. faç. N.O.*), 1842
9⁷⁄₁₆ × 3¹¹⁄₁₆ in. (24 × 9.4 cm)
The Metropolitan Museum of Art, New York, Purchase, Mr. and Mrs. John A. Moran Gift, in memory of Louise Chisholm Moran, Joyce F. Menschel Gift, Joseph Pulitzer Bequest, 2016 Benefit Fund, and Gift of Dr. Mortimer D. Sackler, Theresa Sackler and Family, 2016 (2016.606)

24. *Temple of Vesta, Rome* (*22. Rome. 1842. Temple de Vesta* [corrected over another title]), 1842
3¾ × 9½ in. (9.5 × 24.1 cm)
W. Bruce and Delaney H. Lundberg Collection

25. *Gardens, Villa Medici, Rome* (*27. Rome. 1842. Jardins, Villa Medici.*), 1842
3¾ × 9⁷⁄₁₆ in. (9.5 × 24 cm)
Frédéric Hoch Collection

26. *Hadrian's Villa, Tivoli* (*41. Tivoli. 1842. Villa Adriana.*), 1842
3¾ × 9⁷⁄₁₆ in. (9.5 × 24 cm)
Daniel Wolf Collection

27. *Monastery of Daphni, Attica* (*129. Daphné. près Athènes. Monastère pris du S. O.*), 1842
7⁹⁄₁₆ × 9½ in. (19.1 × 24.1 cm)
Bibliothèque nationale de France, Paris (EG7-754)

28. *Agios Eleftherios Church, Athens* (*101. Athènes. 1842. Anc. Cathédrale. Détails.*), 1842
6⅞ × 8¹⁵⁄₁₆ in. (17.5 × 22.7 cm)
Gernsheim Collection, Harry Ransom Center, The University of Texas at Austin (964:0020:0128)

29. *Palm Tree near the Church of Saints Theodore, Athens* (*89. Athènes. 1842. Palmier près S Théodore.*), 1842
9⅜ × 7⅜ in. (23.9 × 18.7 cm)
Bibliothèque nationale de France, Paris (EG7-750)

30. *Tower of the Winds, Athens* (*115. Athènes. 1842. Tour des Vents.*), 1842
7⁷⁄₁₆ × 9⅝ in. (18.9 × 24.5 cm)
Bibliothèque nationale de France, Paris (EG7-752)

31. *Tower of the Winds, Athens* (*43. Athènes. Tour des Vents.*), 1842
4¹¹⁄₁₆ × 7⅜ in. (11.9 × 18.7 cm)
The J. Paul Getty Museum, Los Angeles (2004.79.2)

32. *Olympieion, Athens, Viewed from the East* (*113. Athènes. 1842. T. de J. Olympien, pris de l'Est.*), 1842
7¹⁄₁₆ × 9⁷⁄₁₆ in. (18 × 24 cm)
National Collection of Qatar (IM.314)

33. *Stoa, Athens* (*127. Athènes. 1842. Stoa*), 1842
7⁹⁄₁₆ × 9½ in. (19.1 × 24.1 cm)
Bibliothèque nationale de France, Paris (EG7-753)

34. *Western Approach to the Acropolis, Athens* (*49. Athènes. 1842. Acropole. Côté O.*), 1842
3⅝ × 9½ in. (9.3 × 24.1 cm)
The Metropolitan Museum of Art, New York, Purchase, Philippe de Montebello Fund, Mr. and Mrs. John A. Moran Gift, in memory of Louise Chisholm Moran, Joyce F. Menschel and Annette de la Renta Gifts, and funds from various donors, 2016 (2016.92)

35. *Propylaea, Acropolis, Athens* (*91. Athènes. Propylées. 1842. Pris de l'intérieur.*), 1842
7½ × 9⁷⁄₁₆ in. (19 × 24 cm)
Daniel Wolf Collection

36. *Temple of Athena Nike, Acropolis, Athens* (*95. Athènes. Acropole. T. de Vénus aptère.*), 1842
7⁵⁄₁₆ × 6¹¹⁄₁₆ in. (18.5 × 17 cm)
Daniel Wolf Collection

37. *East Side of the Parthenon, Athens* (*51. Athènes. 1842. Parthénon. Côté E.*), 1842
3⁹⁄₁₆ × 9⁷⁄₁₆ in. (9 × 24 cm)
Jennifer and Philip Maritz Collection

38. *North and East Sides of the Parthenon, Athens* (*52. Athènes. 1842. Parthénon, Côtés E. et N.*), 1842
3¾ × 9⁷⁄₁₆ in. (9.5 × 24 cm)
Jennifer and Philip Maritz Collection

39. *Facade and North Colonnade, Parthenon, Athens* (*112. Athènes. 1842. Parthénon. Faç. et C. Nord.*), 1842
7⁷⁄₁₆ × 9⁷⁄₁₆ in. (18.8 × 24 cm)
The J. Paul Getty Museum, Los Angeles (2003.82.2)

40. *Ruins and Foreground, Acropolis, Athens (55. Athènes. 1842. Acropole. ruines et 1ers plans (pour tableau))*, 1842
3 11/16 × 9 1/2 in. (9.4 × 24.1 cm)
The Metropolitan Museum of Art, New York, Purchase, Philippe de Montebello Fund, Mr. and Mrs. John A. Moran Gift, in memory of Louise Chisholm Moran, Joyce F. Menschel and Annette de la Renta Gifts, and funds from various donors, 2016 (2016.91)

41. *Erechtheion, Athens (62. Athènes. 1842. T. de Minerve Poliade.)*, 1842
3 11/16 × 9 1/2 in. (9.4 × 24.1 cm)
The Metropolitan Museum of Art, New York, Purchase, Philippe de Montebello Fund, Mr. and Mrs. John A. Moran Gift, in memory of Louise Chisholm Moran, Joyce F. Menschel and Annette de la Renta Gifts, and funds from various donors, 2016 (2016.93)

42. *Capital Detail, Erechtheion, Athens (52. Athènes. T. de Min. Polyade. chap.)*, 1842
4 13/16 × 7 9/16 in. (12.2 × 19.1 cm)
Bibliothèque nationale de France, Paris (EG5-874)

43. *Caryatid, Erechtheion, Athens (56. Athènes. Caryatides. Erecht.)*, 1842
9 1/2 × 3 11/16 in. (24.1 × 9.4 cm)
The Metropolitan Museum of Art, New York, Purchase, Philippe de Montebello Fund, Mr. and Mrs. John A. Moran Gift, in memory of Louise Chisholm Moran, Joyce F. Menschel and Annette de la Renta Gifts, and funds from various donors, 2016 (2016.94)

44. *Pompey's Column, Alexandria (68. Alexandrie 1842. Colonne de Pompée.)*, 1842
9 1/2 × 3 11/16 in. (24.1 × 9.4 cm)
The Metropolitan Museum of Art, New York, Purchase, Philippe de Montebello Fund, Mr. and Mrs. John A. Moran Gift, in memory of Louise Chisholm Moran, Joyce F. Menschel and Annette de la Renta Gifts, and funds from various donors, 2016 (2016.98)

45. *Grand Minaret, Alexandria (73. Alexandrie. 1842. Grand Minaret.?)*, 1842
9 1/2 × 3 11/16 in. (24.1 × 9.4 cm)
The Metropolitan Museum of Art, New York, Purchase, Philippe de Montebello Fund, Mr. and Mrs. John A. Moran Gift, in memory of Louise Chisholm Moran, Joyce F. Menschel and Annette de la Renta Gifts, and funds from various donors, 2016 (2016.96)

46. *al-Naby Daniel Mosque, Alexandria (144. Alexandrie. M. Nabédémiane.)*, 1842
7 1/2 × 9 9/16 in. (19 × 24.2 cm)
National Collection of Qatar (IM.311)

47. *Desert near Alexandria (74. Près d'Alexandrie. Le désert. 1842.)*, 1842
3 11/16 × 9 1/2 in. (9.4 × 24.1 cm)
The Metropolitan Museum of Art, New York, Purchase, Philippe de Montebello Fund, Mr. and Mrs. John A. Moran Gift, in memory of Louise Chisholm Moran, Joyce F. Menschel and Annette de la Renta Gifts, and funds from various donors, 2016 (2016.97)

48. *Fuwa, Viewed from the Island (88. Foûah. pris de l'île.)*, 1842
3 9/16 × 9 7/16 in. (9 × 24 cm)
National Collection of Qatar (IM.3586)

49. *Street in Rosetta (148. Rosette. 1842. Rue E (publiée.))*, 1842
9 7/16 × 7 1/16 in. (24 × 18 cm)
National Collection of Qatar (IM.315)

50. *Minaret and Dome, Khayrbak Mosque, Cairo (121. Kaire. 1843. G. S. Kérabat. Min. et coupole)*, 1843
9 9/16 × 3 13/16 in. (24.2 × 9.6 cm)
Bibliothèque nationale de France, Paris (EG7-742)

51. *Dome, Khayrbak Mosque, Cairo (120. Kaire. S. Kérabat Coupole.)*, 1843
4 13/16 × 7 9/16 in. (12.1 × 19.1 cm)
Bibliothèque nationale de France, Paris (EG5-736)

52. *Minaret of the Maristan, Complex of Sultan Qalawun, Cairo (140. Kaire. Mouristan. Min.)*, 1842–43
7 1/2 × 4 3/4 in. (19 × 12 cm)
Daniel Wolf Collection

53. *Detail, Complex of Sultan Qalawun, Cairo (141. Kaire. Mouristan. Det.)*, 1843
7 3/8 × 4 11/16 in. (18.7 × 11.9 cm)
The J. Paul Getty Museum, Los Angeles (2004.19.1)

54. *Mosque of Sultan Barquq, Cairo (139. Kaire. 1843. G. S. Kalaoun. [mislabeled])*, 1843
9 11/16 × 3 5/8 in. (24.5 × 9.3 cm)
Gernsheim Collection, Harry Ransom Center, The University of Texas at Austin (964:0020:0123)

55. *Minaret, al-Burdayni Mosque, Cairo (131. Kaire. 1843. G. El Bordéni. Min.)*, 1843
9 9/16 × 3 11/16 in. (24.2 × 9.4 cm)
National Collection of Qatar (IM.3585)

56. *Mosque of Sultan al-Hakim, Cairo (117. Kaire. 1843 Gâma Soultan Ansoun détails [mislabeled])*, 1842–43
9 7/16 × 3 11/16 in. (24 × 9.4 cm)
The Metropolitan Museum of Art, New York, Purchase, Mr. and Mrs. John A. Moran Gift, in memory of Louise Chisholm Moran, Joyce F. Menschel Gift, Joseph Pulitzer Bequest, 2016 Benefit Fund, and Gift of Dr. Mortimer D. Sackler, Theresa Sackler and Family, 2016 (2016.603)

57. *Window, Mosque of Ibn Tulun, Cairo (133. Kaire. G. Ebn Touloun fenêtre.)*, 1842–43
7 7/16 × 4 3/4 in. (18.9 × 12 cm)
National Collection of Qatar (IM.316)

58. *West Side, Mosque of 'Amr ibn al-'As, Cairo (149. Kaire. 1843. G. Amr. Côté O. (publiée))*, 1843
3 3/4 × 9 7/16 in. (9.5 × 24 cm)
National Collection of Qatar (OM.12)

59. *Exterior Arch, Mosque of 'Amr ibn al-'As, Cairo (141. Kaire. Gâma Amr. Arc ext.)*, 1842–43
4 13/16 × 3 13/16 in. (12.1 × 9.6 cm)
Bibliothèque nationale de France, Paris (EG3-721)

60. *Mosque of 'Amr ibn al-'As, Cairo*, 1842–43
3 11/16 × 9 1/2 in. (9.4 × 24.1 cm)
Bibliothèque nationale de France, Paris (EG7-877)

61. *Capital, Mosque of 'Amr ibn al-'As, Cairo (151. Kaire. G. amr. Chap.)*, 1842–43
7 1/2 × 4 7/8 in. (19 × 12.3 cm)
Daniel Wolf Collection

62. *Exterior Mihrab, Mosque of 'Amr ibn al-'As, Cairo (179. Kaire. G. Amr Mihrab à l'extérieur.)*, 1842–43
3 13/16 × 3 1/4 in. (9.6 × 8.4 cm)
Bibliothèque nationale de France, Paris (EG2-700)

63. *Mihrab Inscription, Mosque of 'Amr ibn al-'As, Cairo (140. Kaire. G. Amr. Inscription d'un Mihrab.)*, 1842–43
4 13/16 × 3 13/16 in. (12.1 × 9.6 cm)
Bibliothèque nationale de France, Paris (EG3-873)

64. *Detail, Mosque of Amir Ghanim al-Bahlawan, Cairo (130. Kaire. G. S. Gânem. Dét.)*, 1842–43
4 3/4 × 7 1/2 in. (12 × 19 cm)
National Collection of Qatar (OM.22)

65. *Nicolas Perron and His Family, Cairo (155. Kaire. Perron et sa famille.)*, 1842–43
3 3/4 × 4 13/16 in. (9.5 × 12.1 cm)
Bibliothèque nationale de France, Paris (EG3-724)

66. *Ayoucha, Cairo (162. Kaire. Ayoucha assise.)*, 1842–43
3 7/8 × 4 13/16 in. (9.7 × 12.2 cm)
Bibliothèque nationale de France, Paris (EG3-725)

67. *Bedouin from Giza, Cairo (163. Kaire. Bédouine de Ghiseh.)*, 1842–43
4 3/4 × 3 3/4 in. (12 × 9.5 cm)
Daniel Wolf Collection

68. *Sailor, Cairo (224. Kaire. Matelot.)*, 1842–43
3 11/16 × 3 3/16 in. (9.4 × 8.1 cm)
Bibliothèque nationale de France, Paris (EG2-705)

69. *Syros (101. Syra. 1843. Voir 48 même série de grandeur)*, 1843
3 13/16 × 9 9/16 in. (9.6 × 24.2 cm)
Bibliothèque nationale de France, Paris (EG7-751)

70. *Constantinople (103. Constantinople. Sérail. Près de Pera.)*, 1843
3 3/4 × 9 7/16 in. (9.5 × 24 cm)
Pierre de Gigord Collection

71. *Fountain near Galata, Constantinople (105. Constantinople. Fontaine près Galata.)*, 1843
3 11/16 × 9 1/2 in. (9.4 × 24.1 cm)
Bibliothèque nationale de France, Paris (EG7-747)

72. *Hippodrome, Constantinople (104. Constantinople. Hyppodrôme.)*, 1843
9 9/16 × 3 3/16 in. (24.2 × 9.6 cm)
Bibliothèque nationale de France, Paris (EG7-746)

73. *Fishing Huts, Northern Bosphorus (149. Bosphore. N. Pêcheries.)*, 1843
3 3/16 × 3 3/4 in. (8.2 × 9.5 cm)
Serge Kakou Collection

74. *Stepped Street, Scutari, Constantinople (140. Scutari. rue montante.)*, 1843
3 3/16 × 3 13/16 in. (8.3 × 9.6 cm)
Bibliothèque nationale de France, Paris (EG2-871)

75. *Ottoman Camp at Haidar Pasha, Scutari, Constantinople (108. Scutari. 1843. Camp d'haider Pacha.)*, 1843
3 13/16 × 9 1/2 in. (9.6 × 24.1 cm)
Bibliothèque nationale de France, Paris (EG7-748)

76. *Temple of Artemis, Sardis (134. Sardes. 1843. T. de Cybèle.)*, 1843
7 7/16 × 9 1/2 in. (18.8 × 24.1 cm)
The Metropolitan Museum of Art, New York, Purchase, Mr. and Mrs. John A. Moran Gift, in memory of Louise Chisholm Moran, Joyce F. Menschel Gift, Joseph Pulitzer Bequest, 2016 Benefit Fund, and Gift of Dr. Mortimer D. Sackler, Theresa Sackler and Family, 2016 (2016.615)

77. *Spiral Columns, Aphrodisias (66. Aphrodisias. Colonnes torses.)*, 1843
3 5/8 × 3 3/16 in. (9.3 × 8 cm)
Bibliothèque nationale de France, Paris (EG2-713)

78. *Capital, Greco-Roman Theater, Miletus (71. Milet. Théatre ant. chap.)*, 1843
4 3/4 × 7 7/16 in. (12 × 18.8 cm)
The Metropolitan Museum of Art, New York, Purchase, Mr. and Mrs. John A. Moran Gift, in memory of Louise Chisholm Moran, 2018 (2018.2)

79. *Surudjé (Horse Driver), Constantinople (173. Constantinople. Surudjé.)*, 1843
4 3/4 × 3 11/16 in. (12 × 9.4 cm)
National Collection of Qatar (IM.321)

80. *Pyramid of Unas, Saqqara (267. Sakara. Pyramide.)*, 1843–44
3 1/16 × 3 5/8 in. (7.8 × 9.3 cm)
National Collection of Qatar (IM.642)

81. *Pylon of Ptolemy III, Karnak, Thebes (196. Karnac. Pylone. Pris de l'O.)*, 1844
9 7/16 × 7 1/2 in. (24 × 19 cm)
National Collection of Qatar (IM.310)

82. *Ramesseum, Thebes (201. Thèbes. 1844. 202 Rhamséion.),* 1844
7 7/16 × 9 7/16 in. (18.8 × 24 cm)
The Metropolitan Museum of Art, New York, Purchase, Mr. and Mrs. John A. Moran Gift, in memory of Louise Chisholm Moran, Joyce F. Menschel Gift, Joseph Pulitzer Bequest, 2016 Benefit Fund, and Gift of Dr. Mortimer D. Sackler, Theresa Sackler and Family, 2016 (2016.604)

83. *Columns, Temple of Seti, Kurna, Thebes (155. Gournah. Temple col.),* 1844
7 3/8 × 4 13/16 in. (18.7 × 12.1 cm)
The J. Paul Getty Museum, Los Angeles (2006.38)

84. *Temple of Horus, Edfu (167. ? Temple.),* 1844
3 5/8 × 4 3/4 in. (9.3 × 12 cm)
The Metropolitan Museum of Art, New York, Purchase, Mr. and Mrs. John A. Moran Gift, in memory of Louise Chisholm Moran, Joyce F. Menschel Gift, Joseph Pulitzer Bequest, 2016 Benefit Fund, and Gift of Dr. Mortimer D. Sackler, Theresa Sackler and Family, 2016 (2016.602)

85. *Capital, Temple of Horus, Edfu (248. Edfou. Temple. Chap.),* 1844
3 3/16 × 3 7/8 in. (8.2 × 9.7 cm)
Bibliothèque nationale de France, Paris (EG2-710)

86. *Rocks, Philae (240. Philé. Rochers.),* 1844
3 3/16 × 3 11/16 in. (8.1 × 9.4 cm)
Bibliothèque nationale de France, Paris (EG2-708)

87. *Palm Trees, Alexandria (165. Alexandrie.),* 1842–44
3 3/4 × 3 3/16 in. (9.5 × 8.2 cm)
Bibliothèque nationale de France, Paris (EG2-869)

88. *Man Standing under a Tree, Jaffa,* 1844
3 11/16 × 4 3/4 in. (9.4 × 12 cm)
Bibliothèque nationale de France, Paris (EG3-729)

89. *Jerusalem within the Ramparts of the City,* 1844
3 3/4 × 9 7/16 in. (9.5 × 24 cm)
Bibliothèque nationale de France, Paris (EG7-755)

90. *Damascus Gate, Jerusalem (208. Atlit. Syrie Chapelle.* [mislabeled]), 1844
9 7/16 × 7 7/16 in. (24 × 18.8 cm)
The Metropolitan Museum of Art, New York, Purchase, Mr. and Mrs. John A. Moran Gift, in memory of Louise Chisholm Moran, Joyce F. Menschel Gift, Joseph Pulitzer Bequest, 2016 Benefit Fund, and Gift of Dr. Mortimer D. Sackler, Theresa Sackler and Family, 2016 (2016.610)

91. *Damascus Gate, Jerusalem,* 1844
9 7/16 × 3 3/4 in. (24 × 9.5 cm)
Daniel Wolf Collection

92. *Lion Gate, Jerusalem,* 1844
4 13/16 × 7 1/2 in. (12.1 × 19 cm)
Bibliothèque nationale de France, Paris (EG5-878)

93. *Probatic Pool (Pool of Bethesda), Jerusalem (183. Jérusalem. Piscine probatique.),* 1844
7 3/8 × 4 11/16 in. (18.7 × 11.9 cm)
The J. Paul Getty Museum, Los Angeles (2004.79.3)

94. *Tombs, Valley of Josaphat, near Jerusalem,* 1844
3 3/4 × 9 7/16 in. (9.5 × 24 cm)
National Collection of Qatar (OM.19)

95. *Bab al-Silsila Minaret and Mughrabi (Moroccan) Quarter, Jerusalem,* 1844
3 11/16 × 9 1/2 in. (9.4 × 24.1 cm)
National Collection of Qatar (IM.3589)

96. *Robinson's Arch, Jerusalem,* 1844
3 11/16 × 9 1/2 in. (9.4 × 24.1 cm)
The Metropolitan Museum of Art, New York, Purchase, Mr. and Mrs. John A. Moran Gift, in memory of Louise Chisholm Moran, Joyce F. Menschel Gift, Joseph Pulitzer Bequest, 2016 Benefit Fund, and Gift of Dr. Mortimer D. Sackler, Theresa Sackler and Family, 2016 (2016.608)

97. *Dome of the Rock, Jerusalem (222. Jerusalem. 1844. Gde. Mosquée, prise du palais du Pacha.),* 1844
7 3/8 × 9 7/16 in. (18.6 × 24 cm)
National Collection of Qatar (IM.313)

98. *Portal, Church of the Holy Sepulchre, Jerusalem (209. Jérusalem. Porte Eg. du St Sép.),* 1844
7 7/16 × 9 5/8 in. (18.8 × 24.3 cm)
Bibliothèque nationale de France, Paris (EG7-881)

99. *Portal Detail, Church of the Holy Sepulchre, Jerusalem (210. Jerusalem. Det. Porte. Egl. du S. Sép.),* 1844
7 1/2 × 9 7/16 in. (19 × 24 cm)
National Collection of Qatar (OM.30)

100. *Church of the Nativity and Convents, Bethlehem,* 1844
3 13/16 × 9 1/2 in. (9.6 × 24.1 cm)
Bibliothèque nationale de France, Paris (EG7-757)

101. *Tombs, Souq Wadi Barada (Abila) (203. Souk. Tombeaux.),* 1844
3 5/8 × 4 11/16 in. (9.3 × 11.9 cm)
Bibliothèque nationale de France, Paris (EG3-857)

102. *Great Mosque of Damascus,* 1843
3 3/4 × 9 7/16 in. (9.5 × 24 cm)
Bibliothèque nationale de France, Paris (EG7-764)

103. *Great Mosque of Damascus, Viewed from Khan As'ad Pasha (270. Damas. 1843. Gde. mosquée prise du Khan d'effad Pacha.),* 1843
3 3/4 × 9 7/16 in. (9.5 × 24 cm)
Daniel Wolf Collection

104. *Iwan, Damascus (229. Damas. Iwan, 1844.),* 1844
9 7/16 × 7 7/16 in. (24 × 18.8 cm)
National Collection of Qatar (IM.312)

105. *Baalbek,* 1843–44
3 11/16 × 9 1/2 in. (9.4 × 24.1 cm)
The Metropolitan Museum of Art, New York, Purchase, Mr. and Mrs. John A. Moran Gift, in memory of Louise Chisholm Moran, Joyce F. Menschel Gift, Joseph Pulitzer Bequest, 2016 Benefit Fund, and Gift of Dr. Mortimer D. Sackler, Theresa Sackler and Family, 2016 (2016.611)

106. *Temples of Jupiter and Bacchus, Baalbek (237. Baalbec. 1844. Petit et Grand Temple.)*, 1844
7 7/16 × 9 7/16 in. (18.9 × 24 cm)
Bibliothèque nationale de France, Paris (EG7-760)

107. *Hexagonal Court, Temple of Jupiter, Baalbek (290. Baalbec. 1843. Cour Hexagone.)*, 1843
3 5/8 × 9 1/2 in. (9.3 × 24.1 cm)
The Metropolitan Museum of Art, New York, Purchase, Mr. and Mrs. John A. Moran Gift, in memory of Louise Chisholm Moran, 2018 (2018.1)

108. *Wall of the Great Court, Temple of Jupiter, Baalbek (206. Baalbec. Gde. cour carrée. Gds. Côtés.)*, 1843–44
4 13/16 × 7 7/16 in. (12.2 × 18.8 cm)
The J. Paul Getty Museum, Los Angeles (2003.137)

109. *Colonnade, Temple of Jupiter, Baalbek (210. Baalbec. Gd. Temple. Colonnade.)*, 1843–44
7 7/16 × 4 3/4 in. (18.8 × 12 cm)
National Collection of Qatar (IM.630)

110. *Entablature, Temple of Jupiter, Baalbek (299. Baalbec. G. Temple entablement.)*, 1843–44
3 3/4 × 9 1/2 in. (9.5 × 24.1 cm)
National Collection of Qatar (IM.634)

111. *Interior Detail, Temple of Venus, Baalbek (233. Baalbec. 1844. T. Circulaire. Det. Inté.)*, 1844
7 7/16 × 9 1/2 in. (18.9 × 24.1 cm)
The J. Paul Getty Museum, Los Angeles (2003.82.6)

112. *Southeast Colonnade, Temple of Bacchus, Baalbek (300. Baalbec. Petit Temple C. S. E.)*, 1843–44
9 11/16 × 3 5/8 in. (24.5 × 9.3 cm)
Gernsheim Collection, Harry Ransom Center, The University of Texas at Austin (964:0020:0124)

113. *Interior Entrance, Temple of Bacchus, Baalbek (320. Baalbec. P. temple Int. Porte.)*, 1843–44
3 3/16 × 3 11/16 in. (9 × 9.4 cm)
Bibliothèque nationale de France, Paris (EG2-718)

114. *Capital Detail, Mosque at Baalbek (331. Baalbec. Mosquee. Chap.)*, 1843–44
3 13/16 × 2 3/4 in. (9.7 × 7 cm)
Bibliothèque nationale de France, Paris (EG2-828)

115. *Cedars of Lebanon (248. Liban. 1844. Les cèdres.)*, 1844
7 7/16 × 9 1/2 in. (18.8 × 24.1 cm)
Bibliothèque nationale de France, Paris (EG7-761)

116. *Aleppo, Viewed from the Antioch Gate (252. Alep. 1844. Prise de Bab Antakieh. (publiée))*, 1844
7 7/16 × 9 1/2 in. (18.9 × 24.1 cm)
The Metropolitan Museum of Art, New York, Purchase, Mr. and Mrs. John A. Moran Gift, in memory of Louise Chisholm Moran, Joyce F. Menschel Gift, Joseph Pulitzer Bequest, 2016 Benefit Fund, and Gift of Dr. Mortimer D. Sackler, Theresa Sackler and Family, 2016 (2016.612)

117. *Aleppo, Viewed from the Antioch Gate (235. Alep. Prise de bab Antakïeh. (publiée))*, 1844
7 3/8 × 4 13/16 in. (18.7 × 12.1 cm)
National Collection of Qatar (IM.621)

118. *Minaret, Bahsita Mosque, Aleppo (229. Alep. G. Minaret.)*, 1844
4 11/16 × 3 5/8 in. (11.9 × 9.3 cm)
Bibliothèque nationale de France, Paris (EG3-732)

119. *Porte Gallo-Romaine, Langres*, ca. 1847
3 5/16 × 6 in. (8.5 × 15.2 cm)
Musée d'art et d'histoire, Langres (2007.0.13)

120. *Capital Topped with a Cupid, Ancient Baths of Mont-Dore, Auvergne*, 1845–50
3 11/16 × 3 3/16 in. (9.4 × 8 cm)
Musée Gruérien, Bulle (GP-DAG-010)

121. *Mer de Glace, Mont Blanc Massif*, 1845–50
3 1/8 × 3 5/8 in. (7.9 × 9.3 cm)
Musée Gruérien, Bulle (GP-DAG-027)

122. *House Located on the East Side of Obere Gasse, Meiringen*, 1845–50
3 11/16 × 3 3/16 in. (9.4 × 8 cm)
Musée Gruérien, Bulle (GP-DAG-012)

123. *Limestone Rocks between Moutier and Roches*, 1845–50
3 1/8 × 3 5/8 in. (7.9 × 9.3 cm)
Musée Gruérien, Bulle (GP-DAG-019)

124. *Greenhouse Construction, Villa des Tuaires*, 1860s
Albumen silver print
3 13/16 × 6 in. (9.6 × 15.2 cm)
Musée d'art et d'histoire, Langres (2017.0.2)

125. *Men with a Barrel*, 1860s
Albumen silver print
3 13/16 × 5 13/16 in. (9.6 × 14.7 cm)
Musée d'art et d'histoire, Langres (2017.0.29)

126. *Clematis monstruosa and Sophia*, 1860s
Albumen silver print
3 15/16 × 7 9/16 in. (10 × 19.1 cm)
Musée d'art et d'histoire, Langres (2017.0.23)

127. *Self-Portrait in the Garden*, ca. 1860
Albumen silver print
3 3/16 × 5 15/16 in. (8 × 15 cm)
Private collection

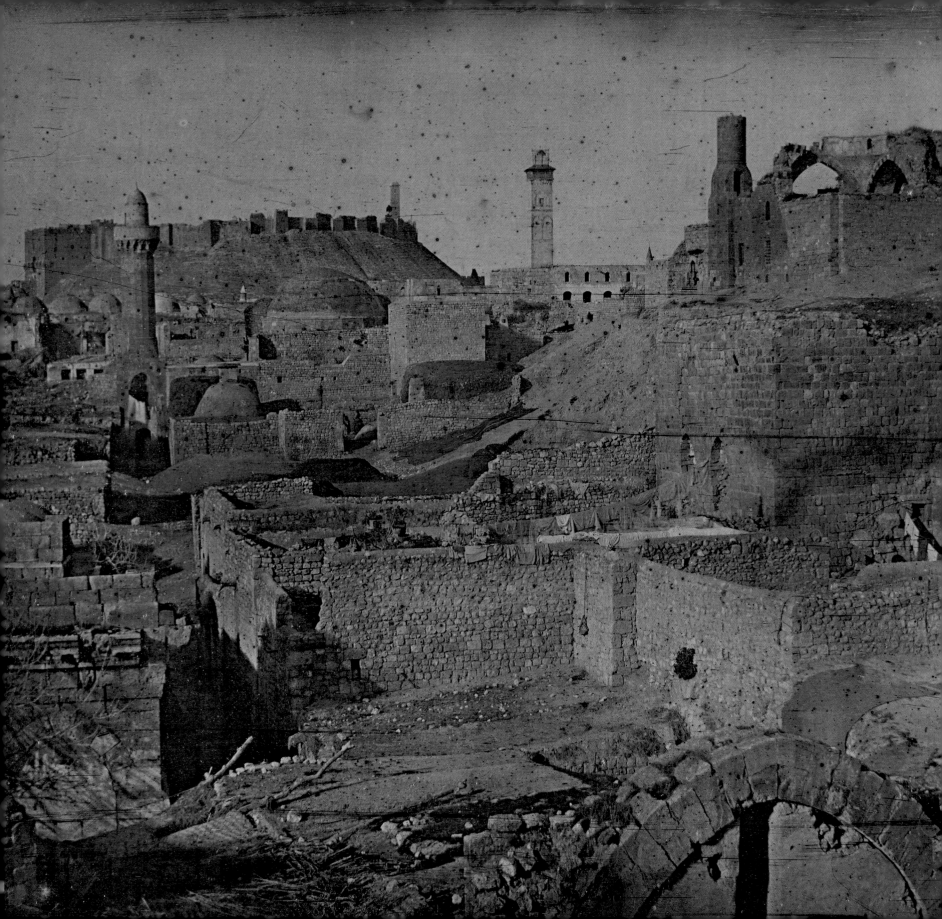

Notes

THE ODYSSEY OF AN ARTIST
AND HIS WORK

1 Henry Brocard, "M. Girault de Prangey," *Bulletin de la Société historique et archéologique de Langres* 4, no. 50 (July 1, 1893), pp. 15–21. Girault's fellow students in Langres were the painters Jules Ziegler and Joseph Berger and the sculptor Joseph Lescornel (or Lescorné); see Jacques Werren, "Jules Ziegler: Un élève oublié d'Hippolyte Bayard," *Etudes photographiques* 12 (2002), pp. 64–97.

2 Brocard, "M. Girault de Prangey," p. 19.

3 See, for instance, Joseph-Philibert Girault de Prangey, "La mosquée d'Ebn Touloun au Kaire" and "La mosquée d'El Moyed au Kaire," in Jules Gailhabaud, *Monuments anciens et modernes: Collection formant une histoire de l'architecture des différents peuples à toutes les époques*, vol. 3, *Moyen-Age, IIe partie* (Paris: Firmin Didot, 1850).

4 Charles de Simony, "Une curieuse figure d'artiste: Girault de Prangey (1804–1892)," *Mémoires de l'Académie des sciences, arts et belles-lettres de Dijon, année 1934* (1935), pp. 55–62.

5 Brocard, "M. Girault de Prangey," p. 15.

6 Simony, "Une curieuse figure d'artiste," p. 62.

7 Twenty years after Girault's trip, Emile Prisse d'Avennes mentioned using the artist's daguerreotypes as source material for a lithographic reproduction of a mosque that had since been destroyed; Emile Prisse d'Avennes, *L'art arabe d'après les monuments du Kaire depuis le VIIe siècle jusqu'à la fin du XVIIIe* (Paris: A. Morel, 1869–77), vol. 4, p. 262.

8 "Procès-verbal de la séance tenue à Paris par la Société française, le 20 et le 25 janvier 1842: Séance du 25 janvier 1842 à Paris," *Bulletin monumental* 8 (1842), pp. 64–65.

9 "Chronique: Retour de M. Girault de Prangey," *Bulletin monumental* 11 (1845), p. 317.

10 Brocard, "M. Girault de Prangey," p. 18.

11 Philippe Quettier et al., *Sur les traces de Girault de Prangey, 1804–1892: Dessins-peintures, photographies, études historiques*, exh. cat. (Langres: Musées de Langres/Dominique Guéniot,

1998), p. 72; Christophe Dutoit, "Dessinateur, historien de l'architecture, photographe, botaniste: Le regard monumental de Girault de Prangey," in *Miroirs d'argent: Daguerréotypes de Girault de Prangey*, ed. Christophe Mauron, exh. cat. (Bulle: Musée Gruérien; Geneva: Slatkine, 2008), pp. 88, 90.

12 Charles de Simony, *Une curieuse figure d'artiste: Girault de Prangey, 1804–1892* (Dijon: J. Belvet, 1937), p. 10. This edition of the lecture is more complete than the article by the same title cited in note 4 above.

13 Ibid., p. 62.

14 We have not been able to determine who these Americans were.

15 Charles de Simony, letter to Jean Prinet, February 27, 1948, Estampes, YE-218-4, Bibliothèque nationale de France, Paris (hereafter BNF).

16 Jean Prinet, letter to Charles de Simony, March 3, 1948, Estampes, YE-218-4, BNF.

17 Charles de Simony, letter to Jean Prinet, March 6, 1948, Estampes, YE-218-4, BNF.

18 These works were first published in the catalogue for an exhibition at the Musée Carnavalet: Françoise Reynaud, ed., *Paris et le daguerréotype*, exh. cat. (Paris: Musée Carnavalet, 1989). Knowledge of these daguerreotypes is what led Jean Adhémar and Jacques Lethève to write, in *Inventaire du fonds français après 1800* (Paris: Bibliothèque nationale de France, 1955), vol. 9, p. 164, that Girault "was the author of several lithographs, as well as more interesting photographs."

19 The inventory of the collection that Simony gave to the BNF indicates 29 boxes totaling at least 994 plates; the number of plates in the twenty-ninth box, "the box that is in Paris," was not mentioned. He would give the exact same inventory to Helmut Gernsheim a bit later. In the inventory given to the Musée Gruérien, however, the eighth box, containing 36 whole plates on Upper Egypt and Palestine, is missing.

20 Charles de Simony, letter to Jean Prinet, June 16, 1950, Estampes, YE-218-4, BNF. Nine hundred was the number remaining after the sale to Gernsheim and the gifts to Paris and Bulle.

21 In 1949 and 1950 the department was occupied with the acquisition of two enormous and costly collections—those of Nadar and Sirot—which did not allow it to devote adequate attention to Simony's offer.

22 Their complete correspondence is conserved in the Alison and Helmut Gernsheim Papers, Harry Ransom Center, The University of Texas at Austin. I thank Stephen C. Pinson for providing me with a copy.

23 Helmut Gernsheim and Alison Gernsheim, *The History of Photography from the Earliest Use of the Camera Obscura in the Eleventh Century up to 1914* (London: Oxford University Press, 1955); and Helmut Gernsheim and Alison Gernsheim, *L. J. M. Daguerre: The History of the Diorama and the Daguerreotype* (London: Secker and Warburg, 1956).

24 The fact that these plates remained unprotected for more than a hundred years and were sometimes handled without the necessary precautions explains the damage evident on some of them: fingerprints, partial erasure of the image by rubbing, oxidation, etc.

25 Quettier et al., *Sur les traces de Girault de Prangey*.

26 Of the eleven daguerreotypes loaned by the BNF to the Orsay, seven were from this original group. See Quentin Bajac and Dominique Planchon-de Font-Réaulx, eds., *Le daguerréotype français: Un objet photographique*, exh. cat. (Paris: Musée d'Orsay/Réunion des musées nationaux; New York: The Metropolitan Museum of Art, 2003).

27 *Fine Photographs*, sale cat. (Christie's, London, South Kensington, May 5, 2000); *Important Daguerreotypes by Joseph-Philibert Girault de Prangey from the Archive of the Artist*, sale cat. (Christie's, London, May 20, 2003); *Important Daguerreotypes by Joseph-Philibert Girault de Prangey from the Archive of the Artist, Part II*, sale cat. (Christie's, London, May 18, 2004).

28 The exhibition, which ran from October 16, 2001, to January 13, 2002, took up a theme first explored by Sylvie Aubenas and Jacques Lacarrière in a book entitled *Voyage en Orient* (Paris: Hazan, 1999).

29 Lindsey S. Stewart, "In Perfect Order: Antiquity in the Daguerreotypes of Joseph-Philibert Girault de Prangey," in *Antiquity and Photography: Early Views of Ancient Mediterranean Sites*, ed. Claire L. Lyons, exh. cat. (Los Angeles: J. Paul Getty Museum, 2005), pp. 66–91.

30 Mauron, *Miroirs d'argent*.

31 *La photographie IV: Collection Marie-Thérèse et André Jammes*, sale cat. (Sotheby's, Paris, November 15, 2008), lots 11–23.

32 *A Historic Photographic Grand Tour: Important Daguerreotypes*

by *Joseph-Philibert Girault de Prangey*, sale cat. (Christie's, New York, October 7, 2010).

33 See in particular the general catalogue of the BNF (catalogue.bnf.fr), the images on Gallica (gallica.bnf.fr), and the sales on Artprice (artprice.com).

SPLENDOR IN THE DUST

1 Another possibility is that he was considering selling them, although there would not have been much of a market. He sold a portion of his library in 1862 (see Sylvie Aubenas in this volume, pp. 1–7). Manuscript notations on several of the extant storage boxes indicate that the contents were verified "exact" in 1865 and 1880; one box indicates a third census in 1872.

2 A notable comparison is Jules Itier, a French customs officer who began using the daguerreotype to document a trade mission to Asia beginning in 1843 until his return to France early in 1846. A little more than one hundred daguerreotypes from this trip have been traced, including views of China, Vietnam, Singapore, Manila, Sri Lanka, and Egypt. See Gilles Massot, "Jules Itier and the Lagrené Mission," *History of Photography* 39, no. 4 (November 2015), pp. 319–47.

3 Gabrielle Feyler, "Contribution à l'histoire des origines de la photographie archéologique: 1839–1880," *Mélanges de l'Ecole française de Rome: Antiquité* 99, no. 2 (1987), pp. 1019–47.

4 Michael Shanks and Connie Svabo, "Photography and Archaeology: A Pragmatology," in *Reclaiming Archaeology: Beyond the Tropes of Modernity*, ed. Alfredo González-Ruibal (New York: Routledge, 2013), pp. 89–103. An earlier version of the essay is available online: http://www.mshanks.com/wp-content/uploads/Shanks-and-Svabo.pdf.

5 The phrase "l'empreinte précieuse et incontestablement fidèle" comes from his letter to the French diplomat Alexis-François Artaud de Montor, August 4, 1844, cited in Philippe Quettier et al., *Sur les traces de Girault de Prangey, 1804–1892: Dessins-peintures, photographies, études historiques*, exh. cat. (Langres: Musées de Langres/Dominique Guéniot, 1998), pp. 86–89. The plaster casts he made in Langres have since been lost. For more on the history and status of plaster casts in relation to archaeology, see Valentin Kockel, "Plaster Models and Plaster Casts of Classical Architecture and Its Decoration,"

in *Plaster Casts: Making, Collecting and Displaying from Classical Antiquity to the Present*, ed. Rune Frederiksen and Eckart Marchand (Berlin: De Gruyter, 2010), p. 429: "These … casts are not archaeological documents in the original sense. Rather, they made it possible to study ancient architecture directly, at a distance from the monuments themselves: to study in an affirmative sense, that is, with the aim of learning to insert these elements 'correctly' in one's own design." The reference to a picturesque or pictorial harvest is from his letter cited above. The "spoils of battle" comes from a letter to Jules Gailhabaud, from about September 1842; see Joseph-Philibert Girault de Prangey, "Lettre de M. Girault de Prangey," *Bulletin monumental* 9 (1843), p. 161.

6 For more on daguerreotypes as both representational and artifactual, see Frederick N. Bohrer, *Photography and Archaeology* (London: Reaktion Books, 2011), p. 11, who also cites Michael Shanks: "What begins as a copy of the real, then acquires its own reality. In this sense, one might say that even as archaeology uses photography, indeed relies on it as an essential scientific tool, photography can also enact a certain operation on the things it records which resembles nothing so much as archaeology, resurrecting unique, and past, moments in the life of a structure." See also the chapter "Digging Deep: Archaeology and Fieldwork," in Bjørnar Olsen et al., *Archaeology: The Discipline of Things* (Berkeley: University of California Press, 2012), pp. 58–78.

7 Charles de Simony, letter to Helmut Gernsheim, August 7, 1952, Series II. Correspondence, 1943–1967, Sci-Sm, 16.3, Alison and Helmut Gernsheim Papers, Harry Ransom Center, The University of Texas at Austin. Of Gernsheim's second-round picks, which he never pursued, ten of fifteen daguerreotypes were from Greece and Italy.

8 Beaumont Newhall, letter to Alison and Helmut Gernsheim, October 19, 1952, Series II. Correspondence, 1943–1967, Newhall, Beaumont and Nancy Wynne, 14.7, Alison and Helmut Gernsheim Papers, Harry Ransom Center, The University of Texas at Austin. Newhall had planned to select four "typical" daguerreotypes from the collection but had to cancel his trip. Gernsheim, who was then to make a selection for him, never returned a second time.

9 In 1836, Edmond de Cadalvène wrote, "La question orientale est une des plus urgentes dont la politique des cabinets européens ait à s'occuper." See his *L'Egypte et la Turquie, de*

1829 à 1836 (Paris: A. Bertrand, 1836), vol. 1, p. vii. See also Hassen El Annabi, "La Méditerranée des voyageurs au XIXe siècle," *Recherches régionales: Alpes-Maritimes et contrées limitrophes* 155 (October–December, 2000), pp. 34–38; and Pierre E. Caquet, *The Orient, the Liberal Movement, and the Eastern Crisis of 1839–41* (Cham: Palgrave Macmillan, 2016).

10 Girault de Prangey, letter to Montor, August 4, 1844, cited in Quettier et al., *Sur les traces de Girault de Prangey*, pp. 86–89.

11 Girault de Prangey, letter from Cairo to Jules Gailhabaud, December 10, 1843, partially reprinted in Pierre de Cussy, "Nouvelles de M. Girault de Prangey," *Bulletin monumental* 10 (1844), pp. 236–37.

12 See Joseph-Philibert Girault de Prangey, "Alep," text accompanying plates 25 and 26 in Girault de Prangey, *Monuments arabes d'Egypte, de Syrie et d'Asie-Mineure, dessinés et mesurés de 1842 à 1845* (Paris: J.-P. Girault de Prangey, 1846), in which he describes a local style mixed with European, Turkish, Islamic, and Persian influences.

13 Flaubert's original quote is from his letter to Louis Bouilhet, December 1, 1849, H1359, ffos 1–5, Collection Lovenjoul, Bibliothèque de l'Institut de France, Paris. Flaubert's correspondence is available online at http://flaubert.univ-rouen.fr/correspondance. There is a wide range of literature exploring the transactional relationship between the East and West, part of a trend to revise standard arguments about orientalism; see, for example, Elizabeth Fraser, *Mediterranean Encounters: Artists between Europe and the Ottoman Empire, 1774–1839* (University Park: Pennsylvania State University Press, 2017): "The emphasis on antagonism between European and Islamic societies has ceded to an interpretive paradigm centered on interaction and exchange, particularly in the early modern period, even in situations defined by asymmetries in power."

14 My thanks to Sylvie Aubenas for sharing her similar thoughts on this self-portrait.

15 Eléosyppe Aubert et al., "Origine et constitution de la Société historique et archéologique de Langres," *Mémoires de la Société historique et archéologique de Langres* 1 (1847), pp. i–vi.

16 See Zainab Bahrani, Zeynep Çelik, and Edhem Eldem, eds., *Scramble for the Past: A Story of Archaeology in the Ottoman Empire, 1753–1914*, exh. cat. (Istanbul: SALT Galata, 2011).

The orientalist and philologist Champollion is best known for his work on deciphering the hieroglyphs of the Rosetta Stone; see Eve Gran-Aymerich, *Naissance de l'archéologie moderne, 1798–1845* (Paris: CNRS, 1998), pp. 76–82.

17 On Taylor and the *Voyages pittoresques*, see Henri Béraldi, *Les graveurs du 19e siècle: Guide de l'amateur d'estampes modernes* (Paris: L. Conquet, 1892), vol. 12, pp. 86–102.

18 Monumental history as applied to medieval art originated with the late eighteenth-century work of Jean-Baptiste Louis Georges Séroux d'Agincourt and his *Histoire de l'art par les monuments, depuis sa décadence au IVe siècle jusqu'à son renouvellement au XIVe* (Paris: Treuttel et Würtz, 1823). For its application in the later nineteenth century, in relationship to the work of Prisse d'Avennes, see Mercedes Volait, "Surveying Monuments in Egypt: The Work of Emile Prisse d'Avennes (1807–1879)" (lecture, General Consulate of Egypt, Djeddah, November 30, 2013, available online at https://halshs .archives-ouvertes.fr/halshs-00923016/document). The seminal nineteenth-century work is Arcisse de Caumont's collected lectures on monumental archaeology, *Cours d'antiquités monumentales [. . .] Histoire de l'art dans l'ouest de la France, depuis les temps les plus reculés jusqu'au XVIIe siècle* (Paris: Lange, 1830–43).

19 Travel to Spain increased after the end of the Peninsular War in 1814; travel to the Maghreb increased after the French invasion of Algeria in 1830. See Alisa Luxenberg, *Secrets and Glory: Baron Taylor and His 'Voyage pittoresque en Espagne'* (Madrid: CEEH; New York: CSA and Hispanic Society of America, 2013), p. 321; and Elizabeth Fraser, "Interpreting Travel in the Ottoman Mediterranean," introduction to *Mediterranean Encounters*, pp. 1–15.

20 Moorish architecture traditionally refers to an articulated style of medieval Islamic architecture that developed in the Maghreb. Popular interest in the Moorish past intensified with several popular publications, including François René de Chateaubriand's *Le dernier abencérage* (first published in 1821), Victor Hugo's *Les orientales* (1829), and Washington Irving's *Tales of the Alhambra* (1832).

21 Isidore-Justin-Séverin Taylor, *Voyage pittoresque en Espagne, en Portugal et sur la Côte d'Afrique de Tanger à Tétouan* (Paris: Gide, 1826–51), vol. 1, p. ii. My emphasis.

22 Ibid., vol. 1, p. i. Ironically, much of Taylor's work was in fact supported by the government.

23 On the shift from "experiential images to detached empirical observations," as noted by William Gilpin and related to the historiography of Islamic architecture, see Katharine Bartsch, "Re-thinking Islamic Architecture: A Critique of the Aga Khan Award for Architecture through the Paradigm of Encounter" (PhD diss., University of Adelaide, 2005, p. 50; available online at http://hdl.handle.net/2440 /22228). The classic essay on the rise of "noninterventionist" or "mechanical" objectivity in the nineteenth century remains Lorraine Daston and Peter Galison, "The Image of Objectivity," *Representations* 40 (Fall 1992), pp. 81–128.

24 Taylor owned Girault's works on the Alhambra as well as his *Essai sur l'architecture des Arabes et des Mores, en Espagne, en Sicile et en Barbarie* (Paris: A. Hauser, 1841). See *Catalogue of the Highly Important, Extensive, and Valuable Library of M. Le Baron J. Taylor*, sale cat. (S. L. Sotheby and J. Wilkinson, London, June 1, 1853), lots 185, 215, 753.

25 Although Taylor used steel engravings (possibly for commercial reasons) for the illustrations in *Voyage pittoresque en Espagne*, he is most closely associated with lithography. Lithographers employed by both Taylor and Girault include Alphonse Bichebois, Nicolas Chapuy, Eugène Cicéri, Adrien Dauzats, Alexandre-Jules Monthelier, and Jean-Louis Tirpenne.

26 For Girault's contribution to the representation of Islamic architecture, see Bartsch, "Re-thinking Islamic Architecture," p. 52. See also Martina Rugiadi in this volume, pp. 157–63.

27 See *Catalogue du fonds de A. Hauser, successeur de Pieri Bénard, marchand d'estampes de la bibliothèque du roi* (Paris: P. Dupont, 1843), pp. 6–12 and 21–23.

28 Etienne-Jean Delécluze, "Feuilleton du Journal des débats: Variété," *Journal des débats politiques et littéraires*, October 25, 1837.

29 The Comité des travaux historiques et scientifiques was created by François Guizot, Minister of Public Instruction, who named Prosper Mérimée as Inspector General of Historic Monuments. See Gran-Aymerich, *Naissance de l'archéologie*, pp. 46–62.

30 Ibid., p. 61.

31 Joseph-Philibert Girault de Prangey, "Rapport de M. de Prangey," *Bulletin monumental* 6 (1840), p. 328.

32 Girault first read his report on February 15, 1840, at a meeting in Paris of the SFA; the full report was presented at the annual meeting in Niort, France (June 20–24, 1840). See ibid., pp. 325–31.

33 Joseph-Philibert Girault de Prangey, letter to Jean-Félix-Onésime Luquet, August 27, 1839, Bibliothèque diocésaine, Langres. I thank Christophe Dutoit for sharing a copy of this letter with me. See also Christophe Dutoit, "Dessinateur, historien de l'architecture, photographe, botaniste: Le regard monumental de Girault de Prangey," in *Miroirs d'argent: Daguerréotypes de Girault de Prangey*, ed. Christophe Mauron, exh. cat. (Bulle: Musée Gruérien; Geneva: Slatkine, 2008), p. 42.

34 Girault de Prangey, "Rapport de M. de Prangey," p. 328.

35 Robert Flocard, in reminiscences of Girault's villa, refers to Girault as Daguerre's "collaborator." See Robert Flocard, letter to Philippe Quettier, November 11, 1997, in the documentation on Girault de Prangey at the Musées de Langres. I am indebted to Christophe Dutoit for sharing a copy of this letter.

36 "Le Cercle des arts," *L'artiste* 12 (1836), pp. 265–66. For lists of members, see *Annuaire du Cercle des arts: Contenant la liste des membres, les statuts et le règlement intérieur du Cercle* (Paris: Crapelet, 1838–73).

37 Vernet was director of the Académie de France in Rome from 1829 to 1835, and Girault apparently met him there. In his report of the death of Paul Delaroche's wife (Vernet's daughter), Louise, Ernest de Belenet recounts an episode, shared by Girault, from Vernet's tenure in Rome. Ernest de Belenet, "Chronique Parisienne," *Echo de la littérature et des beaux-arts en France et à l'étranger* 6 (1846), pp. 387–91. On Delaroche, see Stephen C. Pinson, *Speculating Daguerre: Art and Enterprise in the Work of L. J. M. Daguerre* (Chicago: University of Chicago Press, 2012), p. 120.

38 This episode is documented in two separate works by Prosper Lafaye, an oil painting and an annotated watercolor. I am grateful to Céline Robert of the Musée français de la photographie for sending me a reproduction and associated documentation of the watercolor.

39 Feyler, "Contribution à l'histoire des origines," pp. 1020–21.

40 A full account of all these early photographer-travelers has yet to be undertaken. On Vernet and Goupil-Fesquet, see Michele Hannoosh, "Horace Vernet's 'Orient': Photography and the Eastern Mediterranean in 1839, Part I: A Daguerrean

Excursion," *Burlington Magazine* 158, no. 1357 (April 2016), pp. 264–71; and Michele Hannoosh, "Horace Vernet's 'Orient': Photography and the Eastern Mediterranean in 1839, Part II: The Daguerreotypes and Their Texts," *Burlington Magazine* 158, no. 1359 (June 2016), pp. 430–39. On Joly de Lotbinière, see Jacques Desautels, Georges Aubin, and Renée Blanchet, eds., *Voyage en Orient (1839–1840): Journal d'un voyageur curieux du monde et d'un pionnier de la daguerréotypie* (Quebec: Presses de l'Université Laval, 2010). On Gautier, see Bernd Stiegler, "La surface du monde: Note sur Théophile Gautier," *Romantisme* 105 (1999), pp. 91–95; and Stéphane Guégan, "'Ces bonheurs-là n'arrivent qu'aux habiles': Gautier et la photographie d'artiste," *48/14: La revue du Musée d'Orsay* 28 (2009), pp. 6–23. On Ellis, see Roger Taylor, "Early Daguerreotypes of Italy," in *Making of the Modern World: Milestones of Science and Technology*, ed. Neil Cossons (London: John Murray, 1992), p. 78. A major reason that so few of these photographers' daguerreotypes remain is that they were considered incidental to the lithographs, engravings, or etchings through which they appeared in print. An exception is the collection of Ellis, whose planned publication never came to fruition. His collection of 159 daguerreotypes (including work by Lorenzo Suscipj and Achille Morelli) is at the National Science and Media Museum in Bradford, England.

41 Hector Horeau, prospectus in *Panorama d'Egypte et de Nubie avec un portrait de Méhémet-Ali et un texte orné de vignettes* (Paris: H. Horeau, 1841). The Bibliothèque nationale de France copy (Gr. fol-O3b-425) contains two variants of the prospectus.

42 On authenticity as a signifier of values, such as truth and presence, tied to new representational media that "worked to efface the labor of representation, to produce the image as immediate, fresh, and accessible," see Karen Burns, "Topographies of Tourism: 'Documentary' Photography and 'The Stones of Venice,'" *Assemblage* 32 (April 1997), pp. 37–38.

43 Hector Horeau, letter to Alphonse-Eugène Hubert, September 13, 1839, Estampes Rés., Z-88-4, Bibliothèque nationale de France, Paris, cited and reprinted in Hannoosh, "Horace Vernet's 'Orient' Part I," p. 267, n. 25, and p. 271, appendix 1.

44 On Hubert, see Stephen C. Pinson's entry on Alphonse-Eugène Hubert's *Nature morte (avec Vénus de Milo)*, in *Le daguerréotype français: Un objet photographique*, ed. Quentin Bajac and Dominique Planchon-de Font-Réaulx, exh. cat. (Paris: Musée d'Orsay/Réunion des musées nationaux; New York: The Metropolitan Museum of Art, 2003), p. 160. For Goupil-Fesquet's contact with Hubert and Daguerre, see Hannoosh, "Horace Vernet's 'Orient' Part I," pp. 267–68, 271.

45 Noël-Paymal Lerebours, *Excursions daguerriennes: Vues et monuments les plus remarquables du globe* (Paris: Rittner et Goupil, 1840–44). The first volume was published in 1840 and the second between 1843 and 1844.

46 On the close relationship between travel literature and journalism, see Sylvain Venayre, "Le voyage, le journal et les journalistes au XIXe siècle," *Le temps des médias* 1, no. 8 (2007), pp. 46–56.

47 "Le daguerréotype au harem" appeared in *La Presse* on March 10, 1840, before Vernet and Goupil-Fesquet had returned to France. See Hannoosh, "Horace Vernet's 'Orient' Part II," p. 434.

48 Frédéric Goupil-Fesquet, "Harem de Méhémet-Ali," in Lerebours, *Excursions daguerriennes*, vol. 1. The print as a surrogate for the daguerreotype is reinforced by its approximate size and format on the printed page, and any tension between photographic exactitude and artistic expression is nullified by a presumed parity between representation and depicted subject; the absent daguerreotype is a mere cipher. The only exception are the three images etched directly from daguerreotype plates that appeared in some editions of the second volume. Such images seem out of place in Lerebours's picturesque album.

49 On Gautier, see Stiegler, "La surface du monde," p. 91. For Baudelaire on Vernet, see Daniel Harkett and Katie Hornstein, eds., *Horace Vernet and the Thresholds of Nineteenth-Century Visual Culture* (Hanover, N.H.: Dartmouth College Press, 2017), pp. 2, 4.

50 Stendhal is often credited with first using the term "reporter" in *Promenades dans Rome* (1829). See Venayre, "Le voyage," pp. 51–53.

51 See the record of Girault's Salon entries in the "Database of Salon Artists" maintained by the University of Exeter, http://humanitiesresearch.exeter.ac.uk/salonartists/artist/id/3921.

52 "Chronique: Voyage de M. Girault de Prangey, inspecteur des monuments de la Haute-Marne," *Bulletin monumental* 7 (1841), p. 303; "Procès-verbal de la séance tenue à Paris par la Société française, le 20 et le 25 janvier 1842: Séance du 25 janvier 1842 à Paris," *Bulletin monumental* 8 (1842), pp. 64–65. See also Aubenas in this volume, pp. 1–7.

53 [Alphonse-Eugène Hubert], *Le daguerréotype: Considéré sous un point de vue artistique, mécanique et pittoresque* (Paris: A. Giroux, 1840), p. 4.

54 Ibid., pp. 27–28. Unless corrected with the addition of a mirror, cameras projected a laterally reversed view onto the daguerreotype plate; if this same view was then copied or transferred to a printing plate and printed, the resulting image would appear in its natural orientation. For a fuller discussion of the relationship between Girault's daguerreotypes and prints, see Géraldine-Lucille Hattich, "Joseph-Philibert Girault de Prangey: Ein Pionier der Reisedaguerreotypie" (MA thesis, University of Zurich, 2012). See also Olivier Caumont's essay in this volume, pp. 176–81, which deals with the preparatory watercolors, based on daguerreotypes, for *Monuments et paysages de l'Orient*.

55 Pinson in Bajac and Planchon-de Font-Réaulx, *Le daguerréotype français*, p. 160. Arago first announced Fizeau's method of "fixing" plates at the March 23 meeting of the Académie des sciences; the complete process was described on August 10. The evidence of gilding, which has been confirmed through analysis, underscores the importance of the daguerreotypes themselves in attempting to reconstruct Girault's particular practice. See "Un Daguerréotype Monstre" in this volume, pp. 182–89.

56 Noël-François-Joseph Buron, *Description de nouveaux daguerréotypes perfectionnés et portatifs* (Paris: N.-F.-J. Buron, 1841), pp. 43–47. Buron followed the example of Pierre-Armand Séguier, who had also produced a portable daguerreotype camera.

57 Charles Chevalier, *Nouvelles instructions sur l'usage du daguerréotype: Description d'un nouveau photographie, et d'un appareil très simple destiné à la reproduction des épreuves au moyen de la galvanoplastie* (Paris: C. Chevalier, 1841), especially pp. 15–22. Hubert had also purchased a camera from Victor Chevalier, a relative of Charles. See the entry on Hubert in Marc Durand, *De l'image fixe à l'image animée, 1820–1910: Actes des notaires de Paris pour servir à l'histoire des photographes et de la photographie* (Pierrefitte-sur-Seine: Archives nationales, 2015), vol. 1, pp. 556–57.

58 In 1840, the Société d'encouragement pour l'industrie nationale had announced awards in photography for the year 1841; Chevalier was awarded a platinum medal for his "verres combinés à foyer variable" over Josef Petzval, even though the latter's lens outsold that of Chevalier. See "Extrait

d'un rapport fait par M. le baron Séguier, au nom d'une commission spéciale, sur le concours pour des perfectionnements dans la photographie," *Bulletin de la Société d'encouragement pour l'industrie nationale* 41 (1842), p. 124; Rudolf Kingslake, "Charles Chevalier and the 'Photographe à verres combinés,'" *Image* 10, no. 5 (1961), pp. 17–19; and Mike Robinson, "The Techniques and Material Aesthetics of the Daguerreotype" (PhD diss., De Montfort University, Leicester, 2017), pp. 269–71.

59 On Daguerre's knowledge of optics, see Robinson, "Techniques and Material Aesthetics," pp. 244–54. The history and manufacture of daguerreotype plates is little researched. Brébisson recommended those of the ironworker Jacques Duval, who had been manufacturing them specifically for use in daguerreotype cameras since November 1839. See Louis-Alphonse de Brébisson, *De quelques modifications apportées aux procédés du daguerréotype* (Falaise: Levavasseur, 1841), p. 2. For Duval, see M. Delambre, "Rapport sur les médailles à décerner aux contre-maîtres des ateliers," *Bulletin de la Société d'encouragement pour l'industrie nationale* 40 (1841), pp. 335–36; and "Physique appliquée aux arts: Nouveaux détails sur le daguerréotype," *Journal des connaissances nécessaires et indispensables aux industriels, aux manufacturiers, aux commerçants et aux gens du monde* 1 (1839), p. 530. Duval's shop manager, Pierre-Daniel Guerlpied, had been given a medal by the Société d'encouragement pour l'industrie nationale in 1841.

60 Cussy, "Nouvelles de M. Girault de Prangey," p. 235. Charles de Simony, "Une curieuse figure d'artiste: Girault de Prangey (1804–1892)," *Mémoires de l'Académie des sciences, arts et belles-lettres de Dijon, année 1934* (1935), p. 59.

61 Daguerre himself had experimented with plates of various sizes, and by the end of 1839, Lerebours had created a camera that made images of 12 by 15 *pouces* (approx. 12¾ by 19 inches). On Daguerre, see Alexander von Humboldt, letter to Friedrike, Duchess of Anhalt-Dessen, February 7, 1839, in *First Exposures: Writings from the Beginning of Photography*, ed. Steffen Siegel (Los Angeles: J. Paul Getty Museum, 2017), p. 69. For Lerebours, see Marc-Antoine Gaudin and Noël-Paymal Lerebours, *Derniers perfectionnements apportés au daguerréotype*, 3rd ed. (Paris: N.-P. Lerebours, 1842), p. 6, n. 1. For large cameras (and corresponding images) produced for Lerebours, Giroux, and Chevalier, see Joseph Christian

Hamel, "On Daguerre's Heliography and Prints of His Heliographed Plates," in Siegel, *First Exposures*, p. 394.

62 I thank Grant B. Romer for pointing out that, unlike Daguerre's standard plate, the whole plate used by Girault is not hand-commensurate. Its secure manipulation requires two hands.

63 On the relationship between Ottoman political and social reform, or Tanzimat (established in 1839), and photography, see Stephen Sheehi, "A Social History of Arab Photography; or, A Prolegomenon to an Archaeology of the Lebanese Bourgeoisie," *International Journal of Middle East Studies* 39, no. 2 (May 2007), pp. 177–208; and Stephen Sheehi, "The *Nahda* After-Image; or, All Photography Expresses Social Relations," *Third Text* 26, no. 4 (July 2012), pp. 401–14. Sheehi argues that the adoption of photography was an ideological practice that allowed non-Western subjects to claim ownership of modernity even while it naturalized existing social relationships that they performed for the camera.

64 He also required numerous travel necessities, likely including a canteen, umbrella, tent, camp stool, sheets and towels, and various foods and sundries. See *A Hand-Book for Travellers in the Ionian Islands, Greece, Turkey, Asia Minor, and Constantinople* (London: John Murray, 1840), pp. v–vii.

65 See Grant B. Romer, introduction to *Important Daguerreotypes by Joseph-Philibert Girault de Prangey from the Archive of the Artist, Part II*, sale cat. (Christie's, London, May 18, 2004), pp. 8–11.

66 Marilhat departed France in May 1831 with the Austrian diplomat Charles von Hügel and traveled to Greece, Alexandria, Syria, Baalbek, Lebanon, Tripoli, Beirut, Sidon, Tyr (Tyre), Ptolemais (Acre), Nazareth, Jerusalem, Jaffa, and back to Alexandria before proceeding up the Nile. He returned to France in May 1833 with ten notebooks of drawings. Girault consulted Marilhat's sketchbooks, a well-known resource for Mediterranean views, for his *Essai sur l'architecture*, and Léon de Laborde used them as the basis for many of the illustrations in his *Voyage de la Syrie* (1837). On Marilhat, see Hippolyte Gomot, *Marilhat et son oeuvre* (Clermont-Ferrand: Mont-Louis, 1884). For Girault's reference to Marilhat's sketchbooks, see Girault de Prangey, *Essai sur l'architecture*, p. 64, n. 2.

67 François Fossier, ed., "Correspondance des directeurs de l'Académie de France à Rome," vol. 7, "Premier directorat de Jean-Victor Schnetz (1840–1843)," unpublished manuscript

(previously available on the website of the Institut de France, accessed March 2018 [link discontinued]), pp. 241–48, 252–54, 256–59.

68 Ibid., p. 246. Indeed, a box of Roman views still in private hands (see Aubenas, p. 7) includes images of oxen on the Roman Forum, *pifferari* (folk musicians), and other street types. It is scheduled for auction at Sotheby's, Paris, on November 9, 2018.

69 Girault, "Lettre de M. Girault de Prangey," p. 161.

70 He also made three separate whole-plate views of the Arch of Titus (see fig. 36a–c in this volume). The use of multiple plates for a single view was not unique to Girault. In 1846, Baron Gros in a letter to Charles Chevalier stated that he often used six plates to obtain two or three successful daguerreotypes of a landscape or architectural view, after using the first attempt (which was generally too dark or too solarized) to determine proper exposure for the other plates. See Baron Gros, letter to Charles Chevalier, October 1, 1846, in Charles Chevalier, *Recueil de mémoires et de procédés nouveaux concernant la photographie sur plaques métalliques et sur papier* (Paris: C. Chevalier, 1847), p. 2. It is more difficult to explain why Girault did not wipe these plates and reuse them.

71 Joseph-Philibert Girault de Prangey, letter from Izmir to Raoul-Rochette, April 22, 1843, reprinted in Quettier et al., *Sur les traces de Girault de Prangey*, pp. 83–85.

72 Ibid.

73 Joseph-Philibert Girault de Prangey, letter to Jules Gailhabaud, undated [autumn 1843], partially reprinted in Cussy, "Nouvelles de M. Girault de Prangey," p. 236.

74 In the letter to Artaud de Montor of August 4, 1844, Girault references a previous letter, which he had written to Montor from Cairo on October 30, 1843. The daguerreotypes dated to 1844 from Lebanon are whole plates, while most of the undated daguerreotypes are very small formats; one explanation is that Girault was running low on plates toward the end of 1843 and returned to Baalbek after restocking his supply.

75 Girault describes his intended 1844 itinerary in the 1843 letter to Gailhabaud; see Cussy, "Nouvelles de M. Girault de Prangey," pp. 236–37.

76 Girault de Prangey, letter to Artaud de Montor, August 4, 1844.

77 Ibid.

78 His address, 4, rue Duphot, appears on letters in 1846 and 1847.

79 See Lugt 4211, in Frits Lugt, *Les marques de collections de dessins and d'estampes*, www.marquesdecollections.fr/detail .cfm/marque/11725. On the proposed scope of the project, see his letter to Narcisse-Achille de Salvandy, Minister of Public Instruction, June 4, 1846, F/17/3159, Archives nationales, Paris.

80 Girault's choice of lithography suggests, again, that he preferred more control over the printmaking process; it was also less time-consuming than aquatint etching, which was used for Lerebours's *Excursions daguerriennes*. The change in visual field is much more noticeable in the watercolors and corresponding chromolithographs from 1851; compared to the daguerreotypes, they are extended on both the left and right sides to match the more rectangular landscape orientation of the published prints.

81 Olivier Caumont (p. 179 in this volume) also hypothesizes that the Bosphorus watercolor was made on-site.

82 Girault de Prangey, *Monuments Arabes d'Egypte, de Syrie et d'Asie-Mineure*, [p. 2], n. 1. He repeats the claim [on p. 3] regarding detail number 1.

83 Such mounds were likely present due to ongoing excavation and reconstruction of the site when Girault was there. Again, this suggests that he also completed drawings to complement his daguerreotypes.

84 As universal histories of architecture developed in tandem with studies of Islamic and Gothic architecture, a question arose about whether the pointed arch, or ogive, was Islamic or French in origin, and this question was inevitably enmeshed in claims of Western cultural superiority. Alexandre de Laborde believed that Gothic and Moorish architecture were both essentially Byzantine, whereas the ogive was a European invention. Pascal-Xavier Coste maintained instead that the ogive was brought to Europe through contact with Islamic architecture during the Crusades. Girault acknowledged that the ogive was first present in Egypt, but he ultimately was unable to determine whether it was Islamic or Byzantine in origin. See Alexandre-Louis-Joseph de Laborde, *Voyage pittoresque et historique de l'Espagne* (Paris: P. Didot l'aîné, 1812), vol. 2, p. 44; and Pascal-Xavier Coste, *Architecture arabe; ou, Monuments du Kaire, mesurés et dessinés, de 1818 à 1826* (Paris: Firmin Didot, 1839). For a summary of the various debates about the ogive, see A. Caumont, *Cours d'antiquities monumentales*, p. 216.

85 Girault de Prangey, letter to Salvandy, June 4, 1846.

86 Girault initially wrote to Donaldson on December 21, 1846, to thank him for the honorary membership. See Joseph-Philibert Girault de Prangey, letter to Thomas Leverton Donaldson, December 21, 1846, FNP2/29, RIBA archives, London. My gratitude to Fiona Orsini and Giles Hudson for their help in locating this document.

87 Joseph-Philibert Girault de Prangey, letter to Thomas Leverton Donaldson, March 30, 1847. Christophe Dutoit graciously shared a transcript of this letter. He goes on to elaborate his frustration with Joseph Bonomi, Frederick Catherwood, and Francis Arundale, who, unlike him, had been granted access to survey the buildings within the Haram al-Sharif in Jerusalem in 1833, but had not yet published their measurements or drawings.

88 For example, Girault changed the orthography in the first installment of *Monuments arabes*, from *ben* to *ibn*, and he generally attempted to refer to sites in the Middle East by their Arabic names, designating mosques as *gâma'a*, the Arabic word typically used for mosques. See Georg Ebers, *L'Egypte: Alexandrie et le Caire*, trans. Gaston Maspero (Paris: Firmin Didot, 1881), vol. 2, p. 239. On archaeology's challenge to philology, see Suzanne L. Marchand, *Down from Olympus: Archaeology and Philhellenism in Germany, 1750–1970* (Princeton: Princeton University Press, 1996), p. 124.

89 There are several notable exceptions, including the work of Auguste Salzmann in Jerusalem in 1853 and Prisse d'Avenne's 1858 excursion to Egypt with the photographer Edouard Jarrot. See Anjuli Lebowitz, "Faith in the Field: The Art of Discovery in Auguste Salzmann's Photographic Albums, 1854–1875" (PhD diss., Boston University, 2017); and Mercedes Volait, "Surveying Monuments in Egypt." Even into the 1860s, the representational status of photography within the field of archaeology remained contested.

90 This title page appears in the copy held by the Victoria and Albert Museum National Art Library in London, General Collection (46.E.53).

91 Coste worked for a decade as an advisor on infrastructure projects for Muhammad 'Ali beginning in 1817. Girault visited him in Marseille on September 1, 1860. See Pascal-Xavier Coste, *Mémoires d'un artiste: Notes et souvenirs de voyages (1817–1877)* (Marseille: Cayer, 1878), vol. 1, p. 549.

92 See Sylvie Henguely, "Entre convention et singularité: Les daguerreotypes de Girault de Prangey et les débuts de la photographie en Suisse," in Mauron, *Miroirs d'argent*, pp. 97–142.

93 See Olivier Caumont, "Joseph-Philibert Girault de Prangey (1804–1892): Voyageur, illustrateur et éditeur d'art; Techniques de production des images, du dessin à la photographie," in *Art et artistes Haut-Marne XVe–XIXe siècle: Actes du Ier colloque biennal des Cahiers haut-marnais, Chaumont, 17–19 Octobre 2014*, ed. Patrick Corbet, Alain Morgat, and Samuel Mourin (Chaumont: Pythagore, 2014), pp. 283–84.

94 From the mid-1840s to 1858, Ruskin commissioned and created a collection of about four hundred daguerreotypes of Italy, Switzerland, and France, approximately a third of which depicted (mostly architectural views of) Venice. See Ken Jacobson and Jenny Jacobson, *Carrying off the Palaces: John Ruskin's Lost Daguerreotypes* (London: Bernard Quaritch, 2015). Given the artistic influence of the Islamic world on Venice, it is surprising that Girault apparently did not return there to make daguerreotypes.

95 Burns, "Topographies of Tourism," p. 38. The daguerreotype prompted both Ruskin and Girault to reassess modes of representation.

96 The quote comes from a letter written by Ruskin to his father from Venice, October 7, 1845; see the facsimile in Jacobson and Jacobson, *Carrying off the Palaces*, pp. 18–19.

97 Oliver Wendell Holmes, "The Stereoscope and the Stereograph," *The Atlantic Monthly* 3 (June 1859), p. 744.

98 Brooke Belisle, "Total Archive: Picturing History from the Stereographic Library to the Digital Database," *Mediascape* (Winter 2013), http://www.tft.ucla.edu/mediascape/pdfs /Winter 2013/PicturingHistory.pdf.

99 On photography's role in expanding the visual over the textual in archaeology, and on archaeology as a site of cultural introspection, see Eric Downing, *After Images: Photography, Archaeology, Psychoanalysis and the Tradition of Bildung* (Detroit: Wayne State University Press, 2006), pp. 88–89, 102. On the use of scientific images as self-disciplinary exercises in the cultivation of a memory-based picture of the self, see Jason de Stefano, "From Objectivity to the Scientific Self: A Conversation with Peter Galison," *Qui parle* 23, no. 2 (Spring/Summer 2015), pp. 94–95.

100 On the practice of making disposable "visual notes" as a kind of contemporary conversation, see Jan Simons, "Weightless Photography," in *The Weight of Photography*, ed. Luc Deneulin and Johan Swinnen (Brussels: Academic and Scientific Publishers, 2010), pp. 557–76. My thanks to Andrés Zervigón for directing me to this article.

FRAMING AN ISLAMIC ART

I thank Stephen C. Pinson for inviting me to write this essay and for sharing his in-depth knowledge on Girault. I am also grateful to Mariam Rosser-Owen, Abigail Krasner Balbale, Honorine Chabin, Nebahat Avcıoğlu, Kripa Kewalramani, Courtney Stewart, Aysin Yoltar, Marcie Muscat, and, for their insightful comments, Khaled Malas and Giulia Paoletti.

1 Joseph-Philibert Girault de Prangey, *Essai sur l'architecture des Arabes et des Mores, en Espagne, en Sicilie et en Barbarie* (Paris: A. Hauser, 1841), pp. viii–ix. The same passage appears in Joseph-Philibert Girault de Prangey, "Considérations sur l'architecture arabe," *Bulletin monumental* 6 (1840), pp. 477–83.

2 Perceived today as controversial and imprecise, the definition of "Islamic art" in the West first emerged between the end of the nineteenth and the early twentieth century, but for lack of valid alternatives, it remains the preferred term. For simplicity's sake, in this text I use the term "Islamic," even though it was not used by Girault and his contemporaries. See Nasser Rabbat, "What Is Islamic Architecture Anyway?," *Journal of Art Historiography* 6 (June 2012), https://arthistoriography.files.wordpress.com/2012/05/rabbat1.pdf; and Finbarr Barry Flood, "From the Prophet to Postmodernism? New World Orders and the End of Islamic Art," in *Making Art History: A Changing Discipline and Its Institutions*, ed. Elizabeth C. Mansfield (London: Routledge, 2007), pp. 31–53.

3 As advertised in Joseph-Philibert Girault de Prangey, *Monuments arabes d'Egypte, de Syrie et d'Asie-Mineure, dessinés et mesurés de 1842 à 1845* (Paris: J.-P. Girault de Prangey, 1846).

4 See p. 227 for a list of these titles. Additionally, some of Girault's texts were published in collective surveys: his essays "La mosquée d'Ebn Touloun au Kaire" and "La mosquée d'El Moyed au Kaire" were included in Jules Gailhabaud, *Monuments anciens et modernes: Collection formant une histoire de l'architecture des différents peuples à toutes les époques,* vol. 3, *Moyen-Age: IIe partie* (Paris: Firmin Didot, 1850). Drawings by Girault appear in Emile Prisse d'Avennes, *L'art arabe d'après les monuments du Kaire depuis le VIIe siècle jusqu'à la fin du XVIIIe* (Paris: A. Morel, 1869–77).

5 See Jules Goury and Owen Jones, *Plans, Elevations, Sections, and Details of the Alhambra from Drawings Taken on the Spot in 1834* (London: O. Jones, 1842–45). Also notable was Pascal-Xavier Coste, *Architecture arabe; ou, Monuments du Kaire, mésurés et dessinés, de 1818 à 1826* (Paris: Firmin Didot, 1839); and Prisse d'Avennes, *L'art arabe*.

6 *Monuments arabes d'Egypte* was planned to consist of twenty to thirty fascicles, of which only six were printed and eleven copies are known today. See Lindsey S. Stewart, "In Perfect Order: Antiquity in the Daguerreotypes of Joseph-Philibert Girault de Prangey," in *Antiquity and Photography: Early Views of Ancient Mediterranean Sites*, ed. Claire L. Lyons, exh. cat. (Los Angeles: J. Paul Getty Museum, 2005), p. 88; and Stephen C. Pinson's essay in this volume, pp. 9–25.

7 The few texts on Girault by historians of Islamic art are Maryse Bideault, "Œuvre de Joseph-Philibert Girault de Prangey," in *L'iconographie du Caire dans les collections patrimoniales françaises*, ed. Maryse Bideault and Mercedes Volait (Paris: Institut national d'histoire de l'art, 2010), pp. 35–48; Claire Déléry, "Girault de Prangey: Vers une étude moderne de la céramique monumentale nasride," in *Voyage en Andalousie mauresque: Girault de Prangey*, ed. Michel Maupoix, exh. cat. (Le Blanc: Bibliothèque municipale, 2011), pp. 50–59; Rémi Labrusse, *Islamophilies: L'Europe moderne et les arts de l'islam*, exh. cat. (Lyon: Musée des Beaux-Arts; Paris: Somogy, 2011), pp. 114–15, 120; and Elodie Vigouroux, "Girault de Prangey à Damas (1843–1844): A la lumière des clichés conservés à la Bibliothèque nationale de France," *Histoire urbaine* 46, no. 2 (2016), pp. 87–114. Mercedes Volait's publications offer an overview of Islamic art in nineteenth-century France.

8 Frédéric Hitzel and Sophie Makariou, "Girault de Prangey, Joseph-Philibert (Langres, 1804–Courcelles-Val-d'Esnoms, 1892)," in *Dictionnaire des orientalistes de langue française*, ed. François Pouillon (Paris: Karthala, 2008), p. 446. Today, what Girault called "Arab art" is more often called "Islamic art" (see note 2 above). Only in the 1890s, with the move from racial terms to "Muslim" and its variants, did Western scholars begin to consistently examine Islam as a definable cultural and religious entity; see Stephen Vernoit, "The Rise of Islamic Archaeology," *Muqarnas* 14 (1997), pp. 1–10.

9 In his writings Girault mentions few publications on the subject that were available to him; most were historical, with a few travelogues and literary texts and only a handful of titles on architecture, numismatics, and epigraphy. Significantly, Girault quoted Washington Irving's successful novel *Tales of the Alhambra* (1832), which was pivotal in creating a romanticized notion of the palace in the European imagination; see Lara Eggleton, "'A Living Ruin': Palace, City, and Landscape in Nineteenth-Century Travel Descriptions of Granada," *Architecture Theory Review* 18, no. 3 (December 2013), pp. 374–76.

10 The terms *orientalist* and *orientalism* are employed in this text to refer to the eighteenth- and nineteenth-century scholarly disciplines of non-Western studies; to the nineteenth-century painting style that portrays Islamic culture as a projection of Western fantasies (see fig. 33); or to Edward Said's definition of orientalism as a system of knowledge-production that models its subject—the East—along geopolitical (i.e., colonial and imperialist) and cultural (racial and culturally historicist) lines. For more recent scholarship building on Said's theories, but stressing the diversity of nineteenth-century encounters and overturning the passive position of the represented subjects, see Zainab Bahrani, Zeynep Çelik, and Edhem Eldem, eds., *Scramble for the Past: A Story of Archaeology in the Ottoman Empire, 1753–1914*, exh. cat. (Istanbul: SALT Galata, 2011). On photography specifically, see Ali Behdad and Luke Gartlan, eds., *Photography's Orientalism: New Essays on Colonial Representation* (Los Angeles: Getty Research Institute, 2013); Zeynep Çelik and Edhem Eldem, eds., *Camera Ottomana: Photography and Modernity in the Ottoman Empire, 1840–1914* (Istanbul: Koç University Press, 2015); Ali Behdad, *Camera Orientalis: Reflections on Photography of the Middle East* (Chicago: University of Chicago Press, 2016); Stephen Sheehi, *The Arab Imago: A Social History of Portrait Photography, 1860–1910* (Princeton: Princeton University Press, 2016); and Markus Ritter and Staci G. Scheiwiller, eds., *The Indigenous Lens? Early Photography in the Near and Middle East* (Berlin: De Gruyter, 2018).

11 The school's foundation decree cites "politics and

commerce" as the rationale behind its creation. It also offered instruction in "Crimean, Tartar, and Malay."

12 On different colonial experiences and how they shaped variants in orientalism, specifically in France, see Edmund Burke and David Prochaska, eds., *Genealogies of Orientalism: History, Theory, Politics* (Lincoln: University of Nebraska Press, 2008), especially part 1; and Desmond Hosford and Chong J. Wojtkowski, eds., *French Orientalism: Culture, Politics, and the Imagined Other* (Newcastle: Cambridge Scholars, 2010). In a letter from Beirut, where he was quarantined in 1844, Girault laments France's responsibility in the turbulence and insecurity then happening in Syria and Palestine; see Philippe Quettier et al., *Sur les traces de Girault de Prangey, 1804–1892: Dessins-peintures, photographies, études historiques* (Langres: Musées de Langres/Dominique Guéniot, 1998), pp. 88–89. The region was caught up in the struggle for power between the Ottomans and Egypt, and France's support of Muhammad 'Ali, through 1840, was probably owing to its interests in Algeria.

13 For the personal and politico-cultural networks that fueled successful private enterprises like Girault's, see Ali Behdad, "The Orientalist Photograph," in Behdad and Gartlan, *Photography's Orientalism*, pp. 11–32, especially p. 14. For Girault's membership in academic societies, see "Liste générale des membres de la Société française pour la conservation des monuments, dans l'ordre de leur réception," *Bulletin monumental* 8 (1842), p. 602; "Chronique: Retour de M. Girault de Prangey," *Bulletin monumental* 11 (1845), p. 317; and Victor-Antoine Mourot, *La Terre-Sainte et le pèlerinage de pénitence en 1882: Impressions et souvenirs* (Paris: Librairie Catholique Internationale, 1882), vol. 2, p. 107.

14 For Tunisia, see Joseph-Toussaint Reinaud, "Critique littéraire," *Journal asiatique* 13 (April 1842), p. 355. In Istanbul, Girault expressed hope that he might be given access to religious monuments (Pierre de Cussy, "Nouvelles de M. Girault de Prangey," *Bulletin monumental* 10 [1844], pp. 235–38), but judging from his known daguerreotypes and lithographs, he may not have obtained permits in either Turkey or Syria (see below in the text, p. 159, for Damascus). One exception was the open-air and possibly unused mosque in the ruins of Baalbek (Bibliothèque nationale de France, Paris [hereafter BNF], EG2-828, -829, -830).

15 Girault depicted or described in *Monuments arabes* the interiors of four mosques: Ibn Tulun; al-Azhar; al-Hakim, in ruins; and 'Amr ibn al-'As, the ruins of which had been partly reconstructed (for which, see also Girault's daguerreotype *Vieux Kaire. M.[Mosquée] Amr. Nefs. Cour* [BNF, EG2-701]). Girault wrote additional texts on Ibn Tulun, as well as on the Sultan al-Mu'ayyad Mosque, for both of which see note 4 above.

16 Cussy, "Nouvelles de M. Girault," p. 236. A failure to mention the local fixers and interpreters ("dragomans") who facilitated their travel was common among European travelers, with few exceptions; see Rachel Mairs and Maya Muratov, *Archaeologists, Tourists, Interpreters: Exploring Egypt and the Near East in the Late 19th–Early 20th Centuries* (London: Bloomsbury Academic, 2015). For Ottoman controls on Western photographers, see Esra Akcan, "Off the Frame: The Panoramic City Albums of Istanbul," in Behdad and Gartlan, *Photography's Orientalism*, pp. 93–114, especially p. 96.

17 See Quettier et al., *Sur les traces de Girault de Prangey*, pp. 83–89; Joseph-Philibert Girault de Prangey, "Lettre de M. Girault de Prangey," *Bulletin monumental* 9 (1843), pp. 159–62; and Cussy, "Nouvelles de M. Girault," pp. 235–38. The letters are addressed to the historian and antiquarian Désiré Raoul-Rochette, secretary of the Académie des Beaux-Arts; Alexis-François Artaud de Montor, former diplomat to the Holy Land and a member of the Académie des Beaux-Arts and the Académie des inscriptions et belles-lettres, among other institutions; and Jules Gailhabaud, author of several volumes of *Monuments anciens et modernes* (see note 4 above).

18 Joseph-Toussaint Reinaud, *Monumens arabes, persans et turcs du cabinet de M. le Duc de Blacas et d'autres cabinets: Considérés et décrits d'après leurs rapports avec les croyances, les mœurs et l'histoire des nations musulmanes* (Paris: Imprimerie Royale, 1828).

19 The ideas shared by Reinaud and Girault include the notion of an overarching cultural unity of Islamic art, although Girault stuck to the race-based definition, while Reinaud sometimes used the term *musulman*; that classic *spolia* in Islamic architecture were used for their superior quality and artistry; and that Arabs were nomads and had no architectural traditions (Reinaud, "Critique littéraire," pp. 339, 342; see also Labrusse, *Islamophilies*, pp. 100–101, and note 38 below). Joseph Dernburg [Derenbourg] and Nicolas Perron also translated for Girault.

20 The friars' hospitality would eventually displease the French aristocrat; see his letter to Artaud de Montor, in Quettier et al., *Sur les traces de Girault de Prangey*, pp. 87–88.

21 Correspondence between Schnetz and Raoul-Rochette, in François Fossier, ed., "Correspondance des directeurs de l'Académie de France à Rome," vol. 7, "Premier directorat de Jean-Victor Schnetz (1840–1843)," unpublished manuscript (previously available on the website of the Institut de France, accessed March 2018 [link discontinued]), pp. 246, 258, 283.

22 In his known letters Girault mentions the general consul of Alexandria, Gauttier d'Arc dy Lys, also an orientalist scholar; see Quettier et al., *Sur les traces de Girault de Prangey*, p. 83.

23 *Damas. 1843, prise de la terrasse Baudin* (BNF, EG7-763). Elodie Vigouroux ("Girault de Prangey à Damas," pp. 87–114) suggests that this photograph was taken, not from Baudin's terrace, as annotated on the daguerreotype, but from the roof of the consulate of France, which had opened in 1839. See ibid., fig. 7 and p. 103, for three other views that, when viewed together, may constitute a panorama of the city.

24 Portrayed are "Mme Virginie Vincent," in Aleppo, wearing a presumably local headdress and costume (BNF, EG3-731); "Mme Annette Langerrois," in Istanbul (BNF, EG3-727); and, in Cairo, "Mme Duvigneau," whose image was captured together with those of her daughters, and who may have been the wife of a doctor at the Ecole de medicine and member of Cairo's health council (BNF, EG3-840, -841).

25 Gérard Tisserand, *L'Egypte dans les collections des musées de Langres* (Langres, 1979). It is possible that Girault and Perron connected via common acquaintances in orientalist circles in Paris. Perron had studied with Antoine Isaac Silvestre de Sacy, the putative father of French orientalism, as had Girault's acquaintance Reinaud.

26 Saint-Simonians supported a nonmilitary colonization of North Africa, practiced through the perceived progressive forces of business and technology, to solve French social issues. Many, among them medical doctors, engineers, and architects working for Muhammad 'Ali, had settled in Egypt; see Pamela M. Pilbeam, *Saint-Simonians in Nineteenth-Century France: From Free Love to Algeria* (Basingstoke: Palgrave Macmillan, 2014), pp. 123, 135.

27 Scholars of architecture were especially shaken by theories that the Gothic developed from "Arab" architecture; see

Coste, *Architecture arabe*, p. 27; Prisse d'Avennes, *L'art arabe*, p. 252; Tonia Raquejo, "The 'Arab Cathedrals': Moorish Architecture as Seen by British Travellers," *Burlington Magazine* 128, no. 1001 (August 1986), pp. 555–63; and Mercedes Volait, "Les monuments de l'architecture arabe," in *Pascal Coste: Toutes les Egypte*, ed. Dominique Jacobi, exh. cat. (Marseille: Bibliothèque municipale/Parenthèses, 1998), pp. 116–17. This anxiety likewise emerges in the Royal Institute of British Architects' manual for travelers: "Notices upon any buildings in these styles ['Saracenic, Moresque and Siculo Norman Architecture'] are particularly requested, as affording probably some clue to the origin of Gothic Architecture, independently of their own intrinsic merits." See Royal Institute of British Architects, *How to Observe: Architecture [. . .]* (London: J. Davy and Sons, 1842), p. 34.

28 See Vernoit, "The Rise of Islamic Archaeology," pp. 1–10; Stephen Vernoit, "Islamic Art and Architecture: An Overview of Scholarship and Collecting, c. 1850–c. 1950," in *Discovering Islamic Art: Scholars, Collectors and Collections 1850–1950*, ed. Stephen Vernoit (London: I. B. Tauris, 2000), pp. 1–61; and *Journal of Art Historiography* 6 (June 2012), *Islamic Art Historiography*, special issue edited by Moya Carey and Margaret Graves, https://arthistoriography.wordpress.com/number-6-june-2012-2/.

29 Girault (*Essai sur l'architecture*, especially pp. 204–8) was not the first to subdivide "Arab" architecture in Spain into three styles; earlier examples known to him include Alexandre-Louis-Joseph de Laborde, *Voyage pittoresque et historique de l'Espagne* (Paris: P. Didot l'aîné, 1806–20); and James Cavanah Murphy, *The Arabian Antiquities of Spain* (London: Cadell and Davies, 1815), p. 4. For post-Enlightenment taxonomical approaches in Islamic art, see Margaret Graves, "Feeling Uncomfortable in the Nineteenth Century," *Journal of Art Historiography* 6 (June 2012), https://arthistoriography.files.wordpress.com/2012/05/graves.pdf, pp. 16–20.

30 Cussy, "Nouvelles de M. Girault," pp. 235–38. Whitewashing for sanitation purposes was consistent with the miasmatic theory of contagion of the time. The modernization process would eventually give rise to a modern Cairo shaped on European models and a distinct medievalized city; see Janet L. Abu-Lughod, *Cairo: 1001 Years of the City Victorious* (Princeton: Princeton University Press, 1971), chapters 6–7; and Paula Sanders, *Creating Medieval Cairo: Empire, Religion,*

and Architectural Preservation in Nineteenth-Century Egypt (Cairo: American University in Cairo Press, 2008). Some French scholars working in Cairo held nuanced positions on the loss of antiquity and on modernization, among them Pascal-Xavier Coste, an architect and engineer for Muhammad 'Ali; see Dominique Jacobi, ed., *Pascal Coste: Toutes les Egypte*.

31 Girault's information on the Ka'ba came from Johann Ludwig [John Lewis Burkhardt]'s memoir of his visit; see Girault de Prangey, *Essai sur l'architecture*, p. vi.

32 On the erasure of modernity from the field of Islamic art, see Flood, "From the Prophet to Postmodernism?," pp. 31–53. On medievalization, see Graves, "Feeling Uncomfortable," pp. 20–24. On modern Islamic arts, see Stephen Vernoit, *Occidentalism: Islamic Art in the 19th Century* (London: Nour Foundation, 1997); and Doris Behrens-Abouseif and Stephen Vernoit, *Islamic Art in the 19th Century: Tradition, Innovation, and Eclecticism* (Leiden: Brill, 2006).

33 Girault de Prangey, *Essai sur l'architecture*, pp. v–vi. Islam's notion of the *jahiliyya* (the "time of ignorance" before Islam), embraced by European orientalists, may have contributed to this idea of a cultural "desert."

34 For a constructive approach to anti-Arab bias in Islamic art, see Nuha N. N. Khoury, "The Dome of the Rock, the Ka'ba, and Ghumdan: Arab Myths and Umayyad Monuments," *Muqarnas* 10 (1993), pp. 57–65. For recent archaeological discoveries, see 'Alī Ibrahim al-Ghabbān et al., eds., *Roads of Arabia: Archaeology and History of the Kingdom of Saudi Arabia*, exh. cat. (Paris: Musée du Louvre/Somogy, 2010).

35 See Vernoit, "Islamic Art and Architecture," pp. 6–7. Ideas such as those espoused in Reinaud's writings would become entrenched later in the century when Emile Prisse d'Avennes (*L'art arabe*, p. 252) stated "nation semitique anti-artistique"; see Reinaud, *Monumens arabes, persans et turcs*, pp. iv, 27. Theories equating culture and race boomed in the mid-nineteenth century, notably with de Gobineau's *Essai sur l'inégalité des races humaines* (Paris: Firmin Didot, 1853–55). Demonstrating the longevity of racial theories in the historiography of Islamic art, K. A. C. Creswell famously expressed the "inherent temperamental dislike of Semitic races for representational art" in "The Lawfulness of Painting in Islam," *Ars Islamica* 11/12 (1946), p. 166.

36 Girault de Prangey, *Essai sur l'architecture*, pp. v, 194, 189,

208. Girault prized the "Moorish" style for its achievements in ornamentation which, he suggested, developed thanks to Arabs' knowledge of algebra. On the longstanding interpretation of Nasrid art as derivative in the historiography of Islamic art, and how recent approaches have moved beyond dualistic understandings of cultural influences, see Lara Eggleton, "History in the Making: The Ornament of the Alhambra and the Past-Facing Present," *Journal of Art Historiography* 6 (June 2012), https://arthistoriography.files.wordpress.com/2012/05/eggleton.pdf, especially pp. 6–7, 25; and Mariam Rosser-Owen, "Mediterraneanism: How to Incorporate Islamic Art into an Emerging Field," *Journal of Art Historiography* 6 (June 2012), https://arthistoriography.files.wordpress.com/2012/05/rosserowen.pdf, especially pp. 4, 8–10.

37 Girault (*Essai sur l'architecture*, p. vi) asserted that the first "Arab" monuments were "amorphous imitations of Greek and Roman works," and later ones were "incontestable imitations of Byzantine monuments and Greco-Roman buildings."

38 See Finbarr Barry Flood, "Inciting Modernity? Images, Alterities and the Contexts of 'Cartoon Wars,'" in *Images That Move*, ed. Patricia Spyer and Mart Margaret Steedly (Santa Fe: SAR Press, 2013), pp. 41–72. For Girault's (and Reinaud's) thoughts on figural images in Islamic art, see his *Essai sur l'architecture*, p. 154.

39 Claire Déléry ("Girault de Prangey: Vers une étude moderne de la céramique monumentale nasride," pp. 58–59) talks of Girault's modernity in relation to his methods, although Girault's Alhambra drawings are picturesque in comparison to later ones of the same building (see below in the text, p. 163). On the ways in which empirical representations contributed to decontextualized and ahistorical readings of the Alhambra, see Eggleton, "History in the Making," pp. 4, 8–20.

40 Especially in his illustrated *Souvenirs de Grenade*; see below in the text, p. 163, for later developments in Girault's practice. The term *Orient* is used here in relation to its nineteenth-century usage and the contemporary understanding of the region.

41 The practice was in keeping with the methods of the Académie de France in Rome, where students were asked to present two renderings of an antique building, an "actual-state drawing" and an "ideal reconstruction"; see Irene A.

Bierman, "Disciplining the Eye: The Project of Making Cairo Medieval," in *Making Cairo Medieval*, ed. Nezar AlSayyad, Irene A. Bierman, and Nasser Rabbat (Lanham, Md.: Lexington Books, 2005), pp. 9–27. See also Lorraine Decléty, "Les architectes français et l'architecture islamique: Les premiers pas vers l'histoire d'un style," *Livraisons d'histoire de l'architecture* 9 (2005), pp. 81–82.

42 Philip Carabott, Yannis Hamilakis, and Eleni Papargyriou, eds., *Camera Graeca: Photographs, Narratives, Materialities* (London: Routledge, 2015), pp. 79–80; Stewart, "In Perfect Order," pp. 79, 88; Elizabeth Meath Baker, "Alchemy on a Plate: The First Photographs of Istanbul," *Cornucopia* 29 (2003), pp. 34–49.

43 Girault de Prangey, *Monuments arabes d'Egypte*, "Mosquée d'Amrou, au Kaire" (plate 1). That Girault archived and inventoried his daguerreotypes attests to his continuous interest. Furthermore, some of his contemporaries seem to have known about his corpus of daguerreotypes: both Victor Mourot (*La Terre-Sainte et le pèlerinage*, pp. 106–7) and Prisse d'Avennes (*L'art arabe*, p. 252) mention them, as does Henry Brocard in his obituary of Girault ("M. Girault de Prangey," *Bulletin de la Société historique et archéologique de Langres* 4, no. 50 [July 1, 1893], p. 18).

44 See Quettier et al., *Sur les traces de Girault de Prangey*, p. 86. See also Cussy, "Nouvelles de M. Girault," pp. 235–36.

45 Compare, for example, his daguerreotypes of the Mosque of 'Amr ibn al-'As (pls. 58–63) and his lithograph of it in *Monuments arabes d'Egypte* (plate 5). The intuition that photography was more than a simple reflection of reality is, however, implied in the presentation of Girault's project at the Société française pour la conservation et la description des monuments historiques in January 1842: the daguerreotype was appreciated "especially in the hands of an artist [Girault] who knows how to use it in order to reproduce the subjects according to the angle and conditions more favorable to science"; see "Procès-verbal de la séance tenue à Paris par la Société française, le 20 et le 25 janvier 1842: Séance du 25 janvier 1842 à Paris," *Bulletin monumental* 8 (1842), p. 64. Significantly, photography elicited conflicting responses related to its artistic status, variously presented as a menace to artists, a help to architects, anti-artistic, arid, detailed, and deceiving.

46 James S. Ackerman, "On the Origins of Architectural Photography," in *This Is Not Architecture: Media Construction,* ed. Kester Rattenbury (London: Routledge, 2002), pp. 26–36; Neil Levine, "The Template of Photography in Nineteenth-Century Architectural Representation," *Journal of the Society of Architectural Historians* 71, no. 3 (September 2012), special issue, *Architectural Representations*, pp. 306–31; and Sibel Acar, "Intersecting Routes of Architectural Travel, Photography, and Survey Books in the Nineteenth Century," in *Nineteenth-Century Photographs and Architecture: Documenting History, Charting Progress, and Exploring the World*, ed. Micheline Nilsen (London: Routledge, 2013), pp. 75–92. For the early intersection of drawing and photography in archaeological practice, see Gabrielle Feyler, "Contribution à l'histoire des origines de la photographie archéologique: 1839–1880," *Mélanges de l'Ecole française de Rome: Antiquité* 99, no. 2 (1987), pp. 1045–47; Romain Siegenfuhr, "Les photographies du Caire peintes par Willem de l'amars Testas," in *The Myth of the Orient: Architecture and Ornament in the Age of Orientalism*, ed. Francine Giese and Ariana Varela Braga (Bern: Peter Lang, 2016), pp. 35–50; and Frederick N. Bohrer, *Photography and Archaeology* (London: Reaktion Books, 2011), especially chapter 1 (emphasizing the ambiguity of "truth" in early photographs of antiquities).

47 See Linda Nochlin, "The Imaginary Orient," *Art in America* 71 (1983), pp. 118–31; and Behdad, *Camera Orientalis*, chapter 1.

48 See, e.g., *Jérusalem. Mendiant* (BNF, EG2-786) and *Assouan. Jeune Nubienne. 226* (BNF, EG2-706), both dating to 1842–44. For Girault's French sitters, see note 24 above. Local subjects are largely absent from architectural and archaeological photographs or made subordinate to the landscape, for example, in *Aphrodisias* (*Aphrodisias. Col.* [. . .] *1er plan. [Femme assise de dos au milieu des ruines]*), 1842–44 (BNF, EG2-714). This last approach is in line with the practice of "depopulating the Orient," for which see Ali Behdad, "The Orientalist Photograph," in Behdad and Gartlan, *Photography's Orientalism*, pp. 11–32, especially p. 24. One portrait attributed to Girault in the Qatar Museums, Doha (IM.21994), depicts a dignified Abdullah, son of the Sharif of Mecca (Muhammad Ibn 'Abd al Mu'in, appointed by Muhammad 'Ali Pasha at the time of Girault's travels). If the attribution is confirmed, it may show that Girault reserved a different attitude for Arab elites.

49 In at least one instance, Girault also left his Western subjects unnamed; see *Portrait de deux jeunes femmes aux yeux baissés*, 1842–44 (BNF, EG2-719).

50 For staging in orientalist photography, see Behdad, *Camera Orientalis*, pp. 35–39. In addition to Girault's portrait of "Ayoucha" in this volume (pl. 66), see the one illustrated by Nick Leech in "Looking East from West: Orientalism at the Louvre Abu Dhabi," which has been described as the "earliest known photographic depiction of a veiled woman from the Islamic World" (https://writingtoinform.com/2013/05/26/looking-east-from-west-orientalism-at-the-louvre-abu-dhabi/).

51 For a discussion on how the orientalist gaze operates in the context of Cairo architecture, see Bierman, "Disciplining the Eye," in AlSayyad, Bierman, and Rabbat, *Making Cairo Medieval*, pp. 9–27; and Timothy Mitchell, *Colonising Egypt* (Cambridge: Cambridge University Press, 1988), chapter 1. On the discriminatory vision, this time historical, of Girault's architectural photography in Athens, see Frederick N. Bohrer, "Doors into the Past: W. J. Stillman (and Freud) on the Acropolis," in Carabott, Hamilakis, and Papargyriou, *Camera Graeca*, pp. 95–112.

52 Girault's richly ornamented *Souvenirs de Grenade*, probably intended for a broader public, often depicts fantasized characters, while the densely populated scenes of *Monuments arabes d'Egypte* represent a more plausible variety of figures and activities. Plates with arranged architectural details are in all cases more rigorously architectural and devoid of any figures (apart from those included for scale). The same is true for the images in the more scholarly *Essai sur l'architecture*, the only exception being the lithograph of the Tunisian Bardo, perhaps originally prepared for *Souvenirs de Grenade*.

THE PLEASURE OF RUINS

1 Letter reproduced in Philippe Quettier et al., *Sur les traces de Girault de Prangey, 1804–1892: Dessins-peintures, photographies, études historiques* (Langres: Musées de Langres/Dominique Guéniot, 1998), pp. 83–85, the quoted passage on p. 84; my translation from the original French.

2 I owe a great debt to Lindsey S. Stewart, "In Perfect Order: Antiquity in the Daguerreotypes of Joseph-Philibert Girault de Prangey," in *Antiquity and Photography: Early Views of Ancient Mediterranean Sites*, ed. Claire L. Lyons, exh. cat. (Los Angeles: J. Paul Getty Museum, 2005), pp. 66–91. Stewart

also wrote the informative lot descriptions for two major auctions, *Important Daguerreotypes by Joseph-Philibert Girault de Prangey from the Archive of the Artist*, both held at Christie's in London, part I on May 20, 2003, and part 2 on May 18, 2004.

3 The felicitous term is James Buzard's in *The Beaten Track: European Tourism, Literature, and the Ways to Culture, 1800– 1918* (Oxford: Clarendon Press, 1993), p. 155.

4 I have discussed some of the links between Roman *vedute* and photographs in "'Rambles in Rome': Some 19th-Century Travellers and Photographers," in *Britannia, Italia, Germania: Taste and Travel in the Nineteenth Century*, ed. Carol Richardson and Graham Smith (Edinburgh: Visual Arts Research Institute, 2001), pp. 6–22.

5 Although Girault's daguerreotypes are almost certainly the earliest surviving actual photographs of Rome, at least one other daguerreotypist had preceded him, making eleven images of Roman sites for Noël-Paymal Lerebours's *Excursions daguerriennes*. For that book, however, the original daguerreotypes, now lost, were transcribed by artists and reproduced as prints, often with fanciful additions. The same is true for the three views from Athens. The Roman views are collected in Italo Zannier, "Excursions Daguerriennes in Italia," *Fotologia* 10 (1988), pp. 6–17.

6 See Andrew Szegedy-Maszak, "A Perfect Ruin: Nineteenth-Century Views of the Colosseum," *Arion* 2, no. 1 (1992), pp. 115–42.

7 Any discussion of the "view from above" must begin with Roland Barthes's essay on the Eiffel Tower in Roland Barthes, *The Eiffel Tower and Other Mythologies*, trans. Richard Howard (New York: Hill and Wang, 1979), pp. 3–17. See also John A. Pinto, *City of the Soul: Rome and the Romantics*, exh. cat. (New York: Morgan Library and Museum; Hanover, N.H.: University Press of New England, 2016), pp. 56–59.

8 Christophe Mauron, ed., *Miroirs d'argent: Daguerréotypes de Girault de Prangey*, exh. cat. (Bulle: Musée Gruérien; Geneva: Slatkine, 2008), pp. 52–53.

9 Ibid., p. 52, notes that Girault used the format most appropriate to his subject. See also Stewart, "In Perfect Order," p. 72; and Pinto, *City of the Soul*, pp. 80–81.

10 It was called the Temple of Vesta in the nineteenth century because of its circular shape, familiar from other shrines to the same goddess. Since then it has undergone multiple renamings and is now sometimes referred to simply as "the round temple"; see Amanda Claridge, *Rome: An Oxford Archaeological Guide* (Oxford: Oxford University Press, 2010), pp. 287–88. Filippo Coarelli identifies it as the Temple of Hercules Victor; see Filippo Coarelli, *Rome and Environs: An Archaeological Guide*, trans. James J. Clauss and Daniel P. Harmon (Berkeley: University of California Press, 2014), pp. 316–18.

11 The temple is "Rome's oldest almost completely marble building"; see Coarelli, *Rome and Environs*, p. 316. See also Andrew Szegedy-Maszak, "Roman Views," in *Six Exposures: Essays in Celebration of the Opening of the Harrison D. Horblit Collection of Early Photography* (Cambridge, Mass.: Houghton Library, Harvard University, 1999), pp. 89–106, especially pp. 99–102.

12 One is in a private collection and is included in the present exhibition (pl. 24). The other is in the collection of the J. Paul Getty Museum, Los Angeles (2003.82.1).

13 Pinto, *City of the Soul*, p. 80.

14 See Andrew Szegedy-Maszak, "Forum Romanum/Campo Vaccino," *History of Photography* 20, no. 1 (1996), pp. 24–32.

15 For the new Greek state's use of antiquity in forming its identity, see Yannis Hamilakis, *The Nation and Its Ruins: Antiquity, Archaeology and National Imagination in Greece* (Oxford: Oxford University Press, 2007), especially pp. 57–123.

16 Richard Clogg, *A Concise History of Greece* (Cambridge: Cambridge University Press, 1992), p. 50.

17 Some illustrations of the Athenian antiquities had been published: in 1758, there appeared Julien David Le Roy's *Les ruines des plus beaux monuments de la Grèce*, followed in 1762 by the first of the multivolume *Antiquities of Athens Measured and Delineated*, by two Englishmen, James Stuart and Nicholas Revett. Although Stuart and Revett's work was very influential in the development of the Greek Revival in architecture and contributed to Romantic Philhellenism, it did not become part of the popular imagination.

18 Jeffrey Hurwit, "Space and Theme: The Setting of the Parthenon," in *The Parthenon from Antiquity to the Present*, ed. Jenifer Neils (Cambridge: Cambridge University Press, 2005), pp. 9–33.

19 See Andrew Szegedy-Maszak, "'Well Recorded Worth': Photographs of the Parthenon," in *The Parthenon from Antiquity to the Present*, pp. 331–62, especially pp. 334–36; Haris Yiakoumis, *Hē Akropolē tōn Athēnōn: Phōtographies, 1839– 1959/The Acropolis of Athens: Photographs, 1839–1959/ L'Acropole d'Athènes: Photographies, 1839–1959* (Athens: Potamos; Paris: Picard, 2000), especially pp. 123–35; and Fani Constantinou et al., eds., *Athens 1839–1900: A Photographic Record*, exh. cat. (Athens: Benaki Museum, 2004), pl. 44.

20 Stewart, "In Perfect Order," p. 79 and fig. 7. See also Mauron, *Miroirs d'argent*, p. 55; and Weston J. Naef, *Photographers of Genius at the Getty*, exh. cat. (Los Angeles: J. Paul Getty Museum, 2004), p. 20 and pl. 6.

21 The demolition of the mosque was part of an extensive program, sponsored by the Greek government, to expunge from the Acropolis any buildings that were not from the high Classical period. See Hamilakis, *The Nation and Its Ruins*, pp. 86–99; and Richard A. McNeal, "Archaeology and the Destruction of the Later Athenian Acropolis," *Antiquity* 65 (1991), pp. 49–63.

22 Frederick N. Bohrer, *Photography and Archaeology* (London: Reaktion Books, 2011), p. 45.

23 He also photographed the temple itself; it had been reconstructed a few years earlier as part of the Acropolis restoration project. Girault's picture shows it before the installation across its front of a metal barrier that was used to guard the sculptures, including the Nike, stored in the interior.

24 Following the nineteenth-century custom of using the Latin names for the Greek gods, Girault called it the temple of "Minerva Polias." In antiquity the temple had housed an ancient olive-wood statue, said to have fallen from the sky and revered as Athena Polias; the epithet "Polias" denotes her status as patron of the city (*polis*).

25 In 1806 Lord Elgin took one of the caryatids, which is now in the British Museum, London. In 1978, to protect them from more damage by pollution, the five remaining caryatids were removed from the porch and have recently been installed in the new Acropolis Museum.

26 See Nissan N. Perez, *Focus East: Early Photography in the Near East (1839–1885)* (New York: Abrams, 1988), pp. 167–68.

27 Girault made some one hundred pictures in Baalbek; see Stewart, "In Perfect Order," pp. 79, 84–87.

DAGUERREOTYPE WORK IN FRANCE

This essay is an abridged version of the French text "Girault de Prangey, photographe en France: De la pierre à la plante (daguerréotypes et photographies sur papier)." It does not

address portraiture; for Girault's work in this genre, the known examples of which were almost exclusively made abroad, see the essay in this volume by Stephen C. Pinson (pp. 9–25). I warmly thank Sylvie Aubenas, Stephen C. Pinson, Martyna Zielinska, Julia Bihel, Nora W. Kennedy, Flora Triebel, Marie Langevin, Anne Roquebert, and Stéphane Guégan.

1 See the correspondence initiated in 1948 between comte Charles de Simony and Jean Prinet, curator in the Département des Estampes et de la photographie, Bibliothèque nationale de France, Paris (hereafter BNF) (Estampes, YE-218-4, BNF); I am grateful to Sylvie Aubenas for sharing it with me. As noted by Sylvie Aubenas, it was with regard to the plates later donated to the BNF that Jean Adhémar and Jacques Lethève would point out, in 1955, that Girault "is the author of several lithographs, as well as more interesting photographs"; see *Inventaire du fonds français après 1800* (Paris: Bibliothèque nationale de France, 1955), vol. 9, p. 164. See also Sylvie Aubenas, "La redécouverte d'un précurseur: Joseph-Philibert Girault de Prangey (1804–1892)," in *Le Caire dessiné et photographié au XIXe siècle*, ed. Mercedes Volait (Paris: Picard, 2013), p. 193, n. 11.

2 That is, according to current knowledge, about 15 percent of his overall corpus, as based on the generally agreed-upon assessment of one thousand plates. For an estimate of about 144 as the number of "French" plates in Charles de Simony's collection, see Lindsey S. Stewart, "In Perfect Order: Antiquity in the Daguerreotypes of Joseph-Philibert Girault de Prangey," in *Antiquity and Photography: Early Views of Ancient Mediterranean Sites*, ed. Claire L. Lyons, exh. cat. (Los Angeles: J. Paul Getty Museum, 2005), p. 209, n. 10.

3 For hypotheses relating to Girault's training and his exceptional means of supply for photographic materials, see the essay in this volume by Stephen C. Pinson (pp. 9–25), and for the formats and materiality of the plates, see that by Silvia A. Centeno et al. (pp. 182–89).

4 In 1841, Girault was living at 1, rue des Filles-Saint-Thomas, but in the booklet for the Salon of 1836, the artist's address is given as 1, place du Carrousel.

5 For more on Girault's interest in and work toward preserving France's cultural heritage, see Sylvie Aubenas in this volume, pp. 1–7. On Girault's earliest involvement, see also

Joseph-Philibert Girault de Prangey, "Langres: Fragments gallo-romains, au musée," *Mémoires de la Société historique et archéologique de Langres* (hereafter *MSHAL*) 1, no. 3 (1848), p. 42; and an article he co-wrote with other members of the society, "Origine et constitution de la Société historique et archéologique de Langres," *MSHAL* 1, no. 1 (1847), p. ii.

6 In addition to Girault's orientalist publications, see Nicolas-Marie-Joseph Chapuy and Philippe Moret, *Le Moyen-Age pittoresque: Monuments et fragments d'architecture, meubles, armes, armures, et objets de curiosité du Xe au XVIIe siècle* (Paris: Veith et Hauser, 1837–40), for which Girault contributed eleven plates, including one view of Amiens Cathedral.

7 Fizeau's plate, first announced by Lerebours and then distributed as a "scoop" on the new process exclusively to subscribers, would appear as plate 24 in volume 2 of *Excursions daguerriennes* (1843–44).

8 Daniel Ramée and Nicolas-Marie-Joseph Chapuy, *Le Moyen-Age monumental et archéologique: Vues, détails et plans des monuments les plus remarquables de l'Europe, depuis le 6e jusqu'au 16e siècle* (Paris: A. Hauser, 1840–45), plate 95. Girault also contributed views of Sicily (plates 35, 371) and Spain (plates 183, 394). It should be noted that plate 95, like many others in *Le Moyen-Age monumental*, would be republished in 1863—long after Girault had ceased his publishing activities—as plate 43 in Daniel Ramée, *Sculptures décoratives, recueillies en France, Allemagne, Italie et Espagne, du XIIe au XVIe siècle* (Paris: Lévy, 1863).

9 The fountain was located across from Daguerre's diorama, which burned down in March 1839, and close to the studio that the inventor kept at 17, boulevard Saint-Martin.

10 "Les Fontaines de Paris," *Le Petit Journal*, August 4, 1872, p. 3, mentions the very fountain "formerly so admired for its beautiful effects of freezing during the period of extreme cold."

11 Charles de Simony, letter to Jean Prinet, March 6, 1948, Estampes, YE-218-4, BNF.

12 The Fontaine du Square Louvois, also known as Fontaine Richelieu, was erected in 1839; the Château d'Eau, in 1811; and the so-called Fontaine du Palmier (or de la Victoire), in 1808. Girault's dual interest in fountains and recent buildings also inspired some rare plates made in Switzerland: the Gothic and Renaissance fountains Fischmarktbrunne and Spalenbrunnen, as well as the Neoclassical Schilthof, all in Basel; and the Neo-Gothic Château de l'Aile,

in Vevey. See Christophe Mauron, ed., *Miroirs d'argent: Daguerréotypes de Girault de Prangey*, exh. cat. (Bulle: Musée Gruérien; Geneva: Slatkine, 2008).

13 Charles Philipon, ed., *Paris et ses environs reproduits par le daguerréotype* (Paris: Aubert, 1840), is an example of one such publication. In addition to the Fontaine des Innocents (plate 4 in that publication), it includes an image of the Fontaine du Square Louvois (plate 46) and, most notably, the image of the Château d'Eau in the depths of winter (plate 27). See also the work of Philippe Benoist in collaboration with Louis-Julien Jacottet in *Promenades dans Paris et ses environs: Dessiné d'après nature et lithographié par J. Jacottet* (Paris: Gihaut Frères, n.d.). Of the six images of fountains included therein, all drawn and lithographed by Benoist, two are of the Château d'Eau (1838, plate 12; 1843, plate 12 *bis*), and one of the Fontaine du Square Louvois is presented alongside one of the Fontaine du Palmier as a single plate (1840, plate 38). The remaining two, which would have made a logical continuation of Girault's presumed series, portray the Fontaine des Innocents (1839, plate 29) and one of the fountains at the place de la Concorde (1840, plate 40).

14 Joseph-Philibert Girault de Prangey, "Lettre de M. Girault de Prangey," *Bulletin monumental* 9 (1843), p. 159.

15 In the inventory of his collection, the comte de Simony mentions Langres, Le Pailly, and Chaumont as the locations for an indeterminate number of plates. According to Philippe Quettier, the Société historique et archéologique de Langres (SHAL) would have "owned several hundred" of Girault's daguerreotypes of which we have lost track today, as the present directors of the society confirm. Philippe Quettier, "La villa Girault de Prangey à Courcelles-Val-d'Esnoms: Approche critique et essai de reconstitution," *Bulletin de la Société historique et archéologique de Langres* (hereafter *BSHAL*) 22, no. 330 (1998), p. 366, which, however, cites an erroneous source.

16 Both lithographs appeared in *MSHAL*, the first accompanying the article by Girault cited in note 5 above ("Langres: Fragments gallo-romains," pp. 41–44), and the second an article by Léon Godard ("Esquisse de l'histoire de Chaumont en Bassigny," *MSHAL* 1, no. 6, pp. 115–34).

17 The lithograph is an illustration for Joseph-Philibert Girault de Prangey, "Langres: Porte Gallo-Romaine," *MSHAL* 1, no. 2 (1848), pp. 3–11.

18 Joseph-Philibert Girault de Prangey, "Langres: Porte des Moulins," *MSHAL* 1, no. 2 (1848), p. 30. Because the illustrations in this article are not credited, it is very likely that they were supplied by the author. On the back of the original frame of the plate that served as a model, at top left, is the handwritten inscription "Girad." We propose that this may be read as the name *Girault*, transformed into "Giraud," as often happened in the photographer's lifetime.

19 This pertains, for example, to the daguerreotypes in the Musées de Langres that came from the former collection of Henry Brocard, an architect and archaeologist involved in the restoration of local monuments, who was also the curator of the Musées de Langres, president of the SHAL, and the author of an obituary on Girault in 1893. See Henry Brocard, "M. Girault de Prangey," *BSHAL* 4, no. 50 (July 1, 1893), pp. 15–21.

20 Joseph-Philibert Girault de Prangey, "Langres: Longe-Porte," *MSHAL* 1, no. 6 (1850), p. 140. He made the statement in regard to plate 22, "Musée de Langres: Fragments gallo-romains (10e d'exécution)."

21 Girault de Prangey, "Langres: Longe-Porte," pp. 135–41, suggests the possibility of other comparable excursions, such as to the Gallo-Roman site of Autun.

22 This box, containing sixty-one supposedly "Swiss subjects," was the one that Simony donated in 1950 to the Musée Gruérien in Bulle. All share the same optical, chemical, and dimensional aspects ($3\frac{1}{8} \times 3\frac{1}{2}$ in. [8 × 9 cm]). A third "French subject" found in the box was the Church of Avrigney in Haute-Saône, 50 miles (80 km) from Langres. For the dating between 1845 and 1850 based on historical criteria relative to the Swiss sites depicted, see Mauron, *Miroirs d'argent*.

23 In addition to his known studies of rocks (at Philae) and plants (at Baalbek), Girault was particularly interested in trees typical of the regions through which he traveled: cypress and pines in Italy; palms in Greece and Egypt, where he also photographed cactus; and so on. His botanical and historical interests merged in the cedars of King Solomon in Lebanon and the plane trees of Godfrey of Bouillon in Turkey—"monuments" in their own right.

24 Girault's penchant for flora may have been shared with Ziegler, who in his youth "took most of the courses [in the sciences] taught at the Sorbonne and at the Jardin des Plantes";

see Théodore Pistolet de Saint-Ferjeux, "Ziegler, Jules Claude," in *Biographie universelle ancienne et moderne* […], ed. Louis Gabriel Michaud and Joseph François Michaud (Paris: Desplaces; Leipzig: Brockhaus, 1843–65), vol. 45, p. 518. Girault was surely inspired by his teacher Jules Coignet, whose drawings of trees of many species were widely disseminated as lithographs between the end of the 1820s and the 1830s. Between the late 1830s and early 1840s, this interest of Girault's may have been heightened through possible contacts with notable figures from the Jardin des Plantes, such as Adrien de Jussieu and Frédéric Cuvier, who, like himself, Ziegler, and Coignet, were members of the Cercle des arts; for a list of members by year, see the *Annuaire du Cercle des arts: Contenant la liste des membres, les statuts et le règlement intérieur du Cercle* (Paris: Crapelet, 1838–73).

25 Simony mentions "flower studies" in his inventory.

26 See the thistles portrayed by Brébisson (BNF, EG4-646) and the grapes by Foucault (Société française de photographie, Paris, 151-12).

27 The painter's talent for depicting plants and flowers, which would lead to his recognition as a true botanist by Théophile Gautier, is particularly evident in three paintings conserved in the Musées de Langres: *La rosée répand ses perles sur les fleurs* (1844), *La Vierge de Bourgogne* (about 1845), and *Pluie d'été* (1850, on loan from the Musée de Saint-Dizier). On Ziegler, see Stéphane Guégan, "Jules Ziegler: Peintre" (PhD diss., Université Paris-Sorbonne IV, 2000; my thanks to Stéphane Guégan for sharing a copy); and Jacques Werren, *Jules Ziegler: Peintre, céramiste, photographe* (Le Mans: Reinette, 2010).

28 "We lament those old walls of our native city that are disappearing …; we miss the ivy, the wild plants that made our ramparts, which they adorned, so dear to painters" (Girault de Prangey, "Langres: Longe-Porte," p. 141). See also Arcisse de Caumont, *Le pittoresque nous déborde* (Caen: A. Hardel, n.d.).

29 This is the spelling used by Girault in his captions, although the name also appears as "Dhuy," "Dhuis," and "Duys."

30 The subject of the tree surrounded by rocks also appears in two other plates, one located in Le Pailly. The inventory of the Simony collection locates an indeterminate number of plates made in this town, about eight miles from Langres.

Are they studies from nature, landscapes, and/or views of the castle, perhaps connected with Girault's architectural drawings that were subsequently lithographed for *MSHAL* 1, no. 10 (1858), plates 29, 30 (ca. 1851)?

31 Girault's interest in vernacular mountain architecture was stimulated by his first trip to Switzerland, in 1834, and led to his production of several daguerreotypes of chalets when he returned.

32 See Robert Flocard, letter to Philippe Quettier, December 16, 1997, Musées de Langres (my thanks to Stephen C. Pinson for sharing a copy). See also the sectional plan of the villa at the Musées de Langres, reproduced in Quettier, "La villa Girault de Prangey," p. 371.

FROM DRAWING TO PHOTOGRAPHY: IMAGE-PRODUCTION TECHNIQUES

1 *Vue de Grenade et de la Sierra Nevada*, however, is additionally published in sepia. Joseph-Philibert Girault de Prangey, *Monuments arabes et moresques de Cordoue, Séville et Grenade, dessinés et mesurés en 1832 et 1833* (Paris: Veith et Hauser, 1836–39). It is worth noting that four-color chromolithography was developed only in 1836, by Godefroy Engelmann, meaning that Girault would not have known about it during his first journey.

2 Out of ten line drawings in black, with subsequent enhancements in brown and white. Of the currently known body of work, no monuments documented during this trip were depicted in both black and white and in color.

3 The fact that the image is printed off-center and on the back of another, unrelated print confirms that it was a proof, meant to be checked by the artist.

4 Joseph-Philibert Girault de Prangey, *Monuments et paysages de l'Orient: Algérie, Tunis, Egypte, Syrie, Asie-Mineure, Grèce, Turquie: Lithographies exécutées en couleur d'après ses aquarelles* (Paris: Lemercier, 1851). The title page indicates that "a historical and descriptive text will accompany each plate in subsequent reprints," but that intention was never realized.

5 We may hypothesize that the Fonds Flocard bears evidence of the preparatory work for the 1851 volume: fourteen of the original images used in that volume figure in this collection. It would be the artist's final work for publication, and this selection remained unchanged.

6 This hypothesis was originally formulated by Christophe Dutoit, "Dessinateur, historien de l'architecture, photographe, botaniste: Le regard monumental de Girault de Prangey," in *Miroirs d'argent: Daguerréotypes de Girault de Prangey*, ed. Christophe Mauron, exh. cat. (Bulle: Musée Gruérien; Geneva: Slatkine, 2008), p. 37.

7 Joseph-Philibert Girault de Prangey, *Monuments arabes d'Egypte, de Syrie et d'Asie-Mineure, dessinés et mesurés de 1842 à 1845* (Paris: J.-P. Girault de Prangey, 1846).

8 Private collection, sale Christie's, November 12, 2015, lot 14. The work measures 7½ by 9⁷⁄₁₆ inches, or 19 by 24 centimeters. Some horse-drawn carriages sketched in the foreground are also visible in the photograph. Girault chose to record their silhouettes, no doubt so as to animate the future print.

9 In addition, the obelisk is shifted slightly to the right, to avoid interference with the curve of the basilica's dome.

10 Titles are those of the corresponding lithographs. The daguerreotype of *Palais de Rhamsès, à Thèbes* bears the note "Thèbes Rhamséion."

11 See the title page of the copy of *Monuments et paysages de l'Orient* held by the Victoria and Albert Museum National Art Library, London, General Collection (46.E.53).

"UN DAGUERRÉOTYPE MONSTRE"

The authors would like to thank the Bibliothèque nationale de France, Paris, and the Qatar Museums, Doha, for generously opening their collections of Girault's daguerreotypes to us. We likewise thank colleagues at the Harry Ransom Center at the University of Texas at Austin; the J. Paul Getty Museum, Los Angeles; and the Rijksmuseum, Amsterdam, for sharing information about the Girault plates in their collections. Arthur Kaplan, Research Lab Associate at the J. Paul Getty Museum, and Martin Jürgens, Conservator at the Rijksmuseum, contributed analyses for two Getty and one Rijksmuseum daguerreotypes to the data presented in fig. 59. Thanks also to Metropolitan Museum colleagues Marlene Yadresevits, Ted Hunter, Sean Belair, Anne Grady, and Natasha Kung for sharing their expertise.

1 See Jean-Victor Schnetz, letter to Désiré Raoul-Rochette, April 20, 1842, in François Fossier, ed., "Correspondance des directeurs de l'Académie de France à Rome," vol. 7, "Premier directorat de Jean-Victor Schnetz (1840–1843)," unpublished manuscript (previously available on the website of the Institut de France, Paris, accessed March 2018 [link discontinued]), pp. 241–48: "He pretends to do extraordinary things with his perfected instrument; [but] to the naked eye, these improvements of which he so flatters himself are hardly anything at all"; and Pierre de Cussy, "Nouvelles de M. Girault de Prangey," *Bulletin monumental* 10 (1844), pp. 235–38: "It is by means of a *monster* daguerreotype (forgive me the expression)."

2 The first practical photographic camera designed by Daguerre and offered for public sale in August 1839 employed a 6 by 8–inch plate, measured then by the Paris inch (6½ by 8½ imperial inches); see Noël-François-Joseph Buron, *Description de nouveaux daguerréotypes perfectionnés et portatifs* (Paris: N.-F.-J. Buron, 1841), pp. 43–47.

3 Marc-Antoine Gaudin and Noël-Paymal Lerebours, *Derniers perfectionnements apportés au daguerréotype* (Paris: N.-P. Lerebours, 1841).

4 Ibid., pp. 5, 26–27.

5 Noël-Paymal Lerebours, *A Treatise on Photography: Containing the Latest Discoveries and Improvements Appertaining to the Daguerreotype*, trans. John Egerton (London: Longman, Brown, Green and Longmans, 1843), p. 45.

6 Thomas Willats and Richard Willats, "Catalogue of Photographic Apparatus, Chemical Preparations, and Materials," in Gustave Le Gray, *A Practical Treatise of Photography, upon Paper and Glass*, trans. Thomas Cousins (London: T. and R. Willats, 1850).

7 Lindsey S. Stewart, "Important Daguerreotypes by Joseph-Philibert Girault de Prangey from the Archive of the Artist," in *Important Daguerreotypes by Joseph-Philibert Girault de Prangey from the Archive of the Artist*, sale cat. (Christie's, London, May 20, 2003), pp. 8–11.

8 See "Chronique: Retour de M. Girault de Prangey," *Bulletin monumental* 11 (1845), p. 317: "he traveled in the Orient for three years … [he] is about to return to Paris, laden with a rich crop of observations and views taken by Daguerreotype: one puts the number of views daguerreotyped by M. de Prangey at 3,000."

9 François Arago, "Fixation des images photogéniques sur métal," *Comptes rendus hebdomadaires des séances de l'Académie des sciences* 10 (March 23, 1840), p. 488; Hippolyte Fizeau, "Note sur un moyen de fixer les images photographiques," *Comptes rendus hebdomadaires des séances de l'Académie des sciences* 11 (August 10, 1840), pp. 237–38.

10 Emmanuelle A. Marquis et al., "Exposing the Sub-Surface of Historical Daguerreotypes and the Effects of Sulfur-Induced Corrosion," *Corrosion Science* 94 (2015), pp. 438–44, recently demonstrated that, even though the presence of gold in the image initially confers stability, it may also accelerate the development of porosity beneath the image layer, causing mechanical instability in the long term.

11 Charles Chevalier, *Nouvelles instructions sur l'usage du daguerréotype: Description d'un nouveau photographie, et d'un appareil très simple destiné à la reproduction des épreuves au moyen de la galvanoplastie* (Paris: C. Chevalier, 1841), p. 43; Gaudin and Lerebours, *Derniers perfectionnements*, pp. 35–37.

12 XRF spectroscopy was used to detect the presence of gold and other elements on 108 daguerreotypes by Girault. Of these, 45 showed the absence of gold, suggesting that the gilding process was not performed.

13 Thanks to Marijn Manuels, Conservator, Sherman Fairchild Center for Objects Conservation, The Metropolitan Museum of Art, for his examination and analysis of the plate boxes.

14 Noninvasive Raman spectroscopy analysis of a small group of daguerreotypes by Girault in the collection of the Metropolitan Museum revealed the presence of cyanide residues on the images and/or their versos. Although other sources of cyanide are possible, this is a likely indication that these plates were subjected to cleaning treatments with cyanide solutions in the past; see Lee Ann Daffner, Dan Kushel, and John M. Messinger III, "Investigation of a Surface Tarnish Found on 19th-Century Daguerreotypes," *Journal of the American Institute for Conservation* 35, no. 1 (Spring 1996), pp. 9–21.

Bibliography

PUBLICATIONS BY GIRAULT DE PRANGEY

Monuments arabes et moresques de Cordoue, Séville et Grenade, dessinés et mesurés en 1832 et 1833. Part 1, *Mosquée de Cordou: Vues génerales intérieurs, détails et plans dessinés et mesurés sur les lieux en 1833 par Girault de Prangey*; part 2, *La Giralda et l'Alcazar de Séville*; part 3, *Souvenirs de Grenade et de l'Alhambra par Girault de Prangey: Lithographies exécutées d'après ses tableaux, plans et dessins faits sur les lieux en 1832 et 1833*. Paris: Veith et Hauser, 1836–39.

"Considerations sur l'architecture arabe." *Bulletin monumental* 6 (1840), pp. 477–83.

"Rapport de M. de Prangey," *Bulletin monumental* 6 (1840), pp. 325–31.

Essai sur l'architecture des Arabes et des Mores, en Espagne, en Sicile et en Barbarie. Paris: A. Hauser, 1841.

Choix d'ornements moresques de l'Alhambra: Ouvrage faisant suite à l'atlas in-folio Monuments arabes et moresques de Cordoue, Séville et Grenade. [Co-written with Jules Peyre and Léon-Auguste Asselineau.] Paris: A. Hauser, 1842.

"Lettre de M. Girault de Prangey." *Bulletin monumental* 9 (1843), pp. 159–62.

Monuments arabes d'Egypte, de Syrie et d'Asie-Mineure, dessinés et mesurés de 1842 à 1845. Paris: J.-P. Girault de Prangey, 1846.

"Langres: Porte des Moulins." *Mémoires de la Société historique et archéologique de Langres* 1, no. 2 (1848), pp. 29–33.

"Langres: Porte Gallo-Romaine." *Mémoires de la Société historique et archéologique de Langres* 1, no. 2 (1848), pp. 3–11.

"Langres: Fragments gallo-romains, au musée." *Mémoires de la Société historique et archéologique de Langres* 1, no. 3 (1848), pp. 41–44.

"Langres: Longe-Porte." *Mémoires de la Société historique et archéologique de Langres* 1, no. 6 (1850), pp. 135–41.

Monuments et paysages de l'Orient: Algérie, Tunis, Egypte, Syrie, Asie-Mineure, Grèce, Turquie: Lithographies exécutées en couleur d'après ses aquarelles. Paris: Lemercier, 1851.

ADDITIONAL REFERENCES

Abu-Lughod, Janet L. *Cairo: 1001 Years of the City Victorious*. Princeton: Princeton University Press, 1971.

Acar, Sibel. "Intersecting Routes of Architectural Travel, Photography, and Survey Books in the Nineteenth Century." In *Nineteenth-Century Photographs and Architecture: Documenting History, Charting Progress, and Exploring the World*, edited by Micheline Nilsen, pp. 75–92. London: Routledge, 2013.

Ackerman, James S. "On the Origins of Architectural Photography." In *This Is Not Architecture: Media Construction*, edited by Kester Rattenbury, pp. 26–36. London: Routledge, 2002.

Adhémar, Jean, and Jacques Lethève. *Inventaire du fonds français après 1800*, vol. 9. Paris: Bibliothèque nationale de France, 1955.

Annuaire du Cercle des arts: Contenant la liste des membres, les statuts et le règlement intérieur du Cercle. Paris: Crapelet, 1838–73.

Arago, François. "Fixation des images photogéniques sur métal." *Comptes rendus hebdomaires des séances de l'Académie des sciences* 10 (March 23, 1840), p. 488.

Aubenas, Sylvie. "La redécouverte d'un précurseur: Joseph-Philibert Girault de Prangey (1804–1892)." In *Le Caire dessiné et photographié au XIXe siècle*, edited by Mercedes Volait, pp. 183–94. Paris: Picard, 2013.

Aubenas, Sylvie, and Jacques Lacarrière. *Voyage en Orient*. Paris: Hazan, 1999.

Aubert, Eléosyppe, et al. "Origine et constitution de la Société historique et archéologique de Langres." *Mémoires de la Société historique et archéologique de Langres* 1 (1847), pp. i–vi.

Bahrani, Zainab, Zeynep Çelik, and Edhem Eldem, eds. *Scramble for the Past: A Story of Archaeology in the Ottoman Empire, 1753–1914*. Exh. cat. Istanbul: SALT Galata, 2011.

Bajac, Quentin, and Dominique Planchon-de Font-Réaulx, eds. *Le daguerréotype français: Un objet photographique*. Exh. cat. Paris: Musée d'Orsay/Réunion des musées nationaux; New York: The Metropolitan Museum of Art, 2003.

Barthes, Roland. *The Eiffel Tower and Other Mythologies*. Translated by Richard Howard. New York: Hill and Wang, 1979.

Bartsch, Katharine. "Re-thinking Islamic Architecture: A Critique of the Aga Khan Award for Architecture through the Paradigm of Encounter." PhD diss., University of Adelaide, 2005.

Behdad, Ali. *Camera Orientalis: Reflections on Photography of the Middle East*. Chicago: University of Chicago Press, 2016.

Behdad, Ali, and Luke Gartlan, eds. *Photography's Orientalism: New Essays on Colonial Representation*. Los Angeles: Getty Research Institute, 2013.

Behrens-Abouseif, Doris, and Stephen Vernoit. *Islamic Art in the 19th Century: Tradition, Innovation, and Eclecticism*. Leiden: Brill, 2006.

Belenet, Ernest de. "Chronique Parisienne." *Echo de la littérature et des beaux-arts en France et à l'étranger* 6 (1846), pp. 387–91.

Belisle, Brooke. "Total Archive: Picturing History from the Stereographic Library to the Digital Database." *Mediascape* (Winter 2013). http://www.tft.ucla.edu/mediascape/pdfs/Winter2013/PicturingHistory.pdf.

Béraldi, Henri. *Les graveurs du 19e siècle: Guide de l'amateur d'estampes modernes*. 12 vols. Paris: L. Conquet, 1885–92.

Bideault, Maryse. "Œuvre de Joseph-Philibert Girault de Prangey." In *L'iconographie du Caire dans les collections patrimoniales françaises*, edited by Maryse Bideault and Mercedes Volait. Paris: Institut national d'histoire de l'art, 2010. http://inha.revues.org/4750.

Bierman, Irene A. "Disciplining the Eye: The Project of Making Cairo Medieval." In *Making Cairo Medieval*, edited by Nezar AlSayyad, Irene A. Bierman, and Nasser Rabbat, pp. 9–27. Lanham, Md.: Lexington Books, 2005.

Bohrer, Frederick N. *Photography and Archaeology*. London: Reaktion Books, 2011.

Brébisson, Louis-Alphonse. *De quelques modifications apportées aux procédés du daguerréotype*. Falaise: Levavasseur, 1841.

Brocard, Henry. "M. Girault de Prangey." *Bulletin de la Société historique et archéologique de Langres* 4, no. 50 (July 1, 1893), pp. 15–21.

Burke, Edmund, and David Prochaska, eds. *Genealogies of Orientalism: History, Theory, Politics*. Lincoln: University of Nebraska Press, 2008.

Burns, Karen. "Topographies of Tourism: 'Documentary' Photography and 'The Stones of Venice.'" *Assemblage* 32 (April 1997), pp. 22–44.

Buron, Noël-François-Joseph. *Description de nouveaux daguer-réotypes perfectionnés et portatifs.* Paris: N.-F.-J. Buron, 1841.

Buzard, James. *The Beaten Track: European Tourism, Literature, and the Ways to Culture, 1800–1918.* Oxford: Clarendon Press, 1993.

Cadalvène, Edmond de. *L'Egypte et la Turquie, de 1829 à 1836.* 2 vols. Paris: A. Bertrand, 1836.

Caquet, Pierre E. *The Orient, the Liberal Movement, and the Eastern Crisis of 1839–41.* Cham, Switzerland: Palgrave Macmillan, 2016.

Carabott, Philip, Yannis Hamilakis, and Eleni Papargyriou, eds. *Camera Graeca: Photographs, Narratives, Materialities.* London: Routledge, 2015.

Catalogue du fonds de A. Hauser, successeur de Pieri Bénard, marchand d'estampes de la bibliothèque du roi. Paris: P. Dupont, 1843.

Catalogue of the Highly Important, Extensive, and Valuable Library of M. Le Baron J. Taylor. Sale cat. S. L. Sotheby and J. Wilkinson, London, June 1, 1853.

Caumont, Arcisse de. *Le pittoresque nous déborde.* Caen: A. Hardel, n.d.

———. *Cours d'antiquités monumentales professé à Caen, en 1830, par M. de Caumont […] Histoire de l'art dans l'ouest de la France, depuis les temps les plus reculés jusqu'au XVIIe siècle.* 6 vols. Paris: Lange, 1830–43.

Caumont, Olivier. "Joseph-Philibert Girault de Prangey (1804–1892): Voyageur, illustrateur et éditeur d'art; Techniques de production des images, du dessin à la photographie." In *Art et artistes Haut-Marne XVe–XIXe siècle: Actes du Ier colloque biennal des Cahiers haut-marnais, Chaumont, 17–19 Octobre 2014,* edited by Patrick Corbet, Alain Morgat, and Samuel Mourin, pp. 278–95. Chaumont: Pythagore, 2014.

Çelik, Zeynep, and Edhem Eldem. *Camera Ottomana: Photography and Modernity in the Ottoman Empire, 1840–1914.* Istanbul: Koç University Press, 2015.

"Le Cercle des arts." *L'artiste* 12 (1836), pp. 265–66.

Chapuy, Nicolas-Marie-Joseph, and Philippe Moret. *Le Moyen-Age pittoresque: Monuments et fragments d'architecture, meubles, armes, armures, et objets de curiosité du Xe au XVIIe siècle.* 5 vols. Paris: Veith et Hauser, 1837–40.

Chevalier, Charles. *Nouvelles instructions sur l'usage du daguerréotype: Description d'un nouveau photographie, et d'un appareil très simple destiné à la reproduction des épreuves au moyen de la galvanoplastie.* Paris: C. Chevalier, 1841.

———. *Recueil de mémoires et de procédés nouveaux concernant la photographie sur plaques métalliques et sur papier.* Paris: C. Chevalier, 1847.

"Chronique: Retour de M. Girault de Prangey." *Bulletin monumental* 11 (1845), p. 317.

"Chronique: Voyage de M. Girault de Prangey, inspecteur des monuments de la Haute-Marne." *Bulletin monumental* 7 (1841), p. 303.

Claridge, Amanda. *Rome: An Oxford Archaeological Guide.* Oxford: Oxford University Press, 2010.

Clogg, Richard. *A Concise History of Greece.* Cambridge: Cambridge University Press, 1992.

Coarelli, Filippo. *Rome and Environs: An Archaeological Guide.* Translated by James J. Clauss and Daniel P. Harmon. Berkeley: University of California Press, 2014.

Constantinou, Fani, et al., eds. *Athens, 1839–1900: A Photographic Record.* Exh. cat. Athens: Benaki Museum, 2004.

Coste, Pascal-Xavier. *Architecture arabe; ou, Monuments du Kaire, mesurés et dessinés, de 1818 à 1826.* Paris: Firmin Didot, 1839.

———. *Mémoires d'un artiste: Notes et souvenirs de voyages (1817–1877).* 2 vols. Marseille: Cayer, 1878.

Creswell, K. A. C. "The Lawfulness of Painting in Islam." *Ars Islamica* 11/12 (1946), pp. 159–66.

Cussy, Pierre de. "Nouvelles de M. Girault de Prangey." *Bulletin monumental* 10 (1844), pp. 235–38.

Daston, Lorraine, and Peter Galison. "The Image of Objectivity." *Representations* 40 (Fall 1992), pp. 81–128.

Decléty, Lorraine. "Les architectes français et l'architecture islamique: Les premiers pas vers l'histoire d'un style." *Livraisons d'histoire de l'architecture* 9 (2005), pp. 73–84.

Delambre, M. "Rapport sur les médailles à décerner aux contre-maîtres des ateliers." *Bulletin de la Société d'encouragement pour l'industrie nationale* 40 (1841), pp. 334–37.

Delécluze, Etienne-Jean. "Feuilleton du Journal des Débats: Variété." *Journal des débats politiques et littéraires,* October 25, 1837.

Déléry, Claire. "Girault de Prangey: Vers une étude moderne de la céramique monumentale nasride." In *Voyage en Andalousie mauresque: Girault de Prangey,* edited by Michel Maupoix, pp. 50–59. Exh. cat. Le Blanc: Bibliothèque municipale, 2011.

Desautels, Jacques, Georges Aubin, and Renée Blanchet, eds. *Voyage en Orient (1839–1840): Journal d'un voyageur curieux du monde et d'un pionnier de la daguerréotypie.* Quebec: Presses de l'Université Laval, 2010.

de Stefano, Jason. "From Objectivity to the Scientific Self: A Conversation with Peter Galison." *Qui parle* 23, no. 2 (Spring–Summer 2015), pp. 89–114.

Downing, Eric. *After Images: Photography, Archaeology, Psycho-analysis and the Tradition of Bildung.* Detroit: Wayne State University Press, 2006.

Durand, Marc. *De l'image fixe à l'image animée, 1820–1910: Actes des notaires de Paris pour servir à l'histoire des photographes et de la photographie.* 2 vols. Pierrefitte-sur-Seine: Archives nationales, 2015.

Ebers, Georg. *L'Egypte: Alexandrie et le Caire.* Translated by Gaston Maspero. 2 vols. Paris: Firmin Didot, 1880–81.

Eggleton, Lara. "History in the Making: The Ornament of the Alhambra and the Past-Facing Present." *Journal of Art Historiography* 6 (June 2012). *Islamic Art Historiography,* special issue edited by Moya Carey and Margaret Graves. https://arthistoriography.files.wordpress.com/2012/05/eggleton.pdf.

———. "'A Living Ruin': Palace, City, and Landscape in Nineteenth-Century Travel Descriptions of Granada." *Architecture Theory Review* 18, no. 3 (December 2013), pp. 372–87.

El Annabi, Hassen. "La Méditerranée des voyageurs au XIXe siècle." *Recherches régionales: Alpes-Maritimes et contrées limitrophesno* 155 (October–December 2000), pp. 34–38.

"Extrait d'un rapport fait par M. le baron Seguier, au nom d'une commission speciale, sur le concours pour des perfectionnements dans la photographie." *Bulletin de la Société d'encouragement pour l'industrie nationale* 41 (1842), pp. 124–25.

Feyler, Gabrielle. "Contribution à l'histoire des origines de la photographie archéologique: 1839–1880." *Mélanges de l'Ecole française de Rome: Antiquité* 99, no. 2 (1987), pp. 1019–47.

Fine Photographs. Sale cat. Christie's, London, South Kensington, May 5, 2000.

Fizeau, Hippolyte. "Note sur un moyen de fixer les images photographiques." *Comptes rendus hebdomaires des séances de l'Académie des sciences* 11 (August 10, 1840), pp. 237–38.

Flood, Finbarr Barry. "From the Prophet to Postmodernism? New World Orders and the End of Islamic Art." In *Making Art History: A Changing Discipline and Its Institutions*, edited by Elizabeth C. Mansfield, pp. 31–53. New York: Routledge, 2007.

———. "Inciting Modernity? Images, Alterities and the Contexts of 'Cartoon Wars.'" In *Images That Move*, edited by Patricia Spyer and Mary Margaret Steedly, pp. 41–72. Santa Fe: SAR Press, 2013.

"Les Fontaines de Paris." *Le Petit Journal*, August 4, 1872, p. 3.

Fossier, François, ed. "Correspondance des directeurs de l'Académie de France à Rome." Vol. 7, "Premier directorat de Jean-Victor Schnetz (1840–1843)." Unpublished manuscript, previously available on the website of the Institut de France, Paris (accessed March 2018; link discontinued).

Fraser, Elizabeth. *Mediterranean Encounters: Artists between Europe and the Ottoman Empire, 1774–1839*. University Park: Pennsylvania State University Press, 2017.

Gailhabaud, Jules. *Monuments anciens et modernes: Collection formant une histoire de l'architecture des différents peuples à toutes les époques*. Vol. 3, *Moyen Age: IIe partie*. Paris: Firmin Didot, 1850.

Gaudin, Marc-Antoine, and Noël-Paymal Lerebours. *Derniers perfectionnements apportés au daguerréotype*. 3rd ed. Paris: N.-P. Lerebours, 1841.

Gernsheim, Helmut, and Alison Gernsheim. *The History of Photography from the Earliest Use of the Camera Obscura in the Eleventh Century up to 1914*. London: Oxford University Press, 1955.

———. *L. J. M. Daguerre: The History of the Diorama and the Daguerreotype*. London: Secker and Warburg, 1956.

Ghabbān, 'Alī Ibrahim, et al., eds. *Roads of Arabia: Archaeology and History of the Kingdom of Saudi Arabia*. Exh. cat. Paris: Musée du Louvre/Somogy, 2010.

Gobineau, Arthur de. *Essai sur l'inégalité des races humaines*. 4 vols. Paris: Firmin Didot, 1853–55.

Godard, Léon. "Esquisse de l'histoire de Chaumont en Bassigny." *Mémoires de la Société historique et archéologique de Langres* I, no. 6 (1850), pp. 115–34.

Gomot, Hippolyte. *Marilhat et son oeuvre*. Clermont-Ferrand: Mont-Louis, 1884.

Goury, Jules, and Owen Jones. *Plans, Elevations, Sections, and Details of the Alhambra from Drawings Taken on the Spot in 1834, by Jules Goury, and in 1834 and 1837 by Owen Jones*. 2 vols. London: O. Jones, 1842–45.

Gran-Aymerich, Eve. *Naissance de l'archéologie moderne, 1798–1845*. Paris: CNRS, 1998.

Gran-Aymerich, Eve, and Natacha Lubtchansky. "Raoul-Rochette, Désiré." In *Dictionnaire critique des historiens de l'art actifs en France de la Révolution à la Première Guerre mondiale*, edited by Philippe Sénéchal and Claire Barbillon. Paris: Institut nationale de l'histoire de l'art, 2010– .

Graves, Margaret. "Feeling Uncomfortable in the Nineteenth Century." *Journal of Art Historiography* 6 (June 2012). *Islamic Art Historiography*, special issue edited by Moya Carey and Margaret Graves. https://arthistoriography.files .wordpress.com/2012/05/graves.pdf.

Guégan, Stéphane. "Jules Ziegler: Peintre." PhD diss., Université Paris-Sorbonne IV, 2000.

———. "'Ces bonheurs-là n'arrivent qu'aux habiles': Gautier et la photographie d'artiste." *48/14: La revue du Musée d'Orsay* 28 (2009), pp. 6–23.

Hamilakis, Yannis. *The Nation and Its Ruins: Antiquity, Archaeology and National Imagination in Greece*. Oxford: Oxford University Press, 2007.

A Hand-Book for Travellers in the Ionian Islands, Greece, Turkey, Asia Minor, and Constantinople. London: John Murray, 1840.

Hannoosh, Michele. "Horace Vernet's 'Orient': Photography and the Eastern Mediterranean in 1839, Part I: A Daguerrean Excursion." *Burlington Magazine* 158, no. 1357 (April 2016), pp. 264–71.

———. "Horace Vernet's 'Orient': Photography and the Eastern Mediterranean in 1839, Part II: The Daguerreotypes and Their Texts." *Burlington Magazine* 158, no. 1359 (June 2016), pp. 430–39.

Harkett, Daniel, and Katie Hornstein, eds. *Horace Vernet and the Thresholds of Nineteenth-Century Visual Culture*. Hanover, N.H.: Dartmouth College Press, 2017.

Hattich, Géraldine-Lucille. "Joseph-Philibert Girault de Prangey: Ein Pionier der Reisedaguerreotypie." MA thesis, University of Zurich, 2012.

A Historic Photographic Grand Tour: Important Daguerreotypes by Joseph-Philibert Girault de Prangey. Sale cat. Christie's, New York, October 7, 2010.

Hitzel, Frédéric, and Sophie Makariou. "Girault de Prangey, Joseph-Philibert (Langres, 1804–Courcelles-Val-d'Esnoms, 1892)." In *Dictionnaire des orientalistes de langue française*, edited by François Pouillon, pp. 446–48. Paris: Karthala, 2008.

Holmes, Oliver Wendell. "The Stereoscope and the Stereograph." *The Atlantic Monthly* 3 (June 1859), pp. 738–48.

Horeau, Hector. *Panorama d'Egypte et de Nubie avec un portrait de Méhémet-Ali et un texte orné de vignettes*. Paris: H. Horeau, 1841.

Hosford, Desmond, and Chong J. Wojtkowski, eds. *French Orientalism: Culture, Politics, and the Imagined Other*. Newcastle: Cambridge Scholars, 2010.

[Hubert, Alphonse-Eugène]. *Le daguerréotype: Considéré sous un point de vue artistique, mécanique et pittoresque*. Paris: A. Giroux, 1840.

Important Daguerreotypes by Joseph-Philibert Girault de Prangey from the Archive of the Artist. Sale cat. Christie's, London, May 20, 2003.

Important Daguerreotypes by Joseph-Philibert Girault de Prangey from the Archive of the Artist, Part II. Sale cat. Christie's, London, May 18, 2004.

Jacobson, Ken, and Jenny Jacobson. *Carrying off the Palaces: John Ruskin's Lost Daguerreotypes*. London: Bernard Quaritch, 2015.

Khoury, Nuha N. N. "The Dome of the Rock, the Ka'ba, and Ghumdan: Arab Myths and Umayyad Monuments." *Muqarnas* 10 (1993), pp. 57–66.

Kingslake, Rudolf. "Charles Chevalier and the 'Photographe à verres combinés.'" *Image* 10, no. 5 (1961), pp. 17–19.

Kockel, Valentin. "Plaster Models and Plaster Casts of Classical Architecture and Its Decoration." In *Plaster Casts: Making, Collecting and Displaying from Classical Antiquity to the Present*, edited by Rune Frederiksen and Eckart Marchand, pp. 419–32. Berlin: De Gruyter, 2010.

Laborde, Alexandre-Louis-Joseph de. *Voyage pittoresque et historique de l'Espagne*. 2 vols. Paris: P. Didot l'aîné, 1806–20.

Labrusse, Rémi. *Islamophilies: L'Europe moderne et les arts de l'islam*. Exh. cat. Lyon: Musée des Beaux-Arts; Paris: Somogy, 2011.

Lebowitz, Anjuli. "Faith in the Field: The Art of Discovery in Auguste Salzmann's Photographic Albums, 1854–1875." PhD diss., Boston University, 2017.

Leech, Nick. "Looking East from West: Orientalism at the Louvre Abu Dhabi." *Writing to Inform*, May 26, 2013. https://writingtoinform.com/2013/05/26/looking-east-from-west-orientalism-at-the-louvre-abu-dhabi/.

Le Gray, Gustave. *A Practical Treatise of Photography, upon Paper and Glass*. Translated by Thomas Cousins. London: T. and R. Willats, 1850.

Lerebours, Noël-Paymal. *Excursions daguerriennes: Vues et monuments les plus remarquables du globe*. 2 vols. Paris: Rittner et Goupil, 1840–44.

———. *A Treatise on Photography: Containing the Latest Discoveries and Improvements Appertaining to the Daguerreotype*. Translated by John Egerton. London: Longman, Brown, Green and Longmans, 1843.

Le Roy, Julien-David. *Les ruines des plus beaux monuments de la Grèce: Ouvrage divisé en deux parties, où l'on considère, dans la première, ces monuments du côté de l'histoire; et dans la seconde, du côté de l'architecture*. Paris: Guerin et Delatour, 1758.

Levine, Neil. "The Template of Photography in Nineteenth-Century Architectural Representation." *Journal of the Society of Architectural Historians* 71, no. 3 (September 2012), pp. 306–31.

"Liste générale des membres de la Société française pour la conservation des monuments, dans l'ordre de leur réception." *Bulletin monumental* 8 (1842), pp. 595–615.

Luxenberg, Alisa. *Secrets and Glory: Baron Taylor and His 'Voyage pittoresque en Espagne.'* Madrid: CEEH; New York: CSA and Hispanic Society of America, 2013.

McNeal, Richard A. "Archaeology and the Destruction of the Later Athenian Acropolis." *Antiquity* 65 (1991), pp. 49–63.

Mairs, Rachel, and Maya Muratov. *Archaeologists, Tourists, Interpreters: Exploring Egypt and the Near East in the Late 19th–Early 20th Centuries*. London: Bloomsbury Academic, 2015.

Marchand, Suzanne L. *Down from Olympus: Archaeology and Philhellenism in Germany, 1750–1970*. Princeton: Princeton University Press, 1996.

Marquis, Emmanuelle A., et al. "Exposing the Sub-Surface of Historical Daguerreotypes and the Effects of Sulfur-Induced Corrosion." *Corrosion Science* 94 (2015), pp. 438–44.

Massot, Gilles. "Jules Itier and the Lagrené Mission." *History of Photography* 39, no. 4 (November 2015), pp. 319–47.

Mauron, Christophe, ed. *Miroirs d'argent: Daguerréotypes de Girault de Prangey*. Exh. cat. Bulle: Musée Gruérien; Geneva: Slatkine, 2008.

Meath Baker, Elizabeth. "Alchemy on a Plate: The First Photographs of Istanbul." *Cornucopia* 29 (2003), pp. 34–49.

Mitchell, Timothy. *Colonising Egypt*. Cambridge: Cambridge University Press, 1988.

Mourot, Victor-Antoine. *La Terre-Sainte et le pèlerinage de pénitence en 1882: Impressions et souvenirs*. 2 vols. Paris: Librairie Catholique Internationale, 1882.

Murphy, James Cavanah. *The Arabian Antiquities of Spain*. London: Cadell and Davies, 1815.

Naef, Weston J. *Photographers of Genius at the Getty*. Exh. cat. Los Angeles: J. Paul Getty Museum, 2004.

Neils, Jenifer, ed. *The Parthenon from Antiquity to the Present*. Cambridge: Cambridge University Press, 2005.

Nochlin, Linda. "The Imaginary Orient." *Art in America* 71 (1983), pp. 118–31.

Olsen, Bjørnar, et al. *Archaeology: The Discipline of Things*. Berkeley: University of California Press, 2012.

Perez, Nissan N. *Focus East: Early Photography in the Near East (1839–1885)*. New York: Abrams, 1988.

Philipon, Charles, ed. *Paris et ses environs reproduits par le daguerréotype*. Paris: Aubert, 1840.

"Physique appliquée aux arts: Nouveaux détails sur le daguerréotype." *Journal des connaissances nécessaires et indispensables aux industriels, aux manufacturiers, aux commerçants et aux gens du monde* 1 (1839), pp. 529–32.

La photographie IV: Collection Marie-Thérèse et André Jammes. Sale cat. Sotheby's, Paris, November 15, 2008.

Pilbeam, Pamela M. *Saint-Simonians in Nineteenth-Century France: From Free Love to Algeria*. Basingstoke: Palgrave Macmillan, 2014.

Pinson, Stephen C. *Speculating Daguerre: Art and Enterprise in the Work of L. J. M. Daguerre*. Chicago: University of Chicago Press, 2012.

Pinto, John A. *City of the Soul: Rome and the Romantics*. Exh. cat. New York: Morgan Library and Museum; Hanover, N.H.: University Press of New England, 2016.

Prisse d'Avennes, Emile. *L'art arabe d'après les monuments du Kaire depuis le VIIe siècle jusqu'à la fin du XVIIIe*. 4 vols. Paris: A. Morel, 1869–77.

"Procès-verbal de la séance tenue à Paris par la Société française, le 20 et le 25 janvier 1842: Séance du 20 janvier, à Paris." *Bulletin monumental* 8 (1842), pp. 42–56.

"Procès-verbal de la séance tenue à Paris par la Société française, le 20 et le 25 janvier 1842: Séance du 25 janvier 1842 à Paris." *Bulletin monumental* 8 (1842), pp. 56–72.

Promenades dans Paris et ses environs: Dessiné d'après nature et lithographié par J. Jacottet. Paris: Gihaut Frères, n.d.

Quettier, Philippe. "La villa Girault de Prangey à Courcelles-Val-d'Esnoms: Approche critique et essai de reconstitution." *Bulletin de la Société historique et archéologique de Langres* 22, no. 330 (1998), pp. 365–74.

Quettier, Philippe, et al. *Sur les traces de Girault de Prangey, 1804–1892: Dessins-peintures, photographies, études historiques*. Exh. cat. Langres: Musées de Langres/Dominique Guéniot, 1998.

Rabbat, Nasser. "What Is Islamic Architecture Anyway?" *Journal of Art Historiography* 6 (June 2012). *Islamic Art Historiography*, special issue edited by Moya Carey and Margaret Graves. https://arthistoriography.files.wordpress.com/2012/05/rabbat1.pdf.

Ramée, Daniel. *Sculptures décoratives, recueillies en France, Allemagne, Italie et Espagne, du XIIe au XVIe siècle*. Paris: Lévy, 1862–64.

Ramée, Daniel, and Nicolas-Marie-Joseph Chapuy. *Le Moyen-Age monumental et archéologique: Vues, détails et plans des monuments les plus remarquables de l'Europe, depuis le 6e jusqu'au 16e siècle*. 4 vols. Paris: A. Hauser, 1840–45.

Raquejo, Tonia. "The 'Arab Cathedrals': Moorish Architecture as Seen by British Travellers." *Burlington Magazine* 128, no. 1001 (August 1986), pp. 555–63.

Reinaud, Joseph-Toussaint. *Monumens arabes, persans et turcs du cabinet de M. le Duc de Blacas et d'autres cabinets: Considérés et décrits d'après leurs rapports avec les croyances, les mœurs et l'histoire des nations musulmanes*. 2 vols. Paris: Imprimerie Royale, 1828.

———. "Critique littéraire." *Journal asiatique* 13 (April 1842), pp. 336–66.

Reynaud, Françoise, ed. *Paris et le daguerreotype*. Exh. cat. Paris: Musée Carnavalet, 1989.

Ritter, Markus, and Staci G. Scheiwiller, eds. *The Indigenous Lens? Early Photography in the Near and Middle East*. Berlin: De Gruyter, 2018.

Robinson, Mike. "The Techniques and Material Aesthetics of

the Daguerreotype." PhD diss., De Montfort University, Leicester, 2017.

Rosser-Owen, Mariam. "Mediterraneanism: How to Incorporate Islamic Art into an Emerging Field." *Journal of Art Historiography* 6 (June 2012). *Islamic Art Historiography*, special issue edited by Moya Carey and Margaret Graves. https://arthistoriography.files.wordpress.com/2012/05/rosserowen.pdf.

Royal Institute of British Architects. *How to Observe: Architecture; or, Questions upon Various Subjects Connected Therewith, Suggested for the Direction of Correspondents and Travellers, and for the Purpose of Eliciting Uniformity of Observation and Intelligence in Their Communications to the Institute.* London: J. Davy and Sons, 1842.

Saint-Fergeux, Théodore Pistolet de. "Ziegler, Jules Claude." In *Biographie universelle, ancienne et moderne; ou, Histoire, par ordre alphabétique, de la vie publique et privée de tous les hommes qui se sont fait remarquer par leurs écrits, leurs actions, leurs talents, leurs vertus ou leurs crimes*, edited by Louis Gabriel Michaud and Joseph François Michaud. 85 vols. Paris: Desplaces; Leipzig: Brockhaus, 1811–62.

Sanders, Paula. *Creating Medieval Cairo: Empire, Religion, and Architectural Preservation in Nineteenth-Century Egypt.* Cairo: American University in Cairo Press, 2008.

Séroux d'Agincourt, Jean-Baptiste Louis Georges. *Histoire de l'art par les monuments, depuis sa décadence au IVe siècle jusqu'à son renouvellement au XIVe.* Paris: Treuttel et Würtz, 1823.

Shanks, Michael, and Connie Svabo. "Photography and Archaeology: A Pragmatology." In *Reclaiming Archaeology: Beyond the Tropes of Modernity*, edited by Alfredo González-Ruibal, pp. 89–103. New York: Routledge, 2013.

Sheehi, Stephen. "A Social History of Arab Photography; or, A Prolegomenon to an Archaeology of the Lebanese Bourgeoisie." *International Journal of Middle East Studies* 39, no. 2 (May 2007), pp. 177–208.

———. "The *Nahda* After-Image; or, All Photography Expresses Social Relations." *Third Text* 26, no. 4 (July 2012), pp. 401–14.

———. *The Arab Imago: A Social History of Portrait Photography, 1860–1910.* Princeton: Princeton University Press, 2016.

Siegel, Steffen, ed. *First Exposures: Writings from the Beginning of Photography.* Los Angeles: J. Paul Getty Museum, 2017.

Siegenfuhr, Romain. "Les photographies du Caire peintes par Willem de Famars Testas." In *The Myth of the Orient: Architecture and Ornament in the Age of Orientalism*, edited by Francine Giese and Ariane Varela Braga, pp. 35–50. Bern: Peter Lang, 2016.

Simons, Jan. "Weightless Photography." In *The Weight of Photography*, edited by Luc Deneulin and Johan Swinnen, pp. 557–75. Brussels: Academic and Scientific Publishers, 2010.

Simony, Charles de. "Une curieuse figure d'artiste: Girault de Prangey (1804–1892)." *Mémoires de l'Académie des sciences, arts et belles-lettres de Dijon* 1934 (1935), pp. 55–62.

———. *Une curieuse figure d'artiste: Girault de Prangey, 1804–1892.* Dijon: J. Belvet, 1937.

Stewart, Lindsey S. "In Perfect Order: Antiquity in the Daguerreotypes of Joseph-Philibert Girault de Prangey." In *Antiquity and Photography: Early Views of Ancient Mediterranean Sites*, edited by Claire L. Lyons, pp. 66–91. Exh. cat. Los Angeles: J. Paul Getty Museum, 2005.

Stiegler, Bernd. "La surface du monde: Note sur Théophile Gautier." *Romantisme* 105 (1999), pp. 91–95.

Stuart, James, and Nicholas Revett. *Antiquities of Athens Measured and Delineated by James Stuart FRS and FSA and Nicholas Revett.* 4 vols. London: J. Haberkorn/J. Nichols, 1762–1816.

Szegedy-Maszak, Andrew. "A Perfect Ruin: Nineteenth-Century Views of the Colosseum." *Arion* 2, no. 1 (1992), pp. 115–42.

———. "Forum Romanum/Campo Vaccino." *History of Photography* 20, no. 1 (1996), pp. 24–32.

———. "Roman Views." In *Six Exposures: Essays in Celebration of the Opening of the Harrison D. Horblit Collection of Early Photography*, pp. 89–106. Cambridge, Mass.: Houghton Library, Harvard University, 1999.

———. "'Rambles in Rome': Some 19th-Century Travellers and Photographers." In *Britannia, Italia, Germania: Taste and Travel in the Nineteenth Century*, edited by Carol Richardson and Graham Smith, pp. 6–22. Edinburgh: Visual Arts Research Institute, 2001.

Taylor, Isidore-Justin-Séverin. *Voyage pittoresque en Espagne, en Portugal et sur la Côte d'Afrique de Tanger à Tétouan.* 2 vols. Paris: Gide, 1826–51.

Taylor, Roger. "Early Daguerreotypes of Italy." In *Making of the Modern World: Milestones of Science and Technology*, edited by Neil Cossons, pp. 78–79. London: John Murray, 1992.

Tisserand, Gérard. *L'Egypte dans les collections des musées de Langres.* Langres, 1979.

Venayre, Sylvain. "Le voyage, le journal et les journalistes au XIXe siècle." *Le temps des médias* 1, no. 8 (2007), pp. 46–56.

Vernoit, Stephen. *Occidentalism: Islamic Art in the 19th Century.* London: Nour Foundation, 1997.

———. "The Rise of Islamic Archaeology." *Muqarnas* 14 (1997), pp. 1–10.

———. "Islamic Art and Architecture: An Overview of Scholarship and Collecting, c. 1850–c. 1950." In *Discovering Islamic Art: Scholars, Collectors and Collections 1850–1950*, edited by Stephen Vernoit, pp. 1–61. London: I. B. Tauris, 2000.

Vigouroux, Elodie. "Girault de Prangey à Damas (1843–1844): A la lumière des clichés conservés à la Bibliothèque nationale de France." *Histoire urbaine* 46, no. 2 (2016), pp. 87–114.

Volait, Mercedes. "Les monuments de l'architecture arabe." In *Pascal Coste: Toutes les Egypte*, edited by Dominique Jacobi, pp. 97–130. Exh. cat. Marseille: Bibliothèque municipale/Parenthèses, 1998.

———. "Surveying Monuments in Egypt: The Work of Emile Prisse d'Avennes (1807–1879)." Lecture given at the General Consulate of Egypt in Djeddah, November 30, 2013, https://halshs.archives-ouvertes.fr/halshs-00923016/document.

Werren, Jacques. "Jules Ziegler: Un élève oublié d'Hippolyte Bayard." *Etudes photographiques* 12 (2002), pp. 64–97.

———. *Jules Ziegler: Peintre, céramiste, photographe.* Le Mans: Reinette, 2010.

Yiakoumis, Haris. *Hē Akropolē tōn Athēnōn: Phōtographies, 1839–1959/The Acropolis of Athens: Photographs, 1839–1959/L'Acropole d'Athènes: Photographies, 1839–1959.* Athens: Potamos; Paris: Picard, 2000.

Zannier, Italo. "Excursions Daguerriennes in Italia." *Fotologia* 10 (1988), pp. 6–17.

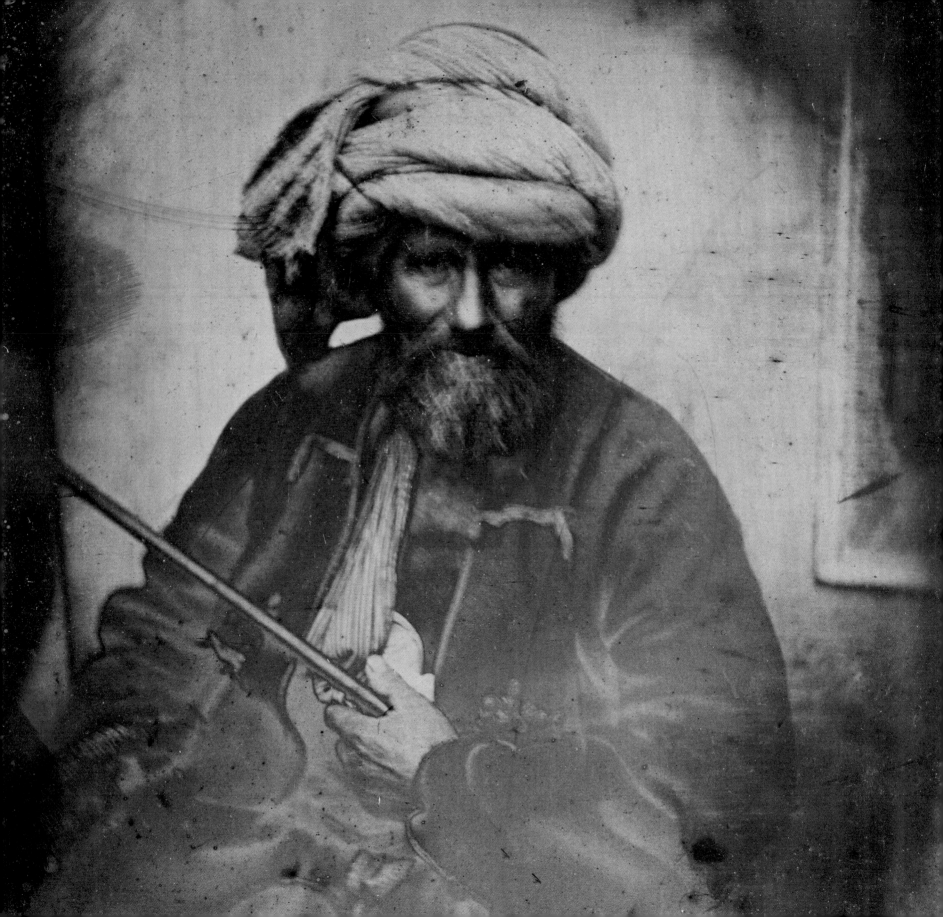

Index

This catalogue is published in conjunction with the exhibition "Monumental Journey: The Daguerreotypes of Girault de Prangey," on view at The Metropolitan Museum of Art, New York, from January 30 to May 12, 2019.

The exhibition is made possible by the Arête Foundation/ Betsy and Ed Cohen.

The exhibition is organized by The Metropolitan Museum of Art, New York, in collaboration with the Bibliothèque nationale de France, Paris.

This catalogue is made possible by the Diane W. and James E. Burke Fund.

Published by The Metropolitan Museum of Art, New York

Mark Polizzotti, Publisher and Editor in Chief
Gwen Roginsky, Associate Publisher and General Manager of Publications
Peter Antony, Chief Production Manager
Michael Sittenfeld, Senior Managing Editor

Edited by Marcie M. Muscat
Production by Paul Booth
Designed by Carl W. Scarbrough
Image acquisitions and permissions by Elizabeth De Mase
Map and renderings by Adrian Kitzinger
Translations from the French by Rose Vekony

Typeset in Le Monde Livre
Printed on Perigord 130 gsm
Color separations, printing, and binding by Trifolio S.r.l., Verona, Italy

Cover illustration: *Olympieion, Athens, Viewed from the East*, 1842 (pl. 32). Additional illustrations: pp. ii–iii: *Desert near Alexandria*, 1842 (pl. 47, detail); p. iv: *Erechtheion, Athens*, 1842 (pl. 41, detail); p. vi: *Tower of the Winds, Athens*, 1842 (pl. 30, detail); p. viii: *Fountain, Place du Château d'Eau, Paris*, 1841–42 (pl. 7, detail); p. xii: *Rocks, Philae*, 1844 (pl. 86, detail); p. xiv: *Plant Study, Paris*, 1841 (pl. 8, detail); p. 8: *Palm Tree near the Church of Saints Theodore, Athens*, 1842 (pl. 29, detail); pp. 26–27: *Gardens, Villa Medici, Rome*, 1842 (pl. 25, detail); p. 156: *Ayoucha, Cairo*, 1842–43 (pl. 66, detail); p. 190: *Iwan, Damascus*, 1844 (pl. 104, detail); p. 212: *Aleppo, Viewed from the Antioch Gate*, 1844 (pl. 116, detail); p. 232: *Surudjé (Horse Driver), Constantinople*, 1843 (pl. 79, detail).

The Metropolitan Museum of Art
1000 Fifth Avenue
New York, New York 10028
metmuseum.org

Distributed by Yale University Press, New Haven and London
yalebooks.com/art
yalebooks.co.uk

Cataloging-in-Publication Data is available from the Library of Congress.
ISBN 978-1-58839-663-1